The Concept of Art

THE CONCEPT OF ART

HAIG KHATCHADOURIAN

University of Wisconsin

New York
New York University Press 1971

to
Elias Awad
and
William Bardawil
rare friends

Preface

In this book, I attempt to sketch the salient features of the ordinary concept of art, as formulated by present-day ordinary aesthetic discourse. The features include a description of the type of object, activity, and the like that 'work of art' and the less general art labels ordinarily refer to; the delineation of the aims of art; and the nature and conditions of the perception and enjoyment of art. The sketch includes an analysis of the uses of 'good,' 'bad,' and other grading labels in aesthetic judgments, the logical connection between these uses (as well as some of the main general criteria for the appraisal of paintings, poems, or symphonies qua art), and the aims of art as determined by ordinary usage. Analysis of the uses of the phenomenological and affective, including "expressive," concepts—which Frank Sibley has called "aesthetic concepts"—illuminates further the ordinary concept of art, revealing the precise mechanism, as enshrined in aesthetic language, whereby the sensuous and nonsensuous features of works of art are ordinarily conceived to serve the aims of art. In this way, the concept of a work of art as an object, activity, or the like exhibiting various features is ultimately linked to the emotional, imaginative, and intellectual effects included in the concept of the enjoyment of art.

In addition to the conceptual inquiry, certain portions of the book, especially sections of Parts II and III, are for the most part straightforwardly empirical; they partly or wholly consist in what some philosophers would call "insights" about art. (Assuming that they are true!) Indeed, the last chapter of the book is almost entirely "extralinguistic," since it is concerned precisely with the *contingent*

relations between ordinary aesthetic value and other types of aesthetic value, that is, with the larger, societal context in which the ordinary conceptual framework of art has its being and from which it draws its vitality. This excursion into the empirical is not at all arbitrary, for I regard it as neither possible nor desirable for philosophers, particularly in such areas as aesthetics and ethics, to confine themselves to the mapping of the conceptual terrain of ordinary (or of technical or critical) aesthetic discourse. My extralinguistic disquisitions in this book must be regarded only as a first step toward extended trips onto that terrain. A number of important general facts, or what appear to me to be facts, emerge from the conceptual analysis, two of which are worth noting here.

First, the ordinary concept of art is more complex and sophisticated than any traditional philosophical concept or conception of art. There is no neat or simple pattern characterizing either ordinary aesthetic discourse as a whole or parts of it. Certainly there are no logically necessary and sufficient conditions for the ordinary employment of 'art' and other art labels. This is hardly news to philosophers familiar with the later work of Wittgenstein and the analytical movement in philosophy. The second point is more significant.

Analysis shows that there is considerably greater unity in ordinary aesthetic discourse, hence in our aesthetic concepts, than most or all of the analytical philosophers [1] who have written on aesthetics suppose. More precisely, there is greater homogeneity within each concept and greater relatedness between the various aesthetic concepts than is generally thought. One very important aspect of the latter point is that there is a definite connection, though a very general and flexible one, between the concept of a work of art and the almost unlimited reasons or types of reasons which laymen and/or critics give for their grading of particular works or types of works as good or bad of their kind, or as art in general. This connection between the concept of art and reasons is due to an important aspect of the concept of art and to the ordinary uses of 'work of art' ('poem', 'painting', 'symphony', and so on). This aspect is the notion of the aims of art. In other words, the ordinary language aestheticians, in their understandable zeal to be faithful to the richness, variety, and complexity of ordinary aesthetic discourse, have tended to ignore

connections or resemblances no less real than the dissimilarities or disjunctions they point out. Their analysis has tended to be insufficient to perceive subtle interconnections. They have tended to go to the opposite extreme from traditional aestheticians.

This is not hard to understand since, as is well known, the "revolution in philosophy" arose primarily as a reaction against the synoptic oversimplifications and "assimilations" of traditional philosophy. But as Søren Kierkegaard warns us in relation to his reaction against Hegelian Idealism, we must endeavor to correct the correctors. On the other hand it would indeed be surprising, in view of the well-nigh staggering complexity and richness of ordinary aesthetic discourse, if the present analysis did not err by oversimplifying here and there. Moreover, the lack of complete fixity in the meanings or uses of ordinary aesthetic expressions makes it mandatory for the philosopher to tidy up, to some extent modify, the concepts expressed. What I hope—and nothing more can be reasonably expected under the circumstances—is that I have succeeded in arriving at a close approximation of the true state of affairs.

It would be wrong to conclude that the present book is essentially polemical in intent. It is not primarily a critique of the linguistic analysts or even traditional aestheticians, though that aim is implicit in the work. Direct criticisms are not infrequently made of the various theories or, in the case of the ordinary language philosophers, conclusions regarding the uses of certain aesthetic expressions.

The illumination of the topography of ordinary aesthetic discourse, or of parts of it, is logically necessary for any adequate piecemeal modification of the uses of any ordinary aesthetic expressions (or the corresponding concepts) inspired by the new kinds of art continually created. Similarly, a firm command of the conceptual prospect is necessary for the possible modification of some of the present ordinary uses of aesthetic expressions in the light of empirical discoveries about, say, the psychological processes involved in the creation of art, or in its perception and enjoyment. For example, precise empirical knowledge of the factors which constitute minimal or optimum conditions for the perception or the enjoyment of particular works or kinds of works of art may make it desirable to modify to some extent the ordinary concept of a "qualified judge," which is so important

for aesthetics as a whole. On the other hand, an understanding of the ordinary concept of art and related concepts shows, I think, that ordinary aesthetic discourse as a whole is remarkably clear and precise; indeed, it is far more so than some of the traditional theories of aestheticians.

Finally, the conceptual framework of ordinary aesthetic discourse enables us to view clearly the insights of artists, aestheticians, and critics, and the discoveries of psychologists and other social scientists, in respect to the empirical characteristics of some or all extant works of art.

In this preface and throughout the book, I speak of "the ordinary or everyday uses" of art names and other aesthetic expressions, "ordinary aesthetic discourse," and "ordinary language." I should make it clear that, strictly speaking, these and similar locutions are imprecisely used. For example, if I were to speak strictly, I should say (at least) "ordinary English" instead of "ordinary language" without qualification. For it is perfectly possible that the logical grammar of 'art' in French or Chinese or Swahili is different in important respects from its logical grammar in English. Indeed, the logical terrain of ordinary discourse charted in this book as a whole is really that of everyday English, that is, the conceptual scheme I try to uncover is the one exemplified by everyday English. Strictly speaking, I have, and can have, no presumptions regarding the everyday conceptual framework of aesthetic discourse exemplified by other languages. This proviso should be kept in mind throughout the book. I believe that my analysis of the notion of art or work of art in Part I, and of the notions of "standard conditions," "qualified perceiver," and the like in Part II, are true of other Indo-European languages—certainly of Germanic and Romance languages. Also, I believe that the standards or types of standards of aesthetic valuation I talk about in Part III, Chapters 11 and 12, cut across language and geographic boundaries, though I certainly do not claim, falsely, that at present critics and laymen in *all* cultures or societies employ the same or the same kinds of standards of valuation as those employed in the West, or even in the United States or Great Britain. My observations are intended to apply to—and they are true, if at all, primarily or wholly of—art criticism in the West, but comparative linguistic (conceptual) anal-

ysis is essential if we wish to understand better how at present, in different parts of the world, people who speak different languages think and talk about art.

I am indebted to the later Wittgenstein for certain matters of sub-stance; particularly for the concept of "family resemblances." The most important debt by far concerns the general, "linguistic" method or aproach which I have adopted from Wittgenstein and Austin. The conclusions arrived at as a whole or in particular chapters cannot be, however, attributed to these or other members of the analytical move-ment. Indeed, some differences in substance, if not in manner of employment of the "linguistic method", here and in, say, *Aesthetics and Language,* are quite basic. Although this book does not pretend to be a complete examination (whatever completeness may mean in this type of inquiry), it is hoped that it will provide a fairly useful scaffolding for further work in empirical and conceptual aesthetics.

I wish to thank Professor Monroe Beardsley for constructive criti-cism of an earlier draft of this book.

HAIG KHATCHADOURIAN

February, 1970
Milwaukee, Wisconsin

NOTE

1. For example, the various contributors to *Aesthetics and Language,* edited by William Elton.

Contents

PART I

The Work of Art

Chapter I

Works of Art
and Physical Reality

The central question with which we shall concern ourselves in Part I is, what is a work of art? Or, more correctly and less misleadingly, what are the everyday uses of a 'work of art' or 'art'? An important part of the latter question is what general features, common characteristics, "family resemblances," and so on—distinguish works of art, (qua called) works of art, from other objects or activities. This question will be dealt with in the following chapters. In the present chapter, we shall attempt to answer another—and in a sense a logically prior—part of the last question, namely, what *sort* or *kind* of things are works of art? Are they percepts, physical objects, ideal or imaginary objects? Stated in linguistic terms, our question then becomes: what sorts or kinds of things does the expression 'work of art' or 'art' name or refer to?

When we use the expression 'work of art' in ordinary discourse in relation to plastic works of art such as paintings and sculptures, at least part of what we sometimes *may* refer to is a sensible thing—such as a particular painted canvas or a particular chunk of carved marble. Part of what I refer to when I speak of works of art, specifically of a 'painting', a 'sculpture', a 'play' is in many cases nonsensible. In some cases 'work of art' refers to something wholly sensible as in the case of certain nonobjective paintings, while in other cases it is partly sensible and partly nonsensible, as in the case of certain representational paintings. It seems clear that, whatever else they may refer to in the same context, these and other such expressions do

refer to certain sensible things. We think of a painting as being in a definite place at a definite time—as hanging in an art gallery, say, on a wall. The *Venus of Milo* is said to be in the Louvre, and Chartres Cathedral in the city of Chartres in France. There are thousands of copies of da Vinci's *Mona Lisa*, but we do not speak of these as the work of art called the *Mona Lisa*. The work of art is the "original," a single object in some one place. Such statements as "I saw the *Mona Lisa*," or "I couldn't see the *Mona Lisa* because the Louvre was closed," would be meaningless if the *Mona Lisa* were not, at least in part, a sensible thing. Though many works of art are, at least in part, single things, they sometimes are a group of things. A panel of paintings, though not a very common phenomenon, may be said to constitute a single work of art. It might be said that the work of art called the *Mona Lisa* is the group of sensible images or percepts received of a particular canvas in the Louvre. But this is not true: what we see varies with lighting conditions, the angle of vision, the distance from which the canvas is seen, and so on. Yet we think of all these perceptions as perceptions of one and the same object—the painting, the work of art, hanging on the wall.[2]

Our view that 'work of art', used in relation to plastic works of art, is sometimes made to refer to something which is partly or wholly sensible might be challenged on different grounds. It might be said that we are confusiong two different things, that the terms 'painting', 'sculpture', 'cathedral', and the like sometimes refer to something sensible, but that this does not mean that 'work of art' refers to something sensible. 'Work of art' or 'object of art' (or 'aesthetic object') might refer, rather, to an imaginary or (wholly) ideal object.[3]

The terms 'painting' and 'sculpture' are not always used in ordinary discourse in such a way as to include or involve the notion of a work of art. Sometimes, not very often, they are used differently. Thus we may call a painted canvas a 'painting' but deem it unworthy of the label 'work of art'. (More often, though, such a 'work' is labeled 'trash', 'smears on a canvas', or 'hen tracks'.) But every work of art is a painting, a poem, a novel, a statue, a play, or some such thing, and a good many poems, paintings and the like *are* works of art in the present, evaluative sense. It is one and the same thing which is called a painting or a sculpture, say, *and* a work of art. The thing called a

work of art is not regarded as just *related*, somehow or other, to the thing called a painting or a sculpture.

Briefly and less misleadingly, the term 'work of art' is sometimes a manner of referring to or speaking about a given painting, poem, and so on. We sometimes do deny the name 'work of art' to things we do call paintings, novels, and the like; but we do so because we regard the latter, qua partly or wholly sensible things, as lacking certain sensible features and capacities generally considered essential for anything to be properly called a work of art, in an *evaluative* use of this expression i.e., good art. Calling a painting, a poem, or a novel a 'work of art' here involves a value judgment, implying, among other things, that the work possesses a certain kind of merit or value, that it is an "achievement" in W. B. Gallie's sense of this term.

Margaret Macdonald gives the following interchange in attempting to show that a work of art is not a physical object, though she does not hold that it is a sensible image, or a mental or "imaginary" object:

'That,' exclaims A triumphantly, pointing to his newly acquired canvas, 'is a great picture!' 'I should not call it a picture,' retorts B, 'but only a pot of paint flung in the face of the gullible public!'

It seems clear that both have located the same physical object but that not both have located a work of art. Nor will it be of much use to tell B to look more closely and carefully, when he will find the work of art hidden in the paint, like a monkey in the branches of a child's puzzle. He may look as hard as you please, but he will not succeed, for in *that* sense there is nothing more to find. It is not perceptual tricks that distinguish a painted canvas from a work of art. . . . What B lacks is not observation but that which A must supply as a critic to support his judgment, instruction and interpretation.[4]

Leaving aside Macdonald's view of the nature of a work of art, and without minimizing the importance of interpretation, what this ex-

ample shows is that a person (B) may refuse to call something a painting, say, because he does not regard it as meriting the name 'work of art', since he reserves the term 'painting' for things of a certain kind (painted canvases) which at the same time he is prepared to call a 'work of art.' Whereas another person (A) may regard the same thing as a painting because he regards it as meriting the name 'work of art'. The example does not show that a work of art is not or cannot be a physical object. The disagreement between A and B is due to at least one of two things: (1) A finds in the painted canvas certain sensible and perhaps certain ideal features which B does not find in it—but which he may come to find on a more careful observation; or (2) B is fully aware of the features A finds in the painted canvas, but does not regard the canvas's possession of these features as sufficient to, or of the kind that, merit its being regarded as a work of art (or 'painting', in which it includes or involves the notion of 'work of art' in the evaluative sense).

Now we certainly distinguish the painting and the canvas (the cloth), or the pigments on the canvas. For instance, we speak about the kind of canvas used and about the chemical constitution of the pigments. In so doing we will be directly speaking about the elements of the canvas or the pigments. The painting, referred to as a work of art, is made up of physical elements—pigments on a canvas, but not merely that. The painting is the colors arranged in certain patterns and relations. When we talk about the pigments, we talk about the painting or the work of art in the sense of its physical or chemical elements. We talk about the work's elements in another sense when we speak about the color qualities of the pigments on the canvas. Yet, in speaking this way, we speak indirectly about the painting as an artifact made of elements arranged in certain relationships. Our distinguishing the painting's constituent elements and the painting as a whole does not imply that the painting is a nonphysical emergent from the combination of physical elements, any more than our distinguishing a chair as a whole, its legs, and the planks of wood it is made of, implies that a chair is a nonphysical emergent arising from the joining of planks and legs.

The use of 'work of art', discussed in relation to plastic works, does not seem to apply to musical works—at least not directly. The expres-

sion 'work of art' seems to be ordinarily applied to works of music in a different way than the way in which it may be applied to plastic works. That is, a second (descriptive) use of 'work of art' seems to arise in relation to musical works. Thus, we do not refer to a particular printed score, a particular record, a particular playing of the work (whether on records or at a concert), or to any number of these as the work of art. We speak of the *score* of Beethoven's *Eroica* Symphony, of a recording of Bach's Fugue in G-minor, of an *interpretation* or *rendering* of Stravinsky's *Firebird*. When we say, "I have Beethoven's *Eroica* Symphony," or "I have Bach's Fugue in G-minor," and then proceed to play a record, the context indicates that what we mean is that we have a record of the Beethoven or of the Bach work. Thousands of copies of the score of Beethoven's symphonies exist as do thousands of copies of the Bach record. There have been and continue to be thousands of actual performances of these works; but we think that there is only one *Eroica* Symphony and one Fugue in G-minor by Bach. We do speak of Beethoven's writing of his Third Symphony, of Bach's writing of his Fugue in G-minor. We point to a score and say "This is a great work," but here we do not mean the printed notation nor any particular performance, or even all actual and possible performances of it.

What, then, is Beethoven's *Eroica* Symphony or Bach's Fugue in G-minor? The answer seems to me that when we refer to Beethoven's *Eroica* Symphony we refer (in part) to the sequence of sound patterns heard on playing a recording of the work or on attending a concert where the orchestra plays the score of the symphony. These sound patterns, listened to at the same time in different places—or at different times in the same or in different places—are thought of as more or less correct instances of certain (kinds of) sound patterns. They are different renderings of the same sound patterns; in this respect, they are analogous to different "tokens" of the same "type." [5] Because they are numerically different renderings of the same work, the same sound patterns, they can occupy different places at the same time—in the sense in which we speak of sounds as being in some spatial location, as coming from a certain spatial source, as being heard in some place. Every written or printed note stands for a kind of sound in one key or another, in some scale or another, and so on.

In ordinary discourse the distinction between a musical work and a performance of it is often passed over. We say "I heard Beethoven's *Third* Symphony tonight," when we mean "I heard a rendering or performance of the *Third* Symphony tonight." Yet we seem to distinguish when we check the score to find out whether the particular rendering or performance was, as we say, musically correct. The same applies, *mutatis mutandis*, to literary works.

Beethoven's *Third* Symphony, then, would seem to be what all the actual and possible interpretations, performances, or renderings of a particular score will have in common, as sequences of sound patterns (each of which is composed of notes with a particular pitch, volume, and so on), if the execution of the notating in the score conforms in every case with the conventions established by musicians. All these variants will share a set of what philosophers call universals. Is a musical work, then, a congeries of universals rather than an individual like a painting or a statue? If so, do we refer to a particular congeries of universals when we speak of a work of music as a work of art? Indeed, the term 'work of art', when used in relation to a musical work, directly refers (at least in part) to certain sequences of sound patterns, these kinds of sound patterns partly or wholly constituting the particular musical work. Nevertheless, it is questionable whether anything is gained by calling a musical work a set, a complex, or a congeries of universals. Also, I shall not attempt to solve (or dissolve?) the so-called problem of universals. Whatever the answer to the first and the solution of (or the manner of dissolving) the second may be, the above characterization of a work of art seems to me to be sufficient for our purposes.

Token/type distinctions of the above sort, we might add, also obtain in relation to some things which do not ordinarily fall within the pale of art—for example, the United States Flag. Certainly, the Flag is not the particular flag in Mr. Johnson's office in the White House, or on Capitol Hill, or any of the thousands of flags flying over American embassies scattered throughout the world. All these are tokens, so to speak, of the United States Flag, which is a kind of flag having a specific kind of pattern consisting of stripes and stars of a certain number, arrangement, color, and the like on a certain kind of background.

What we have said about musical works applies to literary works, though there are complications peculiar to the latter. Any one of Shelley's poems consists of certain types of linguistic symbols in certain arrangements. Each reading of a Shelley poem—considering the patterns of sound involved—is an instance of the sound patterns which constitute the particular poem. However, unlike many, if not all, musical works and in particular those known as absolute music such as Bach's partitas, fugues, and suites, or Beethoven's chamber music, these sounds (and the printed symbols) express more or less definite ideas; they are a part of the poem as much as the sounds themselves. A poem has a nonsensuous, ideal component as well as a sensuous one (sounds), but again the ideas in a poem, in a poetical work of art, are themselves kinds of thoughts ("universals") and not particular instances of ideas (individual thoughts in a psychological sense) in a given reader's mind. Thus any given poem, and hence any poetical work of art, consists in sequences of certain kinds of sound patterns, plus sequences of certain kinds of thoughts expressed by these sound patterns. I do not mean to imply, however, that a *musical* work is always wholly sensuous and therefore lacks a nonsensuous component. Some, perhaps many, works of music do convey ideas of a rather general and indefinite kind, and to that extent contain a nonsensuous or ideal element. That is precisely why I said before that a musical work is "at least in part" a sequence of certain kinds of sound patterns.

What I have just pointed out about literary works applies to kinds of works which normally fall outside the field of art, but which involve the use of linguistic symbols such as scientific and philosophical treatises. Thus we speak of the ideas in Russell's *An Inquiry into Meaning and Truth*, or in Newton's *Principia*. Russell's *Inquiry* consists in a certain number of pages containing certain types of linguistic symbols, of which libraries have instances, plus the conceptual meaning of these (types of) symbols, hence the ideas they express. Similarly, with Newton's *Principia*.

Does our present use of 'work of art' apply, *mutatis mutandis*, to painting, sculpture, architecture, and other plastic arts? It seems to me that it does. With respect to these, the (descriptive) term 'work of art' is ordinarily employed directly in at least two different ways,

unlike literary and musical works—as a matter of fact unlike all temporal works of art including plays, operas, and ballets. Choosing a given painting, say da Vinci's *Virgin of the Rocks*, we apply the term 'work of art' to the particular sensible object—the particular painted canvas—hanging in the Louvre and labeled *Virgin of the Rocks*, then to the color patterns, qua kinds of color patterns, exemplified by the former way. Which of the two ways we do use in a given case depends on the particular situation or context, on our aims and intentions. Note that our first use of 'work of art' is quantitative, while our second use is qualitative, so to speak. Also, the term in the former case is rather general, while in the latter it is a specific sort of label. When we refer to works of art in a general way in ordinary lay discourse, where our objective is to draw attention to certain things called "paintings," "sculpture," or "architecture," etc., and we are not concerned to analyze the specific elements in or qualities of the works, we think of these works and refer to them as (at least partly) individual sensible things. In this use of 'work of art', the term could be replaced by 'painting', 'statue', 'cathedral', and so on, depending on the work involved; but when we are aesthetically analyzing a work (in the "general" sense of 'work of art'), what we refer to or think of as the work of art is at least in part the sensible patterns qua kinds of patterns. In this use, the term 'work of art' cannot be replaced by 'painting', 'statue', 'vase', 'temple', and the like in the quantitative sense. It can, however, be replaced by one of these terms in a nonquantitative use in which two qualitatively identical *Mona Lisas* would be called (say) "two instances of the painting called the *Mona Lisa*," and not "two paintings." Finally, let me add that the second use of the term 'work of art' is the more important use in the aesthetic and critical analyses of specific works and in aesthetics generally, this being the reason why it may be called an (or perhaps *the*) (descriptive) "aesthetic use" of 'work of art'.

In my discussion of musical works, I expressed doubts as to whether it is profitable to speak of a musical work as a complex of universals. The same doubts arise in relation to literary and plastic works of art, insofar as we think of the latter as works of art in our second descriptive sense of this term. A work of art cannot properly be regarded as a complex of Platonic universals, because:

(1) The kinds of sensible patterns of which a work of art, in our present sense of this term, is partly or wholly constituted do not and cannot exist except in particular, individual painted canvases, or in individual blocks of hewn marble; no symphony, composed of certain sequences of sound patterns, exists apart from all actual performances of it in the past, present, and future. This is seen by considering the ways we talk about works of art, some of which we have discussed in the foregoing sections. Indeed, I do not see what meaning could attach to the statement that the patterns we are talking about do or can exist apart from all individual sensible things (apart from any sensible media), since they are kinds of sensible patterns (colors, sounds, and so forth).

(2) The simple empirical fact is that, as we ordinarily say, a given symphony, poem, or painting, as a sequence of certain kinds of auditory or visual patterns, comes into existence at the particular time when a Beethoven, a Shakespeare, or a Picasso conceives and writes the score or the words or paints the canvas. Of course, the sensuous elements involved in each case—sounds, colors, and the like—are there, in a sense, all the time, but the particular arrangements and combinations of these elements, qua kinds of sensuous elements, are the product of the artist's creativity and technical skill. We talk of certain works as having been *lost* after they were created. Though some works are said to be *discovered* or *rediscovered* from time to time, others, believed to be extant, remain *undiscovered*. Also, it is a historical fact that some works of art have been, as we say, destroyed by human or other agencies. It is interesting, though, that a temporal work of art is said to be, or to have been, destroyed if and only if *all* the extant manuscripts, scores, and other records of it have been destroyed and it is impossible to reproduce them from memory. (Where only one record, the original manuscript, exists, its destruction may be the destruction of the work.) In the case of a plastic work, the destruction of the original painting or statue is sufficient. The reason for this difference in the way we speak about temporal and plastic works is not, however, that the latter, but not the former, are complexes of Platonic universals. (It is also not the case that the way in which we talk of the destruction of a work of art as a consequence of the destruction of a certain specified number

of scores or manuscripts implies that a score *is* what we call the musical work and hence a work of art.)

As we earlier tried to show, we do apply the term 'work of art' in our second sense to plastic as well as to temporal works; hence either *both* plastic and temporal works can be regarded as complexes of Platonic universals, or *neither* can be so regarded. As long as some record of a temporal work remains, the particular sequences of sound patterns which form the whole or a part of (what we call) a temporal work can still be identically reproduced; whereas the exact reproduction, even by the artist himself, of the visual and tactile patterns that form the whole or a part of (what we call) a painting or a statue is impossible. The same holds of architectural works. We speak of the rebuilding of a given cathedral, monument, or other architectural structure that has been destroyed, but even then we regard the resulting structure as being different, to a greater or lesser extent, from the one destroyed and hence a new work, at last in details. I need not add anything about the comparative aesthetic value of paintings (especially great ones) and any reproductions of them, or about the aesthetic value of symphonies and poems vis-à-vis the possible aesthetic value of the manuscripts of these scores and poems.

We have not said anything about the feelings or the emotions which a temporal or a plastic work of art may evoke in a hearer or spectator. Are these, or any feelings or emotions in general ordinarily said to form a part of a work? The answer seems to be negative. The feelings or emotions which say, a poem, may evoke in a reader or listener is the effect, in the latter, of the (perception of the) auditory qualities of the word patterns, as well as of the (apprehension of the) thoughts which the word patterns evoke. They are not, in ordinary discourse, said to be part of the poem itself. The same is true, *mutatis mutandis*, of other types of art.

On the other hand, there is another sense in which "feelings" and "emotions" may constitute qualities of a work of art in an ordinary, unextended use of 'quality', to which such writers as O. K. Bouwsma have drawn attention; namely, the sense that the work may be, as we say, "charged with emotion" or "full of feeling." In speaking in this way, we frequently mean that the work is sad,

melancholy, gloomy, gay, and the like, though a work is sometimes said to be full of feeling or charged with emotion without being sad, melancholy, gloomy, or gay. In the latter instances, we say that the feelings or emotions in the work have no special names.[6] These emotional qualities of some works of art are connected in an important way with the feelings or emotions that they arouse in sensitive perceivers in the appropriate circumstances.

As I shall indicate in Chapter 6, the quality of a work's sadness, gaiety, or melancholy obtains by virtue of its "nonaesthetic" sensuous or nonsensuous qualities and/or formal features[7] (N-features), as, for example, the lilt or rhythm and tempo of a work of music, the character of its melodies (whether they are written in a minor or a major key), and so on. The same is true of the other kinds of art to which we apply emotional words. The N-features of a work are causally (psychologically) responsible for the feeling of sadness evoked by a sad waltz or the mood of melancholy created by a melancholy poem, reflected in the way we would answer such questions as: "What do you mean by saying that this sonata (poem) is dry?" We say "Oh, I mean that it does not move me; it leaves me cold"; or better "It leaves one cold." The implication here is that the work lacks the (kinds of) sensuous and ideal features which effectively evoke feeling or emotion. We may have in mind the work's deficiency in realism and naturalness; firm characterization; simple, clear, vigorous language; striking and original images; fresh cadences; and so forth. Some of these features are sensible qualities, but others, such as striking or original imagery, simple and clear language, and firm characterization, are ideal in the sense of being conceptual or imaginative characteristics or both. Many of the affective epithets by which we describe a work's features are transferred epithets, psychological epithets applied, by transference, to a work's own features (it being thought that these features are capable of producing in the hearer or spectator the psychological effects which the epithets denote, under what I shall call "standard conditions").

Further, we often *notice* or *perceive* a work's sadness or gaiety—as opposed to being saddened or buoyed up by it—by noticing precisely those N-features which are in a noncausal sense responsible

for the sadness or gaiety and are causally (psychologically) responsible for the feeling by the sensitive perceiver of being saddened or buoyed up by the work in the appropriate circumstances. We can do this in the absence of any emotional reaction on our part, that is, in the absence of the circumstances necessary for it. In other words, we can notice that a work is sad, gay and the like by being aware of those "aesthetic features" (A-features) which constitute what we call its sadness or gaiety. (See also Chapters 5 and 6.)

Why are the feelings or emotions, which the sensitive perceiver may have in response to a work's sad-making, melancholy-making qualities treated in a different way from ideas in our ordinary ways of speaking about them in relation to art? In other words, why are the latter but not the former regarded as a (possible) component of works of art? These questions should also apply, *mutatis mutandis*, to the distinction between sadness, gaiety, and so forth (also power, virility, flabbiness, flamboyance, delicacy, and so forth, which are referred to by words of a logically different type from the former) as qualities of a work, and sadness, buoyancy, melancholy, and so forth as effects of such works on us. The answers to these questions are, I think, the following:

(1) In literature—the "intellectual" art par excellence—the relation between the words and their conceptual meaning, hence the ideas they express, is different from (a) the relation between the words and their emotional effect, and (b) the relation between the conceptual meaning and the emotional effect. The ideas in a literary work are what the words and sentences conventionally express, not their causal effects, while the feelings or emotions we experience may be in part the direct psychological effects on us of the auditory and/or visual qualities of the words and sentences, and in part the effects of our perception of their meaning, hence the ideas and imagery they convey.

(2) I said "in part" because the feelings or emotions evoked are also in part the causal (psychological) effects on us of the conceptual meaning of these words, hence of the ideas they express. The feelings or emotions evoked are the effects of the words and sentences, qua sensible things, together with their conceptual meaning. In a work of art, especially in a good work, the latter two go hand in hand to

produce a unified effect. It is logical, therefore, to think of the words and their conceptual meaning as belonging together in a different way from the feelings or emotions they may jointly evoke; that is, to think of them as together constituting the work of art, to regard the feelings or emotions they evoke as residing in the listener or reader who experiences them.

(3) That the emotional effect of a literary work is not regarded as a part of the work itself is consonant with the way in which we speak of a thing's causal effects in general, whether the thing may be a stone, a hammer, a cloud, a storm, a car. We regard a thing's causal effects as belonging in a straightforward sense to the thing affected, not to the causal object itself.[8] I do not speak of the effect of a fire on me as an attribute of the fire, but of my body. The effect is produced by the fire, but resides in me. It would, therefore, be rather peculiar if an exception were made in the case of works of art, unless there were a good reason for doing so. I do not see any such reason.

(4) The nature of the ideas said to be in a given literary work is regarded as wholly specified by the nature of the words and sentences, and the like in it, independent of the temperament, past experience, and upbringing of the hearers or readers. That is, ideas are, as we say, objective, whereas the nature of the feelings or motions evoked is regarded as only partly specified by the nature of the words, sentences, and so forth. Their nature is thought of as also partly specified by the hearer's or reader's temperament, mood, past experiences, and the like. The underlying logic, therefore is that feelings and emotions are variable and hence "subjective." Yet a literary work is regarded as "objective" in the sense of having an existence and a character independent of the existence and the character of any particular individual—in the same way as chairs and mountains and clouds are ordinarily said to be objective. It is true that two readers of a given poem may understand the whole poem, or any part of it, differently. A good example is Keats's famous "Beauty is truth, truth beauty," in his "Ode on a Grecian Urn." This, however, we allow for in ordinary discourse without abandoning the above point of view. For instance, we sometimes resort to the explanation that one of the two readers (at least) misunderstands or misinter-

prets this line; that one of the interpretations (at least) is incorrect or wrong. We may assume, that is, that the line itself conceptually means just one relatively definite and fixed thing established by linguistic convention; that this thing is what the poem conveys. None the less, we sometimes attribute the differences in interpretation to the work itself—we say that what it means is not clear, that it is vague or ambiguous. Precisely because we attribute vagueness or ambiguity to the poem itself (when we do), we *may* judge the latter to be a poor work. However, we sometimes regard the ideas in a given poem as vague (or the language it uses as ambiguous) and yet do not, for all that, regard the poem as defective. This occurs when we regard the vagueness or the ambiguity as intentional and, what is more important, as serving an aesthetic end. Many of Edgar Allan Poe's poems come to mind. The existence of such cases does not constitute an exception to what we have said; for the ideas there are naturally vague. Further, we still think of the content of these ideas as being, in principle, identically intelligible to all men. Thus, we may attribute objectivity to the ideas.

Now different spectators, especially spectators coming from different cultures or living in different historical periods, often interpret the representational or the symbolic elements of a work (if any) differently, and to some spectators the elements may convey nothing at all. These things happen particularly when the representation is subtle, sketchy, veiled, or highly individualistic, or when the symbolism is complex, esoteric, peculiar to the artist or to a clique, far-fetched, highly abstract, heavily theological, mystical, or philosophical. The critical and scholarly controversies concerning the interpretation of such works as Franz Kafka's *The Trial* or Thomas Mann's *Dr. Faustus*, to name only two examples, suffice to illustrate this point. But even here, *if* a spectator regards a given painting or statue as representational, or as containing symbolic elements, he would ordinarily regard these elements as part of the work itself. Controversies of the sort alluded to do not concern the general question as to whether these elements, as certain types of elements, are to be considered part of a plastic work of art(the same applies to other art forms), but concern rather the specific question of whether to regard a *given interpretation* of a work allegedly representational or

symbolic as correct or adequate. That is, the latter question concerns whether alleged representational or symbolic elements are properly attributable to the particular work.

The terms "representational element" and "symbolic element" need clarification. Two things have to be distinguished in the so-called representational, and two in the symbolic, elements of a work. In the first case, there is (a) "that which is represented" or the subject of a work, and (b) "the representation," in the product sense of 'representation'. In the second case, we have (i) "that which is symbolized" by a work, and (ii) "the symbols" in a work. That which is represented in, or is the subject of, a plastic work may be any object or thing, or any kind of object or thing, actual or fictitious, animate or inanimate, which the work is said to portray or delineate. For example, that which is represented by the *Mona Lisa* is a woman who may or may not have been a real woman living in da Vinci's time or before it. Where this is an object, situation, character, or scene which actually exists or has existed, it obviously does not and cannot form part of the work which portrays it. But where it is fictitious or imaginary it is, I think, ordinarily spoken of as constituting an ideal component of the work.

The same applies to that which is symbolized by a symbolic plastic work of art, but with at least one interesting exception. When we look at a representational work, we often *see* in it that which is represented, in a sense in which we cannot see that which is symbolized in a symbolic work. That is, we recognize the representation as a (particular) *representation;* we perceive that certain sensuous elements in the work form patterns resembling familiar patterns in the world. This is shown by the way we talk when we fail to discover what is represented by, say, a semiabstract modern painting, and by the way in which the representation may be pointed out to us. Consider the following interchange. A: "The title says this is a portrait of a woman; but I cannot see any woman, fish, or fowl in it." B: "Why, but here it is! Can't you see it? (points)—the face, the neck, the body, the legs. . . ." A: "Oh, I see it now . . . the poor woman has been changed beyond recognition!"

This brings us to "the representation" in a representational plastic work. When we observe a plastic work we see, in a straightforward

sense, certain visual patterns of lines and masses, some or all of which may be "the representation" in the work. As a specific complex of various sensuous elements of a work, "the representation" forms part of the work in the same way in which other, nonrepresentational sensuous elements form part of the work.

The foregoing discussion applies to literature and to music, insofar as they may involve symbolism, and to the latter also, insofar as it may involve representation. We do not ordinarily speak of literary works as involving representation, and therefore what we have just said does not apply to them.

Our analysis of the ways in which we ordinarily employ the terms 'art' or 'work of art' shows that the view, chiefly associated with Croce and Collingwood, that a work of art is an "ideal" or "imaginary" object tacitly involves a basic change in the everyday uses of the term 'art' or a redefinition of the everyday concept of a work of art.[9] Consequently, as noted by Beryl Lake,[10] this aspect of the Croce-Collingwood "theory" is irrefutable. (That part of it which holds that there can be no "intuition" without "expression" is also irrefutable, as Lake also points out, though this is true only with regard to *one* of the two distinct senses in which Croce employs 'expression', and between which he oscillates in his discussion. With regard to the other sense in which he employs the word, which is the more usual use in aesthetic discussions, the statement "There is no intuition without expression" becomes an *empirical* proposition; to *this* Joyce Cary's criticism in "The Gap Between Intuition and Expression"[11] is perfectly applicable.) It may seem, however, that our analysis—or the similar analysis of Margaret Macdonald in "Art and Imagination"—is compatible with a different sort of view; namely, that a work of art is a set, or congeries, of sense data. If it is further held that sense data are mental, we get an idealistic theory of art, though different from the Croce-Collingwood form of it.

In the everyday uses of 'art', is a work of art a congeries of sense data? Whether sense data are mental, physical, or neither is relevant only if the answer to the former question is affirmative. As to the general *philosophical* doctrine that physical objects are congeries of sense data, the assessment of its truth or falsity is clearly beyond

the scope of the present work; and the sense datum theory of art will stand or fall with the general theory.

My view is that on the everyday view a work of art is definitely not a "bundle" of sense data, actual or possible, in Berkeley's and Mill's sense of "a permanent possibility of perception". Of course, we do sensibly perceive works of art since they are necessarily at least partly sensuous. For on the everyday or "common-sense" view visual works of art, like all other sensible objects, are material objects distinct from any sentient being's perception of them, hence of the sensory perceptions themselves (assuming that there are such things as "perceptions," in the sense of "sense data"). Furthermore—and this is opposed to Idealism—they continue to exist replete with colors, sounds, and all other perceived qualities when they are unperceived.

What we have said is true with regard to paintings, sculptures, and works of architecture in *one* of the two everyday uses of 'painting', 'sculpture', 'work of architecture', and so 'work of art'; namely, in that use of it in which these expressions designate the painted canvas, the building, and so forth as a physical object or structure. But we saw earlier that (1) there is another use of 'painting', 'sculpture', and 'work of architecture', and so of 'art' as applied to visual art, in which these words designate the particular kinds of visual forms or patterns—lines, colors, masses—that we find on the painted canvas, in bronze, marble, and the like, or represented in brick, stone, glass, and the like. Furthermore (2) *dances* are partly or wholly sequences of bodily movements of certain kinds (which are a kind of bodily or physical activity), not objects or any other kind of physical things; and (3) works of literature and music are partly or wholly (works of literature are almost always partly) sequences of sound patterns of certain kinds. The question therefore is whether these things can be said to be congeries of sense data.

The visual patterns that we see under normal visual conditions on, say, the painted canvas in the Louvre called *Supper at Emmaus* by Rembrandt, is on the ordinary view or manner of speaking, a set of sensible qualities, in various visual interrelations, *of* the sensible object which we call the painted canvas. The sensible qualities are

thought to exist independently of the perceiver; hence when not perceived they are the same as when perceived under normal visual conditions. These qualities are not sense data, even physical sense data, in any usual philosophical use or meaning of this vague and confusing term. The same holds with a sculpture such as Bernini's *Beata Albertona*, a work of architecture such as Rome's Villa Borghese, or a fourth-century B.C. Corinthian vase. Moreover, in the everyday conceptual scheme a sensible object is not a "bundle" of sensible qualities related among themselves in some way(s); though it is also not a material "substance" or "substratum" in which its sensible qualities are supposed to "inhere." [12]

Similar observations apply to the dance. For example, *Swan Lake* is partly a sequence of bodily movement. These movements are not qualities of any dancer's body in a performance of the ballet, but are movements of some body, of a sensible thing, of a physical "object." On the everyday account of objects and their activities to say this is to say precisely that they are not "sense data," just as the dancer's body, which goes through these movements, is not a congeries of sense data.

The sense-datum theory, in some form, seems prima facie most at home with regard to works of literature and music since, as I have said, these are (partly or wholly) sequences of sound patterns,[13] and sounds are sensible qualities that are not qualities *of* any sensible thing or object. But even they do not satisfy the *Idealist's* characterization of sense data, for on the everyday view they are part of the physical world and can exist unheard. (Also, it is commonsensically supposed that the words in a work of literature have and continue to have their particular meaning when nobody is reading it or listening to a reading of it.) Hence, to call works of literature and music sense data would be merely to draw attention to the fact that they are sensible (qualities). The fact that they are not qualities of any sensible object or thing means that they cannot be properly considered as part of the surface of any physical object or even as connected with any physical object in some way. (I have in mind G. E. Moore's long travails with his Realistic version of the sense-datum theory, in which sense data are public and physical, not mental, entities.) On empirical (scientific) grounds, the only way

in which they can be connected with physical objects is as effects
of the movements of physical objects or physical particles. Here we
encounter the thorny questions as to whether the physical objects are
identical with any sensible objects and whether the notion of a mate-
rial object, consisting of atoms, molecules, and so forth, as some-
thing distinct from a sensible object is a logical construction or
theoretical model representing no actually existing entities.

In this discussion of the everyday conception of a work of art vis-
à-vis sense-datum theories, I have limited myself for obvious reasons
to sense-datum theories as putative metaphysical doctrines in the
traditional meaning of this phrase; in other words, as accounts of the
ontological status of perceived things. I have not said anything about
the more recent understanding of sense-datum theories as wholly
and solely alternative "languages" or conceptual schemes. These
"languages," for their advocates, are more adequate for the descrip-
tion of the facts of our perceptual experience than ordinary, material-
object language.

NOTES

1. The present chapter with minor changes in the opening paragraph,
in punctuation, and in some additions and changes in later pages, is a
reprint of my "Works of Art and Physical Reality," in *Ratio*, Vol. II, No.
2 (February, 1960), pp. 148–61. Reprinted with the kind permission of the
editor.
2. We cannot enter here into the question of whether or not paintings
and statues, or any other sensible things, retain all or some of their per-
ceived qualities when they are unperceived.
3. For a discussion of the Idealist's distinction between a 'painting', a
'sculpture', and a work of art or 'object of art', and for a criticism of the
view that the work of art is an ideal or 'imaginary' object, see Paul Ziff,
"Art and the 'Object of Art'" in *Aesthetics and Language* (Oxford, 1954),
edited by William Elton, pp. 170–86.
4. *Aesthetics and Language*, p. 122. Italics in original. In a later essay,
"Art and Imagination," *Proceedings of the Aristotelian Society*, 1953, re-
printed in Melvin Rader, *A Modern Book of Esthetics*, Third Edition

(New York, 1961), pp. 214–21, she holds that "In the plastic arts . . . the finished work is, normally, a physical object of the same sort as stones and stars," while literary and musical works of art are "physical events which begin, continue, and then cease to exist" (p. 217). "They exist wherever and whenever they are physically manifested" (p. 218).

5. But as Margaret Macdonald points out, there are important differences between musical or literary works and a "type" word; for example, "individual presentations of a work of art have their own independent artistic value, while token words do not fulfill independent grammatical and stylistic functions." (*Op. cit.*, p. 219.) The first part of this statement is true in the sense that the performance of a great actor or violinist may have artistic value as a performance apart from the artistic value of the work performed. However, we do not ordinarily say, as Macdonald says, that such a performance "may be *a work of art* in its own right"; though it is certainly true that "acting and musical execution are also arts." (*Ibid.*) Further, as Macdonald points out, words in the "type" sense may cease to be used at all—may become obsolete, just as musical works may cease to be performed, and literary works may cease to be read or (in the case of plays) performed. On the other hand, the latter may be destroyed (but we do not say that they may "cease to exist"); while we do not say that obsolete words are words that have been destroyed (and we do not say that they have "ceased to exist").

6. Cf. O. K. Bouwsma's discussion, in "The Expression Theory of Art" (reprinted in W. E. Kennick's *Art and Philosophy*), of the uses of 'sad', 'gay', and other such expressions in relation to art. With one or two exceptions, I am in full agreement with Bouwsma's analysis as a whole. For one of these exceptions, see Chapter 6.

Note that in the case of dramatic works such as novels and plays, a good deal of the feelings, emotions, and tensions contained may be the feelings or emotions which the *characters* in them are depicted as experiencing. Cf. the sad, gay, melancholy, or gloomy expression or mien of a human or animal statue, or of the human or animal subject of a portrait. A comparison of the logical grammar of emotional words as applied to charatcers in plays or novels and as applied to other aspects of works of art, or other kinds of art, would be most instructive.

7. In a different sense of 'nonaesthetic' from the sense in which we shall employ this expression in Chapter 4.

8. This point, in another context, is elaborated in my "On Mr. Theodore T. Lafferty's 'The Metaphysical Status of Qualities'," *The Journal of Philosophy*, Vol. LV, No. 10 (May 8, 1958), pp. 397–412.

9. Note that this is not an honorific redefinition in Morris Weitz's sense of 'honorific (re)definition'; 'art' is not used, as a whole, in an evaluative sense in Croce's theory that a work of art is an ideal object, an image.

Of course, it may be argued that only good art is an *organic* image and constitutes (nonconceptual) knowledge or vision of the unique individual. But this is a different proposition from the proposition that a (any) work of art is an ideal object.

10. In *Aesthetics and Language*, pp. 100–107.

11. In Melvin Rader, editor, *A Modern Book of Esthetics*, Third Edition (New York, 1961), pp. 104–15.

12. See my "Objects and Qualities," *American Philosophical Quarterly*, Vol. VI, No. 2 (April, 1969), pp. 103–15.

13. They are not physical events, as Margaret Macdonald holds in "Art and Imagination." Even dances are not events in an unextended ordinary sense of 'event', though the bodily movements in which a dance partly or wholly consists, like all other kinds of bodily movements, are more similar to an event or a series of events than a work of music or literature in its physical aspect. (Note also the current use of 'happening' in 'a happening', as designating a kind of art or artistic activity.) To speak of literary and musical compositions as events is to confuse them with readings or performances of them, respectively. Thus this view could be a carryover from Margaret Macdonald's earlier view that there is no work of art apart from some intepretation (of it). However, she does not say whether a dance is, for her, a physical event or a physical object, though I presume she would have said that it is the former, if she had written on the subject. (See note 1 of this chapter.)

Chapter 2

The Concept of
a Work of Art

I

There are two major questions or kinds of questions which may
be implied in asking What is a work of art? In asking, one may be
asking, first, for an analysis of the uses of 'work of art' (a) in ordi-
nary aesthetic discourse, or (b) in the technical discourse of pro-
fessional critics and/or artists (whether or not the meaning of 'work
of art' is the same in both [a] and [b]. Second, one may be inquir-
ing as to what features, if any, are as a matter of fact common to,
and what features are as a matter of fact peculiar to, things called
works of art—whether some or all of these features are covered by
(i) the ordinary meaning, or (ii) the technical meaning of 'work of
art'. The latter is an empirical question in the usual straightforward
sense in which scientific inquiry, say, is empirical. The answer to it
is discoverable by a careful examination of the sensuous and non-
sensuous qualities of things called works of art. These two questions
must be carefully distinguished, since failure to do so can only result
in confusion and waste. This point needs stressing even at this late
date, despite our present familiarity with the fact that aestheticians,
especially in the past, have frequently failed to make this distinction
or were unclear as to exactly what they were doing in trying to dis-
cover the "nature" of a work of art. This lack of clarity is probably
due in part to the nature of the relation between the two questions.
For an analysis of the ways in which 'work of art' or 'art' is ordi-

narily employed shows us what common features, or what "family resemblances" (as the case may be) are possessed by works of art qua 'works of art'. These either (a) exhaust, (b) coincide with some of, or (c) are completely distinct from the features, if any, which all things correctly called works of art actually have in common.

Even at this late date we come across "theories" which commit the foregoing error, or suppose that the former question is philosophically unimportant. They fail to note that even the attempt to "construct" an empirical, scientific "theory" of the nature of art (in effect, to answer the latter question)—unless a wholly arbitrary meaning is to be given to the expression 'work of art'—must begin with an attempt to find out what kinds of things we exactly refer to by 'work of art' and related expressions in ordinary, lay aesthetic discourse. For our part, we shall mainly concern ourselves with the first, conceptual question. We shall further limit ourselves to the analysis of the uses of 'work of art' in ordinary aesthetic discourse.

The first thing to note about the ordinary meaning of 'work of art' is that it has both a descriptive and an evaluative use. As a purely descriptive term it is the generic name or label of a class of objects, sensible qualities, or activities that are nonsharply distinguished from other classes of objects, sensible qualities, or activities, that is, from what we call nonart. The term is frequently used in the plural, as 'works of art', where it has, at least roughly, the same meaning as 'art'. I think this employment of the expression is most frequently encountered in the utterances of aestheticians, critics, and artists who talk about art in general—about the class of works of art as a whole. Thus it is this use of the expression which is involved when an aesthetician, say, frames universal propositions about art such as that (all) works of art have such and such common features, or such and such aims, and the like. Though the most obvious examples of this use are to be found in the utterances or writings of experts, it is, I believe, an ordinary employment of our expression. Or if it was originally not an ordinary employment of it,. it has now become a part of ordinary aesthetic language. The evaluative use of 'work of art' is widely recognized in the literature. In this use the phrase has a laudatory connotation, normally expresses, and in the appropriate contexts tends to influence, the hearer's at-

titudes and possibly actions. All of these may be involved when, for example, a critic tells a painter that a particular work of his is *real* art, or *is* a work of art. This use involves the concept of degrees of artistic excellence, unlike the purely descriptive use.

The view that the above expressions are sometimes used appraisively is contested by some aestheticians; for example, by Monroe C. Beardsley in his "The definition of the Arts." [1] Beardsley quotes from a letter by Tchaikowsky in which the composer condemns Wagner's *Die Walküre* as not "music," and then comments:

> Nevertheless, though Tchaikowsky could manage to condemn Wagner's *Die Walküre* by refusing to call it "music," this does not mean that "music" is a normative term. For the situation is one in which the blame attaches to Wagner, rather than his opera, on the tacit assumption that *he* called it music. This is shown by the fact that there would be no evaluation if Tchaikowsky's remark, "That's not music," were made, say, of a thunderstorm. [2]

There is some truth in Beardsley's comment which cannot, however, conceal its partial falsity. "This is not music," referring to *Die Walküre*, simply asserts that *Die Walküre* is poor or very poor music; it does not assert anything about Wagner himself. However, by the mere fact of asserting that Wagner's *Die Walküre* is poor or very poor music, the statement *implies* that its author (Wagner) in composing it failed to create a good opera, therefore good music. In that sense the "blame attaches to Wagner," assuming that we can meaningfully *blame* a composer for failing in his attempt to create (good) music. Actually, if any blame attaches to the composer, it is for composing the kind of music which he did compose rather than some other kind (actually, as Tchaikowsky's words show, the kind of music that composer himself liked and composed!). The notion of *poor* music involves the notion of failure to attain a certain standard of musical (artistic) excellence. Failure—artistic failure here—is logically possible only if there is an attempt to conform to

a standard. "That's not music," said of a thunderstorm, is purely descriptive, and necessarily so, precisely because a thunderstorm is a natural phenomenon, quite different in nature from music in the literal meaning of the word. It does not "pretend to be music"; hence, the notion of artistic success or failure is inapplicable to it. Nevertheless, there are contexts in which we can properly speak of a thunderstorm as a fine thunderstorm (though this expression would be elliptical);[3] where the word 'fine' is employed in a non-aesthetic sense. The word may even be employed in an aesthetic sense in such statements as the foregoing where we may judge the thunderstorm to be musiclike, "stormy" music.

A comparison which Beardsley makes is useful here:

> To be a knife at all, an object must have a blade. A blade, by definition, is much thinner than it is broad, and so the knife must have some minimal degree of sharpness, so to speak. But sharpness is also one of the criteria of goodness in knives, one of the grounds on which we say it is "a good knife." Still, this does not make "knife" a value-term, since the degree of sharpness it requires to be a knife falls short of that degree it requires to be a good knife.[4]

Beardsley argues analogously that 'music' is never ordinarily used as a normative (evaluative) term; but while his analogy and the actual arguments he gives, if valid, show that 'music' *is* sometimes employed purely descriptively, they do not show that it is *never also employed* evaluatively. We have already tried to show that his view is actually mistaken. Further, Beardsley appears to forget that a knife must be good, poor, or indifferent; though it is true that "the degree of sharpness it requires to be a knife falls short of that degree it requires to be a good knife." If the degree of sharpness does fall short of that degree it requires to be a good knife, it will *not* be a good knife, but will be either an indifferent or a poor knife.

Although 'work of art' is frequently employed purely descriptively, it always involves, in a certain sense, a descriptive element whenever

it is used evaluatively. The statement "X *is* a work of art" in this sense presupposes that X is a poem, a painting, or a musical composition to begin with.

II

We now come to the heart of our present discussion— to the question whether there are any (a) necessary and (b) sufficient qualities common to all things that can be properly said to be works of art in the ordinary descriptive use of this expression, *insofar as they are called works of art*. The same question applies to the various subclasses of art—music, painting, sculpture, literature, and the like, with their own subclasses.

The first part of our answer is that analysis of the way in which 'work of art', in its descriptive sense, is applied in ordinary discourse shows that there are no determinate or relatively determinate qualities, whether sensible or ideal, which constitute necessary conditions for a thing's being properly called a work of art. This is to be expected at least from the fact that 'work of art', in its present use, is a blanket term covering the amazingly rich variety of subjects and activities called paintings, poems, plays, and so on. But it simply cannot function as a blanket term if it involves in its applications the notion of certain determinate or relatively determinate qualities. Since 'work of art' is here a blanket term for a painting *or* a poem *or* a work of music, and so on, what I am saying is that there are no determinate or relatively determinate qualities which—by the ordinary descriptive meaning of 'poem', 'painting', 'work of music', and so forth—are common to (severally necessary and jointly sufficient for) all poems *and* paintings *and* works of music, qua called *poems, paintings, works of music,* and so on. We can test this assertion by selecting any given determinate or relatively determinate quality or set of qualities we wish and then ask whether its, or their, absence would make us refrain from calling a thing a work of art, if we employ the expression in anything like its purely descriptive ordinary sense. That the answer is "no" cannot be more plainly seen than by considering that not *all* the abstract paintings, lyric poems, or trage-

dies with which we are familiar *actually* have in common any such specific qualities. It follows, *a fortiori*, that the works mentioned do not *need* to have in common any of these specific qualities in order that they may be properly called abstract paintings, lyric poems, or tragedies. And if this is true of the different genres of art, it is *a fortiori* true of any given art form and (even more so) of all the art forms considered together.

It may be thought that we have been belaboring an obvious point, that nobody has ever regarded, at least nobody now regards, 'work of art' as ordinarily defined by any *specific* quality or qualities. What has been and is still widely maintained is that for anything to be a work of art it must possess some particular determinable or determinables, some general trait or set of traits. Whether or not the imputation of our imaginary critic is correct, it is certainly this view which constitutes the more interesting and plausible form of the "essentialist" thesis. On the other hand it is, I think, primarily the former, more drastic form of this view that has been and is still being rejected by those philosophers who adhere to the later Wittgenstein concerning the nature of ordinary language as a whole.

A number of aestheticians, notably Morris Weitz, William Kennick, and Paul Ziff, hold that 'work of art' is a "family resemblance" term, Weitz holding further that the ordinary concept of art is open-textured.

It will be rightly pointed out by the essentialist that the ordinary concept of art, expressed by 'art' or 'work of art' in its descriptive sense, involves the notion of (a) a sensuous medium and (b) the notion of a maker. Nothing is ordinarily said to be a work of art which is not at least partly a sensuous object, a set of sensuous qualities (a sequence of sounds in the case of music and literature), or an activity (such as dancing). A conception, an image or a set of interrelated images, certain feelings, emotions, or other experiences in the artist's mind or imagination cannot be a work of art in the ordinary meaning of this phrase. Nor is this or any other idea, feeling, or experience in the perceiver the work of art, though a work of art may evoke these things in him.

Second, and closely related to this, the expression 'work of art' in its everyday descriptive use seems to have always involved in the

past, and even now *continues* to involve, the notion of human agency. A poem, a painting, or a sculpture is written, painted, or carved as the case may be by some being or beings, termed the artist or artists. In the case of architecture, frequently in sculpture and sometimes in painting, men other than the artist also take part in producing the work, but in every case some human agency produces the work. This means that in speaking of "electronic music," contemporary artists and critics—those who countenance the idea that 'music' is used in a literal sense in that phrase—broaden the ordinary concept of music and of art as a whole. They do so only in the sense that "electronic music" is a borderline case of music in the ordinary descriptive sense of the word.

The layman's uncertain reluctance to speak of "electronic music" as music partly rests, I think, on the fact (and it itself perhaps shows) that in its ordinary employment, "X is music" is understood to imply "X is directly produced by a human being or a number of human beings." (But note that the notions of "direct" and "indirect" production of something by a human being are open-textured. This is a further source of the openness of the concepts of art and its various species.) However, "electronic music" is, relatively, mildly borderline, since the "composer" is responsible for the operation of the computer and the selection and combination, into a musical "work," of the sound patterns produced by the computer. Moreover, these machines have been invented and are programmed by human beings—in the latter case, the "composer."

The fundamental reason for the hesitation of the layman and even some aestheticians to speak of "electronic" or "mechanical music" as music proper and therefore art is, I think, due to the absence of complete purposiveness or design in the production of electronic music.[5] A case in point is Douglas N. Morgan, who mentions the preceding reasons for his "unhappiness about Mr. Beardsley's easy acceptance of the notion of 'electronically composed music'."[6] Morgan's reasons also show how the notion that art must be composed by human beings, or at least by living things, raises conceptual perplexities regarding the proper evaluative use of 'work of art' or of 'good (or 'poor') music', as well as the proper use of 'talent', 'ingenuity', and other evaluative terms applied to artists.

The foregoing is strikingly illustrated in the case of so-called accidental compositions such as the "compositions" of John Cage. Such "works" are even more borderline than "electronic" or "mechanical music," for hardly any purposiveness, if any at all, is involved in their case, in contrast to the latter cases. (To quote Beardsley in relation to Cage's compositions, "One of the methods of John Cage . . . sets up a kind of coordinate system and lets random dots decide on pitch, duration, dynamics, etc." [7] Purposiveness is, however, involved in the case of *musique concrète*, the musical equivalent of *objets trouvés*.) This is also true with random or "automatic writing" of some Surrealist writers such as Lautréamont and Apollinaire.[8] The notion of purposiveness is, as a matter of fact, an essential implication of the ordinary concept of a man-made artifact or a man-devised process or activity. For as I have elsewhere [9] attempted to show, the notion of some kind of function, purpose, or aim which logically implies the notion of purpose or design is implicit in the ordinary uses of all such things. Similarly we shall see in Chapter 4 that implicit in the ordinary uses of 'work of art' and its various more specific art names is the notion of the *aim* to affect human perceivers in a certain kind of way. Since this notion of a certain kind of aim will be shown to be an essential part of the ordinary concept of a work of art and is logically tied with the semantic fact that a work of art is an artifact or man-devised activity, we can appreciate the central role which the idea of human purposiveness, and hence the idea of human agency in general, plays in the ordinary concept of art.

The notion of an *aim* also explains the great hesitation of the layman, who employs the ordinary concept of art, to call "accidental music" or "automatic writing" art. It accounts for people's hesitation to term as painting and, hence, art the works of painters such as Franz Kline, or those paintings produced by methods such as dripping, spraying, or squirting paint on a canvas. The underlying reason for this is, I think, that people believe that in these cases the artist cannot fully—even, perhaps, in any appreciable degree—control the medium he employs; hence that any artistic design he envisions cannot be, or cannot be fully, realized in the produced work. The purposiveness and design are present in the artist's mind, but it

is assumed that the work does not, and cannot, "embody" or realize this purpose or design. The absence of control[10] and purposiveness in the employment of the medium itself are likewise a, or the, fundamental reason for the widespread hesitation of laymen to regard surrealist painting or literature as genuine art.

Does the notion of some kind of *affective aim* which is implicit in the ordinary descriptive use of 'work of art' (see Chapter 3) impose a special purpose or design, or a special kind of purpose or design, on the part of the person producing the work? Does it imply that something which exemplifies the affective aim of art cannot be properly called art unless its maker endowed it, or at least attempted to endow it, with that aim? The answer is, I think, negative. For we invariably judge certain artifacts or certain man-devised activities to be art or not art without even raising the question whether their creators or designers intended to endow them with such an aim. If we call something art, we do so independently of whether it was actually intended to be, to serve as, a work of art. If we refuse to call it art, this is not in any way due to our assuming, rightly or wrongly, that its author did not intend to create a work of art. We do not automatically refuse to call a building a piece of architecture, hence art, if we know that the architect only aimed at producing, say, a comfortable residence for some dozens of people. Similarly we do not automatically refuse to call a Korean rice bowl, a Persian carpet, a length of French tapestry, or a set of Delft porcelain a work of art if we discover that the persons who made them merely aimed at utility or wanted to make money, gain prestige, and the like.

This brings to light fatal flaws in the very prevalent theory that art consists in the "expression" of the artist's feelings or emotions, *insofar as it holds, or may hold, that the artist, qua artist, aims* at "expressing" his feelings or emotions by organizing a sensuous medium; and that the work of art, qua work of art, "expresses" in turn the feelings or emotions deliberately "embodied" in it. (Our remarks obviously do not invalidate the view that a work of art is the "expression of," and itself "expresses," the artist's unconscious or subconscious "experiences"; or that it is the spontaneous overflow of the artist's feelings or emotions.[11] Even if the Expression theory

as described is a true account of what many, or even all, artists actually do, or what they actually intend to do in creating art, the notion of the artist's deliberately "expressing" certain feelings, emotions, or experiences in his work does not constitute a part of the ordinary concept of art. The artist's intention or alleged intention to "express" something—anything—in creating a work of art does not constitute part of the ordinary meaning of 'work of art'.

There is a sense, however, in which the concept of an *aim* can become relevant in the valuation as good or bad art of a given object or activity which is regarded as art in the descriptive sense. This sense of aim is different from the sense in which we have above employed the term and pertains to the work itself rather than the artist who created it. (See Part II, Chapter 8.)

The notion of *duration* is involved in relation to a general element in the ordinary descriptive use of 'work of art'. For anything to be normally called a work of art, it must endure for an appreciable length of time. The notion of an "appreciable length" of time is very flexible and is delimited only very roughly or broadly at its lower limit. We do not call a painted canvas a painting and therefore art if it disintegrates—assuming that that is possible—in the very process of making it. In the case of painting, sculpture, and architecture, the fact that some relatively stable sensuous object is generally employed as a medium generally ensures a certain degree of permanence to the work as a painting, a sculpture, or a work of architecture. However, though no conventional plastic work of art that I know of has this feature, I think we would not refuse to call, say, a certain painted canvas a painting if its colors continually change and/or the forms it contains and their spatial relationships are in constant flux. We might, for all I know, call it a series of paintings rather than a painting, but we should in any case apply the word 'painting' to it. A certain—but only a certain—degree of such fluidity of form is, of course, characteristic of mobiles by virtue of the continual movement of their parts. Every part of a mobile, and the mobile as a whole, endures for minutes, hours, days, months, and so on, unless accidentally or deliberately destroyed. In other words, the relative durability that is involved in the ordinary concepts of painting, sculpture, and architecture, hence in the ordinary

concept of art, is (a) that of a relatively stable sensuous medium, and, in the case of any *particular* painting, sculpture, and so forth, (b) that of a relatively durable or stable arrangement of the parts or other components—colored, carved, or welded forms—of the sensuous medium. In some though by no means all cases (not in the case of mobiles), (b) is consequent on (a). It is at least partly because of condition (b) that I believe many of us would ordinarily refuse, not merely hesitate, to call art any fleeting forms, say, created with a moving light in a dark room. This brings to mind Picasso's experiments in which, with his body and arms, he used to weave intriguing three-dimensional patterns in a dark room, holding a light in his hand. The photographs of these fleeting forms can be regarded as abstract photography. But they are, of course, different from the visual forms actually created by Picasso with the moving light, and photographs are relatively durable or stable things. Some of us will recall at this point the art form called "Lumia," or "an art of light," invented by the American artist Thomas Wilfred. They will recall a "recorded Lumia composition" made in 1955, entitled *Aspiration opus 145*, in the Museum of Modern Art in New York City.

With respect to literature, music, dancing—the "temporal" arts in general—the situation is, not surprisingly, considerably different. What matters there (and the same is true of lumia) is not so much the duration, which may be extremely short, of the particular sounds or movements but the fact, first, that a musical composition, a literary work, or a dance, *as a whole*, spans an appreciable length of time; though each sound, word, or movement in the work may last for only a brief moment. Second, and more important, every component sound, word, or movement, and hence the work as a whole, can be faithfully repeated, re-created, reenacted, or reproduced at will, whenever the necessary conditions such as musicians and musical instruments, readers, and dancers are available.

Recorded "lumias," like musical compositions, poems, and ballets, clearly satisfy the above conditions respecting temporal works of art. The same is true, except for obvious but surmountable practical difficulties, in the case of Picasso's "sculptures" in light (the practical difficulty of faithfully reproducing at will the exact movements Picasso went through in his actual "experiments"). The reluctance

which many people probably feel, to call "lumias" works of art, is probably not due to the fact that they are in part visual, spatial art forms or genres, and therefore that the "lumias" are expected to satisfy the conditions of visual, spatial art as well as the conditions of temporal art. For dances are also visual, and many of them are in part also auditory works: yet no difficulty is felt in their case, even though they fully satisfy only the conditions which we noted above in relation to temporal or auditory works. The real reason for the reluctance seems to be the unusualness of the particular "materials" used as a medium. I therefore think that recorded "lumias" and Picasso-type "sculptures" in light do not constitute genuine border-line cases relative to the present ordinary concept of art; this concept easily permits of their being classed as works of art in the ordinary descriptive use of 'work of art'. This brings us to a very general kind of feature common to *all* works of art by virtue of their necessary employment of a sensuous medium. The temporal quality of the media of all art is no less obvious in the major "spatial" arts of painting, sculpture, and architecture than in the major "temporal" arts of music, literature, and the dance. However, it is clear that in the case of "spatial" works of art time in this usual sense is not involved in them at all qua *works of art*, rather than as some other kind of sensible things. Yet a "feeling," experience, or impression of *duration*, of the *passage* of time, is an important effect produced by certain paintings, sculptures, and other "spatial" works. The latter is also true of literary or musical compositions.

Now all the traits that I have mentioned and briefly discussed so far are severally or jointly also shared by other classes of things; they are not singly or jointly peculiar to works of art. It is not difficult to show that they do not jointly suffice to distinguish art from all other things. But the fact that in the present ordinary use of 'art' in the descriptive sense all art, as art, must involve some direct or indirect human agency clearly distinguishes it from natural beauty as well as from all other natural phenomena. It is true that a piece of driftwood may be said to be "a lovely piece of sculpture." [12] In this and similar ways of speaking, which Beardsley and Weitz adduce in support of the view that 'art' does not have a "genetic reference" and that a work of art does not imply an artist, we em-

ploy 'art', 'work of art', 'sculpture', and so on in a figurative, or a literal but extended, sense. In other words, the piece of driftwood, the strains of Shelley's Skylark, or a beautiful sunset are not borderline cases. They are not produced by man, either directly or indirectly; the driftwood and the sunset are not the handiwork of any living thing on earth.

Although the features discussed above do not jointly constitute a sufficient condition of art, it may be thought that there exists one other general feature of all art which, together with the foregoing features, does constitute a sufficient condition of it: "form."

It must be said at the outset that if form constitutes a necessary condition of art in the descriptive sense, it can only be so in some ordinary meaning of 'form', not in some technical sense. At best it may be, *as a matter of fact*, a universal empirical feature discernible in all things hitherto correctly called works of art in the descriptive sense of 'art'. That is, the statement "All known works of art have 'form' " may express a true universal synthetic proposition about art. There are, as far as I can see, four common senses of 'form' that are at present employed in everyday aesthetic discourse, though probably some and possibly all have originated in the writings or utterances of critics, aestheticians, artists, or historians of art. An examination of these senses, I submit, shows that in none of them does "form" constitute a necessary condition of art in the ordinary descriptive use of this term.

(1) There is, first of all, the current use of 'form' in such expressions as the 'novel form', the 'sonnet form', the 'sonata form', and the 'form of a Sophoclean tragedy', or the 'form of a Shakespearean tragedy'. But in this use of the expression, a sonata is distinguished from a concerto; an epic is distinguished from a tragedy, a tragedy from a comedy. 'Form' here (or form $_1$ for brief) is not at all something common to sonatas and concertos, or epics, tragedies, and comedies—let alone something common to sonatas, concertos and epics, tragedies, comedies, and so on. Even in the case of the sonata, the classical form differs from the romantic form, and Shakespeare's tragedies, say, differ significantly in their formal features from classical Greek tragedies, and so on. In the same way, there is no single common trait or set of traits, respecting the relationship of the

sensuous components and/or the nonsensuous components, of novels or short stories. This is most evident in the case of contemporary literature, music, painting, and the other art forms. The flexibility of the uses of such labels as 'play'—even in its more scholarly, technical employment—gives rise to the controversy whether, say, *Waiting for Godot* or *The Connection* is a play, or whether, say, Joyce's *Finnegans Wake* is a novel.[13]

In sum, instead of a trait or a set of traits common to all sonatas, concertos, and novels, analysis reveals (a) different sets *of relatively specific* crisscrossing resemblances and (b) *still more general* crisscrossing resemblances between sonatas, concertos, and symphonies, tragedies and comedies, and so on as far as form in this sense is concerned.

What this means is that it is false that all works of art can be said to be in the same form $_1$. However what really matters for our present inquiry is whether all works of art, qua (called) works of art, are cast in *some* form or other. The answer is negative. There are many works of art which do not have a, or any, form $_1$. Lyrics, paintings, and sculptures provide us with good examples. The *name* 'lyric' does not refer to a kind of form $_1$; there is no such thing as the lyric form or different lyric forms; similarly with 'painting' and 'sculpture'. There are different genres of painting, such as landscape painting, seascape painting and portraiture, and there are different genres of literary composition, of which the lyric is one. But as understood in relation to these things—and unlike the employment of the word in relation to tragedies, comedies, sonatas, or symphonies, where it involves the notion of a form in the present sense—a genre is not the same as, or does not include, a form $_1$.

(2) In the phrase 'art form' we meet a second, and a different kind of, use of 'form' (or 'form $_2$'). The distinction between one form and another in this sense refers to and is based on the differences between the kinds of sensuous media employed in art. Thus to speak of literature and the other arts as forms is not to refer to the organization of the sensuous or nonsenuous components of a work.

(3) There is a very common third sense of 'form', in which every work has some form, including those works that I claimed do not have (are not cast in) a form $_1$. We ordinarily speak of the form

of a work as opposed to its content. (The word 'content' confusingly enough, is also currently employed in opposition to 'form $_1$'.) By "form" here we refer to the organization of a poem, a musical composition, and so on, independent of the particular words, tones, colors, lines, or shapes that are organized. In this sense (form $_3$) we can speak of the form of *Finnegans Wake* even if we are puzzled as to whether it is a novel. That is, 'form $_3$' can be applied to borderline cases relative to the use of 'form $_1$'. (In any case, this work is a bona fide literary composition, even if we cannot unquestionably call it a novel.) In this sense, every work of art necessarily has a form; for the same reason that every other sensible object, sound pattern, activity, and so on necessarily has a form $_3$. Form $_3$ is a necessary condition for a thing's being correctly called a sensible thing. It is not a necessary condition of art qua art. (This means, at best, that a work of art cannot consist of a single word or musical tone, though it can be a unicolored surface, and even this does not appear to be absolutely definite. For a single word or tone can be said to constitute a limiting case of form; since it will be in "relation" to the silence it breaks. But note that some of John Cage's "compositions" consist of sheer silence!)

We have already discussed a sense of 'form' in which only works of art can have form (form $_1$); form in this sense is peculiar to art. However, I argued that not all things called art are ordinarily said to have form $_1$; for there is nothing shared by all things called works of art in this peculiarly aesthetic sense. Form $_3$, which is common to them all, does not enable us to distinguish art from other sensible things.

(4) The concept of form is employed in everyday aesthetic discourse, and more frequently by artists and other experts, in a very important way constituting our fourth sense of the expression (form $_4$): a sense we come across in connection with the analysis and interpretation of particular works of art. In speaking of form in this sense, we do not think of the organization of a work in abstraction from the nature of the specific elements so organized; form $_4$ is "organic" form, in a sense quite analogous to the one in which the Absolute Idealists speak of an internally related system. No combination of sensuous or nonsensuous elements in a particular work can

constitute a part of that work's form $_4$ *unless* the work's nature is
partly determined by the nature of its terms. Thus, in the present
sense, form has essential reference to the work's "content" distinct
from senses (1) and (3) of this word, the senses in which they cor-
respond to form $_1$ and form $_3$ respectively. Form $_4$ refers to the nature
of the specific elements related in a particular way (that have a form $_3$,
and may have form $_1$) in the work. If the essential reference of form
in this sense to "content" or "substance" is forgotten or ignored,
form $_4$ is reduced to the aesthetically useless sense of form $_3$.

The converse of the foregoing is also true in relation to form $_4$, in
that the specific character of the elements of a work—to the extent
to which they may be integral parts of the work as a whole—is
partly determined by the nature of the relationships they have to
one another.

The following points respecting form $_4$ (coherence, unity, organ-
icity) should be noted. The concept of form $_4$ is also applicable to
artifacts, many of which would not be called art, even "machine
art." (Cf. Weitz's criticism of Organicism in "The Role of Theory
in Aesthetics.") In contrast to form $_3$, *both 'form' and its opposite*—
'formless', 'amorphous', 'disorganized', 'lacking in form'—are in the
present, fourth sense applicable to these things. Thus we speak of
some poems, paintings, sculptures, and other works of art as form-
less, incoherent, disorganized, amorphous, and of other works as well
organized, well constructed, coherent; although, as I said before, all
works of art have form $_3$.

Our expressions are patently appraisive. To speak of a poem or a
painting as well organized or coherent is to imply that it has merit
as such. In every case, this has reference to the arrangement or organi-
zation of its elements. Coherence or unity makes no sense completely
apart from the combined or related elements.

Since these expressions are appraisive in meaning, a poem or a
painting in the descriptive sense of these words can be either coherent
or incoherent. The distinction between the notions of coherence and
incoherence, as they are employed in relation to art, arises within the
realm of art itself. Thus coherence cannot serve to distinguish art
from nonart. For one thing, a good many contemporary works are
deliberately "disorganized" or "incoherent" in the traditional under-

standing of these notions. Their elements lack the sorts of relations which laymen, and even critics and aestheticians, have hitherto tended to identify with coherence. With respect to the entire corpus of past art, to which the traditional notions of coherence and incoherence are applicable, coherence in any degree is not a necessary condition of their being *called* art in the ordinary, descriptive sense. If it is impossible for anything to be a painting or some other kind of art in the descriptive sense and, at the same time, completely "incoherent," either in the traditional or in a more liberal sense, this is because it is impossible for any complex thing (hence anything that has form $_3$) to be completely disorganized and incoherent. It will not be so because some degree of coherence is a "defining feature" of art in the ordinary descriptive sense. (Likewise a work cannot be said to be *completely* disorganized in the presense sense if it has form $_1$.) Thus with regard to form $_4$, it is not true that, in Beardsley's words, a "minimal degree of coherence" is a necessary condition of poetry, music, "visic"—Beardsley's word for the visual counterpart of music—in the descriptive sense of these words.

If 'form' is understood in the present sense, one main problem which arises in relation to Beardsley's notion of coherence is that of giving precise meaning (though only in a general way, if the openness of the concept of art is to be preserved) to the phrase "minimal degree of coherence." However this is defined, it is always theoretically possible to encounter objects or activities, not commonly regarded as art, which exhibit the specified minimal degree of coherence; even if it is impossible to encounter objects, commonly called works of art, which exhibit a degree of coherence less than the stipulated minimal degree.

In the aesthetic theories of Clive Bell and Roger Fry we come across a use of 'form' that is somewhat different from, though clearly related to, form $_3$. Bell and Fry include the forms, lines, and colors of visual works of art in "form" as they employ the word; whereas these things would be part of the content of a visual work relative to our present use of 'form' (form $_3$). Thus the Bell-Fry use of 'form' can be regarded as a fifth sense of the term.

As is well known, Bell and Fry maintain that visual works of art possess "significant form," a unique quality resulting from certain

combinations of forms, lines, and colors; that this quality is one which evokes a peculiar, aesthetic emotion. Some of the chief difficulties with this definition of (visual) art are familiar to students of aesthetics. For instance, the definition is circular or, more correctly, circular in the sense that, logically speaking, the only way in which Bell *could* define 'aesthetic emotion' was by reference to the alleged source of the aesthetic emotion, that is, visual works of art in general and the unique quality of significant form in particular. Bell does attempt to define or explain the nature of the aesthetic emotion in terms of an obscure metaphysical hypothesis about art as a possible revelation of the universal "rhythm of reality," but logically this is of little help. More specifically, Bell's failure to find a satisfactory way of defining 'aesthetic emotion' lies in his isolationism, in his view that the aesthetic emotion is quite different from the emotions of everyday life. This makes it impossible in principle for him to define or explain it, except by circular reference to its ostensible cause— (visual) works of art. The reason for his isolationism is logically twofold: (1) his view, adopted from G. E. Moore,[14] that value is a unique, "nonnatural," hence indefinable quality; (2) connected with (1), his view that the representational and descriptive elements of visual art are not aesthetic features of it. This is the second reason why, for Bell, the aesthetic emotion is necessarily a pecular emotion. The emotions evoked by these "nonaesthetic" elements, which are emotions of the kind aroused in everyday life by artifacts and natural objects that are not art, are "nonaesthetic" emotions; or the aesthetic emotion is what is evoked by the *unique* quality in visual art. Consequently, it must be a unique or peculiar emotion. Of necessity, therefore, this emotion cannot be defined or explained in terms of the everyday emotions of pleasure or enjoyment, ecstacy or rapture and so forth.

Bell opens his theory to further objections by maintaing that "some people may, occasionally, see in nature what we see in art and feel for her an aesthetic emotion."[15] That is, it is possible to get the (or an?) aesthetic emotion by viewing it simply as formal design. This is, in a way, more in line with the fact that sensible things other than art have form in Bell's sense, and with the empirical fact that the formal design of things other than (visual) art—not just "natural beauties"

but also some artifacts—is capable of giving sensitive persons who concentrate on it an enjoyment akin to that which (*good*) art is capable of giving by virtue of its formal features. But it wrecks Bell's definition of art as significant form since this means, apart from other difficulties, that *significant* form is not peculiar to art.

Again, it is false, by the very uses of 'art' or 'work of art', 'good', 'bad', and so on in everyday discourse, that all (visual) art, good or bad, is capable of giving anything like the rapture which Bell believes all art, qua significant form, can evoke. Only good, perhaps the finest, art can do so. This is precisely what Weitz means by saying that Bell's definition of art is an "honorific (re) definition" of the (ordinary) concept of art. I should add that the pleasure which good art can evoke in qualified perceivers is not *sui generis*,[16] whether or not we include in principle, as I do in line with everyday usage, the representational and descriptive elements among the "aesthetic" kinds of features of representational and descriptive visual art.

Finally, the supposition that aesthetic value (or "beauty") is a *unique, nonnatural* quality seems to entail (depending on what exactly we understand by the italicized words, particularly 'nonnatural') the aesthetic irrelevance of the representational and descriptive elements in representational visual art, and the emotions they may be capable of evoking under the appropriate conditions. If this is true, it would follow by contraposition that if the representational elements *are* aesthetically relevant, then aesthetic value is not a unique, nonnatural quality. And as I said above, it is my view that the antecedent clause does follow from the ordinary uses of art names.[17] A further consequence is that Bell's and Fry's rejection of representational and descriptive elements as aesthetically irrelevant constitutes a *second* way in which they have redefined the ordinary concept of art. This redefinition can be called honorific in the sense that it is prompted by Bell's and Fry's application of a chosen criterion of aesthetic excellence that was inspired by the Post-impressionistic art of Cézanne. By ignoring the aesthetic relevance of representational elements, Bell and Fry modify the concept of art, though not by narrowing down the class of things to which 'art' is applicable (or the comprehension of the word in C. I. Lewis's sense), or by eliminating in principle all representational elements as possible criteria features of aesthetic

goodness or badness. 'Art' is used by them in an evaluative sense, as equivalent to 'good art'. Some things which we would ordinarily call good art would not be called "art" by them, since their goodness for us may partly or wholly depend on the nature of their representational elements. The upshot is that fewer things would be called art by Bell and Fry than by us.

<div style="text-align:center">III</div>

On final, methodological point: the reasoning I have employed in Section II is, of course, essentially Wittgenstein's in his celebrated discussion of the notion of "family resemblances" in *The Philosophical Investigations.* As is well known, he illustrates this notion in the case of the everyday uses of 'game', asking, "What is common to them all?," and replying "If you look at them you will not see something that is common to *all,* but similarities, relationships. . . ." [18] This illustrates a convenient strategy, for if there are no characteristics common to all things we call "art," it follows that we do not, cannot properly,[19] call certain things "art" on the basis of any common characteristics. We must observe the following things.

(1) Although the *absence* of common characteristics in all things we call "art" shows that 'art' cannot be correctly applied [20] on the basis of any common characteristics, the *presence* of common characteristics does *not* show that the word is applied on the basis of any (these or any other) common characteristics. The presence of these characteristics may simply be a contingent, empirical fact about things we call "art." That is, the statement "All works of art have characteristic(s) a (a, b, c)" may express a true universal synthetic proposition relative to ordinary language (English); whereas if 'art' is (or were) ordinarily applied on the basis of some characteristic x or set of characteristics x, y, z, the statement "All works of art have characteristic(s) x (x, y, z)" would express an analytic proposition relative to ordinary language (English).[21]

(2) Instead of using the strategy described above, we could directly attempt to show, simply by observing and analyzing how we do employ the word—in the sense of the *criteria* (criteria features)

we employ for applying or withholding the word from application—
that 'art' in the descriptive sense is not applied on the basis of any
common characteristics. If we employ this direct method we would
see, in my opinion, that in the descriptive sense of 'art' we do not
apply the word on the basis of any characteristics which we rightly
or wrongly suppose are common to all things to which we apply it.

(3) Finally, it is extremely important to recognize that if, as I
maintain, 'art' in the descriptive sense is a "family resemblance"
word, it does *not* follow that there cannot be any characteristics, of
any degree of specificity or generality, *common* to all things we ordi-
narily call art in this sense. All things called art could still have com-
mon characteristics—and important ones at that. Indeed, these char-
acteristics may be more fundamental or basic in some sense than the
resemblances on the basis of which 'art' is at present ordinarily
applied. The situation may therefore parallel the situation in the
natural sciences. For example, biologists do discover common charac-
teristics (or resemblances) which are, in an anatomical or physio-
logical sense, more important than the superficial qualities, accessible
to the unaided human senses, on the basis of which the prescientific
everyday class names are, or were, applied. The same is true, *mutatis
mutandis,* of the chemical classification vis-à-vis the everyday classifi-
cation of chemical substances.

Precisely for the foregoing reason, the indirect method Wittgen-
stein uses in relation to 'game' and which I mainly employed in
relation to 'art' in this chapter, has an advantage over the direct
method of establishing the desired conclusion. The indirect method
achieves two objectives in one logical stroke, so to speak. It shows
not only that 'art' *cannot* be *correctly* applied on the basis of any
alleged common characteristics, but also that, *as a matter of fact, no
empirical theory or hypothesis which claims that all things we ordi-
narily call art have some (important) characteristic(s) in common is
(can be) true.*[22] On the other hand, the limitation of this method is
that it is virtually impossible to examine all possible characteristics
or kinds of characteristics, specific and general, which can in principle
lay claim to being common to all things we call works of art. I have
concentrated, partly because of space limitations, on only some of the
more familiar candidates for the status of "common characteristic of

all extant art," which have been put forth by essentialist theories of art in recent times.

To counterbalance what I have just said—and to lay to rest any hopes which these remarks may have given the essentialist—I hasten to add that although the foregoing is actually possible, it is *highly improbable that some determinate or relatively determinate characteristic* will some day be discovered in all actually existing works of art. I say this, first, in the light of my thesis that 'art' is a "family resemblance" word in everyday discourse. For if this thesis is true, there is logically no need or necessity for the existence of any common characteristics in all existing art; and if such characteristics do exist, they would do so by sheer accident. More important, the creative character of art, at least in the West, or the general demand that the artist must strive to be as creative, as original as possible,[23] militates against the probability that all good art, let alone all art, shares some common characteristic(s). Note the logical and contingent, historical relation between this and Morris Weitz's view, in "The Role of Theory in Aesthetics," that to *close* the concept of art would be to foreclose "on the very conditions of creativity in the arts." [24]

NOTES

1. *The Journal of Aesthetics and Art Criticism* (Winter, 1961), pp. 175–87.
2. *Ibid.*, p. 184.
3. See my "Natural Objects and Common Names," *Methodos*, Vol. XIII, No. 49–50, 1961, *passim*.
4. *Op. cit.*, p. 185.
5. Note, for instance, the professional or amateur critics mentioned in Beardsley, *op. cit., passim*.
6. "Art Pure and Simple," *The Journal of Aesthetics and Art Criticism* (Winter, 1961), p. 178 footnote 1.
7. *Op. cit.*, p. 178.
8. *Ibid.*
9. "Common Names and 'Family Resemblances'," *passim*.

10. Cf. Beardsley's remarks, *op. cit.*, p. 179, about the Japanese art of making rock and sand gardens (*bonseki*), and the "controlled accident" it involves.

11. See O. K. Bouwsma's "The Expression Theory of Art" in W. E. Kennick, ed., *Art and Philosophy*, for telling criticisms of the classical Expression theory. See also my more direct criticism of the theory in "The Expression Theory of Art: A Critical Evaluation," *The Journal of Aesthetics and Art Criticism* (Spring, 1965), pp. 335–52.

12. Morris Weitz, *op. cit.*, p. 34.

13. Cf. my "Family Resemblances and the Classification of Works of Art," *The Journal of Aesthetics and Art Criticism* (Fall, 1969).

14. See Melvin Rader, *A Modern Book of Esthetics*, Third Edition (New York, 1961), p. 302.

15. Clive Bell, "The Aesthetic Hypothesis," reprinted in W. E. Kennick, *Art and Philosophy*, p. 37.

16. See Chapter 4.

17. There are also excellent reasons for regarding representational elements as aesthetically relevant; that is, for conforming to everyday usage.

18. Reprinted in Melvin Rader, *op. cit.*, p. 195. Italics in original.

19. I am using 'properly' in a logical sense; since people *may* use 'art' or some other general name 'X' on the basis of a certain characteristic which they *mistakenly* attribute to a group of objects. For instance, it is quite possible that people at one time applied certain general names to a group of things they believed to have common magical or other occult powers. Because this type of situation is possible, we have to draw a distinction between how people actually apply a certain general name and how they should apply it if they are aware of the qualities or properties that the things to which they apply it really have.

20. Without changing its conventional meaning or uses, of course.

21. The situation respecting the analytic/synthetic dichotomy is more complicated, by virtue of the distinction I drew earlier, than has been hitherto recognized.

22. Note that an empirical theory of art can only claim that all extant art has such and such common characteristics, and that this may continue to be true in the future. It cannot claim that the latter will be the case.

23. In those parts of the world where the artist is not required to be original, this point is clearly inapplicable.

24. Melvin Rader, *op. cit.*, p. 206.

Chapter 3

The Concept of
the Aims of Art

In Chapter 2 I analyzed to some extent the descriptive use of 'art' or 'work of art', as these expressions are employed in everyday, and in critical, discourse. I attempted to show, in line with the view current among linguistic philosophers, that these expressions are not applied in the light of any fairly determinate or determinate *characteristics* supposed to be common and peculiar to all things called paintings, poems, sculptures, musical compositions, and so on. (The situation is quite complicated; no single pattern exists, however, with regard to the less general art names, particularly the names of the various genres and major art forms.) Rather, these expressions are applied on the basis of various, or various kinds of, "crisscrossing family resemblances." However, if we stopped here, as the philosophers I referred to generally do, we would have a very incomplete and misleading picture of the everyday and the critic's uses of 'art' or 'work of art'. It would have serious consequences, creating, in particular, a false logical hiatus between the descriptive and the evaluative uses of 'art'. For this picture can only give an incomplete, one-sided connection between statements such as "X is a painting," "Y is a poem," "W is a work of art," using 'painting', 'poem', and 'art' in a purely descriptive way, and aesthetic judgments such as "X is a good painting," "Y is a fine poem," "W is poor art." More precisely, it would leave unexplained the reasons or justification for the criteria employed by laymen and critics in evaluating poems, paintings, and so forth as good or poor art (or as good or poor paintings, poems, and so on).

This, to my mind, is a characteristic and fundamental failing of the views of linguistic philosophers such as Morris Weitz, Stuart Hampshire, and Margaret Macdonald. As a matter of fact, all these philosophers and other contributors to *Aesthetics and Language* (for example Helen Knight) fail to relate except in a very general way the criteria (or the reasons) of aesthetic valuation and the concept of art. Generally, in other words, they refuse to give us a full-fledged aesthetic theory.[1]

My own general view is: (1) a thing's possession of a variable number of certain (variable) kinds of resemblances to certain things regarded as paradigm cases of art, is the basis for our everyday and critical application of 'art' or 'work of art' in their descriptive use. (For simplicity's sake I am ignoring borderline cases.) But (2) the ordinary and critical uses of 'art', or the ordinary and critical concept of art, includes, as an integral part, the notion of certain aims or kinds of aims; this notion, hence the aims or kinds of aims in question, play(s) a fundamental "regulative" role. I mean that something which is generally called art in the descriptive sense on the basis of its phenomenological features would be considered *good* (or *poor*) art, or art (or not art) in the *evaluative* sense, depending on whether (or the degree in which) it is thought to satisfy one or more of the aims of art by virtue of (i) the impact it has (if any) on qualified perceivers under optimum conditions, hence, correlatively, (ii) its phenomenological features.[2]

Consonant with the foregoing, the present Chapter attempts to show that the uses of 'art' or 'work of art' do involve the notion of aim(s), discover what these aims or kinds of aim are, and precisely what roles they play in the current everyday and critical employment of our expressions. Further, I attempt to show that the notion of aesthetic aims itself is open textured and hence that it makes the concept of good (poor) art as a whole open, or the "class" of good art nonsharply demarcated from the "class" of poor art and from the class of "indifferent" art, or vice versa. Another source of openness in the concepts of good, poor, and indifferent art is due to the fact that the concept of each of the aims or kinds of aims of art is open. Hence there is no sharp line of demarcation between the satisfaction and the lack of satisfaction (also between a certain "degree"

of satisfaction and a certain "degree" of lack of satisfaction) of this or that aim. Membership in the "class" of aims of art being contestable in principle, the list of such aims is always in principle an open one. Membership in the class may vary in that new members are always eligible in principle; a current member is always open to "expulsion" from membership.

The precise roles which the notion of aesthetic aims and these aims themselves, play(s) in art criticism in general and aesthetic judgment in particular, will be seen in Part III.

II

It can be readily shown [3] that the ordinary concepts of the various human artifacts and the concepts of man-devised activities or processes include the notion of some use or function, and/or of some aim, purpose, or goal, varying with the particular artifact, activity, or process. Apart from an analysis of the ordinary descriptive use of 'work of art' itself, we should, on this basis, expect the same to be true of the ordinary concept of art. Works of art, in the present ordinary unextended meaning of the word (ignoring marginal cases for the time being), are human artifacts, human activities, or interrelated sensible qualities devised by man. This inference from a genus to one of its species is confirmed by the way in which we speak about art in everyday and in technical contexts, shown even by a cursory examination of the way in which we *evaluate* poems, paintings, musical compositions, and the like. What concerns us at present is the role it plays in determining the "nature" of art in general. However, the descriptive and the evaluative uses of the various art names are related in important ways; the concept of the aim(s) or purpose(s) of art constitutes at least one major link between them. By ascertaining the role which this concept plays in relation to these two (sorts of) uses of art names, we shall get a more adequate understanding of art and pave the way for an understanding of the nature and criteria of aesthetic valuation.

Although the notion of use or function is involved in the ordinary concepts of various artifacts and activities, only the notion of aim or

purpose is involved in the ordinary concept of art. To be sure, we sometimes ask "What is this painting (say) for?" just as we sometimes ask "What is this knife (or car) for?" We may be inquiring about the way in which the particular painting is believed to be needed by someone in the particular situation. Sometimes these questions are disguised assertions made by persons who do not see how the painting is needed in the particular situation. For example, a man may express disapproval of the interior decoration of his house's living room by snapping at his wife, "What is this painting for?," meaning "What is this painting supposed to contribute to the room's appearance?"

A person may use a painting as a decoration, or for all sorts of other purposes, on all sorts of occasions. Other kinds of art can be similarly used in all sorts of ways, but the notion of a certain use or function is not part of the ordinary concept of art, which means that a work of art cannot be, as (called) art, a means to anything. This is, I think, why we normally feel that anyone who is presumed to know what 'art' means, but regards—or attempts to use—art as a means to some social, economic, or political end, is using it in an extra-aesthetic capacity, perhaps even modifying or trying to modify the ordinary uses of 'art'. Consequently I shall label as "extra-aesthetic" any such capacities in which a work of art may be used.[4] This applies to all art forms, genres, forms $_1$, or other subdivisions of art. It applies, for instance, to works of architecture and to ceramics. military marches, epitaphs, incidental music, didactic and satirical literature, caricatures, and so on. It also applies to jewelry, rugs, and other items of furniture, some of which may be ordinarily called art in the descriptive sense. A building or practically any other piece of architecture, in the descriptive use of this word, is normally intended to have some public or private, utilitarian or other use. At the same time *some* works of architecture in this use of the word are also works of art in the descriptive sense of 'work of art'. Whenever a work of architecture in the former sense is a work of art in the descriptive sense, it will possess a function (if any) not qua art but qua hospital or school building, auditorium, railway station, or whatnot.

The same remarks apply to pottery, jewelry, and furniture, which normally have some utilitarian or ornamental uses. Note that decora-

tion or ornamentation is a use of objects; we speak of using a brooch, a painting, or a sculpture as an ornament or decoration. This indicates that ornamentation or decoration is not, and cannot be, part of the aims of art.

I said earlier that a work of art is not a means to anything, but it nonetheless aims at effecting certain things. This is analogous to the way we talk about human beings. A man can be properly said to have some, or not to have any, aims in life, or to have this or that purpose in doing this or that; yet it makes no sense to speak of "a man's uses," or even "a man's functions" as a man, pace Plato and Aristotle with regard to the latter. The mistake of these philosophers was that they assimilated the concept of man to the concept of entities having a peculiar function dictated by their essence or presumed essence: in this case by their taking, in effect, artifacts and man-devised activities or processes as their model.

How can art be meaningfully said to have aims? The query arises, of course, because it is felt that only human beings, or at best living organisms, can have aims in a literal sense. Only in a figurative or a special sense, it may be said, can art be said to have aims.

It seems to me that the notion of aim is applied to art by transference—that 'aim' in such phrases as 'the aims of art' is a transferred epithet. Because men create it for certain ends, the notion of aim is, by transference, applied to art. But this is only part of the reason; most human activities and artifacts, as we saw, are made for some purpose, yet are not ordinarily said to have aims themselves.

Aims can be "practical" or "theoretical"; and men have aims of both kinds. As far as the ordinary concept of an aim is concerned, some of all of the aims of art can be, in principle, practical. In this respect an aim is *partly* like a use, since in its everyday employment the notion of use appears to have a practical connotation. (Note, for instance, how we speak of the uses of applied science or technology but of the aims of theoretical or pure science.) However, there is. a basic difference between saying that a man has a practical aim and saying that an instrument or tool has a use. The latter implies that the object itself brings about certain states of affairs which constitute its use; the former implies that a man uses certain things (which are useful) in order to realize the particular objective.

The use of 'aim' in relation to art appears to be intermediate between the uses of 'aim' in relation to men and the use of 'use' in relation to utensils, tools, and so on. In the first place, the activities or processes in which artists indulge as artists are designed (by the meaning of 'an activity or process of creating a work of art') to bring about a work of art, something which has certain kinds of phenomenological features enabling it, if it is any good, to have certain kinds of impact on people in the appropriate circumstances. By transference, the activity itself is said to aim at the creation of a work of art. Second, and correlatively, something ordinarily called a work of art in the descriptive sense, as something possessing certain kinds of qualities, is designed to produce certain kinds of impact on people in the appropriate circumstances. By transference, the work of art itself is said to aim at producing the kinds of impact in question.

The activities involved in creating a work of art are analogous to the activities involved in a craftsman's fashioning a chair or a cabinet, in that they are the means whereby some human being produces something designed to serve some human or personal end. Likewise the products of these two types of activities are analogous in that both are designed to bring about some kind of state of affairs. Further, both a work of art and an instrument do so by virtue of their dispositional properties—but in different sorts of ways. A work of art arrives at a state of affairs by having certain kinds of impact on perceivers by virtue of its qualities as an object of perception, imagination, and intellect; not (as with a useful object), as a physical object, by cutting, twisting, pushing, or hammering some other object or objects. Stated in general terms, we do not *do* things with works of art the way we do things with objects that have uses in the full physical sense of 'do'. Of course a knife, a chair, or a car can be treated as an aesthetic object, precisely by our attending to its sensuous qualities and structure as a source of a certain kind of impact we call aesthetic, not qua useful. This is why many aestheticians speak of the "aesthetic attitude" as "disinterested," "distanced," or "intransitive."

A second, very important implication of our speaking of art as having aims, and of utensils, instruments, and tools as having uses, is that the *aesthetic* value of the impact produced by a work of art

in the appropriate circumstances *constitutes* the aesthetic value of that work, whereas the practical for example, (economic) value of a useful object, say a knife, is *not constituted* by the value, of whatever kind, of the states of affairs it is capable of bringing about in the appropriate circumstances. Indeed, the value of instruments, utensils, and other useful objects may be far less than the value of the states of affairs they are properly used to bring about.

On the other hand, the kinds of impact whose production is the aim of art logically determines how much aesthetic value a particular work has, if any. This is similar to the way in which the value of the state of affairs which a particular (kind of) useful object is intended to bring about logically determines the object's value (utility in general, or utility for that particular purpose).

(A) It is not difficult to show that both laymen and critics frequently evaluate a work of art in terms of (what they judge to be) its capacity or incapacity to have some kind of impact or effect on and/or to convey some kind of content—the vague words are deliberate—to qualified perceivers under favorable environmental conditions. Examples are (1) "What sort of poem is this—it left me completely cold" or "It made no impression on me at all!" or "It didn't affect (or move) me at all!" or "It is not effective; it is not evocative at all." (2) "This is a very stimulating (effective, provocative, absorbing, thrilling, powerful) novel"; (3) "This is a very enjoyable (delightful, very pleasant, very pleasurable) play"; (4) "This is a very poor painting—it is boring (or irritating, annoying)"; (5) "This is a mediocre symphony: it has very little impact"; (6) "This is a great quartet: it puts one's soul in a turmoil; it evokes the profoundest feelings; it stirs up the soul to its very depths!" (7) "This is a tremendous play (poem, novel): it is extremely thought-provoking" or "It expresses very original ideas."

The relation between the notions *capacity* and *aim* is obvious; for to possess a capacity is to have the ability to realize some goal, to bring about some state of affairs.

Examination of statements (1) through (7), or other statements which evaluate a work in terms of its "effects" or "impact" on or "what it conveys" to qualified perceivers under standard environmental conditions, shows that we employ in our evaluations *many*

different specific or relatively specific criteria. The epithets 'impressive', 'effective', 'evocative', 'thrilling', 'absorbing', enjoyable', 'powerful', and 'thought-provoking', which occur in statements (1) through (7) and in many others like them are relatively general dispositional criteria properties.

Now (B) consider such statements as (8) "This work is full of tenderness" (in reference to Beethoven's "Für Elise"); (9) "That was an exquisite minuet" (a Mozart minuet); (10) "This play is full of pathos" (*King Lear*); (11) "This short story is absolutely terrifying; it has an uncanny quality; it makes one shiver" (Poe's "The Cask of Amontillado," or "The Masque of Death"); (12) "This novel fills one with horror" (a thriller by Agatha Christie). These statements, though still fairly general in nature, involve more specific dispositional criteria features than statements (1) through (7). Despite this diversity, the *general* criteria we employ are, I think, quite limited. These criteria are: (1) the extent to which a particular work has the capacity to stimulate the perceiver's intellect, to make him ponder on life and death, God and the universe as a whole (the "ultimate issues" or matters of "ultimate concern," as some philosophers would put it), and so on. This is one point where philosophical and aesthetic "contemplation" are similar to a considerable extent. (2) A second criterion is the extent to which a particular work has the capacity to stimulate the perceiver's imagination in a manner appropriate to its character, the extent to which it widens his imaginative horizons, makes him—to borrow a pregnant phrase from Søren Kierkegaard—live in possibility. (3) The third criterion is the extent to which a given work has the capacity to stimulate the perceiver's feelings, to evoke in him feeling or emotion, to evoke some particular mood or create some particular atmosphere—and the depth or superficiality of the feelings or emotions, the mood or atmosphere evoked, conjured up or created. (4) The fourth criterion constitutes a regulative principle of art in a special sense of this phrase: enjoyableness. The extent to which a work of art is enjoyable is a major criterion of excellence we employ in ordinary and professional aesthetic discourse.[5] It is clear that, as in the case of the other criteria, this criterion is applicable when the prevailing conditions are standard conditions; meaning, among other things, that the work in question

should give enjoyment at least to qualified perceivers. This criterion differs, to some extent, from the first three criteria in that it concerns the way in which, or the means whereby, the former criteria themselves are to be satisfied by works of art. Further, anything that purports to be art (hence purports to satisfy one or more of our first three criteria) must satisfy this criterion in order to be good art; it must—whatever particular ideas it may express, whatever images, feelings, or moods it may evoke—give enjoyment to the qualified perceiver. This does not merely mean that it must not evoke feelings that are, in their nature, incompatible with the feeling of pleasure; it also means that it must evoke feelings that are positively pleasurable. For example, it must not be boring or irritating. This statement would be patently false if, for instance, it stipulates that the proper way of writing music is, say, Mozart's way of writing it, or if it condemns certain kinds of subject matter, or certain feelings, emotions, or experiences, as *intrinsically* unenjoyable and thus unsuited for the purposes of art. It is always dogmatic and shortsighted for the listener or spectator (and especially for the critic), and stultifying for the artist, to reject certain forms of expression, certain kinds of subject matter, or certain ways of treating this subject matter as intrinsically unenjoyable.

The notion of enjoyableness is built into the general intellectual and imaginative aims of art as we stated them; namely, as the stimulation of the qualified perceiver's intellect and imagination. For it is self-contradictory in ordinary language to say "This work stimulates my imagination (or intellect) but is not enjoyable!" The situation is somewhat different with the emotional aim of art, for though "X is stimulating" may be sometimes used to mean, or to mean among other things, "X evokes pleasurable feelings," the word 'stimulate(s)' may be used in a different way. Thus it is not self-contradictory at all to say "X stimulates nothing but feelings of disgust in me." However, 'stimulates' is rather awkwardly used in this sentence. A more natural way of talking would be to say that "X evokes or arouses nothing but a feeling of disgust in me."

Do our four general criteria of excellence provide us with any major goals of art? To answer this question, let us consider a few aesthetic judgments of a type we have not yet discussed. (C) (13) "This is

not a painting but a blob of paint on a canvas—it lacks all unity"
(or "It is disorganized, chaotic; it lacks a unified theme"); (14) "This
is certainly a good short story: it has unity of plot, it develops with
an inner necessity, its theme is worked out with great skill; it moves
swiftly and surely to a climax; nothing in it is superfluous—every
word, action, and scene contributes to the total effect"; (15) "This
is a fine painting—it has composition, rhythm, balance; its colors are
harmonious (and in the case of representational painting), the figures
it contains are alive and highly individual; it is dramatic but not
melodramatic."

These and similar judgments show that one (our second) major
general criterion we employ to evaluate works of art consists of pick-
ing out all sorts of *formal, material,* and *technical* features in them,
sensuous and/or nonsenuous, as criteria features of artistic merit or
demerit. They also bring to mind other judgments of the same type,
which, however, refer to still more specific features as a basis of
aesthetic valuation. The best and clearest examples of judgments that
single out, or are based on, highly specific criteria features are found
in the detailed critical reviews, studies of individual works, or specific
aspects of individual works by critics, art historians, and artists.

I need not add that more often that not critical judgments are
based on the affective as well as the formal and material features of
the work judged. However, professional criticism, for good theoretical
and practical reasons, tends to base itself chiefly, or wholly, on the
work's formal, material, and technical features rather than on its
affective features.

Examination of our three groups of judgments reveals the simple
but fundamental logical relationship between a work's formal, mate-
rial, and technical features on the one hand, and its capacity to stimu-
late our thinking, feelings, and imagination, and to give us enjoyment,
on the other hand. I mean that the former are the means for the
attainment of the latter under standard conditions (and to varying
extents under varying degrees of nonstandard conditions). In other
and more precise words, under ideally standard conditions, the former
are, causally speaking, wholly responsible for the latter. Or, to put
the matter in another way, works of art possess to varying extents
(in some cases, however, not at all) the capacity to give rise to the

latter under standard conditions. To what extent a particular work will do so at a given moment, in a given situation, depends on the work's formal, material, and technical features—and the extent to which the prevailing conditions are standard conditions.

Since ideas and imagery are, as we saw in Chapter 1, among the elements of works of art, they constitute an important part of the means whereby art realizes its aims. The same is true of sadness, melancholy, and so on as qualities of a poem or a work of music. (See particularly Chapter 6.) On the other hand, the feelings which a work may evoke in sensitive perceivers under standard conditions are not qualities of the work in any usual use of 'quality'. Hence feeling cannot constitute a means, in the same way or sense as ideas and imagery can, for the realization of the goals of art; but they can be aroused in the perceiver as a means to the work's realizing some other aesthetic end. I think, however, that the arousal of feeling is not ordinarily regarded as a means to some other *aesthetic* goal, such as the stimulation of the intellect or the imagination. There is, I believe, a quite widespread popular view that the arousing by art of at least certain kinds of feelings or emotions is designed to uplift or ennoble the soul, or to infect the perceiver with moral attitudes and sentiments conceived as *aesthetic* goals. (Certain aestheticians, such as Plato and Tolstoy, have, of course, held this view.) This is different from the view that, as a matter of fact, some of the feelings or emotions which say, *good* art evokes are morally or "spiritually" uplifting. (For instance, the view that music instills harmony in the soul is part of Aristotle's, as well as Plato's, view of art.)

What we have said about ideas and images does not entail that the expression of ideas and the evoking of imagery, hence the stimulation of the intellect and the imagination, are not goals of art. On the contrary, it seems to me that both are ends of art in their own right as well as means for the arousing of feeling or emotion. The ideas expressed by a work may arouse feeling both directly and indirectly. They may evoke images (images too, even more obviously, evoke ideas); or the work may express ideas mainly or wholly through images, as in much good poetry. Ideas, shorn of their emotional and imaginative associations, if any, by a particular person

because of his unique or common human experiences, have little or no emotional appeal. On the other hand, certain ideas—such existential ideas as those of birth and death, suffering, salvation and damnation, hope and despair, immortality and God—are "impregnated" with feeling or emotion for a large segment of mankind, or for members of a particular society. This makes them vulnerable to exploitation for sensational, melodramatic effects but also enables them to help create genuine imaginative experiences.

Although the stimulation of the intellect, imagination, and feelings, together with the giving of enjoyment, is the aim of art in the ordinary descriptive use of 'art' as we have it at present, only the arousing of feeling and the giving of enjoyment appear to be *universal* aims of art, in the sense that they alone *can be* the aims of every single *actual or possible work of art*, whatever its precise nature. Once more, this is seen from an examination of aesthetic judgments. Our evaluation of paintings, works of architecture, or music shows that we do not normally expect them to express specific concepts or ideas. Indeed, as far I can see, we do not regard the absence of any ideas, even ideas of the most general kind, as in any way detracting from their possible merit; provided that they are regarded as capable of evoking (certain kinds of) feeling in us. I should add that the fact that we do not expect a symphony, a painting, a sculpture, or a building to express any ideas in the sense of thoughts is a direct consequence of a certain *empirical* fact. These kinds of art as a whole, or their individual sensuous components, do not actually express any specific concepts. The reason is that musical tones, colors, lines, and forms do not possess any meaning in the sense of signification, though they may certainly have meaning—especially in their combinations—in the sense of emotional, imaginative, or intellectual significance. This condition is due to the absence of any implicit or explicit agreement or "convention" to use them to mean (signify) something by referring to some object or state of affairs; it is not due to a lack of intrinsic capacity on their part to acquire signification, hence to express specific concepts.

I said that the expression of at least specific ideas, and the stimulation of our intellect with their help, does not constitute an aim of art as a whole. Likewise with the stimulation of our imagination.

We certainly do not expect "absolute music," by the very meaning of the phrase as we apply it to certain kinds of music, to stimulate the imagination; whereas that is one of the things expected of a work of "program music." Contrast "the best kind of musical experience may be one in which physiological and conative and *imaginal elements*—all kept in their due, subordinate place [in relation to the appreciation of the "forms of music"]—contribute vitally to the life of the whole." [6] On the other hand, John Hospers, in *Meaning and Truth in the Arts*, points out that research, for example by Vernon Lee, reports that the more musical listeners among those persons questioned about their experience of music were the "purely musical." These respondents claimed that "whenever they found music completely satisfying . . . anything like visual images or emotional suggestions, was excluded, or reduced to utter unimportance." [7]

The capacity to express the most specific—as well as the most abstract or general—concepts and hence thoughts is found in its fullest form in literature, the intellectual art par excellence, by virtue of its employment of language as its medium. Even the full realization of the "intellectual" capacities of a literary work, qua art, necessarily presupposes a capacity in it for creating an emotional effect under standard conditions. A novel or play of ideas may express very fresh, profound, or important—even great—ideas and yet fail as a novel or play, consequently as art. One main reason may be that these ideas do not have any emotional impact (directly or indirectly) on qualified perceivers under standard conditions. The ideas may be verbally expressed, or embodied in a plot, character, and the like, in such a way that the emotional impact they have, supposing that they have an impact, is incongruous with the work's general emotional tone. (When this happens we usually say that these ideas are out of place.) Or the ideas may have only a slight or superficial emotional impact. The same applies to the role which imagery plays, or is expected to play, in producing an (a powerful and profound, hence lasting) emotional impact.

Two important points emerge which we must make explicit. First, in order to contribute to the over-all aims on a work qua art, the ideas contained in a work must form an integral part of it by virtue of their specific character as ideas and must help the work produce

a unified total effect. The latter partly depends on the manner in which they are concretely worked into or embodied in the work. This means that the intellectual aim of any given work which contains ideas must be integrally related to, and in harmony with, the work's imaginative and emotional aims.

Second, in the light of the special position occupied by the emotional aim of art, the expression of ideas is logically and axiologically subordinate to its emotional aim. On the other hand, it is not at all clear whether the axiological and logical relations, between the *imaginative* and emotional aims of art as a whole, are the same or different from the foregoing. For as stated earlier, nothing prevents an object or activity from being a work of art (in the descriptive sense) or even a great work of art, if its impact is mainly or wholly emotional. Can such a thing be a work of art (in the same sense), let alone a good or great work, if its appeal under standard conditions is (or was) confined to the imagination? The difficulty of deciding this question either way stems, I think, from the seeming fact that a work which conveys some imagery and stimulates the imagination, also—whether always or only generally speaking is a moot question—evokes feeling. Similarly, when the imagery fails to stimulate the imagination it fails (or tends to fail?) to stimulate the feelings. Whereas a work may certainly do the latter (under standard conditions; for example in the case of qualified perceivers) without also stimulating the imagination, absolute music and nonobjective painting and scuplture being outstanding examples.

The foregoing are empirical matters in a straightforward sense, and can be settled only experimentally. Nevertheless, the interesting thing about them is that the *logical* relation between the imaginative and emotional aims of art appears to be uncertain (if it *is* uncertain), in the ordinary "logical grammar" of art words, because we, the users of these words, find ourselves uncertain regarding the foregoing *empirical* matters. The discovery of the empirical answers will therefore place us in a better position to *make* the said relation more determinate, by express stipulation, in conformity with the demands of logical consistency, simplicity, economy, and usefulness.

What we have said about the general aims of art applies to every

work of art as art to the extent to which—as literature, music, painting, sculpture, and so on and as a particular kind of literature, music, painting, and so on—the work is capable of furthering these aims. The qualification is prompted by the fact that there are important differences between some of the art forms or between some genres of one and the same art form, in their capacity to serve the intellectual aim of art. This is directly due to the capacities conferred and the limitations imposed upon these art forms or genres by the nature of the medium or media they employ. In addition to these broad similarities and differences between different arts or genres of art, there are specific similarities and differences arising in relation to certain genres or forms$_1$ of particular art forms. The most important of the genres or forms in question are tragedy, comedy, and tragicomedy in the case of drama; elegies and epitaphs in the case of poetry; comic operas and operettas in the case of music.

In another place [8] I have attempted to show that some genres or forms$_1$ are broadly distinguished by means of certain formal features; others, by means of the kind of "materials" they utilize together with certain formal features; still others are distinguished by means of certain kinds of subject matter and other features pertaining to the content of the works, and so on. We can now add that there are certain genres or forms$_1$ in whose case a differentiating feature is some kind of effect or other. That is, works belonging to one of these genres or having one of these forms$_1$ are expected to produce a certain kind of effect on qualified perceivers under standard environmental conditions. The sources of these kinds of effects, as of any other effects that can be produced under standard conditions, are the formal (formal$_1$ and formal$_4$) and material features of the particular works or kinds of works. Consequently, their being partly or wholly distinguished (as kinds of works) by the production of certain kinds of effects, is the "affective" or "subjective correlate" of those formal and/or material features that, as far as the work's own qualities are concerned (excluding its dispositional properties), distinguish it from other kinds of works. Nevertheless, there is no necessary connection between the "subjective" and "objective" correlates, that is, between the specific kinds of effects which, on the "subjec-

tive" side, distinguish one work from other kinds of works, and the *specific kinds* of material and/or formal features by which these works are "objectively" distinguished.

A work does not have to be cast in the form$_2$ of a play (tragedy) in order to be able to evoke in the qualified perceiver feelings of pity and terror; it can very well do so by employing the form$_2$ of a novel, a short story, a narrative or dramatic poem, a ballet or an opera. The same is true of the kinds of feelings, experiences, or moods which are conventionally associated with comedy. It so happens, historically speaking, that the stage has provided us with one major artistic medium (utilized in the forms we call tragedy) which is eminently calculated to evoke in sensitive persons feelings or experiences such as pity (or, better, compassion) and terror.

The reader may have received the impression that I am maintaining that the aims of art discussed above constitute the aims of art insofar as the *concept* of these aims is determined by the ordinary uses of the terms 'art' and 'aim(s) of art' in the English language (hence in English-speaking societies). The situation is not, however, that simple. First, the ordinary concept of the aims of art is open-textured. Second, it is an essentially contested concept, constituting a major, if not the sole, source of the essential contestedness of the ordinary concept of art as a whole. In other words, the number of those things which may be regarded as constituting the aims of art as we now employ the concepts of art and the aims of art is not vigorously limited and fixed. Moreover, the history of art and the creative character of art give us every reason to suppose that the concept of the aims of art (and with it, the concept of art as a whole) will continue to be open-textured and essentially contested in the future.

The essential contestedness of this concept is revealed by the contestedness of the *criteria* of aesthetic worth that are employed by the layman, and even art critics, in evaluating works of art.[9] Although certain aims of art that we have enumerated and discussed appear to be generally implied in our aesthetic judgments and hence can be regarded as fairly well established, there have been and there are artists or critics as well as aestheticians who contest these aims, rejecting one or more of them and claiming that art aims at some-

thing different. Thus, the mutual incompatibility of some of the criteria actually employed in aesthetic judgments, particularly in different ages, is a direct expression of the contestedness (and openness) of the concept of the aims of art. To that extent, therefore, the mutual incompatibility is an expression of the *essential contestedness* of the concept of art as a whole, even if we exclude the differences we find in aesthetic judgments in different cultures in the same or in different ages. There is prima facie no reason for supposing that the concept of art, as determined by English usage, is identical with or even very similar to the concept of art as determined by the aesthetic usages of some other language—particularly a language that has arisen in, and reflects in the logical grammar of its words and sentences, a culture strikingly different from British or American culture. Indeed, there is prima facie every reason to suppose the contrary to be true. The essential point here is that the concept of art as determined by English usage *is* essentially contested. This condition is in no way logically affected by the presence or absence of any differences (including incompatibility) between the aesthetic criteria implicit in ordinary English usage and those implicit in the ordinary usage(s) of some other language or languages.

The openness and contestedness of the notion of the aims of art logically leads to a corresponding openness and contestedness in the concept of the means, formal and material, whereby the aims of art are realizable or are realized in extant works of art. The disagreements which constitute the concrete symptom and expression of this openness and contestedness are only resolvable by express stipulation. They are quite different from diagreements as to whether a particular technique or medium, a particular formal or material feature of a given work, or the work's particular form (form$_1$ or form$_3$) or content as a whole is conducive to the realization of its generic (and/or) specific) aims. The latter disagreements are factual in nature and are resolvable, in principle, by appeal to the experience of qualified critics and other sensitive and trained perceivers.

The ends which different works or kinds of works aim to realize may be incompatible. A good example, quite clear in the case of music and the plastic arts, is the incompatibility of the aims of many present-day works with the aims of traditional works. It is not evi-

dent whether the difference, and perhaps the incompatibility, pertains to the specific aims of the individual works or kinds of works (and the aims of their creators) alone, or to the generic aims of art as well. On the other hand, some artists in any given period, but particularly in the twentieth century, have claimed that they are indeed trying to broaden or otherwise modify the traditional aims of art. They feel, often very strongly, that it is of the very essence of creative art always to find new generic as well as new specific aims, rather than merely to pour "new wine into old bottles" in the sense of finding new ways of gaining the traditional ends of art. Fauvism and Dadaism in painting, in this century, may perhaps be examples of this.

In such ideas preached by practicing artists, and particularly in the embodiment of these ideas and aims in a considerable number of successful works [10]—works that are, at one time or another, *regarded* as good or are popular with those who shape aesthetic taste—we find one permanent source of the perennial tendency of the concept of the aims of art to change. The tendency of art is to become broader by the inclusion of new aims—which then react on the old, accepted aims, influencing or modifying some or all of them to some extent— or to become narrower by the exclusion of some accepted aim. The tendency is also to modify accepted aims without addition to, or subtraction from, them.

It is my belief, however, that by and large the creations, as opposed to, say, declarations, of highly unconventional artists give us new specific effects or moods, creating novel, or novel complexes of feelings or emotions by the novelty of their techniques or materials or the manner of organizing the latter. The creations do not usually give art new generic aims on par with the four general aims we discerned in the present everyday concept of art. Aestheticians and philosophers, especially metaphysicians, have frequently attempted to influence the prevalent concept or conceptions of art; this has included attempts to modify the generic aims of art which these conceptions involve. Thus, quite a number of the major traditional theories of art seize on some, usually one or two, of the aims of art determined by ordinary usage, as the *only* "true" aim or aims. This is tantamount to stipulating or recommending the restriction of the ordinary concept of the aims of art. At the very

least, it means an overemphasis on the favored aim or aims at the expense of the other aims of art. The potency of such aesthetic or metaphysical theories in the present respect is due to the covert (often unconscious) character of the stipulation. For these theories almost invariably purport to be "really" *descriptions* of the "nature of art." The various forms of the Expression and the Communication theories, and Aesthetic Hedonism,[11] are good examples. Other theories, such as Formalism, do not directly involve a reference to the aims of art since these are, as we have seen, affective in the last analysis. Yet insofar as they overemphasize only part of the theoretically possible means ("form" in the case of Formalist theories) for the realization of the aims of art and regard these alone as essential or important for art, they are in a position to affect the generally accepted generic aims of art. But their actual effect depends on how widely accepted they are. For the acceptance, particularly the wide acceptance, of such a theory may sooner or later influence ordinary usage, enshrining its special "slant" in the everyday uses of the relevant expressions, or the concepts they express.

The gradual acceptance of some stipulated aim as a bona fide aim of art does not make the concept of the aims of art (hence the concept of art) less contestable *in principle*. It does remove the notion of the now accepted aim from the battleground of debate as far as those people who now employ the broadened concept of the aims of art are concerned. This last concept remains just as much essentially contested, however, to the dissenting minority. More important, the general acceptance of the new aim as a bona fide aim of art at a given time does not logically preclude its becoming a bone of contention at some future date; thus it does not logically decrease the essential contestedness of the concept.

There is at least one very familiar historical instance in which a philosophical system has wielded, and continues to wield, tremendous influence on the art, the art criticism, and the aesthetic views of millions of men. The allusion is quite apparent since I am, of course, referring to Dialectical Materialism in general and to Social Realism in particular, in the form in which they constitute the official philosophy or ideology of the Communist world. The "concept" of art which the latter gives us (like the other great philosophies of art in

history, such as those of Plato, Schopenhauer, Hegal, and Croce) is arrived at by deductive inference from the a priori metaphysical system of Marxism. This theory of art is not, indeed, a description or analysis of art at all, but one more example of the modification (not so covert) of the ordinary concept of art in the West—in this case a rather drastic modification of it, since it throws out as "improper" most if not all of the aims of art we have discussed. It substitutes for these aims an ultimately noncognitivist, pragmatic, social, activist, or utilitarian aim. To what extent this proposed "reformation" of the concept of art has already become enshrined in ordinary aesthetic discourse in the Sino-Soviet bloc I do not know. But, as in all other walks of life, the peculiar vocabulary of Marxism-Leninism is abundantly evident in the aesthetic judgments framed by the Communist Chinese and the Soviet official literary and artistic organs, as well as those framed by individual artists of repute and influence there who follow the party line. If this has not already resulted in a "reformation" of the concept of the aims of art, it is bound to do so sooner or later.

The second major source of the essential contestedness of the concept of the aims of art, which also constitutes a theoretically inexhaustible source of the continual broadening of this concept (hence its lack of complete fixity), is the intimate and peculiar relationship that obtains between the aims of art and the means which different works utilize to realize them. It is common knowledge (pointed out with regard to morality, for example, by John Stuart Mill) that phenomena originally regarded as—in the case of activities, indulged in—merely a means to some end gradually tend to be viewed as ends in themselves. They are then sought for their own sake, as desirable in their own right, though they may also continue to be regarded (in the case of activities, indulged in) as means to the end or ends which they serve or are capable of serving.[12] This seems to be eminently true in regard to art; it may well be one source of the dispute between aestheticians—more specifically, between so-called objectivists and subjectivists—as to whether the qualities of a work possess, and/or a work of art as a whole possesses, intrinsic rather than (only) instrumental value, or intrinsic as well as instrumental value. The process described is, to say the least, one major source,

current in the past and recently, of the aesthetic view that beauty is one major, or the only, aim of art; understanding by beauty a certain quality, or a complex or combination of qualities, existing in the work itself and giving pleasure to the perceiver. Since beauty is often identified with "harmony," with a "harmonious organization of elements," and "harmony" is frequently analyzed into such things as "balance," "rhythm," and "composition," we get the view that these "features" of some or all works of art are (that is, beauty for its own sake is) what the artist aims at creating.

In the same way, we encounter, prominently but by no means exclusively in literature, the disputed view that the expression or the communication of true ideas is a major aim of art. The dispute as to whether this constitutes an aim of art in general (or even of literature) is reflected in the dispute as to whether the expression of true ideas is a criterion of artistic merit, and in the actual evaluations of critics and laymen stemming from the stand taken with regard to this matter.

These remarks apply to all the other forms and genres of art, together with their own subdivisions, that are in existence insofar as they do or may have certain specific aims, affective or otherwise, as particular forms, and the like.

A situation exists, analogous in some ways to the ones I have been discussing, concerning the dispute as to whether art has, or should have, a moral purpose. The tendency here is to ascribe a "pragmatic," "practical" purpose to art either in lieu of, or in addition to, the nonpragmatic, nonpractical aims of art. This is patently in conflict with the nature of the enjoyment of art, as logically determined by present-day ordinary aesthetic usage in the West. Therefore, such a recommendation (for it is, as far as the present stage of its development is concerned, just that) cannot be accepted unless the ordinary concept of standard (optimum) conditions of the enjoyment of art is modified accordingly. Modification, to my mind, is far from desirable, apart from the fundamental fact that there does not appear to be any good reason for it. As will become clear, the proposed change would require a very drastic reconstruction of these concepts, and, with it, of the concept of art as a whole. The required reconstruction would be less drastic, though still quite appreciable, if a

recommended moral aim is added to those aims which art has in the present-day conceptual framework of everyday aesthetic discourse. The impracticability of this recommendation, perhaps apart from its usefulness or the opposite, can be partly gathered from the resistance which ordinary aesthetic language has shown to its adoption, as well as from the opposition of many aestheticians to it. On the other hand, the official adoption of the Marxist-Leninist "view" of art by about half the present population of the world can and will certainly lend great strength to this recommendation with the passage of time.

Whether art has or should have a moral purpose is clearly distinct from the question whether art—some or all works of art—is morally good. There is, nevertheless, an obvious logical relation between the two: if art does have a moral purpose it is clear that, other things being equal, a work will be morally good (if the notion of *moral* goodness is applicable to art at all) in proportion as it satisfies the moral aim of art. "Taste and art were good when they enlarged the mind, not when they narrowed it" (said Olive Chancellor in Henry James's *The Bostonians*). If we construe 'good,' 'enlarge', and 'narrow the mind' in a moral sense, the above statement can serve to illustrate the relation between the two notions. However, it is clear that logically speaking art can be morally good or bad, with the above proviso about moral goodness in relation to art, independent of whether it itself has a moral aim. The quotation would illustrate this point if the "enlargement of the mind," construed in a moral sense, is not regarded as an aim of art, or if it is regarded as an aim of art but is interpreted in a nonmoral sense. In the latter case we must also assume that art does not have any other aims of a moral nature.

NOTES

1. Note, for instance, Morris Weitz's remarks on the role of theory in aesthetics in "The Role of Theory In Aesthetics." These remarks are perfectly true as a criticism of traditional, essentialist theories of aesthetics,

but they do not touch or take into cognizance the kind of alternative account which I believe *ordinary* aesthetic discourse provides, and which I am outlining in this book. Cf. also Stuart Hampshire's radical views, in "Logic and Appreciation" (in Kennick, *op. cit.*, pp. 579–85) regarding aesthetic theory in general and aesthetic judgments in particular.

M. Mandelbaum, in "Family Resemblances and Generaliation Concerning the Arts," *American Philosophical Quarterly*, Vol. II, No. 3 (July, 1965), has expressed a view that is, in some important respects, similar to the view expressed above.

2. An earlier, less sophisticated form of this view is outlined in my "Art-Names and Aesthetic Judgments."

3. See my "Common Names and 'Family Resemblances'" for an attempt to show this at some length.

4. In my "Art-Names and Aesthetic Judgments" I rightly stated that "The term use is not ordinarily employed in connection with works of art . . ."; but I now think that I was wrong in what followed: "on the contrary, works of art are often said to have no uses, to be useless. . . . But what is generally meant by saying that works of art are useless is that they have no practical uses. Speaking of uses, one recalls T. S. Eliot's title "The Use of Poetry and the Use of Criticism"; and this use of use does not sound peculiar or strained." (*Ibid.*, p. 30.) I now believe that T. S. Eliot used 'use' figuratively, or that he intended the word to be taken in the sense of "aim" or "purpose."

5. We do not speak of a building or other work of architecture as enjoyable; but we speak of it as being a source of enjoyment—or its opposite, irritation. We also speak of the sight of a building, and so on as giving us enjoyment, or as depressing or irritating; just as we speak of the reading of a novel, the listening to a symphony, and the watching of a play, as enjoyable—or as irritating, depressing, and so on.

6. L. A. Reid, *Proceedings of the Aristotelian Society*, Vol. XLI (1941), p. 120. Italics mine. Quoted from Hospers, *Meaning and Truth in the Arts* (1946), in Melvin Rader, A *Modern Book of Esthetics*, Second Edition (New York, 1952), p. 269.

7. Hospers, *op. cit.*, p. 265, footnote 15. Hospers's whole discussion in the selection referred to is useful and illuminating, though like Reid's discussion, it is empirical and not conceptual in character. Cf. also C. C. Pratt, "Aesthetics," *Annual Review of Psychology*, vol. XII (1961), p. 80, regarding the work of R. Frances in *La Perception de la musique* (Paris, 1958).

8. "Family Resemblances and the Classification of Works of art," *passim*.

9. For evidence of the essential contestedness of the concept of art, see W. B. Gallie, "Art as an Essentially Contested Concept," *Philosophi-*

cal Quarterly, Vol. VI, No. 23 (April, 1955), pp. 97–114. See also Part II, Chapter 7 of this book.

In his "Essentially Contested Concepts," *Proceedings of the Aristotelian Society*, Vol. LVI (1956), pp. 166–98, Gallie characterizes essentially contested concepts as those "the proper uses of which inevitably involve endless disputes about their proper uses on the part of their users" (p. 169). He gives seven defining conditions of essential contestedness (pp. 171–80), the first of which is that an essentially contested concept is *appraisive* "in the sense that it signifies or accredits some kind of valued achievement" (p. 171). Conditions II to IV characterize the notion of achievement involved. The other conditions pertain either to the users of the concept or to various characteristics of it. See also my "Vagueness," *Philosophical Quarterly*, Vol. XII, No. 47 (April, 1962), pp. 138–52, for some of the main differences between *vague* and essentially contested concepts.

10. The word "successful" is essential. For history has shown that only successful works (whether really good or poor does not much matter here) have this power of effecting changes in the concept of art.

11. For a similar view, see Morris Weitz, "The Role of Theory in Aesthetics," *passim*.

12. Were it not for the fact that we should really muddy the issue by employing that terminology, we could have said that phenomena originally regarded as possessing only instrumental value may, in the above manner (by the interesting psychological process of transference from the end to the means) come to be regarded as also possessing intrinsic value. One reason why I avoid using the expressions 'instrumental value' and 'intrinsic value' is that they (especially the latter) are quite vague as they are employed by philosophers. Actually, different philosophers appear to refer to different, though usually related, things in using the latter expression. A more fundamental reason is that I believe that the distinction between "instrumental value" and "intrinsic value" is unsound; that the alleged distinction between two kinds of value is confused. There is a valid distinction between two kinds of reasons for judging something or other as valuable or valueless; but this does not justify us in regarding the valued thing as having one kind of value or another by virtue of its being (judged as) valuable for this rather than that sort of reason.

Chapter 4

The Enjoyment of Art

I

To speak of a person as enjoying a particular work is to say that the over-all quality of the "experience" constituted by the ideas or images conveyed by the work, and by the feelings experienced, is one of pleasure; that, as we say, he is getting pleasure from viewing, hearing, or reading the work. The over-all pleasurableness of the "experience" of enjoying a work does not, and cannot, constitute the *whole* of what we call the enjoyment of the work, for by the meaning of 'enjoyment', pleasure is only one element in enjoyment. When someone says "I enjoyed watching *Hamlet* tonight," and the hearer asks "What exactly do you mean?," a natural reply would be: "The play stirred up such and such feelings—joy, sadness, melancholy, concern, compassion, sympathy, terror—in me; my imagination was fired by the spectacle of a superior being grappling unsuccessfully with himself and the world of men around him; the thoughts that Hamlet in particular ponders and endlessly wrestles with troubled me deeply and made me ponder on death and mortality, love and hate, duty, good and evil." None of these feelings is the feeling of pleasure itself; yet the "experience" as a whole is pleasurable.

It might be objected that the ideas which I pondered, the images that passed before my mind's eye, or the feelings that throbbed in my heart as I watched *Hamlet* are merely the *causes* of my enjoyment of the work, the enjoyment itself consisting wholly and solely of a feeling of pleasure. The premises of this argument are partly true; they would be wholly true if we strike out the word 'merely'

in the phrase 'merely the causes'. But the conclusion does not validly follow from them. The ideas that *Hamlet* expresses, the images and the feelings (other than the feeling of pleasure, if any) it evokes, are certainly among the sources of the pleasure a person may experience in watching the play. Yet they themselves, and most obviously the various feelings that are evoked other than the feeling of pleasure itself, are an integral part of the "experience" that we ordinarily call the enjoyment of *Hamlet*. What is more, these feelings themselves may have a pleasurable quality about them, may be pleasant feelings. If so, they will increase the pleasurableness of the "experience" as a whole. For though there exists a feeling, as opposed to physical sensations, of pure and simple pleasure (or pain), various other feelings are ordinarily said to be pleasant (or unpleasant). Examples are joy and elation (or sadness, melancholy, depression). Hence the enjoyableness of some works of art may consist of the experience of these (other) feelings, together with their pleasurable quality which is inseparable from them, or this in addition to a feeling of pure and simple pleasure. In both cases the enjoyment of art will not be exhausted by a feeling of pure and simple pleasure.

It is not merely that the enjoyment of art may consist in more than the experiencing of pure and simple pleasure; it must necessarily be so by the ordinary meaning of 'enjoyment' and 'pleasure'. The notion of enjoyment includes, but is wider than, that of pleasure. Suppose I watch an ordinary three-hour play. In order that I may be truthfully able to say, when the last curtain has gone down, that I enjoyed watching it, I must have experienced pleasure at least part of the time. The work does not have to be continuously pleasurable or pleasant; it is not necessary for me to have experienced pleasure for three solid hours. But the experience of watching the play must be pleasurable on the whole, and when I emerge from the theater I should, normally, recall the experience with pleasure. Enjoyment is perfectly compatible with one's experiencing *painful* feelings such as compassion, pity, sorrow, grief, indignation, sadness, depression, and terror. Indeed, the experience of painful feelings does not necessarily lessen the over-all enjoyment experienced, though it may lessen the intensity and amount of the over-all *pleasure* one experiences. (Let us note here one difference between painful and

unpleasant feelings: the opposite is true in the latter's case!) These things are true only as long as the painful feelings do not, or the over-all feeling of pain does not, predominate in the experience as a whole.

Further, one is said to enjoy seeking something or someone, or doing something, when one is habitually pleased to see it or him or to do that thing, respectively. Likewise, "I enjoy listening to Beethoven's Ninth Symphony." However, "I enjoyed the Ninth Symphony" may have reference to only one occasion of pleasurable experience.

The compatibility of enjoyment with some experience of painful feelings, or a (mental) feeling of pain in general, is a point of great importance in relation to art. It provides us with a "solution" to a major traditional "problem" in aesthetics: namely, how one can be said to enjoy "sad," "tragic," "terrifying," or "horrifying" works, particularly tragedies, which, in Aristotle's famous phrase, evoke feelings of "pity and terror."

Further, painful feelings, in contrast to unpleasant feelings in any degree or amount, do not, within limits, decrease the enjoyableness of a particular experience. A main reason is that it is possible to have mixed pain and pleasure in the sense of a mingling of painful and pleasant feelings. On the other hand, pain and pleasure, as pure feelings, are antithetical in nature: a feeling of pleasure and a feeling of pain cannot form a complex feeling. Similarly, we cannot have, I think, a complex of pleasant and unpleasant feelings. An unpleasant feeling may however be mixed with a painful feeling.

Fear, terror, and horror are perfectly compatible with enjoyment. Indeed, they may be an important source of enjoyment, as they actually are in good tragedies and detective or horror stories, if, among other things, the perceiver knows that the work aims at evoking these feelings in him.

The enjoyment, hence the pleasure, which has its source in a work of art, cannot exist, *as an experience of a certain kind and not merely causally*, in isolation from this source. This pleasure is a pleasure *in* something; one is pleased *by* something, or *at* something's being the case. The enjoyment derived from a work of art [1] is an enjoyment that one experiences in apprehending and dwelling on some or all of

the qualities of the particular work in their specific interrelations. This is also true of other forms of enjoyment or pleasure, as can be seen by considering the way in which we speak about enjoyment and pleasure in general. We say "I enjoyed (eating) this dish"; "I enjoyed (watching) that movie: it was a most enjoyable experience"; "I got a good deal of pleasure out of (reading) this book." Speaking of the characteristics of an enjoyable work, we say "This poem (or work of music) has a delightful lilt"; "Observe the delightful way in which the painter has juxtaposed the colors on the canvas—note how he has balanced the different elements of the composition"; and so on. The same is true of our enjoyment of other things such as games, ice cream, wine, going on a picnic, and being idle. In every case, enjoyment is the enjoyment of some particular object, activity, or quality having a certain nature; the delight is always a delight in some particular thing having its own character.

It follows that the total experience of any given work of art is always different, to a greater or lesser extent, from the experience of any other work of art. The enjoyment, the pleasurable experience, that any particular work may be able to give us (under standard conditions) has a unique quality. The same is true of those beauties of nature, such as sunrises or sunsets, that are never exactly the same, qualitatively speaking, at any two moments. It is likewise true of any objects or activities that differ sensibly from other objects or activities—including those of the same *kind*—which yield some pleasure if and when we concentrate on their sensuous or other features, and their interrelations, as complex wholes.

In the case of art, the foregoing is true even though the enjoyment of any given work of art is of the same *kind* as that of any other work of art (compared to, say, the enjoyment derived from solving a tough mathematical or logical problem; or from playing tennis, golf, and so on). It is also true despite the fact that the enjoyment of art itself, as a kind of enjoyment, may have very important "family resemblances" to the kind of enjoyment that some other objects or activities may give when we attend carefully to their qualities and their interrelations, as features of a complex whole. Every work of art, as an individual object, activity, or set of qualities, *must* necessarily differ in some respect, with regard to its qualities or its

structure, from every other individual work of art. As shown in Chapter 1, this proposition is analytically true by virtue of the relevant ordinary meaning of 'a (or 'the same') work of art.' If, say, two canvases or two "groups" of verses are identical in all respects, they would not be in that sense ordinarily called two paintings or two poems, and, therefore, two works of art. We should rather speak of the canvases as two versions of the same painting, or one of the two would be regarded as the original painting and the other as a copy. As for the two groups of verses, we should ordinarily speak of them as two copies of the same poem.[2]

If what I have said about pleasure (also enjoyment) is true, the view that in the enjoyment of art only the net amount of pleasure really matters is definitely erroneous. It follows that we cannot validly hold that "pushpin is as good as poetry." Even if it were true that the enjoyment of art is of the same kind as the enjoyment of pushpin, the enjoyment of any particular work of art is, in principle, not comparable to the enjoyment of pushpin. We cannot therefore say, on the basis of the amount of pleasure each may give, that pushpin is as good, or not as good, as poetry or art in general.

What I have said about pleasure, in the sense of the pleasant quality of some feelings, images, or ideas, applies equally to pleasure (and displeasure) as a distinct feeling logically on par with other feelings such as sadness, joy, elation, or melancholy. The pleasure (or displeasure) will be, once more, pleasure (or displeasure) in its particular object or source and so will be colored by its own nature. I might add that it is probably this feature of the logical grammar of 'pleasure', 'enjoyment', and their cognates that led an aesthetic hedonist such as George Santayana in his early aesthetic writings to speak of beauty as "objectified pleasure,", as "pleasure regarded as a quality of a thing."[3] Santayana seems to me to be confused in speaking of *beauty* as pleasure (or the "emotional element," as he also calls it). However, his mistaken identification of the effect, the pleasure, with its cause, the work of art (the "beauty"), is probably due to his awareness of the "intentional" character of the enjoyment of art. He himself says that our attribution of pleasure, as a quality, to the object itself is due to "the survival of a tendency originally universal to make every effect of a thing upon us a constituent of its

conceived nature." [4] Thus, Santayana attempts to explain the "intentional" character of the enjoyment of art, *which is a semantic matter*, by an allegedly empirical hypothesis. In addition to being the wrong kind of evidence in the present context, this hypothesis is probably false. Santayana would have been closer to the truth had he spoken of the pleasantness or pleasurableness of a (pleasing) work as existing in the work in the form of certain dispositional properties of the sensuous and/or nonsensuous features of the work.

In addition to its negative implications in revealing a serious flaw in hedonistic theories of art which dissociate the pleasure from its source or its object—the individual work enjoyed [5]—our analysis has important positive implications for aesthetics. It is one important aspect of the fact that the notion of an emotional response to a work of art is inextricably connected with the concept of a work of art as an object, activity, and so on, consisting of a usually large number of interrelated sensuous and (usually) ideal elements. The concept of the enjoyment of art is but one side of the coin, so to speak, the other side being the concept of the work of art itself as a complex of structured sensuous and ideal elements and hence qualities, showing that any attempt to understand the nature of the enjoyment of art in isolation from the nature of a work of art as a sensuous-cum-ideal object, activity and so on is doomed to failure.

Although this error has been rarely if ever committed by aestheticians, the converse and more serious error of attempting to understand or define works of art without any special reference to their enjoyment is quite common. The error in this approach stems from ignoring the affective *aims* of art as an integral part of the *concept* of art. The connection between the two, far from being incidental, gives our preceding remarks on the "intentional" character of the enjoyment of art considerable significance. It is because the notion of enjoyment is part of the ordinary concept of art that to know that the enjoyment of a work has "reference" to the qualities and structure of the work constitutes some knowledge of the logical grammar of 'art' and 'work of art', or the concept of art. It is by virtue of this notion that the statement "The enjoyment of a work of art is intentional in nature" expresses a true analytic proposition.

II

It is clear that different works of art may have the capacity to evoke all sorts of different feelings such as, pity, terror, joy or elation, sadness, sorrow, melancholy, wistfulness, loneliness, peace, and tranquillity in the qualified perceiver under standard environmental conditions. But no particular feeling or set of feelings is a criterion feature of a work of art in the *descriptive* use of this expression; the correct ordinary application of 'work of art' (or 'art') in the present sense in no way depends on whether the particular object or activity has the capacity to evoke any particular feeling or set of feelings under standard conditions. The same can be easily shown with regard to any particular emotion or set of emotions.

However, it should be remembered that there are certain less general art names which involve in their correct applications a reference to the capacity or lack of capacity of a particular work to evoke some particular feeling or feelings, mood or moods (but not emotions). The capacity of an object or activity of a certain general kind to evoke some particular feeling or feelings, mood or moods, provides us with a basis for the classification of (some) works of art into genres, kinds or forms, and so on over and above the formal and/or material bases of certain kinds of genres of art.

What is applicable to feelings and emotions is applicable to pleasure. A given artifact or activity that has sufficient over-all sensuous and nonsenuous resemblances to unquestioned works of art would not be refused the name 'work of art' in the *descriptive* sense if it fails to evoke any pleasure in anyone under standard conditions. But it would not be called a good (or a very good) work, a work of art in the evaluative sense. On the contrary, it would be called a poor work or poor art, whatever other qualities in may possess, whatever feelings it may be able to evoke under standard conditions. That is, as we saw in Chapter 3, the ability to evoke pleasure (hence to give enjoyment) is a criterion feature of good art: we *expect* a work to give pleasure under standard conditions.

The fact or presumed fact that all works of art are expected to give

the perceiver pleasure, but that no work, as art, is expected to evoke any other feelings implies that pleasure may be experienced independently, even in the absence of other feelings. And, indeed, this is as we should expect since pleasure (and its opposites, pain and displeasure), like all other feelings, is a distinct feeling in its own right. A work may be pleasant without being, say, gay or bright, and it may be unpleasant in the sense that it may evoke feelings that are antithetical to pleasure, such as disgust or boredom, without being sad, melancholy, and the like. Thus, looking at some geometrical abstractions, say those of Mondrian, gives some people considerable pleasure; but we should not normally describe some of these paintings as gay, full of joy, hilarious, and the like. Likewise with many nonobjective sculptures and many works of architecture. In describing these works we may use such epithets as 'virile', 'powerful', 'graceful', 'airy', or 'light'. These, like such feeling or mood words as 'sad', 'wistful', or 'melancholy', refer to sensuous or nonsenuous features of the work, in varying degrees of generality. These expressions do not refer to any feelings, emotions, or moods. There is no feeling, emotion, or mood (or any other psychological state) of power, virility, dignity, or majesty, though we do say "One who looks at this sculpture feels its power (dignity, majesty)" or "One has a sense of its virility (dignity, majesty) when one looks at it." Yet to feel a work's virility or majesty is not to experience definitely any particular feeling or complex of feelings, like being sad or pleased or feeling lonely; nor is it to be in a certain mood or other psychological state, as we are when we are gay or melancholy. It is also not just an awareness of the work's grace, virility, power, and so on. This is clearly seen if we consider such statements as "I felt the tremendous power of Beethoven's *Eroica* Symphony when I listened to it last night" or "I felt its power in the marrow of my bones." (Melancholy is a feeling; so a mood may include a feeling together with other things that are not feelings. Thus a mood usually, perhaps always, includes some attitude toward what we are doing or undergoing at the time, toward others, and sometimes toward life as a whole.) It is essential to note that, whereas we feel sad or pleased as a result of listening to music, reading a novel, or looking at a painting, we feel the novel's, the music's, or the canvas's

power or majesty, and so forth—that is, 'feel' in the latter sense has a referential or intentional component in its meaning absent from the meaning of the word in its former sense.

On the other hand, there are many works of art which we describe not merely as pleasant or pleasurable, but also as sad, gay, depressing, melancholy, wistful, exuberant, and so on—as well as virile, powerful, dignified, and so on, which are not feelings at all. We consider such works failures if we think that under standard conditions they are not sad, gay, wistful, melancholy, terrifying, pity-arousing, serene, calm, and so on. We describe them as colorless, lifeless, or insipid.

<h1 style="text-align:center">III</h1>

Is a work of art expected, by the ordinary use of 'art' in the descriptive sense, to arouse *emotions* in the audience under standard conditions? Or, stated otherwise, is emotion an essential ingredient of a *complete* response to *good* art? Apart from its intrinsic interest, this question is important for aesthetic theory because of the wide currency of the view that emotion is a, or even the, "defining feature" of "aesthetic experience."

To answer this question we must distinguish emotion from feeling, as clearly as is possible on the basis of ordinary usage. A glance at the ordinary applications of 'emotion' is enough to show that this expression, like 'feeling', has numerous meanings or senses. Indeed, 'feeling' and 'emotion' are often employed interchangeably.[6] However our present question arises precisely because there are important senses of each in which the meaning of the two expressions differs. The sense of 'feeling' which we have distinguished before, which is the sense relevant to our discussion [7] of people's responses to works of art, is one of the senses of it in which feeling is distinguished from emotion.

The following are the senses of 'emotion' relating to our present question: (1) "An agitation, disturbance, or tumultous movement, whether physical or social"; and (2) "Any such departure from the usual calm state of the organism as includes strong feeling, an im-

pulse to overt action, and internal bodily changes in respiration, circulation, glandular action, etc. . . ." [8] In other words, our question arises with respect to that meaning of 'emotion' in which the word suggests more agitation or excitement than 'feeling' does.[9]

It seems to me—though the relative fluidity of the ordinary concept of the enjoyment of art and what seems to be the fact that 'emotion' is not used very precisely in ordinary discourse prevent any but the most cautious and tentative conclusions—that emotion, in the relevant sense (sense[2])—is not an essential, inseparable feature of a complete response to good art. No emotion, as opposed to feeling, need be aroused by a good work in order that we may have a complete experience of the work. This is not, and is not intended to be, a contingent fact about the experience of some good art. It is, rather, a semantic matter determined (as far as I can see) by the way we ordinarily use the terms "good art" and "enjoyment of good art."

The probable truth of our contention can, I think, be seen in the same way we saw that feeling, other than pleasure, is not a necessary feature of the full enjoyment of good art; namely, by noting that we should not normally hesitate to regard a particular work as good art (*a fortiori*, art *simpliciter*) if it does not evoke in a qualified judge any emotion at all under favorable environmental conditions—provided that it satisfied other (or the other) conditions of good art. We can, of course, verify the weaker claim that no *particular* emotion or set of emotions is a necessary ingredient of the full enjoyment of good art by considering any particular emotion we care to think of in relation to the ordinary applications of the label "good art," and then repeating the procedure with every other emotion that we know.

This does not mean that there are not good works which may, as a matter of fact, evoke some emotion or other under standard conditions. Indeed, many good plays, novels, and short stories, as well as operas and ballets, do evoke various emotions in the reader or spectator in relation to the characters they contain and their actions and experiences. Other kinds of art may likewise evoke various emotions. But recent experimental findings, if they are to be trusted, appear

to show that emotion is absent in the case of at least *some* instances of what is probably full experience of good art. I quote from Vivas:

> Competently trained persons in music and in poetry are found who deny that the adequate aesthetic experience involves the presence of the emotion. In poetry the mention of only one name should suffice—that of T. S. Eliot. In music the evidence which Vernon Lee has recently offered us is overwhelming. And her evidence is confirmed by previous empirical investigations.[10]

I am assuming, of course, that we can properly take "adequate aesthetic experience," in the above quotation, to mean what we ourselves mean by "enjoyment of good art under relatively standard conditions."

Vivas gives what he calls a "crucial proof" that emotion is an accidental consequence of aesthetic apprehension. He cites "the fact that the same aesthetic object (or even the same object of fine art) is capable of arousing different emotional reactions in different spectators or even in the same spectator at different times." [11] However, this only proves—assuming that the different emotional reactions spoken about arise when standard conditions prevail—that no *particular* emotion can be regarded as an essential constituent of the full enjoyment of art. It does not prove that emotion, generically speaking, cannot be a (kind of) component of the full enjoyment of art. Whether the reactions cited by Vivas were actually observed to occur under standard conditions—whether, for instance, they were the reactions of qualified judges—I do not know.

It may be thought that if emotion involves agitation or excitement, and a tendency to act, it *cannot* be an essential ingredient of the proper response to *any* work of art. For it would seem that agitation or excitement, and a tendency to act, are out of character with the proper enjoyment of art, which (it may be thought) is never one of agitation or excitement and in which any tendency to act

is absent. Indeed, the full absorption in and the savoring of a work's qualities, which (I claim) is an optimum condition of the enjoyment of art in general (see Part II, Chapter 8) appears to be incompatible with any tendency to act while one is reading, looking at, watching, or listening to the work.[12] However, the foregoing extreme conclusion does not follow from these facts, if they are facts; for emotion involves agitation or excitement, and a tendency to act, only when it is experienced in a "subjective" or "personal" rather than a detached or "impersonal" way; that is, when it relates to the perceiver's personal life and concerns. Thus, emotion experienced "impersonally" can and frequently does, it seems to me, constitute an important part of the proper enjoyment of works of art. Note the expression "detached passion" in such sentences as "He writes with detached passion," and "He responded to the play with detached passion."[13] (This can be expressed in the misleading language of Edward Bullough by saying that in such cases we are referring to a "distanced" emotional experience. See Part II, Chapter 8.)

Let me illustrate the distinction between "personal" and "impersonal" emotion. In reading or watching a performance of *Hamlet*, say, we may imaginatively experience the emotions of love and hate [14] for some character in the play (just as I may imaginatively experience individual feelings of sadness, joy, concern, and the like, apart from any emotion that we may experience). We may hate Claudius and imaginatively experience love for Ophelia; we may even "share" Hamlet's emotions for her, though only if we become identified with, or "empathize" with, Hamlet as we read or watch the play.

The emotions we experience may be "personal" or "impersonal" —or, more correctly, we may experience them "subjectively," in a "personal way," or in a "detached" or "impersonal way." In the former case, a person watching *Hamlet* will react emotionally the same as he usually reacts to various real persons or situations. On the other hand, a person will experience emotion impersonally in relation to some character, object, or situation in *Hamlet* if his personal attitudes, biases, proclivities, and life do not color or influence his reactions.[15]

It is a corollary of what we have been saying that "personal" emotion is an "unaesthetic," and not merely a "nonaesthetic," affect (or an "accident" in T. S. Eliot's terminology) *as far as the overall aims of art are concerned,* because apparently, "personal" emotion interferes with the proper perception and enjoyment of art. On the other hand, "impersonal" emotion can be regarded as a "nonaesthetic" affect, a true "accident," *relative to the overall aims of art.* This proviso is intended to remind us that emotion, when detached, can be a genuinely *"aesthetic"* response to particular works of art, as particular works.

It is instructive to mention, in relation to our thesis that personal, "subjective" emotion is an *"unaesthetic"* affect relative to all works of art, the celebrated meeting of Beethoven and Goethe at Teplitz. It may well be this "subjective" or personal character of *some* emotional reactions that Beethoven had in mind at one point during that encounter. I quote from the letter by Bettina Brentano describing the encounter:

Goethe went to see him [Beethoven]; Beethoven played to him. When he observed that Goethe seemed to be deeply moved, he said: "Oh, Sir, I didn't expect this of you. In Berlin too, I was giving a concernt some years ago, I made a great effort and thought I was giving a really good performance and hoped for some decent applause; but, lo and behold! when I had expressed my utmost enthusiasm, not the faintest sound of applause was to be heard. . . . The enigma soon resolved itself in this way: the whole Berlin public was so educated and refined that now they all staggered towards me with their handkerchiefs *wet with emotion* to assure me of their gratitude. *This was quite irrelevant to a crude enthusiast like myself; I could see that I had only a romantic audience, not an artistic one. But from you, Goethe, I won't stand for this. . . .* In this way he drove Goethe into a corner . . . for he [Goethe] was well aware that Beethoven was right.[16]

IV

We have seen that the enjoyment of good art—indeed, of anything that can be a source or object of the kind of enjoyment we ordinarily associate with good art—is enjoyment of it as an object of sense, imagination, and intellect. The "experience" in which the enjoyment consists is woven out of imaginative, intellectual, and emotional strands; but I also noted that such sensations as hunger and thirst, or bodily sensations akin to them, may be imaginatively induced by highly sensuous works. Other physical sensations or states, such as a sense of general physical well-being or languor, can be produced by a voluptuous representational painting or passage in a novel. These sensations and the like are *psychologically* stimulated by what we see, hear, or read, or by what the artist offers to our imaginations. There is, however, a *physical,* hence more direct, way in which some works of *music* can elicit bodily sensations; namely, by the sheer vibrations they create with their ear-splitting volume and powerful rhythms. I am, of course, thinking primarily though not solely of current rock-and-roll performances, complete with electric guitars, loudspeakers, assorted drums, and the human voice—buffeting, engulfing, and drowning the dazed listener in the waves of a sea of high-decibel sounds. The rock musical *Hair* is just one outstanding example (it is also a very fine and gripping work), and so are, in another way, parts of Herbert von Karajan's recording of Brahms's *German Requiem* some twenty years ago. (The "controlled violence," as *Time* magazine put it, of the Italian conductor Sabatini, also comes to mind.)

The overwhelming physical effect on the listener's entire body, not just ears, is of course perfectly calculated. Certainly this is true in the case of rock-and-roll music; it is related in interesting ways to the values and way of life of the hippies and many other members of the current younger set. The pealing of bells and the booming of canons in Tchaikowsky's *1812 Overture* probably have a similar though less overpowering effect. The Walpurgisnacht music in Berlioz's *Symphonie Fantastique* is another possible instance, but per-

haps the shivers that run down our spines are due to its imaginative impact and are not a directly physical effect. A valuable part of the theory of Empathy is its cognizance of the bodily tensions and visceral and other kinds of physical sensations that we may experience in enjoying, say, visual art.

Although we have been talking of performances of *Hair*, the *1812 Overture*, and the like, we can say that the aesthetic enjoyment of the *compositions* in question involves the foregoing sorts of physical sensations, despite the fact that this is only true of the music as performed. We correctly talk in this way whenever the score requires the dynamics and so on, in question, irrespective of whether this is explicitly indicated by the composer.

Santayana's characterization, then, of aesthetic pleasure in *The Sense of Beauty*, as a pleasure of sense and imagination, is incomplete. It is I think universally, or almost universally, true that in the enjoyment of art the perceiver's body is "transparent" and does not draw attention to itself, though the physical sensations that may be produced by the sensuous features of some works of music *are* localized in the listener's body. As with the physical tensions and motor sensations we experience when we empathize with a visual work of art or a work of music, the sensations of being engulfed by the music and carried on its waves do *not* draw attention to the listener's body. Since music consists of sounds, which may, as we ordinarily say, fill the room or auditorium in which it is performed, we feel ourselves part of the music, not separate from it. True, we may not become quite oblivious of our body as we may when the effect is purely imaginative, emotional, or intellectual-emotional, but we may come quite close to it.

Santayana's account is incomplete also in that it tends to ignore (by drawing too sharp a line between the "realm" of value and the "realm" of fact) the intellectual elements in aesthetic enjoyment. Susanne Langer's account of "feeling" in her definition of art [17] is more in line with the everyday account. (But according to Langer the human "feeling" whose form is congruent with some particular work of art as "expressive form," is something we perceive in the work rather than emotionally experience. [18]

In speaking of aesthetic pleasure as pleasure objectified, pleasure

attributed to the work of art as a quality,[19] Santayana draws atten-
tion to an important characteristic of aesthetic enjoyment as a whole
(not just the pleasure it contains). We saw in Chapter 1 that the
feelings or emotions which a work may evoke in perceivers—not
least in qualified perceivers under optimum conditions—are ordi-
narily, as in science, thought of as existing in the perceiver, not in
their cause or object, the work of art itself. Nonetheless, there is
important truth in Santayana's admittedly speculative psychological
theory of the "projection" of our pleasurable response onto the
work as (if it were) a quality of it. For I think that at least some-
times we do *perceive* a work which plunges us into sadness as
though it were suffused with sadness; we seem to "hear" the sad-
ness in the (sad) music; we seem to "see" the melancholy in the
(melancholy) painting. This may be due to empathy, or empathy
may be a consequence of it. We may "feel ourselves into" the work
because we spontaneously "see" it suffused with certain feelings or
emotions or charged with certain tensions, or we may "see" it as
suffused with feeling because we "feel ourselves into it." In the lat-
ter case, we *may* empathize with it because we perceive certain
resemblances between it and the *usual* behavior or deportment of
persons who are sad, melancholy, and the like (as in Bouwsma
and in Hospers). Our perception of a work as though permeated
with feeling is probably a main reason why we come to associate
certain specific or generic features or combinations of features with
sadness, gaiety, and so on and come to refer to the specific or
generic features as qualities which make it sad, melancholy, and so
forth. That is, this is probably one main reason for the use of the
epithets 'sad' and 'gay' as transferred epithets applied to works of
art (in 'drooping, sad-looking lines', 'melancholy melody', 'gay rhy-
thm', and so on).

NOTES

1. What I am saying is perhaps not true of kinaesthetic sensations of pleasure or pain; sensations whose source is (some part of) the body. But these sensations always have some vague or precise reference to some locality, in the sense that they are always felt as localized in some region in the body. This may, perhaps, partly determine the felt quality of the sensation; like *feelings* of pleasure or pain it may give them a unique quality in any particular case. A toothache *qua* (called) toothache, may not be quite the same as any other kinaesthetic pain: stomach ache, headache, and so on. This, if true, would help explain how we come to *know*, in the light of our past experience of these sensations, the location of a given physical pain (the same with pleasure).

2. But we saw that there is another ordinary sense in which these two canvases would be referred to as "two paintings with an identical subject matter, color scheme, composition." (See Chapter 1.) The same is true of poetry. In this sense, therefore, the above remarks about the enjoyment of two paintings and so on are false.

3. "The Nature of Beauty," in Melvin Rader, ed., *A Modern Book of Esthetics*, Third Edition (New York, 1960), p. 48.

4. *Ibid.* Another conception of art as beauty, similar in a number of interesting respects to Santayana's view, occurs in the writings of Samuel Alexander. The beauty of a work of art or "aesthetic object" is a tertiary "quality" added by the mind to the sensible object which we ordinarily call the painting, the work of music, and so on. Further, the significance or expressiveness of a work of art—or the significance of a beautiful sunset—is a result of the harmony or congruence of the object's physical, objective qualities and those qualities of perception, feeling, thought, or imagination which are added by the perceiver. The remarks which I have made in connection with Santayana's view above also apply to the present view.

5. I need not add that my thesis that art has several "ultimate" aims, only one of which is enjoyment—and even enjoyment, as we saw, is a good deal more than pleasure—repudiates another, the most important, contention of hedonism.

6. For instance, *Webster's New International Dictionary*, Second edition, gives "any emotional state; emotion"; also "emotional reactions," as one of the meanings of 'feeling' which it lists. Another sense of 'feeling' it gives is "susceptibility to emotion." Cf. 'emotionable': "capable of

being moved by 'feeling'." It also says that feeling "frequently implies little more than susceptibility to, or capacity for, sympathetic emotion; as, 'a feeling of sadness and longing'."

The difficulty of distinguishing feeling and emotion in ordinary usage is seen by considering that we generally speak of fear, disgust, and joy as feelings; whereas the dictionary alluded to (apparently on the basis of equally widespread usage) regards them as emotions and lists them with surprise and yearning, which are probably genuine emotions, not feelings. The uses of 'feeling' and 'emotion' in psychology do not appear to help matters, since (if the dictionary referred to is to be trusted) 'feeling' is defined by psychologists very broadly as "a state of consciousness, or consciousness in general considered in itself and apart from any reference to an object of perception or of thought; that which *includes* sensation, *emotion*, and thought as subordinate species. That division of conscious life which includes all affective states; consciousness apart from conation, cognition, and sensation." (My italics.)

7. The use of 'feeling' with which we are concerned in the present discussion, and almost wholly elsewhere in the book, corresponds to Gilbert Ryle's fourth use of the word in his "Feelings" (*Aesthetics and Language*, pp. 56–72). But Ryle does not sharply distinguish feelings in the sense of *mental* conditions, which is the sense that concerns us, from general bodily conditions, such as feeling sleepy, ill, slack, fidgety, and the like.

8. *Webster's New International Dictionary*. Hereafter referred to as *WNID*.

9. Cf. *WNID*: "Feeling, the general term, suggests less of agitation or excitement than emotion. . . ." An "emotional" person, for instance, is not merely very susceptible to feeling, but one who is very prone to act—without thinking—under the influence of emotion.

J. Gosling, in her review of Anthony Kenny, *Action, Emotion and Will* (London, [n.d.]), questions the view that all emotion leads to action, as follows: "Fear and anger seem to lead to performances, to action in the central sense. One wonders: is awe an emotion? If so, what is the action it leads to, and in what sense of 'action'?" (*Mind*, Vol. LXXIV, No. 293 January, 1965, p. 130.) But this will not do, since Gosling apparently does not distinguish emotion and feeling. Awe is ordinarily called a feeling, not an emotion. (Similarly, fear and anger, which frequently lead to overt action, are feelings and not emotions.) Further, apart from what Kenny holds, it might be pointed out that an emotion, particularly a strong emotion, includes an impulse to act; it does not necessarily lead to action. Also, if and when a particular emotion leads to action, it need (and does) not always lead to any *particular* action or kind of action: it may lead to different actions or kinds of actions, depending on the circumstances.

10. *Creation and Discovery* (New York, 1955), p. 286. Vivas states that the evidence is found in Vernon Lee, *Music and Its lovers* (New York, 1933), Chapters 1 and 2, and Albert R. Chandler, *Beauty and Human Nature* (New York, 1934), Chapters 6 and 12.

11. *Ibid.*, p. 286.

12. Cf. the traditional aesthetician's use of the word 'contemplation' to designate the experience of art, and the notion of "disinterestedness" in Kant and in various contemporary aesthetic theories—also Schopenhauer's conception of the experience of art as a whole in *The World as Will and Idea*.

13. Compare and contrast this with the locutions "He read the poem, played the sonata, acted, with feeling (or feelingly)" as opposed to "He read the poem, played the sonata, acted, with emotion." 'With feeling' or 'feelingly' is a term of praise, while 'with emotion' is a term of dispraise in this context.

14. These are ordinarily called sentiments as well as emotions. But emotion is a major part of a sentiment, while sentiment itself may be composed of various interrelated feelings.

15. the general question of emotional reactions in the form of emotion, feeling, or other experiences or states, in relation to the enjoyment of art, is considered in Part II, Chapter 8.

16. *Ludwig van Beethoven, Letters, Journals, and Conversations*, edited and translated by Michael Hamburger, London, 1951, pp. 116–17. (My italics.) Perhaps the full enjoyment of good art, especially the full enjoyment of the greatest tragedies, is, in Wordsworth's famous phrase, "too deep for tears." But I do not wish to assert that feeling, as distinguished from emotion, even in the full enjoyment of good art, cannot be so intense as to make us cry, that it is always dry-eyed.

17. *Problems of Art* (New York, 1957), pp. 13–26, *passim*.

18. *Ibid.*

19. Cf. Bouwsma's account of sadness, melancholy, and so on as a quality of a work of art; and compare and contrast my account of this and of the sadness, gaiety, and so on felt by the perceiver upon attending to, for example, a sad or gay work (in Chapters 1 and 6 of Part I).

Chapter 5

Aesthetic Terms
and Aesthetic Ascriptions—I

In Chapter 1 we saw that 'art' or 'work of art' ordinarily refers to a physical or a physical-cum-ideal object, activity, or sequence of sound patterns (in the case of literature, sounds that have significa- tion), which have all sorts of physical, and in many cases also imaginative, intellectual, and/or emotional qualities. In Chapter 3 I attempted to show that an essential part of what is involved in our applications of 'work of art' in its descriptive sense (analyzed in Chapter 2) is the concept of aim, that art has certain aims. These aims, which consist in a work's having certain kinds of imagi- native, intellectual, and/or emotional impact of an enjoyable nature, are realizable by virtue of a (good) work's sensuous and/or non- sensuous features in their particular combinations or organization. Consequently, the enjoyment of a work of art is enjoyment of an object of sense, imagination, and/or intellect, and of something possessing a certain emotional character. We have not considered these features themselves in any detail, in all their rich and com- plex variety and interrelations. In fact, they are one side of the coin or picture of which the aims, and so the enjoyment of art, are the other side. In other words, a discussion of the phenomeno- logical features of works of art would complement and complete the outline of the everyday uses of 'art' we have been sketching in Part I, relating more precisely the impact of a work of art, if any,

to the sensuous and/or nonsensuous features which are responsible for them.

I should mention here that many or all of the types of words we shall discuss do not refer to the sensuous or nonsenuous features of works of art alone; they also have an effective "pole" or "aspect" of meaning or use. In the light of our analysis in Chapters 2 through 4, this is not unexpected.

Among the large variety of words applied by artists, critics, and laymen to works of art are those types of words, themselves a mixed bag, which Frank Sibley has labeled "aesthetic terms." [1] Although the phrase "aesthetic term" is convenient, it both covers too much and too little. There are all sorts of words besides "aesthetic terms" which are also applied to works of art and which, therefore, have some title to the label 'aesthetic term'. On the other hand, some of these words are also applied to things that would not ordinarily be called either natural beauties or works of art, such as everyday objects, faces, and gestures. In the case of such expressions, the phrase 'aesthetic term' may not be, and frequently is not, applicable to them in their latter employments. The reason why Sibley brackets all these diverse types of expressions together is that he believes (and the same is true of Mrs. I. Hungerland) [2] there are certain features characteristic and peculiar to them. Whether this is borne out by close examination remains to be seen. In any event, the phrase appears to be here to stay.

Sibley gives the following as some examples of "aesthetic terms" (hereafter referred to as "A-terms"): 'unified', 'balanced', 'lifeless', 'trite', 'sentimental', 'serene', 'somber', 'dynamic', 'powerful', 'vivid', 'delicate', 'moving', and 'tragic'. He also notes that "expressions in artistic contexts like *telling contrast, sets up a tension, conveys a sense of, or holds it together* are equally good illustrations." [3] These and other words he classifies, or would classify, as aesthetic terms can be grouped, in a rough-and-ready way, into the following four groups:

(A) such words as 'lively', 'powerful', 'insipid', 'unified', 'dynamic', and 'balanced';

(B) such words as 'moving', 'effective', 'pathetic', and 'touching';

(C) such words as 'sentimental', 'tragic', 'comic', and 'melodramatic', in one use of 'tragic', 'comic', and 'melodramatic'; and

(D) such words as 'sad', 'gay', 'melancholy', 'serene', and 'somber'.

Assuming for the moment that the uses of all these kinds of expressions—and it is readily seen that there is considerable variety among each of the foregoing subdivisions [4]—have certain common and peculiar features, the question arises as to whether (E) such words as 'beautiful', 'ugly', 'piquant', and 'pretty', and (F) such words as 'inventive' (work) and 'ingenious' (work) are to be counted among "aesthetic terms." [5] Whatever the answer to this question, such words as (G) 'romantic', 'classical', 'baroque', and 'byzantine', which may have certain "family resemblances" to one or more of the words grouped under (A) through (D) above, are in certain obvious ways of quite a different logical type from any of them, and will be completely ignored in this discussion. Because of limitations of space, I shall also completely ignore words of type (F) and will say very little about words of type (E). Indeed, I shall here concentrate on words of types (A), (B), and (C).[6]

One final preliminary remark. Although words of types (A) through (D), or our "aesthetic terms," are applied to things other than art (in the case of some or all of those that apply to natural beauties, to things other than these latter), we shall confine our attention to their applications to art. In any case, one should not assume that they mean the same, or have the same uses, in relation to art and nonart alike. Bracketing them together on the assumption that there is something common to them in these two classes of uses (cf. Hungerland, in both papers), and trying to find what is allegedly common to their uses in relation to both art and nonart, may put the whole inquiry on the wrong track. The uses of these words in relation to art, which may be at least partly determined by the nature of art itself (the kinds of object to which they are intended to apply) tends to be thereby distorted or missed. For example, we should not assume, without an unprejudiced examination of how these expressions are actually employed, that 'cheerful' in 'a cheerful face' has even the same kind of use as 'cheerful' in 'a cheerful poem' (or 'painting') and that a correct (kind of) analysis of

the one is a correct (kind of) analysis of the other. Certainly, as O. K. Bouwsma has amply shown in his "The Expression Theory of Art," [7] words such as 'cheerful', 'gay', 'melancholy', and 'sad' have a variety of uses—if not also different kinds of uses—in different types of sentences when applied to different sorts of things such as works of art, faces, persons, dogs, and news. It is not even certain that these words (or the other sorts of "aesthetic terms" listed above) have exactly the same uses in relation to poems as to paintings. This in addition to the fact that some of them are not ordinarily applied at all to certain kinds of art (vases; some types of architecture) or are only applied to certain features, aspects, or parts of particular kinds of art.

Like Sibley and Hungerland, I shall confine myself here to what these terms have in common, if anything. There is a good deal with which I am in partial or complete agreement in both their accounts of aesthetic terms (A-terms). At the same time, the discussion which follows should make it clear that there are equally important divergences between our viewpoints. Even where Mrs. Hungerland appears to me to be right, she does not to my mind carry the analysis far enough, though she certainly carries it further and deeper than Sibley, especially in her more recent paper, and I generally agree with her more than with Sibley.

(1) An essential part of Sibley's thesis about A-terms and A-concepts (which is a feature he considers to be common and peculiar to them) is that they are not, in principle, governed by any positive necessary-and-sufficient conditions. In order to see whether this is true, we must distinguish—something which both he and Hungerland fail to do [8]—(a) *logically* necessary or sufficient conditions of use, and (b) *actually* or *contingently* necessary or sufficient conditions of use. Sibley denies the existence of *positive sufficient* conditions in sense (a);[9] to this extent he is, to my mind, perfectly right.[10] "First, "nonaesthetic features" (N-features) or combinations of such features are not, logically speaking, sufficient to make a work balanced, unified, and so on. By this I mean that "X is BCD," "X is CED," "X is REF," and so forth, where 'B', 'C', or 'D' stand for some N-feature, does not *entail* "X is A_1," where 'A_1' is a particular A-term. (The type of condition exemplified by BCD, CED, and so

on, which is such that "X is BCD" [or CDE] does not entail "X is A$_1$," I shall call "logically nondependent conditions of use"[11]; and I shall refer to the logically opposite type of condition of use—the conditions for 'square' or 'triangular' in their geometrical uses[12]—as "logically dependent" conditions.) Second, no N-features or any combination of N-features are, positively, logically indispensable for the applicability of a particular A-term.

This is only part of the picture; for if we take sense (b) of 'sufficient condition', it is my contention, contra Sibley[13] and Hungerland, that aesthetic terms *are* governed in their actual employment by positive and not merely negative conditions that are, jointly, *actually* sufficient conditions of use. In other words, although no N-ascription is logically related to any A-ascription, there is some kind of contingent relation between the two, or between N-qualities and A-qualities. Let me explain that I do not mean that there is a certain fixed number of specific N-features which, if present in a work, would make a majority of users unhesitatingly apply a particular A-term to it. On the contrary, in any given instance it is not possible to say a priori how many N-features, and what N-features or kinds of features, would be actually sufficient, for different users, for the application of a particular A-term. The number, kind, and combination of such features regarded as sufficient in the case of different persons is quite variable.

There are various reasons for the variableness of the number and/or kind of N-features which different persons, or the same person at different times, would regard as actually sufficient for a particular A-ascription. In the first place, different persons demand different numbers of the same N-features, or combinations of N-features, because some people are more strict, others more lax in their usage, than others. This is a general feature of our employment of language and is not specifically connected with the character of A-terms as A-terms. However, A-terms of types A and B, and some words of type C (for example 'melodramatic') are partly *evaluative* (that is, they are specialized grading labels in Urmson's terminology). In their case, the foregoing situation obtains at least partly because of this element in their uses, just as some people set the standards for the use of 'good' or the other general grading

labels higher or lower than others. Here the position on the scale of value or disvalue on which a particular person places the quality of being balanced, unified, or delicate at least partly determines how strict or lax he would normally be in judging the N-features possessed by a particular work as actually *sufficient* to make it balanced, unified, or delicate. That is, the position depends on the degree of importance which he attaches to a work's being balanced, unified, or delicate, for its *goodness* or *badness* as a whole. This is intimately connected with what W. B. Gallie calls the essential contestedness of value concepts. Actually, it is one aspect, or a main logical source, of this contestedness.

Second, the number of N-features whose presence would make a particular person willing to apply a given A-term 'A $_1$' varies with the *nature* of the particular N-features and/or the particular combination of N-features involved in the particular instance. Some N-features, or some combinations of certain N-features, are regarded as more or less A-making qualities, so to speak, than others; and not surprisingly this itself is one common source of disagreement among critics and laymen (cf. the situation with regard to moral ascriptions). By appealing to N-features *a, b, c, d* or by appealing to a certain combination of *a, b, c,* and *d,* a person P may speak of a particular work as possessing *some* unity, while a second person Q, appealing to the same features or combinations of features may speak of it as possessing *great* unity, and so on. In the case of the evaluative-cum-descriptive A-terms the crucial point here—and I think it is characteristic of our employment of all evaluative-cum-descriptive terms—is that the evaluative "weight" a group of users attach to the term in question determines for them the kind and number of N-features which they deem actually sufficient, in that instance, to make the A-term in question applicable to the object. What specific features, and generically what kinds of features, would count as grounds for the application of a particular A-term, is usually not—certainly not wholly—determined by the individual user. More precisely, it is not determined by him, except perhaps marginally,[14] in proportion as the term he employs has precise conventional uses.

However, many if not all A-terms that occur in the writings of

critics and artists, and especially aestheticians, suffer from, in some cases very considerable, vagueness.[15] Consequently, they are commonly applied by one person in a different, sometimes a very different way from another: one person calls a painting balanced or unified, but another calls it unbalanced or disunified. In this type of case the same A-term is not applied to the same object by both persons even if they perceive the same N-features in it. They disagree because they mean something different in some degree or other by 'balanced' or 'unified', and because, *as A-terms, neither of these meanings determines the features or kinds of features* that would be, positively, logically sufficient for the term's application to it. The word 'unified' is a notorious example. Actually, one main reason for the variable application of A-terms to a work of art by aestheticians and critics in the history of art is their common (to my mind mistaken) conception of A-terms as nonaffective, using 'affective' in a broad sense; in their attempts to fix the uses of these words in terms of the sensuous or other N-features of the work itself, without reference to their actual or putative effect, or the impression they have on qualified perceivers under optimum environmental conditions.

I said that there are variable numbers and kinds of N-features whose presence in a work of art constitutes actually (positive) sufficient conditions of the application of particular A-terms. In addition, it may be perhaps empirically true that the *presence* of certain N-features or combinations of N-features is *actually necessary for the presence* of some particular A-feature(s). This, if true, would in a sense provide actually, or empirically, positive necessary conditions for the application of some or all A-terms. For in their absence, a particular A-feature "A_1," or "A_2," and so on would be absent from a particular work, and so the corresponding A-term 'A_1', or 'A_2', and so on would be, as a matter of fact, inapplicable to the work. This is to be distinguished from whether there are any negative actually sufficient conditions of A-terms, whether, that is, the presence of certain N-features or combinations of N-features actually prevents a work from having a certain A-feature or certain A-features, and in that sense makes the corresponding A-term(s) inapplicable to it.

(2) Although Sibley insists that A-concepts are not governed posi-

tively by necessary-and-sufficient conditions, he maintains that "taste concepts [A-concepts] may be governed *negatively* by conditions." [16] That is, "There may be . . . descriptions using only non-aesthetic terms which are incompatible with descriptions employing certain aesthetic terms." [17] This means, in effect, that negative logically sufficient conditions for the use of A-concepts may exist and that it would be logically impossible for a work to have a particular A-feature unless it had some particular N-feature or combination of N-features (cf. Mrs. Hungerland). This is not inconsistent with Sibley's (and Mrs. Hungerland's) view that there are no positive logically sufficient conditions for the use of A-concepts, for "Concept A_1 is governed by negative logically sufficient conditions" does not entail "Concept A_1 is governed by positive logically sufficient conditions," any more than the converse is true. Suppose that in the absence of any of a set of N-features A, B, C, and so on a painting cannot be "balanced"; it does not follow that it must be "balanced" if these features are jointly present.

It is quite possible that some or even all A-concepts are governed by negative logically sufficient conditions. On the other hand, it is possible that some or all of these concepts have only actually necessary conditions, for it may be empirically true that only certain N-features or certain combinations of certain N-features actually give rise to some particular A-feature or features. In the latter case, the truth or falsity of a statement of the form, "The presence in a painting, say, of N-features A, B, and C, or a certain combination O of A, B, and C, is actually necessary for the painting's having quality A_1," [18] can only be determined by empirical investigation of the experience of different spectators. At present we are not in a position to make more than some simple, tentative, and limited generalizations, such as "a combination of colors, all pale" would probably not look garish to many (perhaps all) perceivers. I might add that the existence of positive actually necessary conditions cannot be validly inferred from what I believe is the fact that there are positive actually sufficient conditions for the various A-concepts that we have. On the other hand, the existence of positive actually necessary conditions would entail the existence of positive actually

sufficient conditions, provided that the number of such conditions is finite. (In the case of art, the number of such conditions cannot but be finite.)

Whether the situation is as described by Sibley and Hungerland, or as I have just described, is to my mind quite indefinite. My guess is that with respect to some particular A-term or concept, the actual usage of some people would follow the pattern described by Sibley and Hungerland, while the usage of others would follow the pattern I described. Whether this is so, and what the proportion is of people who treat certain N-features or combinations as logically necessary for the correct application of a particular A-concept, can only be discovered by an inquiry into the linguistic habits of a large segment of, say, the English-speaking people. There is, of course, no guarantee that a person would not behave one way with respect to one A-term and another way with respect to another A-term. The actual situation, I suspect, is even more complicated than this. For if I am right in holding that it is a factual question whether certain N-features make a painting, a poem, or some other kind of art have a certain A-feature, we probably have an instance of an important phenomenon noted by philosophers. Certain contingent facts F relating to the referent of a particular word 'X'—certain features XYZ which are rightly or wrongly believed to be possessed by all members of class "X"—*may* get built into the meaning or uses of 'X' in the course of years or centuries. While this process is going on—and in some cases it may never be completed—uncertainty respecting things of which F are true, or false, characterize 'X's' applications. This uncertainty or indefiniteness may lead to the openness of concept X in the appropriate direction; on the other hand, uncertainty may make concept X vague rather than open, or both vague and open.

The upshot is that, quite probably, "All the colors of a painting P are pale but P is (looks) garish" would be definitely self-contradictory to some people (Sibley and Hungerland), while for others (Isenberg) it would be perfectly self-consistent but astonishing.[19] Still others would be uncertain and hard-put to say whether it is self-contradictory or merely astonishing. For this last group of people the process I described above has not reached its logical conclusion; for them the concept of "garishness" is open with respect to this

type of case. (A-concepts are also open in other ways.) On the other hand, I think it will be agreed that nobody would regard as self-contradictory "The colors of a painting P are predominantly pale, but P is (or looks) garish." We would be strongly inclined to say that this statement is factually false.

(3) Concepts such as *square* and *triangle*, in their mathematical use, are nondefeasible, since they are delimited in terms of logically necessary-and-sufficient conditions. All concepts of this description are necessarily nondefeasible. For whatever other features it may have (is large or small, acute-angled, right-angled, and so on), a geometrical figure is necessarily a triangle if it is three-sided. That it would be a triangle only in the absence of certain ("defeating") conditions is simply false. Now at least some concepts *not* governed by positive logically necessary-and-sufficient conditions must be defeasible. That is, defeasible concepts are a subclass of concepts of this type. For instance, the concept of a contract, which H. L. A. Hart gives as an example of a defeasible concept,[20] is a concept of this type. But a concept C would not be defeasible if (a) a certain variable number of a variable range of N-features A, B, C . . . , or A, C, D or D, F, G . . . , or whatever, constitute positive *actually sufficient* conditions for its application to a particular thing O; and (b) this is true no matter what other features X, Y, Z, and so on are (i) also present in O or (ii) absent from it. If in a given instance (b) is true, then X, Y, Z, and so forth would not be defeating conditions of C; their presence or their absence would not be logically necessary for C's application. If this is correct, and if as I maintained A-concepts have positive actually sufficient (though variable) conditions of application, condition (a) is satisfied by A-concepts. But do they satisfy condition (b)? The answer, I think, is yes. A-concepts are not defeasible concepts, as Sibley rightly maintains. Generally, certain definite conditions are, *logically* speaking, defeating conditions of so-called defeasible concepts; the latter are concepts into which the notion of certain defeating conditions is built. This is not true of A-concepts. We saw that there *may* be N-features of works of art or other kinds of things which count against the application of 'delicate', 'unified', or 'harmonious' to a particular work. For we sometimes truly say "This would have been

a delicate (or very delicate) painting, vase, or poem if such and such features were absent." These features are not defeating conditions in the sense or way in which certain features are defeating features of defeasible concepts. They may be severally or jointly actually sufficient to make us hesitate or refuse to apply a particular A-term to a thing. In no case—precisely because they are not governed by positive logically sufficient conditions—will the meaning of that A-term necessitate our withholding it. Whether a certain feature weighs for or against the application of a given A-term depends, in the last analysis,[21] on whether it is thought to contribute to or detract from the kind(s) of effect(s), mood, and so forth which is (are) called a "unified effect," a "harmonious effect," a "sense of power," and so on. With regard to defeasible concepts, there are broadly defined a priori conditions, determined by "convention", which theoretically determine (at least in the nonborder-line cases) whether a particular feature, or, at least, a particular *kind* of feature, can constitute a defeating condition. In this respect defeasible concepts are like concepts governed by logically necessary-and-sufficient conditions, such as *square* in its geometrical usage.[22] Indeed, whether this characterization is correct (see below and note 22), I think the essential difference between defeasible and A-concepts is that the former, but not the latter, are governed by *positive logically sufficient* conditions, though *in a special way* which makes them defeasible. That is, in the absence of certain broadly defined (defeating) conditions, the presence of certain features in a thing or situation is logically sufficient for the application of a particular defeasible concept to it.

(4) My major thesis is that most or all A-terms in groups A, B, and C are affective terms, hence, *a fortiori*, that they are what I call "capacity words," or C-words for short.[23] I mean that the notion of a capacity or power to affect, in some way or other, qualified perceivers under optimum environmental conditions is involved in the conventional uses of the different A-terms. Therefore, a judgment of the form "X is (or has) A_1" logically *implies*, in an ordinary sense of this word different from 'entails' and from 'presupposes', that X tends to produce a certain kind of effect, evoke a certain kind of mood, create a certain kind of atmosphere or state of mind,

make a certain kind of impression, and/or give a sense of something or other to sensitive and trained perceivers under optimum environmental conditions. In the case of some A-terms, perhaps a certain group of them, such as 'imaginative', 'suggestive', and 'thought-provoking', a judgment of the form "X is (or has) A_1" has the implication, or the additional implication, that X has the capacity to stimulate the imagination or the intellect, as the case may be.

These implications are a logical consequence of the "descriptive" element, generally speaking, of the uses of these types of A-terms and are independent of the specific descriptive element of their meaning or uses. The latter determines the specific effect, impression, mood, and so forth, or the particular kind of effect, and so on, which is conventionally associated with individual A-terms. It therefore distinguishes one A-term from another, as far as the descriptive element of their uses is concerned. The second aspect of the uses of our A-terms (this is also shared by group D of A-terms) is their phenomenological aspect; namely, their designation of certain kinds of quality or feature which may be possessed by works of art (also other kinds of things). Like the effective aspect, this aspect of their uses is determined, generically and specifically, by their ("descriptive") meaning as opposed to their evaluative uses. Indeed, the two sorts of uses are two sides of the same coin and are logically complementary. For a work X has the capacity (if it has such a capacity) to affect qualified perceivers in the way, W, implied by the descriptive uses of a particular A-term 'A_1', by virtue of its possession of A-feature A_1; 'A_1' is an A-term in whose uses the notion of effect, and so forth, W is conventionally involved. For example, a painting has the capacity to give us a sense of (its) delicacy if it possesses the quality of being delicate; the capacity to give the qualified perceiver a sense of (its) delicacy is implicit in the conventional descriptive uses of 'delicate (painting)'.

A work's N-features, especially in certain combinations, are, as we say, responsible for its A-features; they make the work delicate, powerful, dynamic—or the opposite. Consequently, a second major implication of "X is (has) A_1" is that X possesses (an unspecified number of) N-features which make it A_1. In the case of visual art,

where under certain perceptual conditions a work looks or appears different from the way it really is, "X has N_1, N_2, N_3. . . ," or "X has combination C of N_1, N_2, N_3 . . ." (N_1', 'N_2'', and so on being names of different N-features), and so "X is A_1," implies, in a non-logical, factual sense, "X looks or appears (or would look or appear) N_x or N_y . . . under such and such perceptual conditions."

Note that "X is (has) A_1" does not assert that X possesses some particular N-feature, or a particular set or combination of such features, any more than it asserts that it has this or that effect on the hearer, or some special group of people (qualified perceivers), or the majority of people who perceive X.

(5) If our account of the uses of A-terms is correct, it follows that in the final analysis the condition for the correct application of an A-term to a work of art is the capacity or lack of capacity [24] of that work to have the appropriate kind of effect(s) E, and hence, correlatively, possession or lack of possession by the work of those N-features which are recognized as making the work A_1, under optimum conditions. (These N-features, under these conditions, enable X to produce effect(s) E.) At the same time, it is always an *empirical* question whether a certain combination of certain N-features in a particular work does have a certain (or a certain kind of) effect under optimum environmental conditions on discriminating and trained persons. This explains important facts about A-features. One of these—which Sibley's and Hungerland's accounts fail to explain because of their failure to recognize the affective aspect of the uses of these terms—is the fact, noted by Sibley, that no mere description of a work's N-qualities-in-relation, however exhaustive or accurate, can as such enable the hearer to know what A-features it has; since the description cannot as such enable him to know what kind of effect or impression it will have on him, whether it will look delicate as opposed to, say, garish or flamboyant, powerful or virile as opposed to, say, strident, piquant as opposed to beautiful; and so on. I say "as such" because past experience of similar works would give him an experiential basis for prediction with some degree of assurance or other. To a lesser extent, the same would be true if he had observed other kinds of things that are qualitatively or structurally similar to the particular

work; but unless either of the foregoing obtains, he can only make wild guesses as to whether the work is what he and/or others would call delicate, garish, and so on. Only experience of the work can give him the requisite grounds, the necessary factual basis, for making such judgments as "I find this work quite delicate (garish)." Similarly, only the experience of some person—especially a considerable number of persons the speaker considers to be qualified judges—can make it reasonable to say "This work is lively (lifeless)" or "This work is unified." [25] A corollary of this is that a person may agree with someone that a particular work has such and such N-features, or combinations of N-features, and yet not agree that it is delicate, powerful, or insipid as the case may be, even though both may mean the same or roughly the same by the words in question. The person may fail to experience the kind(s) of effect, say, which the object has on the other person. This is perfectly in line with what I regard as the fact that no set or combination of N-features is a logically sufficient ground for any correct ascriptions. It also explains why, as Sibley says, "these occasions when aesthetic terms can be applied by rule are exceptional, not central or typical, and there is still no reason to think we are dealing with a logical entailment." [26]

(6) We ordinarily speak of a work's balance, unity, harmony, and garishness (also sadness, cheerfulness, and the like) as qualities or features of it, just as (and just as much as) its lines and colors, structure, rhythms, and the like. The former are qualities or features in a different use of these words (use two) than its latter use (use one). In the latter use of 'quality' or 'feature', a work of art consists wholly of its nonsensible and/or sensible N-features in their multifarious spatial, temporal, intellectual, or imaginative interrelations. A basic question which immediately arises, therefore, is What is the precise sense in which A-qualities or features are qualities or features? First, are they sensible or nonsensible qualities or features? It would seem that if they are qualities or features in any sense, they must be either the one or the other.

There are two ways in which a quality (or feature) may be said to be sensible or nonsensible: (a) in the sense that it is or is not, respectively, a quality (or feature) of some sensible element or

aspect of the object that has it; and (b) in the sense that it is or
is not, respectively, noticeable by eye or ear, whether alone or with
the help of the intellect, imagination, and so forth; though the
perception of the sensible N-features of a work is necessary for the
observation of any A-features, whether sensible or nonsensible.
With regard to (a), it is clear that some A-features are sensible
while others are nonsensible. The latter relate to such things as
the imagery, ideas, symbolism, plot, characterization, representation,
or narration in (some) works of art. But some A-terms are predi-
cated of both sensible and nonsensible aspects of a work of art,
which means that, in the present sense, a certain kind of A-feature
"A_1" may have both sensible and nonsensible species. Among the
many sensible A-features are balance, harmony,[17] dynamism, power,
forcefulness, delicacy, garishness, flamboyance, sensuous unity, and
their opposites. We speak of the harmony, delicacy, garishness, or
flamboyance of the color scheme of a painting, the delicacy or dy-
namism of its composition, the balance of its forms, and the unity
of the sensible elements of a painting as a whole. Similarly, *mutatis
mutandis*, with the other arts. On the other hand, power, non-
sensuous unity, delicacy, coherence, and liveliness are also non-
sensible features in the present sense. For example, we speak of
the power, or the opposite, of a writer's imagery, characterization,
plot, or ideas, and of the liveliness or lifelessness of his dialogue.
Unity or coherence, and possibly harmony, is somewhat peculiar,
since it pertains to the relationship(s) of the nonsensible and the
sensible aspects or elements of a work, rather than, like other
A-features, to the sensible aspects or the nonsensible aspects sepa-
rately.[28]

Garishness, musicality, or the quality of being rhythmic are
among those A-features which pertain only to the sensible aspects
of (some kinds of) works of art; the words 'garnish', 'musical', and
'rhythmic' designate only sensible A-features.

In the second sense of 'sensible' and 'nonsensible', the balance
or lack of balance of a visual composition, the harmony or dis-
harmony of a color scheme or a visual composition, are sensible
A-features, because as we say, we notice them by eye. The same
is true with respect to harmony or disharmony in the case of instru-

mental music, sculpture, and architecture; but the power of a painting, a sculpture, or a poem is not observed by eye or ear. The same is true of a work's vitality or lack of it, and perhaps, of its unity or lack of unity (in contrast to the balanced quality of the composition of a painting), including *the unity of its sensible elements.* Note that we speak of 'a balanced look' but not 'a unified look' or 'a powerful look'.

The situation is actually more complicated than described. If noticing by eye or ear itself involves, either always or in the case of art alone, some conscious or unconscious "interpretation" of what is seen or heard (I do not mean our labeling it "balanced" or "harmonious"), the noticing of no A-feature would consist in merely seeing or hearing the sensible N-features of a work of art. That would not, however, entail that what is thus perceived is not sensible, in our second sense of 'sensible'—similarly with the perceiver's being appropriately *affected* by the particular work, or his having been appropriately affected by some other work(s), as a condition [29] of his noticing or recognizing a particular A-feature. Note that being affected by the work in the appropriate way is, in the last analysis, a logical condition of our noticing *any* A-feature in groups A, B, and C, whether it is noticed by eye or ear. The particular sense, feeling, or impression that the work gives us suffuses or pervades, so to speak, our perception of the work,[30] that is, its various N-features. It is a process or experience in which feelings (sometimes also imagination and thought) are fused, so to speak. This is not, I think, anything unusual or peculiar to our perception of certain features or aspects of works of art (A-features). For we all usually look at the world—perceive things and persons—through a thin or thick veil of feeling or emotion, in addition to draping it with a gossamer web of fancy and a sturdier intellectual net of categories and concepts.

It is useful to point out a basic difference between A-features and dispositional properties. Such properties as solubility, malleability, laziness, and intelligence are themselves capacities or powers, whereas A-features are not, but *have* capacities or powers. This is why I called A-terms capacity words, as distinguished from dispositional words. As I suggested earlier, the uses of A-terms are bipolar, so to

speak. The affective aspect of these uses picks out the dispositional facet of A-features. That is, as regards the sense, impression, or effect which certain configurations of N-features have on the perceiver, a particular A-feature has a certain capacity given to it by these N-features themselves, to affect qualified perceivers in a certain way or kind of way under optimum environmental conditions. This, I think, is what we mean when we say that a certain kind and/ or arrangement of N-features gives us a sense of unity, delicacy, power, and the like.

The objective and the affective descriptions we employ to talk about A-features are logically inseparable. For example, the way we talk about the appearance of a painting under normal perceptual and other conditions and the way we talk of the sense, impression, or effect it gives us or has on us, are complimentary. It would be self-contradictory, not merely false, to say "I have a sense of X's balance but it does not look balanced to me" or "X has a unified effect on me but it does not look unified to me." The relation between the objective (phenomenological) and the affective aspects of the uses of A-terms is logical, not (at present, at any rate) a merely contingent, psychological relation. Or stated in the "material mode of speech," we cannot possibly notice the balanced or delicate quality of the object unless we get a sense, impression, or feeling of its being balanced or delicate. In the less misleading "formal mode of speech" this means that we cannot, on the basis of what we see, hear, or read, *justifiably* or *properly* apply a particular A-term unless or until the work gives us a certain sense, impression, or feeling. We may get such a feeling without knowing which N-features or, even, which combinations of N-features are responsible for it, but we cannot possibly fail to notice the balanced or delicate look of the work if the latter gives us such a sense of impression. These two last propositions imply that noticing or observing a particular A-feature is not *merely* the noticing of any particular N-feature or even any particular combination of N-features, including those which are actually responsible for the A-features in question. Merely hearing or seeing (sensibly, or mentally) any N-feature or combination of N-features is not enough for noticing any A-features. To see a painting's unity, delicacy, and so forth is to see certain N-features or combinations of them *as unified*,

as delicate, and so forth. In other words, to ascribe A-features to a work is to see or think of it under a different sort of *description* from the sort involved in ascribing N-features or even N-gestalts to it.

Another important point is that, with regard to all A-features designated by A-terms in group A, B, or C, what the qualified perceiver gets or has (under optimum conditions) is not just an impression, an effect, a feel, a feeling, or sense that has a certain experienced quality or tone, but an impression (weak, strong, or overwhelming) *of the work's* strength or power, delicacy, vitality, virility, vivacity, or a sense or feeling *of* the work's tremendous power, a sense of its form, or of its delicacy, power, vivacity, flamboyance, and so on. The affective component is essentially "intentional," directed toward its phenomenological component, and so toward its N-features as possessing the capacity to produce these effects.

(7) A-features are phenomenological features (most or all are gestalt features, as Hungerland emphasizes). This should not lead us to suppose that we *ordinarily* regard them as in some sense subjective or mental features, that their *esse* is *percipi,* though admittedly this sense is subtly different from the sense in which Berkeley and J. S. Mill conceived of the sensible N-features of an object as existing in the perceiver's mind. We ordinarily speak of them as being noticed or recognized by human observers (beings that have the ability to see, hear, feel, imagine, and think), under certain conditions. They are not said to arise, to come into existence, when they are perceived. We also speak of them as qualities or features *of* objects, that is, works of art, though, as I pointed out earlier, in a somewhat different sense or way than N-features. Their *esse* is not *percipi,* though clearly some philosophers would maintain the contrary. We should not be misled by the fact that, if our analysis so far is correct, a work's N-features or combinations of N-features must (originally) make some kind of impression, must have some kind of effect, or give the perceiver a sense of something or other (delicacy, power, unity), in order that we may be able to recognize a particular A-feature in the work. The sense, impression, or effect in question is not ordinarily said to be a quality of the work itself, least of all a quality of what we call the work's delicacy, power, and so on; the capacity to affect us in this way is attributed to the work. As I said before, it is attri-

buted to those N-features of the work held responsible for the A-feature(s) in question.

This view of A-features [31] clearly forms part of the general ordinary way of thinking and talking about perceived objects and their sensible qualities, what philosophers call the common-sense view or naive realism. It is also in line with what I believe is the fact that in our everyday way of thinking a work of art is not "ideal" or "imaginary"; it is, partly or wholly, a physical or sensible thing—a physical object, occurrence, or, in the case of music and spoken poetry, a pattern of sounds—possessing its own physical (N-) features independent of any perceivers. Indeed, even with regard to works of art which are partly nonsensuous or ideal (many are of this description), the intellectual and imaginative elements are ordinarily regarded as bona fide components or aspects of the work just like its sensuous components.[32] Whether naive realism in general, and with it the foregoing account of A-features, is acceptable, is a matter of great importance for philosophy.

NOTES

1. In "Aesthetic Concepts," *Art and Philosophy*, pp. 351–73.
2. "The Logic of Aesthetic Concepts," *Proceedings of the American Philosophical Association, 1962–1963*, pp. 43–66, and "Once Again, Aesthetic and Non-Aesthetic," *The Journal of Aesthetics and Art Criticism* (Spring, 1968), pp. 285–95. Hereafter referred to as *LAC* and *OAAN*, respectively.
3. *Op. cit.*, pp. 351–52. Italics in original.
4. Also, there is some overlapping between the four categories; in one use 'tragic' and 'comic' can be, I think, classified under (D). Similarly 'powerful' can perhaps also be classified under (B).
5. 'Romantic,' in one common lay use of it, can be, I think, classified under (D). But in the sense in which it is employed by historians of art, it obviously has a different sort of use.
6. It can be shown, for instance, that there are certain basic differences between most words of this type and most or all words of types (A),

(B), and (C); through both Sibley and Hungerland regard them as of the same *general* type as the other "aesthetic terms."

7. In *Aesthetics and Language,* edited by William Elton (Oxford, 1959).

8. Mrs. Hungerland's failure to do this leads her, like Sibley, to hold that A-terms have no *criteria* of correct use.

9. See *ibid.,* pp. 354 f.

10. By "positive necessary-and-sufficient condition" I mean a condition whose presence is both necessary and sufficient for the correct application of a particular term 'X'; and by "negative necessary-and-sufficient condition" I mean a condition whose presence in both necessary and sufficient for the inapplicability of a particular term 'Y'. It is seen that a condition C whose *presence* is sufficient for the application of 'Y' is a condition whose *absence* is necessary for the application of 'not-Y'; while a condition D whose presence is necessary for the application of 'Y' is a condition whose absence is sufficient for the inapplicability of 'Y'. These distinctions apply both to logical and to contingent or empirical conditions.

11. Cf. R. M. Hare on 'good', in *The Language of Morals* (Oxford, 1961), Chapter 5, and *passim.*

12. Which are wholly determined, logically speaking, by the meaning or definition of 'square' or 'triangular'. Cf. Sibley, *op. cit.,* 353–54.

13. Mrs. Hungerland comes closer to recognizing this distinction though she never clearly utilizes it. See OAAN, *passim.*

14. The problem is more acute when users from different societies, or different historical periods, are considered.

15. The fact that many of these expressions are, or originally were, metaphors does not improve matters.

16. *Op. cit.,* p. 355. Italics in original.

17. *Op. cit.,* p. 355. Mrs. Hungerland too says essentially the same thing in OAAN, pp. 290 and 294. That the incompatibility is supposed to be logical in character is clear from the context.

18. See *op. cit.,* p. 355.

19. As far as we know or believe these N-qualities, as a matter of fact, never or almost never make a painting garish. Cf. Sibley, *op. cit.,* footnote 4, p. 372, on Isenberg's view.

20. In "The Ascription of Responsibility and Rights," *Logic and Language,* First Series, edited by A. G. N. Flew (Oxford, 1955), pp. 145–66.

21. I say "in the last analysis" because it still remains that the particular user will have to judge, on the basis of the empirical facts stated above, whether it would be proper for him to apply the particular A-term to the object in question. But this is true with regard to the application of any kind of word or phrase.

22. The above is something of an idealization. Actual defeasible concepts, such as those that occur in legal discourse, do not usually determine in clear-cut fashion the specific factors which are to count as defeating conditions. I think one of the main functions of the law courts is continually to refine or tighten these concepts in the direction of the model skeched above. See Hart, *op. cit., passim.*

23. I think it can be shown that this is not true of most A-terms in group D.

24. Also, in the case of many of these terms, which are scalar in nature, this refers to the degree in which it is capable or incapable of this.

25. One important reason is that the perceptual, imaginative, or emotional effect of the individual colors, lines, forms, and so on that go to make the painting is modified or transformed by their relationship to one another and so to the painting as a whole. Mrs. Hungerland makes some interesting observations on this matter. Similarly, with poems, sculptures, and so on.

26. *Op. cit.*, p. 360.

27. 'Harmony' may also be predicated, though probably in a metaphorical sense, of the imagery and ideas in a novel or poem. Compare and contrast 'coherence'.

28. An important question into which I shall not go is the extent to which delicacy of composition (painting) and delicacy of imagery (poetry) are similar, also delicacy of composition vis-à-vis delicacy of colors; and the same with the other A-features.

29. Whether it is, or has become, a logical condition or whether it is (still) a contingent condition will be seen later.

30. Consequently we tend to attribute it to the work, we seem to "see" it in the work in some sense. This is probably one psychological source of the classical expression theory of art. (Also, cf. Santayana, and Bouwsma's critical comments on his view, in "The Expression Theory of Art." But Bouwsma is concerned with A-terms in group D.)

31. It is interesting to note that the same is true of the nonaesthetic uses of A-terms—their applications to things other than works of art or natural beauties.

32. The same is true of the *feeling* of which a work may, as we say, be full. (See Chapter 1.)

Chapter 6

Aesthetic Terms
and Aesthetic Ascriptions—II

The present Chapter continues the analysis of the uses of "aesthetic terms" undertaken in Chapter 5. The subject is of crucial importance for an understanding of art (as well as for an understanding of ordinary language as a whole). In Section I I shall consider some interesting similarities and differences in the uses of various types of aesthetic terms (A-terms). In Section II I shall consider the applications to works of art of a special group of A-terms (group B in Chapter 5); namely, 'sad', 'gay', 'cheerful', and other so-called expressive words. In Section III I shall point out some similarities and differences between A-terms in general and dispositional words.

I

In Chapter 5 I emphasized the affective uses of A-concepts and attempted to show how recognition of this aspect of their uses accounts for various important features of their uses which were not and could not be explained by Sibley's, and even Hungerland's, account of these concepts. We must note certain differences between groups A, C, and D of A-terms,[1] with regard to this aspect of their uses.

(1) Even a superficial examination of these groups of A-terms shows that they form a spectrum with regard to generality or specificity of meaning and, so, of application (or vice versa). They range

from the most general or inclusive, such as 'beautiful', 'unified', and 'harmonious', and their opposites, through 'pretty', 'powerful', 'feeble', 'imaginative', 'warm', 'balanced', 'stilted', 'turgid', to 'flamboyant', 'delicate', 'garish', 'piquant', and 'loud' (used as an A-term). Stated otherwise, (a) the phenomenological features which are, among other things, designated by the various A-terms range from general over-all features of works of art to fairly general to more specific or regional features. The same is true of (b) the affective responses or kinds of responses implicit in their uses. Indeed, the more general the phenomenological features referred to or designated by an A-term, the more general is (are) the response(s) implicit in its application. The opposite is true in respect to A-terms with specific or relatively specific phenomenological reference.

In (a), the phenomenological features which 'unified', 'balanced', and 'harmonious' designate may be large aspects of a work or even the work as a whole as well as more or less specific regional features. The composition of a painting as well as the painting as a whole may be balanced (in the latter case not merely insofar as the composition is balanced); we speak of a coherent theme, plot (hence unity of action), characterization, and so on. It is understood, however, that the ranges I am talking about, especially the range of affective responses, are very uneven, since there is no precise way of measuring or specifying the degree of generality or specificity of different A-terms relative to one another or to some absolute standard. I should add that even the most general A-terms (and so the poorest in "descriptive" content), such as 'unified' and perhaps 'beautiful', are less general than some other kinds of words that are applied to works of art and other classes of things: 'good', in 'good painting', 'good poem', or 'good art'. ('Good' is not, of course, an A-term in our usage.) At the other end of the scale, even the most "specific" A-terms are fairly general, as is seen in the case of 'delicate', 'gaudy', and 'flamboyant'.

I have ignored the fact that some A-terms are applicable to other things than art (or certain kinds of art) and that some apply to more kinds of things that are not art than others. Once we take this fact into account, we see that an A-term which, as it applies to art, is, say, only fairly general, may become a "very general" label; and one which

is already very general (for example, 'beautiful') as it applies to art may become even more general, an "extremely general" label, and so on. Indeed, when we do this we notice that we have here two sources or sorts of generality or specificity of application; namely, generality or specificity of application to (a) different phenomenological features or kinds of features (and/or involving the notion of different or different kinds of affective responses); and (b) different classes or kinds of objects, situations, processes, activities, and the like. Both (a) and (b) are distinct though logically related; different A-terms differ with respect to their generality or specificity of application in either or both of these ways.

Although all A-terms in groups A, C, and D have an affective component in their meaning, there appears to be a sense in which we can say that the meaning of some A-terms has more primary reference, or primarily refers to, the phenomenological rather than the affective component or aspect of their application. The opposite is true with other, I think a relative minority of, A-terms. Thus 'beautiful', contrary to the view of hedonists and other subjectivists, has more primary reference, though only in a very general way, to phenomenological features of things said to be beautiful than to the appropriate responses of the perceiver to these things. Even if this is false, 'balanced', 'unified', 'delicate', 'gaudy', 'flamboyant', 'turgid', 'rhetorical', 'imaginative', and 'intellectual' are true examples of it. On the other hand, such words as 'warm', 'emotional', 'cold', 'ineffective', 'powerful', 'pulsating', 'taut', 'romantic', and 'sensational' have more primary reference, in their meaning, to affective responses; other A-terms may be intermediate between these two types of terms or may involve more or less a balance between the phenomenological and affective poles of their meaning. Perhaps such terms as 'lyrical' and 'epic' in one use of the word, and 'tragic' and 'melodramatic' in another, are examples.

It is important not to fall into the error of supposing that any A-term in our three groups is either solely phenomenological or solely affective in its meaning. As a matter of fact—concentrating on the latter—I do not think that any word which is applied in sentences of the form "X has . . ." or "X is . . . ," where 'X' refers to a work of art, *can* be wholly affective. The word 'affective' in this context

should not be confused with 'emotive' as the latter is employed by emotivists or other philosophers, for even in the affective aspect of their uses the words we are considering are cognitive. "This music has tremendous power" *states* that the music has a certain kind of A-quality, and that it has a certain kind of capacity. It does *not conventionally* evince the particular speaker's sense of its power, or its emotional impact on him, if any. If the speaker has a sense of its power, this would be conveyed by the tone of his voice, his facial expression, or other physical means.

(2) Related to the foregoing are other differences between A-terms—expressive terms [1] as well as the other groups of terms. Corresponding to the scale of generality of meaning and/or the preponderance of affective or phenomenological meaning noted under (1), A-terms or A-concepts can be ranged on a vertical scale of "logical orders" or "levels." Some A-terms or A-concepts would belong to one order; others to a higher order; and so on—just as, relative to any N-term, any A-term belongs in a certain sense to a logically higher order. Thus if (a) the forms in a painting are perfectly symmetrical (N-feature), they will be, qua composition, perfectly balanced (A-feature). If the work is balanced as a composition and has a color scheme that we would describe as harmonious (A-feature), it would have a unified effect (a higher-order A-*feature*). An A-term 'A_2' belongs to a higher order than another A-term 'A_1' if the A-ascription "X is A_2" logically implies, in the sense of *presupposes*, but is not in turn implied by, "X is A_1 or B_1 or C_1 or A_1B_1 or B_1C_1 or $A_1B_1C_1$. . . ," where 'B_1', 'C_1', and so on are of the same order as 'A_1'. On the other hand, a *true* A-ascription with a variable number of terms of the form "X is A_1, B_1, C_1, and so on" will provide an *empirically sufficient* basis or ground for the true higher-order ascription "X is A_2." To illustrate, "X is unified" logically implies (presupposes) "X is balanced and/or has a harmonious color scheme and/or has a unified subject matter . . ."; while as we said above, "X is balanced, has a harmonious color scheme . . ." empirically justifies us in saying "X is probably unified."

The psychological relation between a second or higher-order A-feature "X" and a lower or first-order A-feature "Y" which may give rise to it—for A-features designated by terms belonging to dif-

ferent orders can themselves be said to belong to these orders—can be simply indicated. The total effect on qualified perceivers under optimum environmental conditions, which we call a unified total effect or a sense of unity, is an effect of the particular regional N-features of the painting, such as its color scheme and composition, acting in concert. This can be expressed more specifically by saying that the first of these two sets of features produces an effect which we call a sense of color harmony, and the second produces a sense of balance; so that the over-all effect of the painting qua composition and color scheme is one of harmony and balance, or unity. Of course, unity may result from other kinds of features of a painting such as a unified symbolic or narrative subject matter, and balance may be created by all sorts of asymmetrical compositions.

(3) There are other interesting similarities and differences between A-terms in their application to art. If we include their applications to things other than art, especially to things other than natural beauties, we discover still other similarities and differences between them (also between their "aesthetic" and "non- or extra-aesthetic" uses). Some A-terms apply to all art, others only to some kinds of art, only certain art forms; some apply more or less widely than others to nonart, leaving aside natural beauties.

'Unity', 'coherence', and their opposites have, perhaps, a greater range of application than any other A-terms, not excepting 'beauty', though the reasons given vary widely for saying that something has unity. In some of their nonaesthetic uses, 'unity' and 'unified' are not employed affectively, for example, in 'offering a united front' and 'social unity' (cf. 'social harmony').[3] I think, however, that they are partly dispositional. Actually a sentence such as "There is a lot of disunity in this country at present" is, if not wholly dispositional, at least a mixture of dispositional and categorical elements. It roughly means "Americans tend to think, feel, act, and react differently over many issues." 'Think' and 'feel' are themselves partly dispositional words in these particular uses.

Compare the uses of 'dynamic', 'delicate', and 'powerful'. 'Dynamic' applies to persons, faces, gestures, conversation and situations as well as many kinds of art (but not to a rug or a piece of jewelry as a whole);[4] 'delicate' applies to features and build or constitution as

well as to all kinds of art. The uses of 'dynamic' indicate what I think is a general feature of A-terms, namely, that there are varying degrees of similarity between the features we designate by a given A-term 'A₁' in its aesthetic applications and in its various nonaesthetic applications.[5] The delicacy of delicate features (small and regular) is more akin to that of, say, a delicate vase or composition than a delicate constitution is to either. But a person with a delicate constitution may be physically delicate or fragile-*looking* as a whole; and this involves a resemblance to delicate paintings and especially (with regard to the element of fragility) to delicate vases. On the other hand, the notion of fragility does not apply to delicate features or to persons with delicate features, except, for example, in a fanciful way or in a figurative sense of 'fragile'.

Thus there appear to be (what is probably true of many A-terms) various crisscrossing resemblances between these different uses of 'delicate'. (Again, if a woman is petite, she *may* look fragile; and she *may* have regular features too!) But the use of 'delicacy' in 'delicate features' or 'delicate constitution' is different from its use in 'delicate poem'. Poems cannot literally look delicate;[6] they are not said to be "delicate-sounding" or "not delicate-sounding" either. Even here, specifically, the only thing to which, I think, we may ordinarily apply the epithet 'delicate' is "feeling," as in "There is a great deal of delicacy of feeling in Edwin Arlington Robinson's 'Sheaves'." 'Delicate' applies to vases, paintings, and sculptures as a whole, to certain aspects of poems (but we do say "Edwin Arlington Robinson wrote delicate poetry"). When we speak of delicacy with respect to music, I think we usually refer to "feeling." We say "Mendelssohn often writes with great delicacy of feeling," and "the Overture to *Midsummer Night's Dream* is full of delicate feeling." Similarly we speak of delicacy in relation to the music of Debussy, having in mind the delicacy of feeling that we find in his melodies and harmonies. I am inclined to think that we also sometimes speak of 'delicate melodies', 'delicate themes', and even 'delicate music'. In applying these terms to a theme or melody, or a work of music as a whole, we *imply* that it is full of delicacy of feeling. Further, poetry and music that are full of delicacy of feeling produce an effect in sensitive and trained persons that is at least similar to the effect produced on them

by delicate vases, paintings, sculptures, works of architecture; some fountains, arches, bas-reliefs; certain kinds of monuments, illuminated manuscripts, and miniatures. Indeed, delicate vases, paintings, and so on, just like delicate poetry and music, are vases, paintings, and so on that are full of delicate feeling. Thus, the effect of any work of art that is said to be "delicate," under optimum conditions, is at least of the same kind, while the N-features which make the work delicate vary from one art to another in addition to the variability of the specific N-features of different delicate paintings, or different delicate sculptures, which make the works delicate.

'Delicate' *means* the same in regard to all works of art. This does not of course mean that the N-features or combinations of N-features which look (are) delicate must be, or actually are, the same in every case. In actual fact, what makes two paintings, two poems, and so forth (even two paintings or poems with very similar N-features) delicate is never exactly the same. For no two paintings (originals) or two poems have exactly the same N-features and/or organization of N-features; yet we clearly speak of all sorts of paintings and poems as delicate.

Some of the epithets we use to describe works or aspects of works of art we call delicate are 'light', 'airy', 'floating', 'soaring', and 'ethereal' (cf. how we describe Moorish architecture); we would not necessarily apply all of them to every kind of work we call delicate. For example, 'soaring' and (usually) 'airy' would not appropriately characterize a delicate vase as a whole, though in some instances it is quite appropriate to, for example, the designs on a delicate vase, and similarly, *mutatis mutandis*, with paintings. There is a use of 'painting' in which a painting as a whole cannot be soaring or airy or floating, and another use of it—where it refers specifically to the painted designs, colors, and so on—in which it certainly can be so.

The epithets 'light', 'airy', 'floating', 'soaring', and 'ethereal' are withheld if we describe a work or some aspect of it as powerful, although 'delicate' and 'powerful' are not logical opposites (contrast 'delicate' and 'clumsy' or 'crude'; also 'heavy'), they seem generally to exclude each other in actual fact. The delicate and the feminine tend to go together, and power tends to go with masculine attributes; however, "X is delicate but powerful" is not self-contradictory, if by

"delicacy" we have in mind delicacy of composition or conception coupled with a powerful impact. At the same time, delicacy of colors in visual objects is opposed to garishness and to flamboyance.

Just as 'delicate' goes with 'airy' or 'light' (and 'exquisite'), 'powerful' goes with, forms part of, a cluster of A-terms which includes 'dynamic', 'alive', and 'vivacious'. The qualities to which these last three terms refer can also coexist with delicacy; the A-terms in question can even be predicated on the same N-features or configurations as 'delicate'. A face can be both delicate and vivacious, but delicacy is much more naturally coupled with languor, which is opposed to vivaciousness and to dynamism.

The range of application of 'beauty', 'beautiful', and their opposites, like the range of application of all, or all other A-terms, is restricted to certain kinds of things or qualities, though we do apply them to both art and nonart. They are, like A-terms in groups A, C, and D, specialized grading labels. Indeed, they have been historically the most popular grading labels of art in use. Significantly, 'beauty' has been traditionally regarded not so much as a grading label but as the defining feature of art and so-called natural beauties. (Cf. Morris Weitz on "honorific definitions.") There is hardly any kind of object under the sun to which we could not ordinarily apply 'beauty', 'beautiful', or their opposites, but we do not seem to apply them, in their *aesthetic* uses, to at least as many kinds of situations and states of affairs (the hustle and bustle at a supermarket on a Saturday morning, the tieups on the freeways of a large city during the rush hours, or a state of war between two countries). Likewise they are not applied to some kinds of events, happenings, or occurrences. We do apply them widely to art, but even here there are exceptions. Novels, plays, and short stories as a whole are not said to be beautiful or not beautiful (or ugly), in the present, aesthetic use of these words. As in the case of all kinds of art (to which the notions of beauty and ugliness appear to apply), these words are applied to style or manner of composition (or execution), though not to the story (plot), the characterization, or the dialogue (save its style) of a work of fiction. For example, the phrase "beautiful story (plot, or characters)" has a different meaning from the one we are concerned with here.

Further, these words are not applied even to all *good* art. As J. O. Urmson points out, "we should hesitate to call many things for which we have a great aesthetic admiration 'beautiful,' . . . 'beautiful' is a relatively specialized word of aesthetic appraisal." [7] This point is important, since it dramatizes the fact that in regarding beauty as the alleged necessary and sufficient condition (feature) of all art and/or all good art, many traditional aestheticians really broaden, and thereby modify, the ordinary meaning or uses of 'beauty' and 'beautiful' (with a corresponding change in the uses of their opposites). By broadening their applications in this way, they rob them of whatever usefulness they have by eliminating the criteria features of beauty in the word's ordinary employment. For it is the existence of these criteria features which, though far from clear or precise or agreed upon, make the applications fairly informative and so moderately useful in everyday discourse. In other words, by broadening their applications so drastically in this way the aestheticians in question empty them of a good deal of their everyday meaning, making them quite vague. To say that something [8] is beautiful becomes simply another way of saying (a) that it is a work of art in the descriptive use of 'work of art', or (b) that it is a work of art in the evaluative use of the phrase—that it is good art. Part of its vagueness and the confusion engendered by it in its traditional philosophical employment is also due to the way in which its meaning, hence its application, has tended to oscillate between (a) and (b). The usefulness of 'beauty' in its ordinary employment [9] is due to its application to certain kinds of art, and certain kinds of natural objects and so forth, *but not others*, or, *a fortiori*, to certain kinds of A-features (and so N-features) but not others. Thus we ordinarily speak of the beauty of many of Raphael's paintings and many of Mozart's concertos, symphonies, sonatas, and so on; but we do not, I think, commonly speak of the beauty of many contemporary paintings, sculptures, poems, or works of music, especially those of the avant-garde.

Like all (other) A-terms, 'beautiful' does not refer to one particular N-feature or combination of N-features, but to an A-feature (or to a feature which resembles A-features in important ways) for which different sets and combinations of N-features are responsible. Since it is an affective word, subjectivists such as George Santayana are

partly right about its uses. Certain N-configurations or gestalts, which we say make the work or thing in question beautiful, possess the power to produce a certain kind of pleasure well described by Santayana in his aesthetic writings. (Although the pleasure of perceiving a beautiful object is not a bodily pleasure, such an object does sometimes have a physical effect too, giving us goose pimples or making a shiver run down our spine. Again, sometimes the beauty is so great, so exquisite that it is positively painful, tightening the throat and making tears well up in our eyes.) However, subjectivists err in ignoring or minimizing its phenomenological character, just as a pure objectivist would err in ignoring its affective character.

A further point of interest here is that 'beauty' applies mainly to the sensuous aspects and so the sensuous features of things, and, in this respect, is similar to (other) sensuous A-features and different from primarily or wholly nonsensuous A-features. Also, beauty is definitely a gestalt feature, like many (other) A-terms, but unlike certain others.

The meaning of 'beauty' and 'beautiful', like the meaning of any (other) A-term, and the meaning of 'good', 'bad', or 'poor', is constant in all its *aesthetic* applications, whether it is applied to a work of art, to some other kind of artifact or activity, or to a natural object or phenomenon; and whether it is applied to a painting, a work of music, a poem, the sound or color patterns of a composition, the imagery or ideas in a poem, the style of a novel, or anything else. The meaning of these words does not vary in any sense or way. A *fortiori*, the evaluative uses or element of meaning of these words is constant in all their aesthetic applications. (Indeed, the *positive* grading role of these words is invariant in any and all their applications, even when they are applied with a different meaning from their aesthetic sense or meaning.) The criteria of beauty, on the other hand, are various and variable. Therefore they do not logically determine (fix) or even affect the meaning of these words. (Contrast Helen Knight on 'good' in "The Use of 'Good' in Aesthetic Judgments.")[10]

An important question which arises at this point is How do we succeed, when we do succeed, in distinguishing beauty from the various specific or relatively specific pleasurable A-qualities such as delicacy, power, and exquisiteness? An essential part of the answer, I

believe, lies in the fact that 'beauty' is a higher-order grading label, relative to the (other) A-terms. In this respect, it is like 'good', which is also a higher-order grading label relative to other, specialized, grading labels, including 'beautiful' itself, except that 'beauty' is partly "descriptive" while 'good' is wholly evaluative. Thus, the latter is not and cannot possibly be an A-term, for all A-terms are partly or wholly "descriptive," though, of course, not all descriptive-cum-evaluative terms are A-terms. Such specialized grading labels as 'cowardly', 'brave', 'virtuous', 'miserly', 'temperate', 'kind', 'considerate', 'loving', and 'compassionate', many of which are names of virtues or vices, are inapplicable to works of art or to natural beauties, and so are not A-terms.

I said that 'good', like 'beautiful', is a higher-order grading label. I should now add that it is a higher-order grading label relative to 'beautiful' itself. Thus "X" is a beautiful poem" *entails* "X is a good poem" (or at least "X is a good poem as far as its beauty is concerned"); beauty is among those (A-) features which make or help make a work good or are partly or wholly responsible for its goodness. "X is a good poem" *implies* (in a sense different from "entails") "X is a beautiful poem *or* X has such and such other kinds of A-features (which we would not call beauty but are nonetheless other good-making features)."

Now 'beauty' is, or is like, an umbrella term, which covers a variable number of positive A-terms of lower order(s), and so collectively but only implicitly refers to the A-features (consequently, the N-features responsible for them) to which these A-terms individually refer. What we call beauty is possessed by something by virtue of its possession of a variable number of certain less general A-features. Hence, 'beauty' also collects or collectively refers to the over-all pleasurable effects of these various A-features—or the combinations of N-features responsible for them—on qualified perceivers. 'Beauty' collects the over-all pleasurable effects which delicacy, grace, harmony and unity, tenderness, or a large number of other positively evaluative A-terms have on qualified perceivers. 'Beauty' implicitly refers to all of these effects in concert. Let us note that "X is enjoyable" implies, in the sense of "presupposes," "X is powerful, dynamic, vivacious, beautiful and/or. . . ." Thus the (open) set of positively evaluative

A-terms, such as delicacy and power, "define" the enjoyment of a work of art in the sense that they make a work enjoyable or good. They give us the specific or relatively specific reasons, or the criteria, for a work's being enjoyable or good just as N-ascriptions constitute reasons for a work's being delicate, beautiful, and so forth. But "X is enjoyable" is not synonymous with, does not state, "X is delicate and/or powerful and/or. . . ."

I have talked a little about the relation of 'beautiful' to some lower-order A-terms, as well as about the relation of the word to one higher-order general grading label, namely, 'good'. There is at least one A-term, namely, 'haunting', which is even more general in application than 'beauty' or is of a relatively higher order. Thus we have such statements as (a) "Such and such N-features (probably) make a melody delicate, graceful (with long, flowing lines), exquisite, and so forth"; (b) "A melody which is delicate, graceful, exquisite, and so forth is a beautiful melody";[11] and (c) "A very beautiful melody is haunting, is hauntingly beautiful." 'Haunting' is a positive [12] evaluative and affective A-term too; since to say "X is haunting" is to say (roughly) "X leaves a trace in the memory," "X makes a strong impression," hence "X continues to move us" and "X has a lingering effect." Sometimes it roughly means, or implies, "X continues to move us and stimulate our imagination or our intellect after the work is no longer heard, seen, or read."

(4) All evaluative A-terms have one common feature and one feature which varies from one term to another. The former is (a) their positive or negative grading function, in terms of the effect, impression, or whatever of the A-features they refer to, and which they are conventionally intended to have on qualified perceivers under optimum environmental conditions; hence correlatively (b) the fact that the N-features of the work which has the particular A-features are psychologically responsible for these effects. The element of difference in their uses is that they have different ("descriptive") meanings. Consequently, they necessarily refer to different phenomenological, gestalt, A-features in the works to which they apply. A logical consequence of this is that the N-features or combinations of N-features which are contingently responsible for these phenomenological A-features are themselves different in the case of

different A-terms, though they may, and indeed do, overlap in a greater or lesser degree. This happens, for instance, with those A-terms which overlap in ("descriptive") meaning. 'Delicate', 'graceful', and 'exquisite' are good examples. The same is true of A-terms belonging to a particular order of generality and A-terms of a higher order of generality, which collect that which the former severally refer to, such as 'beautiful' on the one hand and 'delicate', 'exquisite', 'languid', 'harmonious', 'tender', and 'unified' on the other. However, *what* particular N-features or combinations of N-features are responsible for a particular A-feature, and which of them overlap in the case of different A-features, is, as we saw before, a factual matter.

The nature of the subsets of N-features (or combinations of N-features), which are responsible for the effect which the qualified perceiver experiences or the impression he gets under optimum environmental conditions, causally determines the character of the effect as a psychological experience. Indeed, and this is important, there is no way of identifying and describing the latter except with reference to the subsets of N-features which give rise to them. In other words, they are ordinarily described and distinguished as "a sense of power," [13] "a sense of rhythm," "a sense of unity," "the effect which a vivacious work has," and the like. Thus they are identified and distinguished in terms of publicly observable N-features (the A-making features),[14] not in terms of their private subjective "feel," which, but for the preceding, would themselves be indescribable, though qualitatively different as psychological effects. The overwhelming effect which the power and majesty of Michelangelo's *Moses* has on discriminating spectators is surely different from the effect which the grace and airy lightness of a Mozart minuet has on listeners. The latter is different from the effect produced by the exquisite and haunting beauty of the First Movement of Mozart's Symphony no. 40 in G-minor, and so on.

(5) In Chapter 5 I sketched the relationship, as I saw it, of A-features to N-features, including the way in which A-terms or concepts can acquire in the course of time certain logically necessary conditions, how certain N-features, as A-making features, may get built into a particular A-concept. The following describes in a more comprehensive and sophisticated way the possible vicissitudes of

evaluative A-terms and concepts vis-à-vis the N-features responsible for them. The same general patterns are discernible in the case of metaphysical, epistemological, ethical, and other types of concepts. Ideally, a work of art X which gives the qualified perceiver a certain sense, impression, or feeling S, would be described as "A_1" (or as having "A_1") and would be positively or negatively graded for being A_1. At this point, no single N-feature or combination of N-features is (positively) logically necessary and sufficient for something being A_1. (Hence in the sense that *no* particular N-feature(s) or combination(s) of N-features are *specified in the meaning* of 'A_1' as logically necessary-and-sufficient for the use of 'A_1', 'A_1' can be regarded as not *logically* governed by criteria of use.)[15] This is even true of A-terms with restricted meaning such as 'balanced'. For example, "symmetrical" is not part of, nor is entailed by, the meaning of 'balanced'.

On the other hand certain N-features—or, more commonly, particular combinations or types of combinations of N-features—may become generally associated with 'A_1' in a given place or time. This may happen because (a) experience shows that works which have these particular features produce the sort of effect or impact which the critics, artists, or aestheticians in that place or time generally associate with 'A_1'. Or (b) the foregoing may happen for something like the opposite reason. Certain preconceptions or views regarding the nature of man, art, or reality as a whole may lead people to single out certain N-features or combinations of N-features as A_1-making features. The positive or negative grading of these N-features or combinations of features then becomes a logical consequence of the respective positive or negative grading of the effect, impression, mood, and the like which a work is thought capable of producing or evoking by virtue of its possession of these N-features. The latter provide the criterion or standard of evaluation. Whether (a) or (b) above actually takes place, either of two things may happen next.

The N-features or combinations of features "associated" with the applications of 'A_1' may (c) become for the duration part of concept A_1 as generally employed by critics, aestheticians, or artists, sometimes even by the educated general public, in that place and time. This defines or helps define the meaning of 'A_1' in a way in which it was not defined before; the built-in features are now treated as logic-

ally necessary (in some cases, also as logically sufficient) conditions, converting concept A_1 into a very common type of concept. This has the advantage of making more definite the kinds of effects it implies,[16] but obviously at the expense of restricting in principle the kinds of objects which can be properly said to have these effects. As a consequence, the effects which works possessing these or similar N-features have, come to be called "a sense of balance," "a unified effect," and so on. These concepts are determined by the concepts of those features which are psychologically responsible for the effects they refer to, rather than the converse, as in (a). This should be distinguished from the fact that the effects, impressions, moods, and so on which a work or anything else produces under standard conditions are describable and so logically distinguishable only as effects and so on of works or things having such and such publicly observable features.

On the other hand the N-features in question may (d) fail to establish themselves as logically necessary (or as necessary-and-sufficient) conditions, or even as contingently sufficient conditions. This may be due to a general division of aesthetic or philosophical opinion, in the case of (b) above, or to the inescapable qualitative differences in the effects, on different critics or aestheticians, of works possessing the same N-features. In this type of case, disagreements regarding who is or is not a *qualified judge* have the same effect. Indeed, disagreements regarding these two basic matters reinforce each other and usually lead to greater divergence of opinion about a work's effects than is the case when agreement is reached as to who is qualified, or best qualified, to judge the character of these effects.

Whether (c) or (d) happens, the long-range net result is the same. For a new generation or age usually succeeds in dislodging the particular N-features and so on as logical or contingent criteria features of A_1, replacing them by other N-features, or combinations of N-features, in one or another of the ways I sketched above. This pattern may either proceed indefinitely, or end after a long or short time.

A further complicating factor is that the evolution of A_1 may follow different patterns in its application to different arts. Or looking

at the matter differently, we can say that we have distinct concepts, A_1', A_1'', A_1''', and so forth relating to different arts, or even to different genres of the same art, which have evolved differently in the history of Western art, the concepts of unity that we meet in the history of Western art being excellent illustrations.

I have not said anything about a further possible complication in the evolution of A-concepts: a situation where certain N-features or combinations of N-features are neither definitely excluded from nor definitely included in a particular A-concept A_1.

(6) We must now look a little more closely at the uses of 'sense of', 'impression of', 'effect', 'mood', and 'atmosphere', which are the main expressions we employ in describing the psychological "action" of works of art relative to the perceiver.

(a) The words 'sense' and 'impression', as well as 'effect', have various though not unrelated uses in aesthetic and nonaesthetic situations. Limiting ourselves to the former type of situation, we should note, first, that they are ordinarily applied selectively rather than interchangeably or indiscriminately in relation to different A-terms or the A-features they name. The same is true of 'mood' and 'atmosphere', except that they appear to have the same meaning or sense in their nonaesthetic and aesthetic employments. To illustrate this difference in the uses of our five expressions, note how we speak of deriving a sense of power from a work X or having a sense of X's power; of X's being given a sense of dynamism, delicacy, vivaciousness, or unity; or having a sense of harmony, tranquillity (also "a sense of its tranquillity"), peace, serenity, sublimity, or majesty. We speak of the work's giving an impression of great power, control (we also speak of our having or not having a sense of great control, but not a sense of control), a sense of lightness, and so on. We speak of a work's making a deep impression on us, but this is a more general use of 'impression' than the foregoing. A work may leave a deep impression by virtue of its possession of any number of different positive, good-making A-features; 'leaves a deep impression' is more or less synonymous with 'has a strong effect', whereas 'gives an impression of great power, control, and so forth' is clearly more specific or definite in its employment. A work which gives someone an impression

of great power will probably make a deep impression on him, but the converse is clearly untrue.

Again, we speak of a work's creating a romantic (but not lyric) atmosphere, or an atmosphere of gloom; we do not speak of its creating a gloomy mood or a mood of gloom, though we speak of its putting the listener, reader, or spectator in a romantic (but not lyric) mood, and so on with the other A-terms.

It is noteworthy that 'sense of' and even 'impression of' do not, in their present uses, carry the implication or connotation of superficiality and unreliability which they carry in some of their nonaesthetic uses, as, for example, when applied to our initial reactions to strangers or new places (in such sentences as "I had the impression *that* . . ."). One reason is that "impression" is not restricted to initial reactions in its applications to works of art and natural beauties. An impression of great power or great control may wear thin or change, but not because, in some sense, it may turn out to have been mistaken—as an impression can in relation to people and places, as in "He gave me a false impression (or the false impression that . . .)." The impression may wear thin or change if and when the perceiver becomes desensitized to the work's charms by habituation or familiarity. In other words, if a work does give a person P an impression of X or Y or Z, it must necessarily ("objectively") possess A-feature X or Y or Z. It would be self-contradictory to say "W gave P an impression of X at time t_1 but it was not really (an) X." [17] Thus 'an impression of delicacy, power, and so forth' does not mean "an appearance of delicacy, power, and so forth" in the sense in which 'appearance' allows for 'mere appearance' as contradistinguished from 'is really such and such'. The same is true, *mutatis mutandis*, of 'sense of' in its aesthetic applications. A person may *fail* to get a sense or impression of a work's power, unity, dynamism, and so on because of the absence of the proper (optimum) perceptual conditions, or because of his lack of training or sensitivity. If he does get a sense or impression of its power, it cannot be a mistaken impression. Failure to get a sense or impression of a work's particular A-features does not mean, entail, or imply getting a sense or impression of something else, that is, of some objectively nonexistent

and therefore illusory A-features. It means, rather, failure to apprehend or recognize any A-features in the particular situation.

The foregoing constitutes one important difference between the aesthetic uses of 'sense' and 'impression' on the one hand and the uses of 'effect' on the other hand. If a work has a certain effect on a person P under conditions C, the cause of this effect is not necessarily attributable to the work, or only to the work, but would be so provided C are optimum conditions, including P's being a sensitive and trained perceiver. That is, "Effect E of a work W on P under optimum conditions C is the effect which W has the *capacity* to produce under optimum conditions by virtue of its own A-features (and so the N-features which are responsible for them)," is necessarily true or analytic. But "W has effect E on P under conditions C" is contingently either true or false depending on whether conditions C are optimum or nonoptimum.

The above remarks regarding 'effect' apply to 'mood' and 'atmosphere'. For the mood or atmosphere created by a particular work to be *necessarily* attributable to the work—rather than to the perceiver's state of mind and emotional state, physical condition, and the like, or to environmental factors such as the work's physical setting—the prevailing conditions must be optimum.

The same basic difference we have noted arises with respect to the uses of certain phenomenological "correlates" of these expressions; namely, 'looks A_1' and 'sounds B_1'. A passage of music, or the work as a whole, may sound raucous rather than dynamic or passionate to listener P under listening conditions C, but it cannot be validly inferred from this that the passage or work is indeed raucous unless conditions C are optimum and P is a qualified listener. Thus from "X sounds raucous" we cannot invariably infer "X is raucous"; the same is true with regard to "X looks delicate" and "X is delicate." There is no contradiction in saying "X looks (looked) delicate to *me* but I may be wrong"—not meaning "but it may not be *looking* delicate to me," which would be self-contradictory, but "I may be wrong that it is delicate." We say "The other day when I first heard Tchaikovsky's Sixth Symphony it sounded very passionate to me, but now it sounds just plain sentimental. And I think it is sentimental." This is perfectly self-consistent.

'Sense' and 'impression' are closely related, while 'effect' is (also 'mood' and 'atmosphere' are) somewhat separate. The phrase 'effect of a work' does not qualify in the way 'sense' and 'impression' do, that is, 'of a work's power, delicacy, control, unity', and so on are not used with 'effect'. We do not speak of "an effect of a work's power" but of a work's effect on us. Similarly, we speak of a work's delicacy, not of "an effect of its delicacy," and so forth. 'Effect' itself is qualified by 'strong', 'weak', 'lasting', and 'fleeting', marking the strength or intensity of an effect or its duration. Qualifications not totally unlike these are also utilized in relation to 'power', 'control', 'unity', and 'harmony'. We speak of 'a sense of great, tremendous, perfect control', 'a sense of great, tremendous, overwhelming power', 'an impression of a work's perfect, divine, unearthly harmony', and so on. 'Effective' and 'ineffective' are A-terms having an obvious and close relation to 'effect'.

A sense of power, unity, harmony, or an impression of a work's power, dynamism, control, and so forth is not a *feeling* in any usual sense of 'feeling'; whereas the effect of a work on a person may (and usually does) consist in or include an emotional effect, the arousing of some feeling(s), or some emotion(s). Actually, 'effect' covers the stimulation of thought and imagination as well as the feelings and emotions; while 'sense' and 'impression' cover none of these things. 'Mood' and 'atmosphere', on the other hand, are clearly—to my mind primarily—emotional words, though a mood, certainly an atmosphere, may include imaginative and, to some extent, intellectual elements.

II

(1)(a) Writers on the subject of "expressive" words often fail to note that these terms apply only to some arts or kinds of art, that not all works of art are ordinarily said to be gay or cheerful, sad or melancholy. Suffice it to note that whereas *all* expressive words are applied to works of literature or music of any kind, we do not seem to apply all—or to apply all without certain qualifications—to paint-

ing and sculpture. We speak of a cheerful, gay, melancholy, serene, or gloomy painting or sculpture, but I do not think we speak of a sad painting or sculpture, except in the sense of a painting or sculpture with a sad subject matter such as a crucifixion or a death. Even with regard to subject matter, 'sad' appears to be out of place in a description of landscapes, seascapes, and still lifes. Further, we do not speak of sad, gloomy, or melancholy vases, and when we speak of a cheerful vase—if we do so at all—we have in mind a vase which has bright and cheerful colors, or a cheerful design. A similar situation obtains with regard to works of architecture. Some buildings such as churches, cathedrals, castles, fortresses, or old mansions are said to be gloomy; some buildings, fountains, and other monuments may be said to be cheerful-looking. In the case of buildings the epithets are applied to both their exteriors and interiors, but I do not think we speak of a sad or even sad-looking building, monument, fountain, and the like; we do perhaps speak of a melancholy looking structure or edifice. 'Gay' and even 'gay-looking' are also applied sparingly and selectively to works of architecture, but let us remember that all sorts of other A-terms, which may or may not also be applicable to other kinds of art, are applied to works of architecture. For example, 'towering' is applied to some sculptures or even paintings, but 'towering' is clearly inapplicable, except figuratively, to nonspatial art.

Some expressive words apply to certain kinds of features, elements, or aspects of works of art—those kinds of works, as a whole, to which they apply to begin with. We speak of the sad, depressing, or melancholy story of some novels, short stories, or plays. We do, perhaps, talk of the cheerful or gay manner in which an author writes, yet do not, I think, speak of a gay or cheerful, sad or melancholy, style. That is, we do not speak of sad or melancholy dialogue, except perhaps in the sense of dialogue about something sad or melancholy; we perhaps speak of cheerful dialogue with reference to what is talked about. Even this last statement seems rather strained. No expressive words appear to be normally applied to the characterization, as opposed to the particular characters, in a work of fiction.

(b) A work of art—any kind of art—need not be either sad or gay, melancholy or serene, even though it will always have some

character or individuality, like an individual person.[18] Character, though it includes expressive quality in all the applications of 'character', is a broader notion. O. K. Bouwsma therefore restricts the usual meaning of 'character' in "The Expression Theory of Art," in identifying character with expressive quality. Character includes or depends on such other things as style, manner of treatment as distinct from style, and subject matter. At the same time, the absence of any definite or identifiable expressive quality in a particular work does not mean that it is ineffective, lifeless, or insipid, for a work can be greatly effective without being necessarily gay, cheerful, melancholy, and the like.

(c) The concepts conveyed by expressive words are open-textured.

(d) The concepts conveyed by expressive words are purely descriptive, with the exception of 'depressing' and 'gloomy' (when the latter is used as an A-term and not as an N-term).

(2) Expressive terms, like A-terms in groups A, C, and D, do not name or refer to any specific N-features or N-configurations. A sense of sadness can be conveyed by a work, or the sadness which the work may evoke in the listener [19] can be brought about in many different ways by virtue of many different N-features or configurations.[20] This also means, as Bouwsma emphasizes, that sadness is not some specific or isolable feature of a sad work, though his unhappy analogy to the redness of an apple gives the impression that he thinks otherwise. Yet Bouwsma also maintains that "Sad music has some of the characteristics of people who are sad. It will be slow, not tripping: it will be low, not tinkling. People who are sad move more slowly, and when they speak, they speak softly and low. Associations of this sort may, of course, be multiplied indefinitely." [21] That is, Bouwsma thinks in effect—since he does not use this terminology or these concepts—that these N-features or configurations are actually responsible for the work's sadness (A-feature). In so thinking he actually restricts, in the face of contrary empirical facts, the range of N-features or configurations which make a work sad. Thus though some sad music is low and slow, some is loud and fast; while some sad music is in a minor key, some is in a major key, and so on. Each of these features, *in isolation*, is perfectly compatible with both sadness and gaiety or cheerfulness—and with both sadness and melancholy. Many

more such features are relevant in music such as melody, rhythm, harmony, and choice of instrument(s), as well as dynamics and volume. What makes a work of music sad or gay, cheerful or melancholy, is the joint presence, and especially the joint presence in certain combinations, of these or other kinds of N-features. The number of such features or combinations present is also important. The test of whether the resulting work is sad, gay, and so forth is how it sounds to the sensitive or trained perceiver and its effect on him. These remarks apply equally, *mutatis mutandis*, to the other kinds of art to which some, or all, of these epithets are normally applied.

We must note that the recognition of the *general* expressive qualities of some works of music, a literary work, or a representational painting or sculpture often require no special sensitivity or training. But the discrimination of the subtler nuances or shades of expressive quality—of sad as opposed to melancholy, reflective as opposed to brooding or moody music, serious as opposed to somber poetry, cheerful as opposed to gay music—does require considerable sensitivity and experience in listening, familiarity with music, and richness of inner personal experience. The same is true of the other arts. On the other hand, sensitivity and training are requisite for the recognition of the *general* expressive quality of nonobjective painting and sculpture and the more complex or profound works of absolute music. The nature of a work's subject matter and its treatment play an important role in enabling the perceiver to determine the work's expressive quality. These "clues" are absent from nonobjective art and absolute music and so make it harder for the perceiver to determine their expressive character and whether his emotional or imaginative reactions to the work, if any, are appropriate to it.

The difficulty is compounded with complex or profound works of absolute music or nonobjective art. In these instances, it is usually far easier to determine what the work's character is *not* than to determine what it is. For example, we have no difficulty in judging that Beethoven's Fourteenth Quartet cannot be properly described as gay or cheerful. It is much more difficult to say whether it is sad or melancholy, and to what extent—and which phrases, melodies, or movements in it are brooding, say, or merely serious and reflective. But

even in far less complex or profound works it is often easier to exclude certain descriptions than to make adequate ones.

The upshot is that Hungerland appears to me to be mistaken, in OAAN, in holding without qualification that the recognition of expressive qualities in works of art requires no special sensitivity or training.[22] She is misled by the fact that children can detect the sadness, cheerfulness, and so forth of a person's face.[23] Actually, even with regard to this and other extra-aesthetic applications of expressive words, the situation I sketched regarding their aesthetic applications obtains. For though a child, say, can tell the difference between a definitely sad and a definitely gay face or behavior, it finds it harder to tell apart sad and melancholy faces, or cheerful and gay persons. Experience and inner maturity are required, though not training and aesthetic sensitivity, unlike some of the aesthetic applications of these expressions.

Now practically all but one or two such terms—namely, 'gloomy' when used as an A-term, and 'depressing'—are purely descriptive. But as I just said, some of their aesthetic applications require taste or aesthetic sensitivity. This shows that the question of whether a particular concept is a "taste" concept is logically distinct from and independent of the question of whether it is partly or wholly evaluative. It is possible for expressive qualities, or some other kinds of A-qualities, to require taste for their recognition even though the words that name these qualities are not evaluative. (Their nonevaluative character is possibly connected with what I believe is the fact that expressive words, with the exception of 'depressing', are not "capacity words.")

(3)(a) In order to apply any A-term to a work of art on the basis of observed similarities between its N-features or their organization and the features of certain things that are not art but which are commonly said to be delicate, garish, flamboyant, dynamic, and so forth, all we need is "judgment." We do not need sensitivity or taste; though these qualities by no means make A-terms function as N-terms. On the other hand, to apply them correctly in the light of their effect on us—in which case they would partly function as *evaluative* expressions—we need training and taste.

(b) These expressions are not absolutely necessary for describing art. The critic can use them as a general signpost for the general audience in his efforts to help them perceive the work's character as a whole. And to say that a work—especially a profound or complex work—is sad or gay, melancholy or serene is merely to begin to say what it is really like, what its character is as a work of music, a painting, or art.

(4) A fundamental difference between expressive words and A-terms in groups A, C, and D should now be noted. With regard to many of the former, those N-features which make a work or some part of it sad, gay, cheerful, or gloomy *may* infect the perceiver with sadness or gloom, or put him in a gay or cheerful mood. Their capacity to do so is a contingent fact, which is why there is no logical contradiction in saying "X is a sad poem but it does not sadden P under optimum environmental conditions," where 'P' stands for a qualified perceiver. That is, a sad work is not necessarily (analytically) saddening.[24] These A-terms, in their aesthetic uses, only signify certain phenomenological qualities of works of art. The same can be shown to be true, *mutatis mutandis*, of their extra-aesthetic applications to human beings and their behavior. These A-terms do not include in their uses the notion of a capacity to sadden, depress, put in a melancholy mood, and so on. Looked at in another way, we can identify or describe the sadness of a sad work independent of the appropriate feelings, and so forth the A-terms may be able to arouse in qualified perceivers under optimum environmental conditions. They are identifiable or recognizable directly, whether sensibly or mentally, *merely as features which resemble certain characteristics of human beings or of their behavior which, we say, make human beings or their looks, facial expressions, and so on, sad.* In this, *but only in this sense* we can apply 'sad', 'gay', and 'cheerful' to the works of art in question. We must *feel* their effect in order that we may be entitled to apply these terms to works of art *in their own right*, rather than merely by *analogy* with things that are not art. That is, we must feel their effect in order to know experientially that these N-features *make* the work sad, gay, or cheerful, or in order to experience these A-features as the sadness, cheerfulness, or melancholy *of a work of art*—as, moreover, the sadness, cheerfulness, or melancholy

of the *particular* work of art. Only on the basis of our experience can we really know what it is for a work of music, a poem, or a novel to be sad, gay, and the like. Only then can we experience the unique quality of the sadness, and so on of the work as an individual, unique thing.

The foregoing should be distinguished from the fact that the experience of a number of delicate, garish, or powerful works enables the perceiver to *recognize* the delicacy, garishness, or power of new works even when they do not affect him in any way, do not give him a sense of delicacy, power, and so forth.

The foregoing is also true, *mutatis mutandis*, of groups A, C, and D of A-terms and even other types of A-terms, including 'beautiful', 'pretty', and 'piquant'. There is a fundamental difference between expressive words and groups A, C, and D of A-terms, which is a corollary or consequence of the difference noted above; namely, that expressive words are not affective words, so that the relation between expressive features and the sense or impression they may give or the effect they may have is only a *contingent, causal relation*. The corollary in question is that we can logically identify and describe the sadness or gayness and the like of a sad or gay work as a *phenomenological* feature, without reference to the effect these features may have on qualified perceivers under optimum environmental conditions.

In contrast to this, we saw earlier that the relation between a work's being delicate, powerful, and so forth, and its having the appropriate effect under optimum conditions, is logical, not contingent. This means that we cannot *describe* the delicacy of a particular work of art, as an A-feature of (a) a work of art and (b) a particular work of art, independent of the latter and vice versa. The only other way would be to describe these features or their effects under optimum conditions by analogy with the qualties or the effects of certain "nonaesthetic objects," such as the features of a face or certain movements, which we would ordinarily call delicate, powerful, and so forth. On the other hand, the powerful or delicate effect of a work of art can only be *identified* [25]—this is different from its description—as the effect produced, under optimum conditions, by certain N-features or kinds of N-features in combination. Since the latter

are directly observable either sensibly or mentally, there is no danger of circularity in the identification of delicate or powerful effects, and so forth.

III

Let us consider some similarities and differences between A-terms, including expressive words, and dispositional words. This should further clarify the uses of expressive words.

(1) In Chapter 5 I maintained, in agreement with Sibley and Hungerland, that A-concepts are not governed by positive logically sufficient conditions. The same can be said of dispositional concepts (D-concepts). Neither of these types of concept (a) need be, or (b) can be, governed by positive logically sufficient conditions. As regards (a), the ability, capacity, tendency, or inclination to behave in certain ways can be, in principle, satisfied by things having a wide range or variety of features.[26] An object does not need to have a certain specific N-feature or a specific set or combination of such features in order to have the capacity or tendency to behave in certain ways. Further, (b) no ordinary dispositional concept *can* be governed by positive logically sufficient conditions. For one thing, a concept governed by such conditions is necessarily a closed concept, whereas a dispositional concept is necessarily open-textured. A main reason for this is that the notions of ability, inclination, capacity, and tendency themselves, as we ordinarily have them, are of necessity open.

(2) I said that the absence of positive logically sufficient conditions makes all dispositional properties open-textured. In this respect, too, they resemble A-concepts. The openness of the latter is seen if we note, for instance, the possible existence of borderline cases of delicacy vis-à-vis, say, lifelessness or anemia, or of garishness vis-à-vis flamboyance, or vivacity vis-à-vis stridency. This should not be confused with the contingent fact that the untrained or insensitive observer may fail to detect subtle differences between the works, which leads him to call them both 'delicate', say, or 'powerful', when a more discriminating person will recognize that one is, say, delicate and the other anemic.

The borderline cases relative to A-concepts may be of two general sorts. A particular work may lack some N-feature(s) whose presence —together with some of the N-features the work does have—would have been deemed sufficient by a particular observer P for the unquestioned application to it of 'delicate' as opposed to, say, 'anemic'. Or a particular work may possess certain N-features which would have made a perceiver P consider it, say, delicate, had their impact not been counterbalanced by the impact of certain contrary N-features which tended to make the work anemic or lifeless.

The open texture of A-concepts is a logical consequence (cf. dispositional concepts) of their not being governed by positive logically sufficient conditions.[27] More specifically, as capacity concepts (which are a subset of concepts not governed by logically necessary-and-sufficient conditions) they are necessarily open-textured. For it is of the nature of such concepts that the list of N-features which in a particular instance may constitute (positive) actually sufficient conditions of application, is, in Sibley's phrase, an open list. The number and combination of such features is variable. This is partly because of the particular kind(s) of ability, capacity, effect, function, use, and so on something is expected to have in order that the concepts which may apply to it are not precisely delimited. The precise delimitation of these concepts requires the tightening, if not closing, of the concepts of (a) optimum environmental conditions and (b) qualified perceiver. These concepts are themselves open-textured in our everyday aesthetic employment of them.

NOTES

1. For my reasons for excluding A-terms in group B, see Section III below.

2. Despite my unhappiness with this label, I shall use it for convenience.

3. 'Coherence' has a more restricted use, as does 'balanced'. Note the remote analogy between 'balanced judgment' and balanced composition'.

4. Whereas 'unity', 'coherence', and 'balance' apply to all kinds of art.

Note that when we apply 'dynamic' to novels, plays, and short stories, we commonly imply that they contain a lot of action; they are not static. But what is a dynamic poem? One that contains dynamic ideas and/or imagery and has a strong effect? Compare and contrast 'dynamic' here with its employment in 'dynamic painting', 'dynamic sculpture', and 'dynamic music'. Although the phenomenological characteristics referred to in the different cases may be partly or wholly different, the implication is that a dynamic work of any kind has a powerful impact on the qualified perceiver under optimum environmental conditions.

5. However, the similarity may, naturally, be greater or less with regard to different kinds of art.

6. This is not true of certain special kinds of poetry, notably concrete poetry.

7. Kennick, *op. cit.*, p. 557.

8. I have in mind here only what we would ordinarily call a painting, a poem, or a symphony—or art—in the ordinary "descriptive" (nonevaluative) use of these words. I am ignoring, for simplicity's sake, artifacts and activities which are not usually included in the class of what we call art in the present sense, as well as so-called natural beauties.

9. That is, when it is used discriminately in the way described above, by art critics and the tutored layman. I do not have in mind its application by artistically untutored laymen. These commonly use it indiscriminately, and so too generally and vaguely, though even they, I think, use it in a more restricted way than those aestheticians who employ it synonymously with 'art' or 'good art'. For instance, I believe that most laymen at present would (still) consider many of Picasso's Cubistic and post-Cubistic paintings nonbeautiful, even ugly.

10. Kennick, *op. cit.*, pp. 589 f.

11. Or "Its delicacy, grace, and so on make it (very) beautiful, give it beauty," in a different sense of 'make' than the sense in which it occurs in (a). Similarly, with 'give'.

12. At least when applied to art!

13. 'Sense of power' should be distinguished from 'powerful effect', which has a more general application. A work which gives us a sense of power, especially of great power, does (analytically speaking) have a powerful effect on qualified perceivers under optimum environmental conditions. But a powerful effect can be contingently produced by works possessing many A-features other than power.

14. This account as a whole is applicable, *mutatis mutandis*, to those nonaesthetic uses of "aesthetic terms" in which an affective element is involved.

15. Though I would regard this as an unnecessary restriction of the uses of 'criterion'. Contrast Sibley and Hungerland.

16. That is, of making concept A less open with respect to the effect or kind of effect, and so on, whose notion it includes.

17. Contrast "I had the false impression (belief) that the work was romantic (or, for example, symbolic)."

18. A person too need not be, *at a particular moment*, sad or gay, melancholy or cheerful. He also need not be either in a good or a bad mood.

19. Note that it must look or sound sad and so give the perceiver a sense of its sadness, if he is properly to apply the epithet 'sad' to it. (But see an important qualification under [4] above.) However, its eliciting or not eliciting a *feeling* of sadness from him is a *contingent* matter. Thus "X is a sad piece of music" implies (1) "X has certain (unspecified) sad-sounding qualities," and hence (2) "X sounds or will sound sad under optimum conditions."

20. Cf., *mutatis mutandis*, 'work of art', 'poem', 'symphony', and so on, as well as 'good (poor) poem, painting', and so on. See my "Art-Names and Aesthetic Judgments."

21. *Art and Philosophy*, p. 281.

22. She commits what I think is a greater error by generalizing from these A-terms to all A-terms: in our classification, to terms in groups A, C, and D.

23. *Op. cit.*, pp. 285–86. Contrast LAC, p. 53.

24. One of the few A-terms in group B that constitutes an exception is 'depressing', which is clearly affective in its conventional employment.

25. Except analogically, in the appropriate way.

26. Cf. my discussion of names of artifacts and man-devised activities in general, in "Common Names and 'Family Resemblances'." See also my "Art-Names and Aesthetic Judgments." Like A-terms, the names of artifacts and man-devised activities are "capacity words."

27. This shows that we cannot, as Morris Weitz for instance does in "The Role of Theory in Aesthetics," properly define or characterize open-textured concepts as simply concepts which lack logically necessary-and-sufficient conditions. Our entire discussion of A-concepts in this and the preceding chapter shows that "lacking logically necessary-and-sufficient conditions" is too broad to serve as a proper definiens of 'open-textured concept'.

PART II

Standard Conditions of
the Enjoyment of Art

"If I wished to see a mountain or other scenery under the most favorable auspices, I would go to it in foul weather, so as to be there when it cleared up; we are then in the most suitable mood, and nature is most fresh and inspiring. There is no serenity so fair as that which is just established in a tearful eye."

Henry David Thoreau

Chapter 7

Standard Conditions of
the Perception and Enjoyment of Art:
A General Discussion [1]

In Part I I frequently referred to what I called "standard conditions of aesthetic enjoyment," [2] in relation to our discussion of the layman's and the expert's employment of art names. Since the notion of standard conditions (hereafter referred to as E-conditions) involved in these applications is of central importance for an adequate understanding of art, it deserves a separate and detailed treatment. The aim of the present chapter is to start off this discussion by a general analysis of this concept. Since as we shall see there are two general types of E-condition, "minimal" and "optimum" (hereafter referred to as M-conditions and O-conditions, respectively), our discussion will embrace both. The two chapters that follow will deal with the specific features of two of the most important types of O-conditions, namely, psychological and epistemic conditions, some or all of which are explicitly or implicitly referred to by laymen, and especially critics, in aesthetic discourse in general and aesthetic judgment in particular.

Let us begin with a general characterization of M- and O-conditions. The former are those physical, physiological, psychological and epistemic factors that are, in the first place, absolutely necessary for people's enjoyment of a work of art insofar as, or in the sense that, they are necessary for its apprehension as a sensible object—or for the apprehension of that part of it which is sensible.

Light waves of a certain range of frequency are necessary for the perception of a painting; functioning ears are necessary for the perception of a work of music. Hence these factors are necessary for the enjoyment of paintings or music, respectively.

O-conditions, like M-conditions, consist of various physical, physiological, psychological, or epistemic factors. However, a work of art can be apprehended and even enjoyed (though neither can be done fully), in the absence of these qualities. They are, however, necessary for the complete apprehension of a work's qualities, and so for its full enjoyment as art. Let me add that some conditions, generically speaking, may be both minimal and optimum conditions, depending on the amount, degree, or intensity in which they happen to be present. Light and sound are two simple examples.

The presence or absence of standard conditions, especially optimum conditions, plays an important role as a partial determinant of the quality and intensity of our apprehension and enjoyment of any given work of art; hence it also helps to shape our evaluation of a work to the extent to which our aesthetic judgments may rest on the quality and intensity of our enjoyment of the particular work. A clear understanding and mapping of these conditions with respect to the different art forms, the different genres of the same art form, and so on is therefore quite important for responsible practical criticism. On the theoretical plane, in aesthetics, an understanding and careful mapping of the *concept* of standard conditions, and particularly the concept of O-conditions, is essential for a proper understanding of the nature of a work of art, its apprehension and enjoyment, and the criteria of aesthetic valuation. The absence, to my best knowledge, of systematic and thorough investigations of the concept of standard conditions in general and the concepts of M- and O-conditions in particular by aestheticians and others interested in art makes our task especially urgent.

The mapping of the actual minimal conditions relative to the different art forms, such as painting, music, or sculpture, raises no serious difficulties. We all know these conditions in a general way; the exact degrees, intensities, or amounts in which they are, or may be, necessary conditions of our apprehension of works of art can be accurately determined by appeal to our present scientific knowl-

edge of the mechanism of sense perception, thinking, feeling, and imagination. What these conditions actually are, and in what degrees or intensities (or ranges of intensities) they are necessary for the apprehension of works of art, we are not here concerned to discover. We might mention the obvious fact that, generically speaking, the same minimal conditions of *perception* obtain with respect to all visual works of art; the same conditions of perception, with respect to all auditory works of art.

The situation is significantly different and quite complicated in the case of the optimum conditions of aesthetic enjoyment. As a consequence, there is far less agreement among laymen and art experts as to what conditions are optimum. For one thing, unlike most or all minimal conditions, optimum conditions vary to a greater or lesser extent, either qualitatively or quantitatively, or both, with different art forms, different genres of the same form, and so on. Some of them even vary to some extent with individual works of art. For instance, they vary in subtle ways with (the kind of) the work's subject matter, general tone, and the like, with, for example, whether the work is "sad" or "gay," "serious" or "light." The amount or the intensity of the conditions present is also important; for many if not all optimum conditions are optimum only within certain broadly defined qualitative or quantitative limits. Their variety, both qualitatively and quantitatively speaking, is not surprising in view of the fact that many of the conditions are psychological factors. I mean factors which have reference to the contemplator's temperament, state of mind or mood, the nature and extensiveness of his general and artistic knowledge, and the nature of his beliefs; hence, they are also factors which have a direct or indirect reference to the society and the age in which he lives, and so on. Even physical and physiological optimum conditions are often quite complex, qualitatively and quantitatively, as seen, for example, if one considers the many physical factors, visual, acoustic, or both, involved in the designing and operation of a concert hall or art gallery. One might recall, in this connection, the recent controversy which raged around the use of the Guggenheim Art Center in New York, designed by Frank Lloyd Wright, as an art gallery.

The situation is still more complicated with respect to plays, ballets (not merely because they involve both visual and auditory conditions of perception), and works of music, particularly operas, since these works must be performed in order that they may be heard or seen, therefore fully appreciated as plays, ballets, or works of music. The minimal aim of a performance is to make the work performed be *heard* or *seen* by an audience; its maximal and more characteristically aesthetic aim is to make the work heard or seen to best advantage, to create optimum conditions for the work's enjoyment as art. Accordingly, a performance will be a good or a poor performance depending on the degree in which it creates these conditions. The complex and variable factors involved in the execution and "interpretation" of ballets, works of music, and all but "closet" plays (plays not intended for performance) further complicate the problem of determing their optimum conditions. Note, for instance, the many physical and psychological factors that have to be carefully considered in the production of an opera or even the performance of a symphony.

The *depth* and *intensity* of an experience of a given work should be carefully distinguished from the *completeness* or *fullness* with which the work is enjoyed on a given occasion. A work may be fully or completely enjoyed—as fully or completely as it is capable of being enjoyed under O-conditions—and yet the experience may lack. depth or intensity. On the other hand, a work may move us very strongly and profoundly even if it is perceived under quite unfavorable conditions, as when it is incompletely enjoyed. I need not add that up to a point the experience would be, by the very meaning of our terms, even more intense or profound if the conditions under which it is perceived are O-conditions.

The upshot is that the degree of completeness of one's—anyone's —enjoyment of a given work wholly depends on the degree in which the prevailing conditions, including those which pertain to the perceiver's physical, mental, and emotional state, are O-conditions. On the other hand, the work's intensity and depth depend on its own qualities—hence on its artistic excellence—as well as on the degree in which the prevailing conditions are O-conditions, particularly the degree of the perceiver's emotional and intellectual ma-

turity, aesthetic sensitivity and discrimination, general knowledge, knowledge of art and human life, and so on. The relation between the completeness or incompleteness of our enjoyment (and the degrees of the latter) on the one hand, and the depth and intensity of the experience, may be more precisely stated as follows: the enjoyment of a given work reaches the point of maximum possible intensity and depth when the prevailing conditions are all O-conditions, hence when the work is fully enjoyed. Similarly, the work's impact reaches its lowest point when none of the prevailing conditions is an O-condition. Within these limits, however, the relation between the intensity and depth of enjoyment on the one hand, and the degree of its approximation to a complete enjoyment of the work on the other hand, varies from one work to another. We are here assuming that the perceiver is a qualified judge.

We now turn to the determination of the ways in which we can discover, both qualitatively and quantitatively, the specific factors or kinds of factors which constitute standard conditions relative to the various arts we actually possess. Since the methods of determining the M-conditions were briefly mentioned in the preceding section, I shall limit the present discussion to O-conditions, which are more complex and of greater theoretical and practical importance than the former. This is further justified by the fact (which will presently become apparent) that the methods of discovering the various O-conditions are themselves relatively complex, and raise methodological questions of considerable importance for aesthetics as a whole.

Broadly speaking, there are two major and related methods, or kinds of methods, whereby we can discover what we are looking for. The first consists in the examination of ordinary aesthetic discourse and the discourse of practicing artists, critics, and other art experts. The second consists in the appeal to the relevant empirical facts we have about works of art and about our responses to them, in the usual straightforward use of the phrase 'empirical facts'. For the sake of convenience, I shall henceforth refer to these methods as the conceptual and empirical methods for the discovery of O-conditions, respectively.

(A) The conceptual method consists, first, in noting and anal-

yzing the reasons that (1) laymen and (2) art critics would cus-
tomarily give whenever they hesitate to pass (or refrain from pass-
ing) value judgments on a particular work X, in view of the condi-
tions under which they have read, heard, watched, or seen it.
(These conditions include "subjective" factors, that is, conditions
pertaining to the perceiver himself). The different reasons that may
be given would provide different conditions unfavorable to the
enjoyment of X, or of the kind of art X is, or even of all art.
From this, we can logically infer that the absence of these condi-
tions would constitute either (a) neutral conditions that neither
favor nor interfere with our enjoyment of X, or (b) O-conditions
relative to X, and so on. Where a given unfavorable condition has
an opposite, we can safely conclude that the latter would consti-
tute, in some degree, intensity, or amount (or some range of these)
an O-condition relative to X, and so on. For instance, a particular
perceiver may hesitate or refuse to pass a value judgment on X
because he feels that he is not a qualified judge of X, the kind of
art X is, or art in general. He may feel this because he thinks that
he does not possess, say, a sufficiently mature or discriminating
artistic taste. It is obvious from this that the possession of a mature
and discriminating taste—however these are to be understood—
constitutes O-conditions of the enjoyment of X. Indeed, in the
case of this example it is perfectly obvious that the perceiver's
possession of a mature and discriminating taste is an O-condition
relative to *all* works of art. For the condition clearly has no neces-
sary reference to any specific feature or features of X, or to X as a
whole as a work of art with a specific nature.

The repetition of this procedure with respect to works falling
under different genres of the same art form, as well as works falling
under different art forms, will enable us to arrive at an exhaustive
list of O-conditions relative to art are a whole.

The procedure outlined does not always reveal, or help reveal,
the desired conditions. For, as I noted before, we sometimes regard
a particular work as "good" (or "very good, great," and so forth)
even under what we consider to be unfavorable conditions. When-
ever we do so, our judgment will be based on our evaluation of
(1) the quality of the effect that the work had on us, and/or (2)

the work's sensible qualities and the ideas, imagery, or symbolism it contains. (The appeal to (1) or (2) or both, it will be noted, *a fortiori* forms a basis for the evaluation of particular works under standard O-conditions.) In general, however, the present type of situation arises only under what the judge regards as moderately unfavorable conditions. As a matter of fact, the tendency to suspend judgment about the aesthetic worth of a given work becomes stronger to the degree in which the prevailing conditions under which the work has been seen, heard, or read are regarded as unfavorable for its full enjoyment. Thus only in the case of works that the contemplator comes to regard—on other grounds—as "great" or "very great" will he, in all probability, venture a judgment based on his apprehension of the work under extremely unfavorable conditions.

To discover whether a given aesthetic judgment of a particular work is based on what the judge regards as O-conditions, or whether it is made despite the prevalence of what the judge regards as unfavorable conditions, we must adopt the procedure of in every case discovering the reasons supporting the judgment. If we do so, we shall sometimes discover that the judge makes such statements as "I think X is a fine (or excellent) work, *despite* the fact that I was unable to listen to (or hear) it properly." The reasons given for the latter qualification would, as before, provide us with the unfavorable conditions—hence, in a general way, the corresponding O-conditions—we are looking for.

Aesthetic judgments of the form, "I think X is a fine work despite . . .", discussed above will be well founded only if some, but not all, of the conditions of perception involved are unfavorable, and more specifically, only if the perceiver is a qualified judge. This is not necessary at all, however, as long as we are merely concerned with discovering the O-conditions of the enjoyment of art by observing and analyzing such judgments and the reasons supporting them. It is true, nonetheless, that normally the judge would not (if he understands the way in which aesthetic language functions) make such judgments unless he *regards* himself, rightly or wrongly, as a qualified judge.

We can directly discover the O-conditions of the enjoyment of

art, which are implicitly or explicitly appealed to in aesthetic discourse, by noting what perceptual and other conditions are regarded as present whenever someone judges a work X to be a *poor* (or a very poor) work on the basis of his own experience of it. If we know how to use aesthetic language properly (and are careful and reasonable!), we do not pass adverse judgment on any work unless we regard the prevailing conditions as more or less standard conditions, in both of our senses of this term. The same procedure can also be utilized whenever someone passes a favorable judgment on a work Y; that is, whenever we discover that the perceiver regards Y as a good work because it possesses certain sensible or nonsensible properties, and/or has evoked in him intense and profound feelings of a certain kind under what he considers to be *optimum* conditions of perception.

The analysis of the layman's and the expert's aesthetic discourse in the manner outlined in the foregoing section reveals considerable disagreement regarding the optimum, if not the minimal, conditions for the enjoyment of art. Even in the absence of such a survey of factors conventionally regarded as O-conditions, it is quite apparent to anyone familiar with the world of art that considerable disagreement exists. The question which has generated a great deal of controversy is, first, which general environmental factors are favorable, which unfavorable, and which immaterial for the perception and enjoyment of art. Second, there is disagreement as to whether a particular amount, intensity, or degree of a particular factor, widely regarded as an O-condition, is an optimum degree, amount, or intensity of that condition. An example of the first is the controversy among critics and aestheticians as to whether any knowledge regarding the artist—and if so of what kind—is requisite for the full perception and enjoyment of his works in general or for any of them in particular. Thus it is widely debated whether familiarity with the artist's intent, if any, in creating a particular work, the intended meaning of the symbolism he may be employing, and the like are or are not O-conditions or even M-conditions. An example of the second is the debate as to how much knowledge about an artist's life, or any particular part or aspect of it, is requisite for the full enjoyment of his works.

What I have so far said about standard, especially optimum, conditions should make quite clear the importance of our agreeing about them. As long as the O-conditions are not accurately agreed upon, both qualitatively and quantitatively, we cannot know definitely whether any particular work has been completely enjoyed in any given case or cases, or whether there is more to the work than any perceiver thinks there is to it. As a consequence it will not be possible to reach or approach final agreement about the work's character and content, or its aesthetic merit (except if the work possesses such great artistic worth that it will exhibit its finer qualities even under extremely unfavorable conditions). A work will reveal most fully, hence can be best *interpreted* and *judged*, when it is perceived under O-conditions.

A certain amount of lay and expert disagreement respecting O-conditions—consequently, about the proper interpretation and correct evaluation of particular works—is however inescapable. First, it is inescapable because it is always possible to discover or deliberately to create, particularly with the help of present-day advances in technology, new and different physical and psychological conditions for the perception and enjoyment of art. It is not possible to foresee or predict with any definiteness (at least not with finality) how these conditions would affect the qualified judge's perception of particular works falling under the same or different art forms or genres. Only actual experience, only the qualified judge's repeated actual confrontation with a work or a number of works under these new conditions, can enable him, and therefore all those who respect his judgment, to determine whether or not these conditions are favorable or unfavorable relative to the particular work or works. It is also impossible to envision at any given time all the possible physical, physiological, psychological, or epistemic conditions that can naturally arise or be deliberately created under which particular works may be perceived. We must wait for experience to tell us, whenever any of these new conditions naturally obtains or is created,[3] whether and within what precise quantitative limits it is an O-condition.

The third reason is that new genres and even new art forms can and probably will continue to be created in the future, as in the

past, not merely original individual works. The full apprehension and enjoyment of the new works, particularly those that fall under new genres or new art forms, will almost certainly require the presence of already-known O-conditions in new combinations and/or in new degrees or intensities. What is more, works falling under new genres or art forms will most probably require very new and varied conditions in order to be completely enjoyed, or even, perhaps, simply to be apprehended as works of art. Clearly it is impossible to know or foresee what these conditions are before the new works are created, and attempts are made to look at them, listen to them, and the like as works of art.

The truth of the foregoing points does not impugn what gave rise to the discussion; namely, the desirability of reaching agreement concerning O-conditions. By this I mean the desirability of reaching agreement as to whether any particular condition—whose nature, at least in a general way, is already *known*, and which is known to be involved in the apprehension or enjoyment of some or all extant works of art—is a favorable or an unfavorable condition. Any list of *specific* optimum conditions on which we agree will not and cannot be exhaustive; conditions known to be O-conditions relative to given extant works, genres, or art forms may be subsequently found to be unfavorable relative to other, new works, genres, or art forms and vice versa. The agreement on O-conditions reached in any given time will not in any way destroy or impair the flexibility, hence the usefulness, of the *concept* of optimum conditions itself. The concept remains as flexible as ever; only the membership in the class of O-conditions continues to swell.

It is important to note that general agreement on O-conditions in relation to particular art forms, genres, or individual works does not preclude the possibility of disagreement respecting the artistic merit of these art forms, genres, or individual works. Since the concept of art includes, in W. B. Gallie's words, the notion of "achievement," it is—at least insofar as it includes that notion—"essentially contested." [4] Even supposing that general agreement is reached respecting O-conditions, and even if a particular work is apprehended under what are generally regarded as O-conditions relative

to it, as a particular work or as a particular kind of work, there will always remain the possibility of disagreement about its artistic merit as determined under these conditions. The presence of at least a considerable number of O-conditions is necessary for the correct evaluation of a work of art, but these conditions do not in any way determine or affect the work's artistic *merit*. Moreover, even if we all agree as to what constitutes O-conditions relative to a given work, genre, and so on, there is always room for disagreement as to whether these conditions are present in a given instance. Such disagreement, whenever it arises, will tend to affect our *assessment* of the worth of particular works.

As W. B. Gallie points out, a certain amount of disagreement or lack of uniformity in aesthetic valuation—and I might add, in contrast to moral valuation—is not undesirable:

> If we should hear about or happen upon a society whose aesthetic valuations showed as high a degree of uniformity, in respect both of particular assessments and general point of view, as do, say, our valuations of scientific achievement, we should be inclined to say that, however *artistically gifted* some of its members might be, its artistic life—its production and enjoyment of works of art—was of an unhappily stunted kind.[5]

It remains, however, that complete disagreement in these matters is only slightly less undesirable than complete agreement.

It is plain that the said disagreement about O-conditions cannot be resolved by appeal to lay or even expert aesthetic discourse, through an examination of aesthetic discourse—both of the way in which people use aesthetic expressions and the beliefs they *convey* with their help. For no disagreement arises in everyday discourse with regard to the application of expressions whose usage *is* fixed by the linguistic habits of a group of people. That is precisely why we have to appeal to direct empirical observation, preferably in the form of controlled, rigorous experiments, in order to arrive at well-founded agreement. Indeed, we must appeal to empirical facts

in order to determine the role played by any newly discovered factor appearing to affect the perception and/or the enjoyment of art one way or another.

The appeal to empirical facts in the present connection can be useful in two important ways. First, it helps us to determine more precisely the quantitative—extensive or intensive—limits within which certain factors that are generally regarded as O-conditions *are* O-conditions. Second, it helps us to resolve disagreements about the aesthetic role played by any given factor, that is, whether that factor is an O-condition, and, if so, within what precise quantitative limits.

Theoretically speaking, there are two sorts of empirical facts which we can take as our frame of reference in attempting to determine with precision the O-conditions relative to a given work W. First, there are W's sensuous and nonsensuous (ideal) features; second, there are the feelings or emotions evoked by W in different perceivers (as many as possible). In the second case, our guiding principle would be the following: any given factor C would be an O-condition relative to W if its presence enhances—or if its absence mars, weakens, or even destroys—W's emotional, intellectual, and/or imaginative impact on a qualified judge J contemplating it. A condition X would then be an unfavorable condition relative to W if its presence mars, weakens, or even destroys, or if its absence enhances, W's impact on J. By the words 'mar' and 'weaken' I mean "lessen in intensity or in depth."

Our guiding principle, in charting the path of our empirical investigation, reveals at the same time the disadvantage or limitations inherent in pursuing this path. The present procedure, whatever its merits, cannot enable us to discover or reach agreement about the O-conditions involved in the notion of a *qualified judge J*, since qualified judges must be used in order to discover, or to reach agreement about, these conditions. It would be difficult if not impossible for our method, in the present state of the science of psychology, to determine accurately the *quantitative* limits within which a given condition C is optimum, neutral, or unfavorable relative to W's apprehension and enjoyment. According to our guiding principle, or as a corollary to it, these quantitative limits

correspond to, and hence can be determined by, measuring the limits within which J's enjoyment of W is enhanced by the presence, or marred—if at all—by the absence, of C. But the precise measurement of such subjective responses is perhaps not possible in terms of our experimental techniques. This condition, apart from the possibility that the limits within which the presence, or the absence, of a condition C enhances, mars, or neither enhances nor mars the enjoyment of W, may vary from one qualified judge to another. It may vary even with different readings, viewings, or auditions of it by one and the same qualified judge.

This does not, however, stand in the way of our determining, by appeal to the responses of qualified judges, whether a particular factor is, generically, an O-condition relative to a particular work or group of works belonging to the same genre or art form. At the same time, it is certainly not impossible to determine on other grounds what particular individuals, active in the field of art, are qualified judges, though the present approach does not enable us to determine who is or is not a qualified judge with respect to a particular art form or genre, hence with respect to a particular work that belongs to a certain genre or art form. Our troubles are not over if and when we have agreed on the qualifications of a good critic or qualified perceiver, or even on whether this or that particular person is a good or a poor critic. For an empirical survey of the responses of a large number of critics or other experts to a work under the same environmental conditions may not reveal a consistent pattern.

It may be thought that in such cases we can discover the O-conditions relative to W if S_1 and S_2 represent two successive occasions on which an individual J, *whether or not he is what we would call a qualified judge*, reads, listens to, or looks at a work W. The conditions C_2 present on occasion S_2, under which J perceives W, taken as a whole, would be more favorable than conditions C_1 present on occasion S_2, taken as a whole, if J, after perceiving W on occasion S_2, discovers A-features in work W which he had failed to notice when perceiving it on occasion S_1. It is essential that (1) J's enhanced perception of W not be due to concentrated reflection on it, subsequent to his encounter with it, on occasion S_2. Rather,

it should be a direct awareness of those sensible, imaginative, intellectual, or emotional A-features of W which were earlier unnoticed. Likewise, (2) the heightened awareness should not be the outcome of J's hearing or reading analyses of W supplied by others. (But an appeal to some *interpretation* of W, whether supplied by others or conceived by J himself, may be inescapable.) Awareness of W's A-features should not be (3) due, at least not entirely, to J's greater familiarity with W on occasion S_2 than on occasion S_1 as a consequence of his repeated exposure to it. If these three conditions are not or cannot be satisfied, the desired conclusion about C_1 and C_2 cannot be drawn.

I shall assume—what is not evident at all—that it is possible to determine and discount the effect of familiarity in the situations we are envisaging. Whether it can actually be done can only be ascertained in the light of empirical work regarding the role of familiarity in the perceptual, imaginative, and intellectual awareness of—and the emotional response to—works of art. The difficulty I mentioned earlier immediately arises if we consider (1). The need to appeal to the responses of qualified judges in order to determine whether the conditions present in S_2 are *really* more favorable than those present in S_1 arises when we ask whether the putative A-features "noticed" in W on the former occasion, but not on the latter occasion, are really present in W. Disagreements on this score are not infrequent; the good taste of persons regarded as qualified perceivers is the ultimate court of appeal.[6]

The experimental control of the factors outlined in (1) and (2) above, to ensure the success of our observations regarding C_1 and C_2, should not be too difficult. In order to discover the particular aspect(s) or element(s) of C_2 that is (are) more favorable, or less unfavorable, than the particular aspect(s) or elements(s) of C_1, C_2 and C_1 must be made as nearly identical as possible in all respects but one—and we must repeat the experiment in exactly the same way, but with different physical, physiological, or psychological factors as variables. If it is possible to carry on this procedure with respect to all the factors constituting C_1 and all those constituting C_2, we should be able to discover many if not all of the factors that, as kinds of factors, constitute optimum conditions

relative to the particular work. The repetition of these experiments with other works belonging to the same genre, works belonging to different genres but the same art form, and works belonging to different art forms, would provide us with lists of O-conditions relative to each of these categories.

The quantitative limits of the favorable conditions relative to a particular work W, a particular genre, or even a particular art form as a whole discovered in the preceding manner can next be determined through the statistical correlation of extensive or intensive variations in each of our favorable conditions; or they can be determined in a given number of them taken together, and the various degrees in which the enjoyment of a specified number of perceivers is enhanced relative to W or the particular genre or art form. The technical and practical difficulties here pertain mainly to the precise determination of the latter; the controlled quantitative variation of the O-conditions themselves, especially the physical factors among them, should not be particularly difficult. In order that a precise correlation between quantitative variations in the prevailing conditions and any possible sharpening or heightening of aesthetic insight may be possible, it is probably necessary to start with a workable conventional standard of "aesthetic insight," one which admits of precise or relatively precise gradations or degrees of "aesthetic insight," hence degrees of heightened or sharpened insight relative to it. If this is found to be impracticable, we must be satisfied with the grading of particular aesthetic insights *relatively to one another*. A person perceiving a work W on occasions S_1 and S_2 will evince a greater degree of insight I_2 on occasion S_2 than the degree of insight I_1 he evinces on occasion S_1, if he apprehends n-sensuous and/or ideal A-features of W *as a work of art*, at S_1, and $n + x$ A-features of it (the *same* n-features plus at least one additional feature) at S_2. The three provisos we made earlier in relation to the general principle I outlined should also be understood as applicable here.

Utilizing this rule, we can now correlate quantitative variations in any given O-condition or complex of conditions with any observed variations, in the manner just stated, in a given judge's apprehension of W on a number of successive perceptions of it. A similar

method, at least of the "relative-gradation" type, can perhaps be used for the relatively precise determination of the variations in the depth and intensity of a judge's responses to a work W, with quantitative variations in a given O-condition C. It seems unlikely to me, however, that the same degree of precision is attainable here as in the measurement of variations in aesthetic insight, since feelings and emotions lack the "public," "objective" character of the sensuous or (even) ideal features of works of art. This is one chief reason why the empirical investigation of O-conditions by reference to the qualities of works of art themselves, and to our perception of them, is superior to the method which appeals to our emotional, "subjective" responses to the works. The other advantage of the former method is that, in contrast to the latter method, it can be properly employed irrespective of whether those who perceive W are qualified judges. Indeed, the method under discussion can enable us to discover whether a given perceiver is a qualified judge relative to a given work, a given genre, or a given art form as a whole, and even the extent to which he is a qualified judge relative to other qualified judges. Thus in terms of this method, a perceiver of a work W, or a group of works R, S, T, U belonging to the same genre, or to different genres of the same art form, will be a qualified judge relative to W, or to R, S, T, U, to the extent to which he can perceive the "finer" or "subtler" [7] aesthetic features—sensuous or ideal—of W or R, S, T, U. A judge A will be a relatively *more* qualified judge of W or of R, S, T, U than a judge B in the degree in which he discovers a greater number of aesthetic, especially a greater number of "finer" or "subtler," sensuous or ideal A-features of W or of R, S, T, U. In both cases, it is assumed that the perception of the aesthetic features is a result of the judge's own direct perception of W or R, S, T, U, and, in the latter case, that A and B (preferably simultaneously) perceive W or R, S, T, U the same number of times under identical "environmental" [8] conditions.

In the former case the results obtained will be well established in proportion to the prevailing "environmental" conditions being non-optimum conditions.[9] A judge will be ideally qualified relative to a given work W, or works R, S, T, U, if he is able to perceive—

under "environmental" conditions all of which are extremely adverse relative to W or R, S, T, U—the maximum number of "finer" or "subtler" A-features of this work or of these works that can be perceived by an *un*qualified judge under the corresponding O-conditions. It is clear, however, that this characterization of an ideal judge cannot serve as a basis for an experimental determination of whether a given factor is optimum relative to some particular work or works, *unless* we first discover, by means of some other strategy, someone who is *not* a qualified judge relative to this work or these works. This, to put it mildly, is not difficult at all.

NOTES

1. The first few pages of this chapter are reproduced, with minor changes or additions, from my "Standard Conditions of Aesthetic Perception," *Proceedings of the Fourth International Congress on Aesthetics,* Athens, September 1960 (Athens, 1962), pp. 637–40, with the kind permission of the Hellenic Society for Aesthetics.

2. In the whole of the present part of the book, I am concerned with these conditions as standard conditions of the enjoyment of art. This is the way in which the adjective 'aesthetic' is employed here and is intended to be understood. However, some or all of them are also conditions of the aesthetic or aesthetic-type enjoyment of things other than art. Those which are so are conditions of aesthetic enjoyment in a more inclusive sense of 'aesthetic'—the sense of it employed in Part I, Chapter 4, for instance, where I spoke about the possible "aesthetic-type" enjoyment of things other than art.

3. The envisioning and actual creation of new O-conditions of the perception and enjoyment of art is an important part of the creative artist's— the painter's, the architect's, the theatrical director's—work. The creative artist, with his strong, fresh imagination, his exceptional sensitivity, his sharp intuition, is in a better position than most people—certainly in a better position than the aesthetician or the layman—to break new ground in this direction. But only actual experimentation with these conditions will bear out or disappoint his intuitions.

4. "Art as an Essentially Contested Concept," pp. 97–114, *passim.*

5. *Ibid.,* p. 114. Italics in original.

6. See Part I, Chapters 5 and 6.

7. By the "finer" or "subtler" features of a work of art I mean, following ordinary usage, those features that are not obvious, are not on the surface so to speak, features whose perception requires a trained or naturally acute sensibility, which may include a penetrating analytical and synoptic intellectual faculty. The perception of a work's finer A-features is impossible without an awareness of its finer N-features, though the latter is by no means sufficient for it. The N-features in question are of two kinds: specific sensuous or ideal qualities (specific rhythms, nuances of sound or color, on the one hand, and specific ideas, facets of character, or specific psychological qualities on the other hand), and specific or pervasive relationships of these or other qualities of the work. The latter are generally "finer" or "subtler" than even the former features, since it is empirically observable that the discerning of relations, especially pervasive or fundamental ones, within a work of art, is rarer than the discerning of its specific qualities.

8. I am using 'environmental' between quotations marks because I am here excluding the physical, physiological, and psychological conditions that pertain to the perceiver himself. Thus the term 'environmental condition' is here used in a narrower sense than elsewhere in relation to standard and nonstandard conditions of the perception and enjoyment of art.

9. Thus in order to employ this strategy it is necessary first to discover, say with the help of the general method outlined earlier, what "environmental" factors constitute nonoptimum conditions relative to the work or works perceived.

Chapter 8

Optimum Conditions of
the Perception and Enjoyment of Art:
Psychological Factors

In Chapter 7 I discussed the concepts of M- and O-conditions of the perception and enjoyment of art. I shall concentrate on psychological O-conditions in this chapter; while in Chapter 9 I shall discuss epistemic O-conditions. I shall not concern myself further with M-conditions. Many of these are well known, and in any case they fall within the purview of empirical science. Since I have elsewhere discussed physical O-conditions,[1] I shall not say anything about them here. I shall also not say anything about biological O-conditions; as there is nothing to be gained by the reproduction of the current biological literature on the subject.

There are various psychological factors that constitute O-conditions of the perception and enjoyment of art in general. Whenever these conditions prevail, and the perceiver is able to concentrate fully on a particular work, he will enjoy the work—if he enjoys it at all—by virtue of the often subtle interplay of its various qualities. He will enjoy it independently of whatever relations it has to its creator's personality and life, and independently of any bearing it may have on the perceiver's practical concerns. This does not logically preclude the possibility of the perceiver's using a work of art for various, including practical, purposes, that is, not treating it as art. It does not even logically preclude the possibility that a work of art may have, as art, other aims than those of giving pleasure,

stimulating the intellect and imagination, and so on (we saw that as a matter of fact it does not incontestably have other aims). It does not contradict the fact that the particular work may have various relations to the world and to human life, in its form and content. A work of art may be aesthetically related to the physical setting, if any, in which it happens to be perceived at a particular time.

One obvious psychological O-condition is the perceiver's full concentration on, attention to, or complete absorption in the particular work—while some degree of attention is an M-condition of all art, to begin with. This does not mean that the perceiver must ignore the physical setting of the work (a sculpture or a work of architecture) whenever such a setting is present. To clarify this point, we must distinguish two kinds of physical factors, which I shall symbolize as "F_1" and "F_2". One important factor of type F_1 is the range of intensity, volume, and distribution of white *light* which constitutes an O-condition relative to visual art.[2] White light plays an essential part of its role as an O-condition by illuminating the surface or surfaces of the visual work of art itself. This aspect of its role as an O-condition will not be impeded in any degree if the spectator does not attend to and does not perceive, either consciously or subliminally, any part of the work's physical setting, if any. An extreme example of this is provided by a situation in which the surface of the work alone is illuminated, its entire surroundings plunged in complete darkness.

However, it is clear that if the foregoing obtains, light would *lose part* of its efficacy as an O-condition. Illumination possesses an aesthetic value as a perceived quality, as it suffuses the work's physical environment with its coldness or warm glow. This will be lost if the work is perceived as though in a spatial vacuum.

The architectural design and the color schemes of the physical setting are important examples of factors of type F_2—for rather obvious reasons. They cannot play any role as O-conditions unless they are perceived, consciously or subliminally. Since some attention is necessary for conscious perception, it is seen that some attention to these factors and to others of the same kind (factors F_2)

is necessary in order that they may play their proper role as (physical) O-conditions.

The physical setting of a work as a whole, hence factors F_1 and F_2, should create an atmosphere conducive to unimpeded concentration on the work. For example, it can do so by helping the perceiver put aside any distracting thoughts or feelings that may occupy him.

(1) The gist of the foregoing remarks regarding attention can be stated as follows. The optimum amount of attention relative to a given perceiver and a given work is that amount of attention which results in the perceiver's becoming oblivious to literally everything but the work, and those visual or auditory factors in its setting which constitute physical O-conditions. Oblivion to everything but the work itself would therefore be aesthetically desirable only if and when *all* the factors constituting the work's physical setting are *un*favorable ones! Such a situation, it need hardly be added, is the last thing one could desire in the perception of works of art.

(2) A corollary of full attention to the work perceived (with the appropriate qualifications regarding its physical setting) is that the perceiver should not be carried away by fantasy adventitious to, but triggered by, the form or content of the perceived work. This should be clearly distinguished from the stimulation of the perceiver's imagination by the imaginative elements of the work itself, if any, such as the imagery in a poem. Failure to do so, or to recognize the legitimate stimulation of the imagination by the content if not also the form of many works, tends to lead to extreme and untenable formalism and "isolationism" in aesthetics.[3] On the other hand, the view that the formal$_1$ features of a work alone are aesthetic features of it—that a work of art is form alone—leads to ignoring the imaginative impact of a work's representational or other nonformal features (whenever they obtain) as aesthetically irrelevant. The aesthetic theories of Clive Bell and Roger Fry are a good example of the latter.[3] At the same time, isolationism may be a ground for, or a consequence of, the ignoring of the nonformal imaginative elements, since their emotional impact on the perceiver is thereby ignored as likewise unaesthetic. The alleged "aesthetic emotion"

would then become *sui generis,* quite unlike any emotions we experience in actual life. This is, of course, precisely what Clive Bell and Roger Fry maintain.

We must remember that many good works induce or even compel total attention to themselves. Indeed, complete absorption in a work can only be brought about by the latter's qualities: no amount of effort on the perceiver's part can take the place of the spell cast by a good work on the perceiver; no amount of initial interest in the work can long *sustain* one's attention, even when induced by deliberate effort. The work's physical setting and the perceiver's psychological openness to the work can only prepare the ground for it. This is precisely what these things, as the "context" of a work of art, are for.

(3) The above sketch of the role of full attention as a general O-condition leads us naturally to a more controversial matter. This is the view, still widely held by aestheticians, that a certain special attitude, called the "aesthetic attitude," is necessary for the proper perception and full enjoyment of art—or for having what is usually called an "aesthetic experience." As far as I know, this view stems in one of its several forms or variations from Kant's *Critique of Judgment.* Kant speaks of natural beauty as well as of art as the object of an "entirely disinterested . . . satisfaction." [4] It will also be remembered that such detachment from practical concerns, together with what is regarded as the corresponding positive attitude, has been more recently emphasized by Edward Bullough in his concept of "psychical distance," or "aesthetic distance" as it is now more commonly called. Sheila Dawson, Jerome Stolnitz, Eliseo Vivas, and Vincent Tomas are among the many contemporary aestheticians who accept and utilize the concept of an aesthetic attitude. On the other hand, George Dickie has recently argued that the notion of an aesthetic attitude is confused, that there is no such thing as a special or peculiar attitude properly called an aesthetic attitude with which a work of art may or may not be approached—the "aesthetic attitude is a myth." [5]

Dickie considers and criticizes three main varieties of the theory, ranging from its strongest to its weakest form: that of Bullough and his followers, that of Stolnitz and Vivas, among others, and that

of Vincent Tomas. In the case of each of these varieties and many of the instances he considers, in which an alleged aesthetic attitude is absent, he rightly shows that all that obtains is either (1) attention to only *some* features, or some aspect or part of the work, or (2) partial or complete inattention to the work as a whole. Thus Dickie is certainly right in holding that when Miss Dawson says that "the person with a consuming interest in techniques of stagecraft over-distances the play . . . ," she is merely using a technical and misleading way of describing a case of inattention. In this case, "something is being attended to, but . . . it [is not] the action of the play. To introduce the technical term 'distance,' 'underdistance,' and 'overdistance' does nothing but send us chasing after phantom acts and states of consciousness." [6] The same is true of Dickie's example regarding a student, Jones, listening to a piece of music "for the purpose of being able to analyze and describe it on an examination the next day and Smith listens to the same music with no such ulterior purpose." This does not means "Jones's *listening* differs from Smith's. . . . There is only one way to listen to (to attend to) music, although the listening may be more or less attentive and there may be a variety of motives, intentions, and reasons for doing so and a variety of ways of being distracted from the music." [7] Thus Jones does not have a special *attitude* toward the work in any usual sense of 'attitude'. We do say that such a man *approaches* the music with a "utilitarian *purpose* in mind" and even, perhaps, with a "utilitarian attitude" or "the wrong attitude" or that he has a "wrong approach to art." But 'approach' in every case here does not refer or pertain to his actual listening to the music or even to his examination and analysis of it. The same is true when we speak of someone as "*looking at* a painting with utilitarian eyes": we are clearly using 'eyes' and hence 'looks at' in a metaphorical sense. These expressions refer to the motives or intentions of the perceiver, not to the perception of the work itself.

These conclusions are reinforced if we examine the *everyday* uses of 'attitude' in the pertinent sense or meaning (something which Dickie does not do). But whatever the exact analysis of the uses of the word—and this is still a controversial matter—it is, I think,

perfectly plain that a person P's having a certain attitude A toward something S at time t implies, among other things, P's being disposed or inclined to make certain kinds of value judgments about S. No attitude is valuationally "neutral." Even P's indifference to S at time t_1 (and indifference is an attitude) implies or involves P's being strongly inclined or disposed to regard S as uninteresting, useless, or worthless—all value words. If P suspends his judgments at time t, regarding S's value or lack of value and so forth in general or in a certain respect, he would be said not to have any special attitude toward it. Not having any special attitude toward it is not the same as P's having some kind of "general attitude" toward it, though he may certainly have such an attitude. A general attitude would be, for example, one of "wait and see."

On the other hand, the inclination or disposition to judge a painting or a poem as good or bad in any sense or respect is necessarily involved in, or implied by, a spectator's or reader's attention to and enjoyment of its various N-qualities and their interrelations, and to the A-features for which these are responsible. Moreover, such an inclination or disposition is not included in the alleged "aesthetic attitude" by its proponents or advocates. However, attention to the work is commonly motivated by some kind of interest in it; this does *imply* or *involve* a disposition or an inclination to judge it as interesting, worthwhile, enjoyable, and so on. Full attention to or concentration on the work's sensuous, imaginative, and intellectual features (if and when the particular work has features of the latter two kinds), and the sheer delight in them, are themselves distinct from and do not involve or imply the kind of inclination or disposition described, or any other kind of disposition or inclination.

There is, to be sure, something common to having an attitude of some kind toward something and the way we "approach" a work of art when we voluntarily (as opposed to being forced to) attend to it. In both cases, we are ready to respond to it in a certain kind of way or in certain kinds of ways. In the case of the latter, we are prepared to enjoy if it is enjoyable; in the former case, we are prepared (or disposed) to *continue* to like or dislike, approve or disapprove of it, and so on.[8]

Dickie seems to me to be perfectly right in his interpretation of the other examples he considers. But he appears to me to miss a fundamental point about Bullough's "psychical distance" and Stolnitz's and Vivas' "disinterestedness," which is well illustrated by the former's example-of the jealous husband who "underdistances" Othello. Dickie says that this man "is unable to keep his attention on the play because he keeps thinking of his own wife's suspicious behavior." He later adds that in this case something is being attended to, but it is not the action of the play itself. This is certainly not the whole story, and may or may not even be part of it! The point which Dickie misses (about which Bullough and the other advocates of an aesthetic attitude themselves seem unclear) is that the jealous husband does not, or perhaps even cannot, *respond* or *react properly, fittingly, in a manner appropriate to Othello* as (a) work of art, and (b) as a particular work of art with a particular character. This failure is due to the great similarity between his personal situation and the situation in which Othello believes himself to be. We would ordinarily say "He is not in a position to respond properly (or appropriately) to *Othello*." Hence he would not or cannot be, in our terminology, a qualified perceiver or judge of *Othello*—or of other, probably all other, works of fiction, operas, or ballets which have the same general theme. (He may be, of course, in a position to judge properly, "objectively," plays, novels, or operas with a different subject matter or theme.) His personal feelings, attitudes, experiences, and the like color and interfere with his emotional reaction to *Othello*, preventing him from reacting to it in what we regard as a way appropriate to its nature; namely, the way in which a man who is not in his personal predicament can and may react. That is, his emotional *reaction* would be "subjective" rather than "objective"; the feelings or emotions which *Othello* evoke in him are not those which would have been evoked if he were not in the state of mind in which he is. They are not wholly determined by *Othello's* qualities. Rather, they are partly determined by his feelings for, and attitudes toward, his wife, her lover, or suspected lover. It is partly determined by this because he *cannot* react in the described way, "subjectively," *unless he reacts to the work itself*, or at least to its par-

ticular plot. His reaction is occasioned by (and its character partly explicable through) this. It is not irrelevant to the play's plot. This also means—showing how Dickie's account of the situation is incomplete or leaves partly unexplained this type of situation—that, unlike the other cases Dickie discusses, the perceiver's emotional reaction is not due to partial or complete inattention to the work: it arises in his attending to it and while he is attending to it, indeed *because* he attends to it! Of course, his special attention to Othello's jealousy, to his belief that he is a wronged husband, and so on, by virtue of its personal interest to him, may lead him to ignore or miss other features of the play. This may make his emotional reaction even more one-sided than it would be if he attends, is able to attend, to all, or all the important features, of the play. Whether this occurs in the particular instance would depend on a number of variable factors, such as the character and temperament of the perceiver, the freshness or remoteness (hence the strength and vividness, or weakness and haziness) of the original feeling or experience of being wronged, and the degree of the man's preoccupation with it; and so on.[9] In other words, it may or may not transpire.

Even in the former case it does not, in the particular situation or kind of situation discussed, account for the whole nature of the perceiver's reaction. Indeed, the reaction itself can only obtain as a consequence of his initial attention to, and apprehension of (hence reacting to) the particular features of *Othello* which have a special personal relevance to him. If our jealous husband enters the theater already fully preoccupied with his personal problems, nursing his wrong, mentally railing at his wife or her suspected lover, he would almost certainly fail to notice what occurs on stage. He would probably stare at the stage with unseeing eyes. He would not, therefore, have the opportunity to react the way we have imagined him to react. If the experience is fresh, he may be unable to pay attention to the play beginning with Act III, Scene 3, when Iago first arouses Othello's suspicions. In such cases, we have an important element of inattention to some of the play's features. The experience may, however, be an old one, or only the remembered experience of a friend, and it may not hinder him from following the play closely, throughout. Nonethe-

less it may subtly, perhaps unconsciously, affect his reactions without preventing him from reacting appropriately to other features of the play—those unrelated to his personal concerns. For example, he may well react in this way to the beauty and the dignity of the poetry.

It remains, however, that the jealous husband's reaction to *Othello* does not stem from the absence of anything that can be properly called an "aesthetic attitude." He may certainly be incapable of changing or curbing that reaction even when or if he is, or becomes, aware of its subjectivity. In this, Dickie is surely right. We cannot speak of the reaction itself as constituting, or including as a component, any attitude—certainly, any attitude that can affect, influence, or determine the very *perception* or *apprehension* of *Othello*. Also, the man's reaction to the tragedy does not constitute a reaction possible only when a man is reading a poem, looking at a painting, or listening to music; our hypothetical husband may react in the same way to other things such as a drab report in a newspaper about a wronged husband and his reactions to his wife's unfaithfulness, a chance overhearing of the word 'cuckold', a picture of his wife's lover, or the sight of someone who looks like him. These, and many other stimuli, may serve to evoke the particular feelings, emotions, thoughts, associations, and so on. This is one of the main things which the advocates of the "aesthetic attitude" themselves emphasize, one of the main practical benefits which, according to Dickie himself, aesthetics has derived from the myth of the aesthetic attitude. It has (as Stolnitz claims) "played an important role in the freeing of aesthetic theory from an overweening concern with beauty." [10] It can also help to bring home, I might add, that all sorts of things besides art can be sources of enjoyment similar in various ways to the enjoyment that has its source in works of art, when their sensuous or nonsensuous qualities and interrelations are fully attended to.

The following conditions are necessary in order that the impact of a work of art on the perceiver may be appropriate to it. First, he must fully attend to the work and, sometimes, to it alone when attention is appropriate to the work, to the latter's physical setting. Otherwise, attention to the work may interfere with his response

to the work in a manner appropriate to it. Second, his reaction will be appropriate, as our example illustrated, only if it is *not* colored by his personal feelings, experiences, associations, and the like. These two conditions constitute part of what distinguishes a qualified perceiver of the particular work from an unqualified one. It is noteworthy that "objectivity" admits of degrees. Complete objectivity in one's reactions may be, probably is, only a theoretical ideal. This is an important consideration in our assessment of the astuteness or validity of a particular judge's evaluation of a work. The prejudicial role which such subjectivity plays in his case can perhaps be discounted by our comparison of this evaluation with the evaluations of other critics, who (we know) are subjective in other known respects.

One of Bullough's valuable ideas—which Dickie's account of what may be involved when we listen to music, read a poem, and the like, also misses—is that "It will be readily admitted that a work of art has the more chance of appealing to [hence being appreciated by] us the better it finds us prepared for its particular kind of appeal. . . . The success and intensity of its appeal would seem . . . to stand in direct proportion to the completeness with which it corresponds with our intellectual and emotional peculiarities and the idiosyncrasies of our experience." [11] He adds a little later that "It follows that the qualification required [in the perceiver] is that the coincidence should be as complete as is compatible with maintaining Distance." [12] Unfortunately, though, Bullough mistakes or misrepresents this idea when he formulates it in what he terms the "antinomy of Distance"; "What is . . . , both in appreciation and production, most desirable is the *utmost decrease of Distance without its disappearance.*" [13] Surely this misrepresents the situation in terms of Bullough's own terminology, since if the antinomy of distance is what he says above, '(utmost) decrease of distance' cannot mean what Bullough means by 'underdistancing'. Yet I cannot see what other meaning it can have within his framework. If decrease of distance is anything like what he means by underdistancing, it cannot, by the meaning of the latter term, be a desirable state of affairs. Underdistancing is loss of distance, the inability or unwillingness of the perceiver to put

his practical concerns and preoccupations completely "out of gear," as he (tries to) listens to the music, reads the poem, and the like. The reason why any decrease of distance is loss of distance is that "proper" distance is not a range but a limit.

Looking at the matter from a somewhat different angle, Bullough's valid idea of the importance of the "coincidence" of the perceiver's experiences, temperament, and idiosyncrasies with the work's character for his full enjoyment of it is completely lost in his attempt to formulate it in terms of distance. It is not difficult to see why this should have happened: there is an obvious logical connection between the two notions. The greater the coincidence in question the harder it is, other things being equal, for the perceiver to "distance" himself from these very experiences which constitute the coincidence, qua personal or "subjective."

This is not the end of Bullough's troubles. The concepts of underdistancing and overdistancing themselves are shot with logical confusions. More precisely, the term 'overdistancing' seems to me to be devoid of meaning, infecting the supposed logical antithesis between overdistancing and underdistancing. The notion of underdistancing makes sense only in contrast to "proper" distance, not overdistancing, which has no meaning. Bullough confuses, say, a theatergoer's *indifference* to what happens on the stage in a performance of *Othello* with "distancing" or "lack of distancing." *Lack* of distance is not the same as underdistancing in the sense in which Bullough uses it, in the case of the jealous husband; that is, as the opposite of overdistancing.

The foregoing confusions can be summarized in the form of a dilemma: (a) If underdistancing is defined as the opposite of overdistancing, then neither is logically homogeneous with proper or optimum distance. The latter cannot be the "mean" of which these two are the "extremes." For overdistancing makes no sense given Bullough's definition of 'distance'. On the other hand, (b) 'underdistancing' can be given a meaning—as not detaching the work sufficiently from our personal concerns—in relation to the notion of proper distancing. But if we do give it a meaning it cannot be the opposite of overdistancing, and, therefore, on the same logical scale.

It is clear that (a) inattention to a work or (b) wrong responses to it can have many different causes or reasons. It is noteworthy, however, that if the work perceived is a nonobjective painting or sculpture, absolute music, or a nonrepresentational ballet, these reasons cannot be exactly those I have considered in relation to Bullough, and Dickie's criticism of the notion of aesthetic attitude. That is, they cannot be exactly the same with regard to works that do not have a pictorial content, do not have a plot, do not tell a story, and so on. In the same way, though for a different reason, these reasons cannot but be somewhat different in the case of many works of architecture. Even here an inappropriate reaction to the work may result from personal feelings, emotions, or associations that may be evoked by the melody, the colors or forms, and so on. These may subtly or otherwise color the perceiver's reactions and make them more or less inappropriate. To give an example analogous to Bullough's example regarding the jealous husband, our jealous husband may react inappropriately to Beethoven's Seventh Symphony if one of its themes reminds him of his wife, who is very fond of that theme, especially if he and his wife were in the habit of listening together to that work. Or he may "see," as we say, his wife's face in the geometrical forms of the nonobjective painting, and so on.

One's reactions will also tend to be inappropriate when one listens to music, reads poetry, and so on that has, as we say, sentimental value to oneself. Here the inappropriateness is due to one's reactions being colored by personal feelings, attitudes, memories, and the like. The reactions differ from our earlier example in that they consist in pleasure rather than displeasure, anger, or agony.[14]

Although undivided attention to the work one wishes to enjoy is necessary for its full enjoyment, one must observe its qualities in a certain way in order to perceive their structure, the work's gestalt features. Thus if we are looking at a painting, we must, in Isabel Hungerland's words, "concentrate on certain visual parts, subordinate or neglect others, and . . . look at certain parts together or in quick succession." [15] The same applies to other kinds of art. However, it is misleading to speak of this, as Hungerland does, as taking a certain perceptual viewpoint in relation to the work. This way of speaking can easily lead one to suppose that a certain special attitude—the

alleged aesthetic attitude—is involved here. Hungerland also speaks of "looking at X [a particular painting] in a certain way." But this is, I think, a perfectly proper figurative way of speaking.

NOTES

1. "Optimum Physical Conditions of the Enjoyment of Visual Art," forthcoming in *Dianoia*, and "Optimum Physical Conditions of the Enjoyment of Auditory Art," *Rivista di Estetica*.

2. Except phosphorescent paintings and sculptures, in which case complete darkness, the total absence of light, constitutes an O-condition.

3. Cf. Bell's confusion in this respect, in his *Art*. Actually the confusion is a consequence of his fixation on the purely formal or plastic features of visual art.

4. Page 55 in the J. J. Bernard translation (London, 1931).

5. "The Myth of the Aesthetic Attitude," *American Philosophical Quarterly*, Vol. I, No. 1 (January, 1964), pp. 56–65.

6. *Op. cit.*, p. 57.

7. *Ibid.*, p. 58.

8. All this notwithstanding, it should be pointed out that *psychologists* use 'attitude' to mean: "A state of mental, especially emotional readiness for some form of activity. . . ." (*Webster's New International Dictionary*, Second Edition.) 'Attitude' in this usage is certainly a much more appropriate label than in its everyday usage, of the state of affairs which I have described above and which aestheticians call an aesthetic attitude.

9. Note that the extent to which his reaction is subjective may vary with whether he is watching *Othello* or, say, *Anna Karenina*. The latter would probably inflame him more than the former, since Anna, unlike Desdemona, was unfaithful to her husband.

10. *Op. cit.*, p. 64.

11. Kennick, *op. cit.*, p. 538.

12. *Ibid.*

13. *Ibid.*, p. 539.

14. C. C. Pratt, in "Aesthetics," *Annual Review of Psychology*, Vol. XII (1961), refers to some of the experimental work that has been done regarding factors that in our ordinary way of speaking may prevent or tend to prevent a perceiver from responding in the appropriate way to the work perceived; though he follows Bullough in speaking of these fac-

tors as those which shift or disrupt psychical distance. He says "Since proper psychical distance is shifted or disrupted by all sorts of factors, experimental aesthetics for many years has been on the lookout for those factors, and the search still goes on. Factor analysis has rediscovered a number of them (Gordon, D. A., "Individual differences in the evaluation of art and the nature of art standards," *J. Educ. Research*, 50, 17–30 [1956]). Das, Rath & Das ("Understanding versus suggestion in the judgment of literary passages," *J. Abnormal Social Psychol.*, 51, 124–28 [1955]) have followed Sherif in studying the effects of prestige and suggestion. Asthana ("Individual Differences in aesthetic appreciation," *Educ. and Psychol.*, Delhi, 3, 22–26 [1956]) has found that changes in preference are brought about by altered instructions. Lawlor ("An Investigation concerned with changes of preference which are observed after group discussion," *J. Social Psychol.*, 42, 323–32 [1955]) has been able to show that group discussion of paintings makes for greater agreement in rank orders" (p. 85).

15. "Aesthetic Perception," *Proceedings of the Fourth International Congress on Aesthetics* (Athens, 1962), p. 621.

Chapter 9

Optimum Conditions of
the Perception and Enjoyment of Art:
Epistemic Factors

In the preceding chapter I outlined some general psychological O-conditions. In this chapter I shall outline some major epistemic O-conditions. The two chapters are closely connected. As will be remembered from the discussion in Chapter 8, I pointed out that certain psychological factors constitute some of the conditions that make up what I called a "qualified judge (or perceiver)." The rest of the factors that enter into the makeup of a qualified perceiver (or judge) are epistemic factors. It is these, among others, that I shall consider here.

A work of art together with the character of its spatiotemporal setting—which if appropriate will harmonize with and enhance the work's aesthetic qualities—determine the character of the conditions whose realization by the perceiver would be most congenial for his perception and enjoyment of the work. Some favorable conditions even help "give" aesthetic significance to N-qualities which, under less favorable conditions, would be aesthetically indifferent. We must therefore be guided by this in our attempt, as an audience, to create the subjective O-conditions relative to a particular work we wish to enjoy. At the same time, it is an important conceptual fact about *good* art that, in one sense, it can be enjoyed in different ways, under different types of conditions; there are in principle different sets of subjective and objective factors which constitute O-conditions

relative to it. In the case of the best art the possibilities involved are well-nigh inexhaustible. The only way to discover these different O-conditions is through actual experimentation that is stimulated by creative imagination. The more inventive directors, stage and costume designers, orchestra conductors, and so on continually do this kind of experimentation. The opposite is true of average and especially of bad art: its possibilities are limited. If this is correct, one can even go as far as to regard this as a possible practical criterion (or, at least, indication) of the aesthetic goodness or badness of a particular work!

I said that it is characteristic of good art that, *in a sense*, it can be enjoyed in different ways, under different types of conditions. In another sense, only very special and narrowly defined, or highly specific and stringent, conditions can constitute the most favorable *subjective* conditions for the enjoyment of good art. That is, good, especially the best, art makes great demands on the perceiver's powers of concentration and observation, on his analytical and conceptual powers, on his power of perceiving subtle relations (hence, on his sharpness of perception), and on his imaginative and emotional sensitivity. But interestingly enough, if the judge is equipped with these qualities, he can enjoy the work even under very uncongenial environmental conditions.

Perhaps there is no greater disagreement among aestheticians and critics about the role of biographical knowledge in the enjoyment of art than with respect to knowledge of the artist's putative intentions in creating a particular work. In order to see whether the artist's intentions—in some sense of 'intention'—is an O-condition in the layman's or the expert's use of the concept of O-conditions, we must examine the way in which we talk about such intentions in relation to art. I believe that if we do so, we shall discover the following:

(1) That knowledge of the *artist's* intention, in the sense of "a set of dispositions or consciously entertained goals which the artist has in mind when he produced the work," [1] is not, generally speaking, a condition of the full enjoyment of the particular work.

(2) That knowledge of the *work's aim*, whenever this notion is applicable to the particular work or kind of work contemplated, is requisite for full enjoyment of the work and so is an optimum condition relative to it. Now an examination of ordinary usage appears

to show, prima facie, that both types of knowledge constitute an optimum condition. We frequently make such statements as: (A)* "I didn't (or I didn't very much) enjoy the play because I couldn't see what it was all about"; or "I didn't enjoy the novel (poem, opera, short story, and, sometimes, ballet) because I couldn't see its point, what it was driving at, or what it was trying to do or say"; (B) "I didn't (or couldn't) enjoy the play (novel, etc.) because I couldn't see what its author was driving at; what he was trying to do or say; what point he was trying to make; what he intended to convey or aimed at conveying." Statements of type (B) are *sometimes* really about the alleged intentions of the artist in creating a particular work. In many other instances, they are only apparently about them; they are really about the work's aims, though they are couched in language that makes them seem to be about the artist's aims. In order to see how and why this is so, let me quote a passage quoted by Kuhns in his "Criticism and the Problem of Intention." [2] E. Kitzinger, in *Early Medieval Art in the British Museum*,[3] comments on an ivory panel of the late fourteenth century as follows:

There is a positive intention behind [these features of 'subantique' art]. . . . There is in this carving an almost deliberate protest against realism. The sculptor makes it clear that he has no confidence in formal beauty and naturalism. He disregards the laws of nature; he shows that he is not interested in such things as three-dimensional space and the autonomy of the human body. For these he substitutes other values. His concern is the abstract relationship between things rather than the things themselves.[4]

Kitzinger—and the same applies, *mutatis mutandis*, to similar passages commonly met with in the writings of critics and art historians —*may* literally intend this passage to be construed as a set of putative empirical statements describing what he believes to be the artist's aims in creating the ivory panel. Very frequently this is what critics and art historians *wish to mean* when they speak in this fashion. But

if so, it is either (a) a guess or hypothesis with respect to the artist based on the work's N- (and/or A-) features,[5] or (b) a hypothesis about the nature of the aims and values of the artist—in this case the sculptor—that purports to rest on grounds external to the ivory panel itself. For example, it may be presumed to rest on the utterances of the artist about the panel or about his entire artistic output. In this case, the hypothesis would be plainly about the artist's aims and values; its confirmation or disconfirmation is to be sought outside the work. (It is a commonplace that what the artist intends and what he actually realizes in a work may or may not coincide.) In any event, supposing the hypothesis to be confirmed, it will constitute certain psychological and axiological facts about the sculptor. These may certainly have biographical interest for the student of art, but they do not—they could not—add anything to our enjoyment of the panel itself. As for (a) above, nothing is added to our enjoyment of the work if we impute certain intentions to the artist on the basis of an examination of the work's qualities. For nothing whatever is added to our knowledge of these qualities by this imputation or hypothesis, either about the artist (about his intentions, if any, when he created the work), or about the work. Indeed, the inference from the work to the artist is at least partly based on the perceiver's analysis or interpretation of the work's aims.

There is, however, a third possible interpretation of the foregoing quoted passage and of similar passages; namely, that it is merely a different but sometimes misleading way of talking about the work's aims themselves. If the particular critic or historian is shown (in the light of biographical evidence, etc.) that the sculptor did not actually aim at or even consciously think about the things imputed to him, he may reply in either of the following two ways: (a) he may say that the artist *unconsciously* aimed at the things imputed to him; or (b) he may say that, since he is merely describing what he finds in the work, the objection is irrelevant to his claim and in no way constitutes evidence against it. In the latter case he would be saying, in effect, that his statements were wholly and solely about the work's aims. In (a) he would be maintaining his claims at the expense of making them empirically unfalsifiable. It is methodologically illegitimate to psychoanalyze the artist, so to speak, on the basis of the

work. For one thing, the work may or may not have realized the artist's alleged unconscious "intentions" or "values." On the other hand, where such "psychoanalysis" is, in principle, possible—if the artist is still alive; or if, though dead, has left autobiographical material in the form of letters, diaries, and the like that could be used as data—the psychoanalysis would reveal something about the artist's psyche. But such knowledge would not be, in addition, of value in the attempt to understand or enjoy the work aesthetically.

Our conclusion that, *in many cases*, knowledge of the artist's intentions (if any)[6] in creating a given work of art is not necessary (since it is irrelevant) to its enjoyment qua art should be particularly welcome to those who appreciate the difficulties that, in many cases, beset attempts to discover the actual or alleged intentions of the artist at the time he conceived and/or produced a particular work. Many of these difficulties have been repeatedly pointed out by aestheticians and critics.[7]

Notwithstanding these difficulties, we sometimes encounter works that cannot be fully understood and enjoyed unless the artist's aims are discovered. As Richard Kuhns puts it: "The awareness of an intention in the artist is generated by the work, not by something behind it." [8] Various types of situations in which this is necessary have been recognized: in such situations, knowledge of the artist's aims or intentions does constitute an O-condition. Quite frequently these are situations in which (a) the work's drift, direction, point, or aim remains, in some degree, unknown or unclear to the perceiver, despite his most searching analysis of the work; or in which (b) the sensitive and trained perceiver is unable concretely to feel the work's drift or get a sense of its general pattern and direction, even after he has become thoroughly familiar with the work under environmental O-conditions.[9]

Although appeal to the author's intentions is imperative for a better understanding, if not for fuller enjoyment, of a work that lacks or appears to lack a clear and coherent aim, this is not the only kind of occasion on which the layman or even the professional critic may be puzzled by a work and therefore seek enlightenment by trying to discover the artist's intentions in creating it. We also tend to do this in the case of coherent but very complex, original or experi-

mental works, or in the case of works that are couched in a highly
personal language (in a literal sense in the case of literary compo-
sitions)—works which employ highly personal symbolism, for ex-
ample. This tendency is particularly notable if the symbolism exists
on several levels or expresses a personal philosophy or theology. But
knowledge of the artist's aims will provide an understanding of the
work's aims (or other aspects of the work) only when the two coin-
cide. When they do not coincide, no amount of knowledge about
the artist's aims will further better understanding and fuller enjoy-
ment of the work. This is true with regard to both good and poor art.

A discussion of epistemic O-conditions would be incomplete with-
out a consideration of the way in which the perceiver should regard
the ideas that are found in many works of art. The question must
be raised as to whether his proper reaction includes (a) complete
neutrality with regard to the truth-value of the ideas expressed in a
particular work, or, rather, includes (b) the acceptance or rejection
of these ideas depending on his agreement or disagreement with
them. (This question should have been answered, strictly speaking,
in our discussion of the various psychological O-conditions in
Chapter 8. But we are treating it in the present chapter because it
contains an epistemic component.)

An examination of ordinary aesthetic discourse pertinent to this
matter reveals that what we might call *aesthetic assent* to any ideas
expressed by a particular work (borrowing the phrase from T. S.
Eliot) is an essential part of a proper response to art: the full aes-
thetic enjoyment of such a work is possible only when the perceiver
completely withholds his judgment regarding the truth or falsity of
its ideas considered as propositions. Thus when someone says, "I
don't enjoy T. S. Eliot's *Four Quartets*, because I don't agree with
the ideas (or philosophy) expressed in them," many of us [10] would,
I think, say that he reads the *Four Quartets* "in the wrong way," that
his enjoyment of the work is marred by the intrusion of his own be-
liefs into the work—or, if you like, by their standing between him
and the work. His approach to the work is prejudiced rather than
open-minded; he is not completely receptive to the work as art. Or
we might say that he approaches the work not as art, which it is, but
as a philosophical or scientific treatise, which it is not. That is, we

might say with Eliot that "when you judge poetry it is as poetry you must judge it, and not as another thing." The same may be said of a novel, a short story, or any other kind of art which may express ideas that—taken out of their context in the work, ignoring their role (if any) in the production of the aesthetic effect of the work as a whole, and treating them as propositions—will be either true or false (assuming that they are sufficiently precise to have a truth-value).

I have used the term "ideas" (instead of "beliefs") expressed by (some) works of art. This is, I think, in conformity with ordinary usage and marks the important distinction between the cognitive components of a work as components of a work of art—therefore as functioning aesthetically, which gives them their reason for being and provides the reason for their being expressed in the way they are—and these elements abstracted and isolated from that matrix. It is true that, even in the latter case, they would be ideas and not beliefs if they were not attributed to any human being (in this case, to the artist) or if they were attributed to someone only qua entertaining and not qua holding them. But in contrast to their character as part of the work, they are, if abstracted, ideas in a contextual vacuum. They are like indicative *sentences* that someone finds on the blackboard in a classroom, written by some unknown person. These can be regarded as utterances that *will* express true or false *statements* if and when they are asserted by someone—say by the student or teacher who reads the sentence as he is about to erase the blackboard.

Even in the relatively simple case of a literary composition, I do not claim that the indicative sentences which express (some or all of) the ideas in the work are themselves mere (unasserted) sentences rather than statements in the present, relatively technical meaning of the terms 'sentence' and 'statement.' I am saying that they function *like* sentences as opposed to statements because they are not, qua forming part of the work, asserted by any actual human being in any situation. (They may be, of course, utterances put in the mouth of some character in the work; but that does not make them statements in our sense or in the ordinary sense, in which statements are said to be made by some real sentient being.)[11]

Some aestheticians claim that such indicative sentences are state-
ments and hence that the ideas they express are propositions in some
current philosophical or logical use of the term 'proposition'.[12]
Further, some claim that they are held by their author himself, and
they are treated as beliefs rather than as mere ideas capable of being
asserted or denied (hence of being true or false) but not as actually
asserted or denied by anyone. This way of looking at the matter—
and it is a perfectly natural way of looking at it since the artist is the
author of the ideas as of everything else in the work—is like fleeing
Scylla only to be wrecked on Charybdis. The author as a person may,
and sometimes actually does, believe that the ideas he has expressed
in the work are true. But it is illegitimate to suppose that this is al-
ways so, simply because they are the author's ideas. More important
than this is the objection that the attribution of these ideas to their
author as a person, as actual beliefs (even if we assume that it is
always legitimate to do so), would be completely irrelevant for our
present, aesthetic purposes. For what the artist himself believes as a
person—though certainly interesting in many cases and sometimes
very useful as an aid to understanding why the artist expresses the par-
ticular ideas he does express—does not in any way affect the logical
status of these ideas. The fact that the artist believes them, if he does,
does not make them less different from beliefs in the ordinary sense
of this word: since the artist and his beliefs—and his championing
of these beliefs—are extraneous to the work. Their status, as compo-
nents of the work, is in no way affected by them as separate asser-
tions. Those who make these biographical facts in any degree relevant
to the question of the status of these ideas in a work of art commit
the further error of confusing or illicitly identifying characteristics of
the work with the personal qualities or the personal states of mind
of their creator. However, although I am in essential agreement on
this matter with such writers as Eliot, I think that it is misleading to
put the distinction between the personal beliefs of the artist and the
ideas expressed by him in a work of art as one between the artist's
beliefs as a man and his "beliefs as an artist." (Cf. Eliot: "We can
distinguish between Dante's beliefs as a man and his beliefs as a
poet. But we are forced to believe that there is a particular relation
between the two, and that the poet 'means what he says'.")[13] The

phrase "so-and-so's beliefs as artist (poet, painter, and so on)" is, I grant, commonly used; and I understand, I think, what those who use it—Eliot, for example—wish to convey by it. But it tends to confuse the literal-minded person who fails to see that it is an elliptical or figurative expression standing for something quite complex. Apart from the foregoing considerations, this way of talking may give the false impression that, at different times, or in his dual capacity, the artist may actually hold two different sets of beliefs—one as a man and another as an artist—as though a Dante, a Shakespeare, or a Beethoven were each somehow two entities rather than a single entity.

With regard to the appreciation or enjoyment of the work, knowledge of the artist's beliefs is important only if we are unable to make out clearly the ideas it expresses; for example, when in the case of a literary work the language employed is ambiguous, vague, extremely involved, highly figurative, or personal, and the like.

It may be seen that my view is in agreement both with Coleridge's view that "suspension of disbelief" is necessary for full enjoyment of a particular work and with Eliot's view that "poetic [or, in general, aesthetic] assent" to any ideas expressed by a particular work is necessary for its full enjoyment. I agree with these views in the sense that, and because, I believe that they conform to the "logical grammar" of the relevant aspects of ordinary aesthetic discourse. They are, if you like—whether or not this is the way Coleridge or Eliot conceived them to be—correct analyses of the everyday concept of O-conditions with respect to the issue under consideration. (Moreover, I agree with Eliot regarding the *different* proposition that "the reader can obtain the full 'literary' or [if you like] 'aesthetic' enjoyment without sharing the beliefs of the *author as a man*." [14] And again, "I deny . . . that the reader must share the beliefs of the poet [as a man] in order to enjoy the poetry fully." [15] There is no particular difficulty about this negative part of Eliot's thesis. For one thing, as emphasized earlier, the artist's beliefs as a man and the ideas expressed in the work he creates are two different things.)

But what constitutes a proper "attitude" toward the ideas that may be conveyed by a work? My view is that ordinary discourse stipulates that our attitude should be such that any divergences between

our beliefs and the ideas conveyed by the work, considered as propositions, will not detract from whatever enjoyment the work would be capable of giving if no divergences did exist. More correctly, the truth or falsity that the ideas will have if they are abstracted from the work and are considered as assertions by someone should be a matter of indifference for us as the work's perceivers (though it may, or perhaps should be, a matter of concern for us as human beings, in relation to our daily, practical life).[16] The reason for this stipulation in everyday discourse is, I think, quite clear. It is intended to guard against the diminution or complete loss of any enjoyment that the work as a whole—ideas and all—may be capable of giving if and when the perceivers happen to believe that the ideas expressed, qua propositions, are false. Or, and this is perhaps a more fundamental way of looking at the matter, it is intended as a safeguard against the confusion of the aesthetic role that the ideas conveyed may play with the noetic role they would play if they were abstracted from the work and were considered as propositions in the usual sense.

I am aware that if the perceiver regards the ideas expressed as true, he may enjoy the work more than if he believed them to be false or if he had no opinion about their truth or falsity. But this implies that any added enjoyment that he derives from this will be for the wrong reason and must be discounted in one's assessment of the work's enjoyableness.

Eliot puts what appears to be the positive part of his thesis in terms of the notion of poetic assent, which he distinguishes from philosophic belief. What he means by poetic assent is illustrated by the following passage about the appreciation of Dante's poetry; "if you can read poetry as poetry, you will 'believe' in Dante's theology exactly as you believe in the physical reality of his journey; that is, you suspend both belief and disbelief." [17] The first part of this statement seems to give positive content to the notion of poetic *assent* or "belief" as distinguished from philosophic *belief*. But the second part of the statement neutralizes this impression. If "poetic assent" is merely suspension of belief and disbelief, then it is not assent in any ordinary or quasi-ordinary meaning of 'assent'. If it is something more positive, just like belief itself, then "suspension of belief and disbelief" [18] does not adequately express that notion.

The proper way of "approaching" a work of art, in the present connection, is not only one of suspension of belief and disbelief in the usual sense of these expressions, that is, as they are ordinarily applied to statements or the ideas they express (and so, as they apply to these ideas in a noetic, extra-aesthetic capacity). That merely clears the ground for the positive aspect of the proper approach, which consists in treating the ideas *as if they are true*. More correctly, it consists in the perceiver's *responding* to them as he would respond to them, letting them affect him the way he would let them affect him, if he believed that they were true. They would then have the emotional and dynamic appeal of ideas known or believed to be true, by being accorded all the attention and respect which the latter normally receive. In this way and in this way alone would they have the power to move us—to move us as deeply and completely as their nature makes them capable of doing. In this way they would have the greatest degree of philosophical, theological, moral, or "existential" significance they could possibly have for us by virtue of their intellectual content. (The notion of significance as it arises in relation to the ideas expressed by a work of art in particular, and in relation to a work of art as a whole, will be analyzed in Part III, Chapter 11.)

Let us compare this to the scientist's or philosopher's reviewing of various hypotheses or ideas or possible answers to a question in which he is interested as a scientist or a philosopher. He is interested in discovering which of these hypotheses, ideas, or answers is true; as aesthetic perceivers, this is precisely not what we are or should be interested in with regard to the ideas occurring in a work. Our "attitude" toward them is therefore not critical but "acquiescing"; it is one in which we imaginatively "accept" them as opposed to raising questions about their truth or falsity. Further, because the scientist's or philosopher's interest in ideas differs from the perceiver's interest in the ideas in a work of art qua art (also because of the artistic manner in which the latter may be presented, which is usually not true of philosophical or scientific ideas) we may, as perceivers, respond emotionally to the ideas in a work of art but not to the ideas constituting a philosophical or scientific hypothesis. What is more important, the scientist's or philosopher's "relation" to the ideas he

considers, as a scientist or philosopher, will be purely intellectual; in contrast, an emotional response to the ideas in a work of art is perfectly proper—it is part of an aesthetic response. These distinctions show the propriety of Eliot's comparison of "believing" in Dante's theology with "believing" in the physical reality of his journey in *The Divine Comedy*. Essentially the same observations apply to the proper "attitude" toward the episodes depicted in a dramatic work, its setting, the characters, and, in the case of opera and ballet as well as drama, the various conventions involved in the presentation of the action on the stage. In general, the injunction to the audience or reader is: treat (try to respond to) that which the work depicts or otherwise presents as if it were real, or true, as the case may be. This is why some aestheticians speak of a certain "tacit agreement" between the artist and the perceiver. I have added the qualification "in general" because there are, indeed should be, limits to this "assent." Some poor works strain the perceiver's willingness to do this to the breaking point. Glaring inconsistencies of character, the behavior of a character (particularly a major character) in a totally unmotivated way, and transparent *deus ex machina* devices in the plot are a few instances in point. Let me add that—other things being equal—the ease or difficulty with which the perceived work itself enables the qualified perceiver to "assent" to it is one mark of the work's artistic merit or demerit, respectively. Quite often, things are not equal. For one thing, as Bullough points out in describing what he regards as "distance" as a quality of works of art themselves ("underdistanced" and "overdistanced" art),[19] works of art differ in the ease or difficulty which they offer the perceiver in his attempt to enjoy a work properly and fully (in his attempt to take a "distanced attitude" in Bullough's theory). And this may or may not be a reflection of or dependent on the work's artistic merit or demerit. There can be (and there is) good and bad realistic art and good and bad "idealistic" art (such as fantasies and science fiction). An outstanding exception to this would be pornography, if any pornographic writings, paintings, films, and the like are regarded—by linguistic stipulation—as art in the descriptive sense. Moreover, Bullough rightly points out that the spatial or temporal distance of a work of art from the perceiver constitutes a rather special form of "psychical distance."[20] And spatiotemporal distance is

obviously unrelated to the particular work's aesthetic worth. The situation *may be*, however, different with regard to *"represented spatial distance, i.e. the distance represented within . . . the work."* [21] Sometimes the absence or near absence of such distance may be a fault, sometimes a merit. It depends on the particular painting or kind of painting.

The perceiver's treatment of the plot, characters, setting, and the like of a dramatic work as though they were real is the psychological counterpart and the logical correlate of verisimilitude as an attribute of some literary compositions or representational paintings and sculptures (compare and contrast Bullough). We cannot properly condemn certain works as unlifelike unless they fail to give us the illusion of reality: unless they fail to act on us in a way similar *in some respects* to the way in which real things act on us, or as they would have acted had they been "real"—provided that we have kept our part of the bargain by doing our best to treat them as though they are real. (The qualification "in some respects" is important, for there are ways or respects in which what a work of art depicts, if anything, cannot possibly be like any real thing. Failure to see this constitutes a fundamental error of the more extreme forms of the imitation or even representation theory of art.) But then, can any work fail to appear lifelike if we treat that which it depicts as though it were real? The answer seems to be a definite yes, since there are limits to anyone's imaginative assent to a work, however tolerant he may be of inconsistencies, preposterous coincidences, chance happenings, or other forms of artificiality. The degrees of tolerance which people evince at a given time are partly dependent on the character of their age or culture and its conception of what is or is not possible. It is not wholly an individual matter.

It may be asked whether the foregoing does not constitute or involve some kind of *attitude* on the perceiver's part, an attitude which can be labeled an aesthetic attitude or part of an aesthetic attitude, even though this is not what such aestheticians as Bullough, Stolnitz, and Vivas mean by "aethetic attitude." My view is that the answer is no,[22] though admittedly what I have described can be easily confused with an attitude. To treat the ideas in a work of art, its story or plot, characters, or anything else that it may depict in the manner

described above is simply to make an effort—which is not an attitude and does not necessarily involve or presuppose an attitude of some kind—not to let their truth or falsity, their resemblance or lack of resemblance to the real world or to actual persons, occurrences, and so on interfere with or obstruct our enjoyment of them as art. It is true that if the perceiver admired or revered the particular work or its creator, he would normally make a serious effort not to let anything in or outside the work interfere with his enjoyment of it. Or if he is contemptuous of it or its author, he would normally not take pains to attend to it in this way—if he attended to it at all. A positive or a negative attitude therefore tends to make the perceiver attempt or not attempt, ready or not ready, to react to the work of art in the right way and hence for the right reasons. But these things are not an attitude and do not presuppose the existence of some attitude toward the work. Indeed, what I have been saying is that we should read, listen to, watch, or look at *all* works of art in this manner, and so respond to them in the right way, independent of their merit or demerit or of what we may come to think of them once we have listened to them, read them, and so forth. And clearly this is logically and empirically possible before we have formed any idea about a particular work and before we have any idea whether we are going to like or dislike it.

NOTES

1. Richard Kuhns, "Intention as a Category in a Theory of Criticism," *Proceedings of the IV International Congress On Aesthetics* (Athens, 1962), pp. 641–43. The interested reader is also referred to Richard Kuhns, "Criticism and the Problem of Intention," for an enumeration and discussion of the different uses of 'intention' in current aesthetic literature.
 2. *Ibid.*, pp. 14–15.
 3. (London, 1940).
 4. *Ibid.*, pp. 13–14.
 5. Some aestheticians would speak of an inference based on the work's features. But an inference presupposes the existence of a definite logical

or factual relation between the ground and consequent. Even 'factual connection' is too strong a term for the description of the present situation.

6. Note the important difference between what an artist may intend a particular work to convey or "say" and the kinds of effect he wishes to produce by means of it, and his intention *to create it*, before he has actually done so. An artist may intend to create a work of a certain description; and he may succeed in creating some work of art (he may realize his aim to produce a work of art) but may fail to create a work of art of the desired description. On the other hand, although an artist may or may not have any particular aims that he desires the work to realize— he may or may not have, as we say, any particular aim in mind *in* creating the particular work—he may nonetheless aim at creating a work of art of a certain kind; for example, one employing the stream-of-consciousness technique, a symbolic or an "existential" work, and so on.

7. See for example Richard Kuhns, "Intention as a Category in a Theory of Criticism," *passim*; "Professor Frye's Criticism," *Journal Of Philosophy*, Vol. LVI, No. 19 (September, 1959), pp. 749 ff.; and "Criticism and the Problem of Intention," *Journal Of Philosophy*, Vol. LVIII, (January, 1961), pp. 5-9.

8. "Criticism and the Problem of Intention," p. 15. In the articles alluded to in note 1, Kuhns is concerned with the role which knowledge of the artist's intention plays in criticism. But much of what applies to the critic in the present connection also applies to the perceiver who is not also a critic, and vice versa. (See Part III, Chapter 10)

9. I cannot go along with Eliot's tendency in *The Frontiers of Criticism* to equate the understanding and the enjoyment of a work (for the right reasons). Cf. "To understand a poem comes to the same thing as to enjoy it for the right reasons." *Ibid.*, p. 17. But Eliot really identifies understanding and enjoyment by express stipulation. For as he goes on: "One might say that it means getting from the poem such enjoyment as it is capable of giving. . . ." *(Ibid.)* So my point is essentially that Eliot's departure from ordinary usage wipes out an important distinction. But he appears to restore it when he says that genuine poetry may communicate before it is understood. Here 'communciation' appears to be used more or less in the same way as our (the ordinary) 'enjoyment.'

10. It is clear that those who hold the Marxist-Leninist view of art, or social realism, would reject what follows as false, in line with their attribution of social, political, and related functions to art. They rightly regard these ideas as capable of playing a central role in the realization of these (alleged) functions. The official attitude of the Soviet hierarchy toward Pasternak's *Dr. Zhivago* illustrates this.

11. The relation between ideas in a work and the work as a whole is

often so complex that even in the case of literary compositions the distinction between 'sentence' and 'statement' gives only a very partial and (taken by itself) somewhat misleading picture of the situation. As for paintings, sculptures, musical compositions, and so on, the distinction clearly cannot apply except in a highly analogical way.

12. Cf. John Hospers. "Implied Truths in Literature," W. E. Kennick, *op. cit.*, pp. 309–23. But Hospers does not offer any evidence for his view.

13. "Dante," in *Selected Essays, 1917–1932* (New York, 1932), p. 230.

14. *Ibid.*, p. 229. Italics mine.

15. *Ibid.*, p. 230. But we must not suppose that this and the preceding quotation are factually true statements. If my analysis of ordinary aesthetic discourse is correct, these statements are analytically true, are true (partly) by virtue of the everyday uses of 'enjoy fully'.

16. Note the parallelism between the distinction between the perceiver qua perceiver and qua man, and the distinction Eliot draws between the poet qua poet and qua man.

I shall leave it to the reader to decide whether the observations in the text above alluded to here concern a form of "distancing" in Bullough's use of this term.

17. *Ibid.*, p. 219.

18. Similarly—but in the opposite way—with Coleridge's "suspension of *disbelief*."

19. Bullough's use of 'distance' here is unfortunate, since it refers to a phenomenon of quite a different sort from what he calls "psychical distance," the alleged aesthetic attitude. This and its clearly metaphorical character (which it shares with its latter use) *can easily* mislead the unwary reader.

20. Kennick, *op. cit.*, p. 534.

21. *Ibid.*

22. But note my remarks on the psychologist's use of 'attitude' in note 1, Part II, Chapter 8.

PART III

The Criticism of
a Work of Art

Chapter 10

The Uses of "Good"
in Aesthetic Judgments

In Part I I considered some aspects of the ordinary concept of a work of art; in Part II I considered both the concept of standard conditions and certain types of factors that appear to constitute standard conditions of the perception and the enjoyment of art. Since the concept of standard conditions relative to art is logically connected with the concept of a work of art, that inquiry was intended to clarify further the latter concept. In this third and final part of the book, I shall consider the valuation of art. This constitutes a further fundamental facet of aesthetic discourse and completes our inquiry.

In this chapter I shall analyze the uses of 'good' and 'poor', and other value terms as they occur in aesthetic judgments made by critics, artists, and laymen. I shall begin with (1) judgments of the form "X is good art" (or "X is a good work"), and "Y is poor art" (or "Y is a poor work"). I shall then consider (2) judgments of the form, "W is a good (very good, and so on) poem," "N is a poor (very good, and so on) painting," and so forth. In order to attain a degree of clarity not usually encountered in current discussions of aesthetic or other types of value judgments, and in order to avoid the errors which these discussions are prone to, I shall make an important distinction between what I shall call (value) "judgments" (following common philosophical usage) and "value sentences." By 'value sentence' I mean a sentence in which 'good', 'poor', or some other value term occurs, in a contextual vacuum, as such. The sentence "X is

good art" is an example of this. By 'judgment', on the other hand, I mean a value sentence *in use* as applied by someone at a given time in a given place. Thus this distinction corresponds to P. F. Strawson's distinction between "sentence" and "statement" in relation to descriptive utterances in the indicative mood. Although we shall see some interesting differences arising in relation to the two, it should be pointed out that a value sentence *means* and hence *states* something or a number of things (depending on whether the words occurring in it are univocal). Consequently it *entails*, or *logically implies*, something or a number of things (depending on the number of things it means). But, unlike a judgment, it does not assert anything whatever. On the other hand, a judgment X *entails*, or *logically implies* whatever the value sentence X entails or logically implies, by virtue of its being the latter, in some actual or imagined context. For these reasons—as well as because in actual aesthetic discourse we deal with judgments rather than value sentences as such—we shall chiefly discuss the aesthetic uses of 'good', 'poor', and so on in relation to *judgments*, referring to value sentences as the need arises.

I

(1) The first and most obvious point is that the judgment "X is good art" is explicitly and directly about a particular work X (which is a particular poem, painting, symphony, and so on in the descriptive use of these words). It is not directly or explicitly about any other work or works, or about the person making the judgment— including his feelings, emotions, or attitudes.[1] Moreover, the judgment asserts, in a straightforward sense of this word, that X is good art.

(2) Since, by definition, a judgment is made by some person A at a given time in a given context, we are justified, *if certain conditions prevail*, in *inferring* from A's making the judgment that, at that moment, he believes (or believed) that X is good art. This inference is justified if A is conscious of what he is saying and fully understands its meaning, and he says it seriously, sincerely, and so on. If we believe that A is lying, joking, or being ironical, speaking in his sleep, under

the influence of drink, narcotics, or anesthesia, we would not ordinarily say that he believes that X is good art. If he is lying, joking, or being ironical, we would go on to say that he does *not* believe X is good art, does not mean what he says. On the other hand, the question of what he means or does not mean would not make sense— hence would not arise—if A merely recites "X is good art," utters it in his sleep, in a state of delirium, or the like.

The following exchange will explain what I mean. A: "John said the other day that your painting is perfectly good art." B: "I suppose I can assume that he meant what he said, that he believes that my painting is good." A: "I certainly think so. John did not seem to be merely trying to be nice, or speaking tongue in cheek." I think we do not ordinarily say that John's *judgment*, in the above circumstances, implies in some sense that John believes that X is good art. I do think we say that the hearer can properly *infer* this from the fact that the speaker apparently made it seriously, sincerely, and so forth. And the ordinary use of 'seriously', 'sincerely', and the like in "A seriously, sincerely said Y" analytically (logically) implies that A believed Y. When we are unsure of the speaker's sincerity or seriousness, we usually ask, "Do you really mean what you say?", meaning in this case: "Do you believe what you said?" We say "I know he didn't believe what he said, that he was pulling our leg. I know it from his expression, his voice. If anyone thinks he believed it simply because he said it, he is utterly wrong." Note that the propriety of inferring the foregoing is independent of the particular judgment or kind of judgment made. The same inference can be justifiably made under the same, "standard," conditions, in the case of descriptive statements such as "The earth is round" and "This table is brown." But I do not wish to insist too strongly on the inapplicability of 'imply' and 'implication' in this connection.

(3) The judgment "X is good art" *logically implies*, in an ordinary sense of this expression [2]—that is, by virtue of the ordinary meaning of 'good art'—that X is worthy of being praised, prized, liked, or made much of, hence that the fitting attitude toward it is a "pro-attitude." At the same time, we can justifiably infer, whenever the above-mentioned or like standard conditions prevail, that (a) its author *believes* that X is *worthy* of being praised, prized, liked, made

much of, and (b) he likes or enjoys X. When someone seriously and sincerely asserts that a particular work X is good art, we do not feel that there is anything presumptuous or odd in the hearer's reacting with "So you like (or enjoy X)." A common reply to this is "Yes, I do!" We are rather discomfited when we get, instead, "No, I don't!" The remark requires explanation. The explanation which I think we would get in this particular type of case (unless the speaker is joking, being ironical, or the like) is that the speaker assumes, believes, or supposes X to be good on the authority of someone he regards as a reputable expert or critic, or even on the authority of a book, a magazine article, television, a parent, and the like. (If the person, say a child, is merely parroting the opinion of someone else, say an older person, in saying that "X is good art," the prevailing noetic conditions will be nonstandard ones.) But whenever we hear this explanation we immediately tend to retort, "But then you should not have categorically said that X is good art—you should have said that you think, believe, or assume that X is good art, on the authority of someone else." The last phrase is essential here, since a person may seriously, and so on say "I believe that X is good art" on the basis of his own reactions to X, but may not be sure whether his reactions are, and so his judgment is, the right or proper one. Thus he may think that X is good art *because* he likes or enjoys X (or liked or enjoyed it so far), but may have some doubts as to whether he is *qualified* to *judge* X.

The upshot is that a self-contradiction would be involved if a person qualified to judge X or works of the same kind as X, seriously, and the like, asserts that X is good art *on the basis of his own responses* to it under O-conditions, and yet maintains that he does not like or enjoy (or has not so far enjoyed or liked) it.

Similarly with the statement "X is poor art—but I like (enjoy) it," made under the same kinds of conditions as the foregoing. Whenever anyone makes such a statement we either assume (with him) that at least his own responses to X cannot be trusted, and/or that the conditions under which he has read, heard, or seen X have not been O-conditions.

It is clear that if, as I claim, the speaker's making "X is good art" *implies* (under the above-specified conditions) that he likes or enjoys

X, this statement cannot possibly *state* or *mean*, or include in its meaning, that the speaker likes or enjoys X. Also, of course, "X is good art" is not, in ordinary or in critical discourse, elliptical for "I like X and so I think that it is good art" or anything of the same kind.

A certain amount of respect is attached to a work X that is considered to be good art. The greater the degree of excellence attached to it the greater this respect generally is. If X is judged to be a great work, a masterpiece, or a classic, respect may turn into deep awe, including a feeling of profound amazement at the depth or sweep, power or exquisite delicacy, violence or gentleness, or technical perfection displayed by it. Concomitantly, we feel profound awe as we marvel at the artist's genius, his skill, insight, sensitivity, taste, humanity, emotional or intellectual maturity, and the like. To borrow the apt expression from W. B. Gallie we used before, "X is good art" states that X, as good art, constitutes an achievement, and the sense of wonder or awe, and the praise which the honorific words 'good', 'very good', and the like involve in their customary uses are but the proper attitude toward this achievement. Let us recall, however, what we pointed out in Part I, namely, that the achievement of a good poem, good painting, and so on as a work of art is due to its being good of its own kind—good as a poem or painting, and so as art. A poor poem or painting cannot be meaningfully said to be, as a poor poem or painting, an achievement in any degree. What modicum of achievement it represents, if any, will be due to whatever artistic *merits* it has, if any, alongside its defects. If it is an extremely poor poem, painting, and so forth, we should say that it has not achieved anything as art, or as a poem or painting. We do not ordinarily regard a poem or a painting as possessing merit superior to (say) that of a table or a chair, just because it is a poem or a painting rather than a chair or a table.

Writing a *good* poem or painting a good painting is frequently regarded as a greater achievement than the construction of a good chair or table. This is partly due to the greater difficulty of writing a good poem or painting a good picture than making a good table or chair, but it is chiefly due to the greater value attached to good poems or paintings. (I am assuming here that the chairs or tables in question

are not also works of art.) This greater value is obviously not aesthetic value; it is of a more general sort than aesthetic value and the (specific) value of good chairs or tables (as good of their own kind). It is the one involved in such statements as "Works of art [meaning *good* works] are valuable," and "Works of art [meaning good works] are more valuable than tables [meaning good tables]." The same general (kind of) use of value terms is involved in maintaining that it is good to be happy or to have knowledge.

We said that to state that X is good art is to imply, among other things, that X is worthy of being praised, made much of, or prized. This means that whenever necessary, and as much as possible, we shall try to preserve it from damage, destruction, or loss—that is, it would be reasonable or rational to conserve it. The notion that what is good should be preserved is of course not confined to aesthetic worth. Whether this—say, in the case of art—consists of or includes a moral obligation to conserve what is good is an important question, but one into which we cannot enter.

(4) In addition to what it states and logically implies, the judgment "X is good art" expresses certain things, *under the standard conditions listed above*, in a sense of 'express' different from 'mean' or 'state', or 'entail'; that is, in the sense which the Ethical Emotivists believe is involved in the case of moral judgments. It is the sense in which interjections express joy, fear, surprise, or some other feeling, emotion, or attitude. It is also analogous to the use of 'expression' and 'express' in such statements as "The look in her eyes expressed profound horror" and "There was an expression of amazement on her face."

The following appear to be expressed by "X is good art" under standard conditions:

(a) The speaker's or writer's own feeling or attitude of *liking* or *enjoying* X. This is the "expressive function" of 'good'. Other aesthetic value terms such as 'very good' and 'excellent' have a similar expressive function. The difference in the expressive element in relation to "X is good art," "X is very good art," "X is excellent art," and so on lies in the extent of the liking or enjoyment involved. The statement "X is very good art" expresses the author's greater liking for X, qua art, than "X is good art." However, there is no precise gradation in

the extent of liking involved in the use of 'good', 'very good', 'excellent', and so forth. Moreover, whether any difference in expressive content is intended when a person uses "X is excellent art" and "X is a first-rate work," or "X is first-rate work" and "X is a masterpiece," pretty much depends on the individual user. Some people distinguish 'excellent', 'first-rate', and 'masterly', while others use them interchangeably. It is clear that this expressive element is closely related to (what we claimed to be) the fact that "X is good art" logically implies that the speaker or writer likes or enjoys X. When someone states that X is good art, his judgment implies that he likes or enjoys X. If the prevailing conditions are standard noetic conditions, and if the judge has made his judgment on his own initiative and so forth, we can validly infer that *he actually* likes or enjoys X. At the same time, his statement "X is good art" *itself* can and does *express* this liking for X. As a matter of fact, we usually discover whether the speaker actually likes X from his tone of voice, the expression on his face, and, sometimes, his gestures; that is, from whether we detect any *expression of the appropriate feelings* (liking or enjoyment) in his utterance. Unfortunately, we are not infrequently deceived: the speaker only *seems* to be expressing these feelings, and we are taken in by his clever dissembling. If we are experienced, we do not hastily conclude that because the speaker appears to be speaking with feeling he is serious, sincere, and so forth, or that standard noetic conditions actually obtain.

(b) The statement "X is good art" *sometimes* expresses a *desire* on the part of the speaker that the hearers should likewise like X, or enjoy it whenever they see, hear, or read it in the future; that they should commend it as he himself commends it; that they should want—nay, be anxious—to look at it, read, or reread it, or listen to it as often and as carefully as they can. This is particularly true if the speaker judges X to be a very fine or excellent work, or a masterpiece. Sometimes, whenever the speaker or writer thinks (rightly or wrongly) that the safety or even the very existence of the work is threatened, "X is good art," made under standard noetic conditions, *may* also express its author's desire [2] that the hearer should likewise desire that X may be preserved, and be prepared if possible to help preserve it from loss, damage, or destruction. This element is perhaps

most frequently and clearly expressed by such judgments as "X is a very rare masterpiece," "X is absolutely unique in the art treasures of the world," or "X is a priceless work." It frequently takes the form of "But X is a *rare masterpiece!*" or "But X is absolutely unique!" in *protest* against the intention or the attempt or some group, government, or individual to destroy X, say, in time of war or revolution, or because of some political or economic exigency. (The threat to the great temple of Abu-Simbel in the Nile Valley is a topical example of this last type of reason.) It is clear that in the case of literature or music the text or the score of the work will be in question; while the original painting, sculpture, or work of architecture will be in question in the case of these plastic arts.

Closely linked to the expressive function of "X is good art" is its "dynamic" function, which is analogous to the dynamic function of ethical judgments about which writers such as C. L. Stevenson have written so prominently. The sentence "X is a good art" and similar aesthetic sentences are not only *conventionally intended to express* the speaker's liking, and his commending, X; they are also conventionally intended to influence the hearer's (1) feelings or attitude, and (2) his judgment about X. The former may mean different things in different contexts. If the hearer has not been exposed to X and has no feelings at all about it, the judgment will be intended to dispose him favorably toward X, so that when he is exposed he will enjoy it. On the other hand, if the hearer is familiar with X and is indifferent to or dislikes it, the judgment will be intended to instill a favorable attitude toward X or to combat, and, if possible, reverse the hearer's unfavorable attitude. It is obvious that there are other possible types of situations in which aesthetic judgments are intended to influence the hearer's feelings or attitudes toward particular works, whole classes of art, or art as a whole.

(c) Aesthetic judgments, such as "X is good art," are also normally intended to influence the hearer's critical judgment or evaluation of the particular work. This is a dynamic function of aesthetic judgments distinct from (1) above. For a person may like, or may be influenced, by another to like a particular work and yet may not regard it as good art; though there is, I think, a general tendency on a man's part to consider as good (or poor) art those works which he

likes (or the opposite). A person's emotional attitudes or taste may be unconsciously influenced by the judgment of his elders, teachers, favorite authors or critics, or other mentors; and yet he may consciously and intellectually reject his own taste or emotional attitudes, thus shaped, as unreliable or unsound. The converse of this statement is not, I think, as generally true. A person may regard a work X as good (poor) art, or may be moved by another's praise (or condemnation) of it to regard it as good (poor) art, without thereby liking or coming to like X. In any case, whether an aesthetic judgment succeeds in influencing the hearer's emotional attitude, critical judgment, or both depends on all sorts of variable factors. This is an obvious fact unfortunately overlooked by many who emphasize the dynamic function of aesthetic (or other, ethical) judgments. For instance, it depends to a considerable extent on who the judge is, or rather, on how sound, authoritative, or respect-commanding his aesthetic judgments are regarded by the hearer. Thus in many cases it depends on the relationship, if any, between the judge and the hearer. The dynamic capacities of a given aesthetic judgment, or a series of them, are not solely a function of the laudatory or opposite meaning—hence the positive or negative emotive coloring—of 'good', 'very good', 'poor', 'very poor', and so forth as the case may be. It is clear that the critical judgments of an Eliot, a Read, a Berenson or an Edmund Wilson, the critics of the *New York Times* or the *Literary Supplement of The London Times,* carry immensely greater weight with many people interested in the arts than the judgments of a John Smith or the critics, if any, of a little town's local paper.

At the same time, and in contrast to this, the pronouncements of a respected elementary- or high-school teacher may play a much greater role in shaping the tastes of his or her students than all the learned critical treatises of the renowned critics. Indeed, the cumulative effect of the aesthetic judgments, among other things, of one's high-school or college literature or art teachers, spread over a period of months or years, may be so profound and lasting as to be almost indelible. This is particularly true of childhood and adolescence and most of all in the case of sensitive, impressionable persons. The youngster's general artistic taste, not merely his reactions to or judgments about particular works, may thus be molded. It remains, how-

ever, that the judgments of an Eliot or a Wilson on literature (particularly about certain specific genres of literature), or of a Herbert Read or a Berenson on painting (particularly about certain specific periods or schools) are generally more trustworthy, more judicious, more worthy of being heeded and followed than those of a John Smith or one's art teacher.

Despite the importance of attendant circumstances in making possible or reinforcing and enhancing the dynamic roles of aesthetic judgments, these functions of the latter frequently cannot be fully realized without the help of reasons. And whenever such reasons are successfully provided, in the sense that the hearer regards them as sound, we accept the judgment whether our emotional attitude toward the work is affected. Thus the justification of aesthetic judgments is an activity intimately tied up with their dynamic or persuasive functions. Moreover, if our distinction between the intellectual and emotional dynamic functions of aesthetic judgments is sound, it is seen that reasons may play a logical, as well as psychological, role in relation to this function of aesthetic judgments. Providing good reasons for "X is a good art," say, is seen as the presentation of rational arguments for the justification in a literal sense of this word (in the sense of 'validation', as Herbert Feigl, for example, uses this word) of the judge's belief that X is good art. It is not merely a psychological device to influence our feelings or judgment in the desired way. (On the other hand, it is not merely the mustering of logical arguments to convince us of the correctness of the judgment; though it is, perhaps, primarily intended to do so, by the fact that it *is* logical argument.)

It is true that reasons given for "X" is good art" may sometimes affect our judgment of X, even if we do not regard them as good reasons, merely through their influence on our feelings toward X. These feelings, thus influenced, may bring about the desired judgment or the desired change of judgment. The crucial point, however, is that we do not, either in lay or professional critical discourses, normally speak of being *convinced* if our judgment is swayed by any psychological forces operating on us. This means that disputes are not *always* wholly due to differences in our feelings or attitudes toward these works; that even when these differences are eliminated, the

question of whether the particular work *is* good or poor remains. Moreover, even when two persons A and B initially agree in liking or disliking a work X, they may or may not agree on the reasons why they think (if they do) that X is good or poor, respectively. Another person C may judge A's reasons as sound and B's reasons as unsound (or less sound than A's reasons), whether he feels the way A and B feel about X. All this is directly related to our earlier remarks about liking a work X and X's being good or poor art. We maintained, first, that "X is good art" does not mean "I [the speaker] like X." The former means that when A and B disagree about X's goodness or badness, A is not saying that *he* likes X and B saying that *he* does not like X. If this were what they were in fact saying, there could not possibly be any genuine disagreement or dispute, any difference of *opinion* as opposed to feeling, about X's goodness or badness.

The upshot is that when we give reasons for X's goodness, we are not thereby giving reasons for our liking or not liking X. Further, the fact (if it is fact) that when a person says "X is good art" he does not, as such, imply that he actually likes X, means that the question Why do you think that X is good art? does *not* logically *imply* (it also does not mean) Why *do you* like X? Thus even if one's asking the latter question were an oblique way of asking why one's emotional attitude toward X is what it is, the answer to this question would not be a proper answer to the former question. It would be absurd for our judge to reply to "Why do you *think* (believe, judge) that X is good art?" by saying: "Because I like X." What is more, the fact that "X is good art" does not, as such, imply "I like X" means that anyone who knows the meaning of these two statements, and who asks "Why do you think X is good art?", *will not be thereby asking* "Why do *you* like X?"

Closely related to the two aspects of the dynamic function of aesthetic judgments we have noted is (3) their function in influencing the hearer's behavior. Like the other two aspects of the present function of these judgments, this element may or may not be present in any given instance. It may also be absent even when the speaker intends to influence the hearer's attitude or judgment. It may even be absent when the judgment, together with the attendant circumstances, *actually influence* the hearer's attitude toward, or critical

opinion of X. But an aesthetic judgment cannot, empirically speaking, influence the hearer's behavior—say make him buy X if X has been praised—unless it influences his attitude toward X or his critical opinion of it. However, aesthetic judgments may actually influence the hearer's behavior even when the speaker does not aim to do this by his judgment or in any other way for that matter. The present, "influential" role of aesthetic judgments is, of course, most frequently discernible, and with best (in the opinion of many artists with pernicious and devastating) effect, in the pronouncements of professional critics. An important part of the critic's task is to direct and guide the reader, listener, or spectator to enjoy the best in the particular art at a given time and place. Respected professional critics certainly wield great power over the ordinary art lover in the books, records, or paintings—or the concert or theater tickets—he buys. Hence the artist's almost proverbial dislike for critics. But the respected critic does not only affect the layman's behavior; he also frequently affects, positively or negatively, the behavior of artists themselves. It takes an extremely self-confident or opinionated artist not to be influenced, next time he takes up paint and brush or pen and paper, by a prestigious critic's panning of his latest exhibition or most recent play. There are many examples of obscure but talented artists who were able to perfect their art and therefore, in some cases, attain recognition thanks to the criticism and encouragement they received from friendly critics or fellow artists. The vicissitudes of the great temple of Abu-Simbel in the Nile Valley illustrate the present "influential" role of aesthetic judgment. We can imagine how the anxiety of some nations to *preserve* that art treasure may have been brought about, or stimulated, by the pleas of archaeologists, artists, and other art lovers. Thus the safeguarding of that treasure for posterity, now fortunately assured, is at least in large measure due to the recognition of the temple's great artistic worth.

(5) In addition to the various things which we said "X is good art" implies, alone or together with certain other propositions about the speaker or the particular work X used as further *premises*, this judgment has two further implications about the character of X itself. Indeed, it would be surprising if "X is good art," which is directly about X in a perfectly straightforward sense of 'about', did not

imply anything at all about the sort of thing X is qua art. If we analyze the kinds of situations in which we apply the expression 'good art', I think we discover that a work is called "good art," under what are regarded as O-conditions, if it is regarded as having realized, or as capable of realizing in an eminent degree one or more of the affective aims of art which we discussed in Part I [3] and which will be further discussed in Chapter 11. That is, a work is regarded as good art if it is believed to be capable of emotionally moving us, of stimulating our imagination or our mind, and thereby giving us enjoyment. Whether a particular work X will be regarded as good if it only exhibits, or is thought capable of exhibiting, *one* (any one) of the foregoing sorts of effects depends on the particular judge if not also on X.

Some individuals or groups notoriously employ more stringent standards in their valuation of art than other individuals or groups. Thus some judges regard enjoyableness as a necessary but not a sufficient condition—while others regard it as both a necessary and a sufficient condition—of excellence. The former view is usually based on the assumption that what matters in art is not merely the fact of enjoyment but its quality or kind. In other words, the nature of the feelings evoked or capable of being evoked, the presence or absence of imaginative or intellectual stimulation, and the like are equally, perhaps more important, for these judges. However, like enjoyment, to which it is so closely related, causally or psychologically speaking, a work's ability to move emotionally is also, as we saw in Part I, definitely necessary for the work's being properly regarded as good. As with enjoyableness, different people may disagree as to whether it is a sufficient or only a necessary condition of goodness.

Be this as it may, it is I think true that a work will be more or less widely regarded as good art in proportion to the *number* of aesthetic aims it realizes. Indeed, one main basis of people's—especially the professional critic's—grading a particular work, as regards the *degree* of its goodness, is the number of aesthetic aims it realizes. The other main basis is the *extent* to which the work realizes *each* of the aesthetic aims it strives to realize, under standard conditions. This itself is resolvable into two or more factors. Other things being equal (provided that the work, as a whole, is enjoyable), the deeper and

the more intense the work, hence the more lasting the feelings evoked by it under standard conditions, the better it is generally judged to be. Similarly a work is rated higher than otherwise if, other things being equal, the ideas it expresses or stimulates in us, if any, are profound, sweeping, and humanly significant. For these reasons such expressions as "very stimulating" and "very evocative" are generally taken to imply high praise, since both expressions cover several of the aims of art, that is, stimulation of the imagination and of the mind (thought), and the arousing of feeling.

We can now say, therefore, that "X is good art" *logically implies* "X realizes, under standard conditions, one or more (preferably more than one) of the aims of art, in a sufficiently marked or eminent degree." (What constitutes a "marked or eminent degree" is usually a relative matter.) Correspondingly, a work X is judged to be good art if it is believed to possess sensuous or nonsensuous features [4] which enable it to realize the aims of art in an eminent degree under standard conditions. Thus "X is good art" also implies that X possesses certain unspecified sensuous or nonsensuous features of a certain kind, features which enable it to realize (one or more of) the aims of art in an eminent degree, under standard conditions. It is absolutely essential to realize that "X is good art" does not imply that X possesses any *particular* sensuous or nonsensuous N-feature, or any particular set of such features. As stated in Part I, this is to be expected from the crucial fact that there are no necessary and sufficient N-features of a specific or relatively specific nature, an "essence" which makes an object, activity, or set of sensible and other qualities a work of art in the descriptive sense. The absence of an "essence" renders unsound the view that the goodness of a good work is due to its possession, in a marked degree, of some or all of the features that the essentialists regard as necessary or sufficient for a thing's being a work of art in the descriptive sense. This is directly seen from the nature of the reasons people adduce in support of their judgment that a particular work X is good art. As we shall see in greater detail in Chapter 12, these reasons sometimes [5] consist in the judge's pointing out what he believes are the sensuous or nonsensuous features of X which he regards as good-making features.

The important point is that a very wide variety of features is ad-

duced by different people in judging X to be good art, or in one and the same person's appraisal of different works X, Y, Z, and so forth, as good art. No single feature or group of N-features is regarded as *necessary* for a work's being good art, though in regard to a particular work X, Y, or Z, a certain limited number of N-features possessed by it is deemed sufficient to qualify it as good art. So "X is good art" logically implies that X possesses some unspecified subset of N-features a, b, c, d, and so forth, or a, c, n, p, or c, f, g, r, or another subset, which makes it good art. Some of the subsets may partly overlap; some good works may possess certain good-making N-features in common, while there may be good works that have no single good-making feature in common. Like the larger "family"—the family of works of art, good or bad—to which they belong, good works *may* possess certain crisscrossing "family resemblances." More important, there is no single specific N-feature or group of N-features that must be present in all works A, B, C, D, and so forth in order that they may be correctly *called* "good art." If two or more works, A, B, and C have certain specific good-making features in common, or if the good-making features of the one also constitute the good-making features of the others, this will be an interesting contingent fact about them. They will not possess these common features qua "good art" in the ordinary sense of the term.

What we have been saying about the aesthetic use of 'good' ('very good', 'excellent', and so on) applies point by point, *mutatis mutandis*, to the aesthetic uses of 'poor' ('very poor', 'extremely poor', and so on) in judgments of the form "Y is a poor work," and to 'bad' in judgments of the form "Y is bad art." Thus to say that a particular poem, painting, or musical composition Y is a poor work of bad art is to grade it low on the scale of artistic excellence, to evince a feeling or attitude of dislike or distaste toward T and to attempt to induce, by the negative emotive coloring of 'bad', 'poor', and so on, a like reaction toward Y in the hearer, and to influence his behavior accordingly. Whenever the appropriate noetic conditions we outlined in relation to 'good' prevail, we can also correctly infer that the speaker dislikes Y, that he believes that Y is worthy of dislike, disapproval, and so on. Thus, among other things, "Y is a worthless work, is trash" logically implies that Y lacks the capacity to realize

any of the general aims of art—that it is incapable of giving any enjoyment to qualified perceivers under standard conditions, that, on the contrary, it arouses in these persons irritation, displeasure, boredom, and other unpleasant feelings. On the other hand, "Y is a very poor work" is commonly used to imply the same as "Y is a worthless work" or is assigned a slightly higher position on the scale. And the latter means that Y either evokes somewhat less intense feelings of irritation, displeasure, boredom, and the like than a work said to be completely worthless, or that it evokes no response at all, makes no impression at all on qualified judges under standard conditions.

Further, "Y is poor art (a poor work)" may imply that Y is only capable of producing a feeble positive effect in qualified judges under standard conditions, and therefore, that it serves the general aims of art only very imperfectly. It gives the qualified judge little pleasure, or what pleasure it gives is superficial and of short duration. The grading of particular works may progress from "passable," "mediocre," "average," "fair," up to "above average", "fairly good," and thence to "definitely good," "quite good," and the higher, more positive gradations of the scale.

Corresponding to the foregoing, "Y is poor art" logically implies that Y lacks certain (kinds of) sensuous or nonsenuous features which are deemed by the judge to be necessary for its realizing, in an appreciable degree, the general aims of art or those of them which it attempts to realize. And this sometimes means that Y possesses features that incapacitate it from producing any but "unaesthetic" effects, such as irritation, displeasure, or boredom, under standard conditions.

We should emphasize that the above discussion regarding one use of 'good' and 'poor' in aesthetic judgments applies without qualification only when a work is believed to be artistically complete. A fragmentary poem would not be ordinarily called a poor poem if it fails to create a well-rounded effect. Nor would we expect an obviously unfinished painting to be very effective. But (1) sometimes it is very difficult if not impossible to decide whether a given work is to be regarded as artistically complete. Aristotle's concept of "having a beginning, a middle, and an end" is, to say the least, not always

helpful, even in tragedy, to which it was originally meant to apply. Some of the difficulties are illustrated by Keats' "Hyperion" and Schubert's "Unfinished Symphony." The latter is certainly a complete musical work though an "unfinished" classical symphony, while the former seems to me to be both a fragment of a poem ('poem' being used here as the name of a literary genre) and artistically incomplete. Furthermore (and this is also significant for other reasons), the artist and his public sometimes disagree about the *artistic* completeness or incompleteness of a given work. (2) We may and sometimes do pass judgment on an unfinished work, calling it a good or a poor work (though we often speak of it as a "fine *fragment*" if we regard it as good) [7] on the basis of what there is of it (as in Keat's *Hyperion*). Also, on the basis of the extant portion of an unfinished work, people often make guesses as to the artistic merit the work would have were it complete.

II

Our analysis of aesthetic judgments of the general form "X is good art," "Y is a poor work," in Section I enables us to deal quickly with the less general, more commonly framed judgments that have the form "X is a good painting," "Y is an excellent poem," "N is a fine symphony," "The *Aeneid* is a masterpiece of epic poetry," "*Hamlet* is a great play," and so on. To assert that a given work is a good (poor) poem, painting, symphony, and so on is logically to imply that it is good (bad) art, a good (poor) work, though not vice versa. More importantly, the analysis of such judgments as "X is a good (poor) poem" is basically the same, *mutatis mutandis*, as the analysis of "X is a good (poor) work," "Y is good (bad) art." The reason is simply that the aesthetic uses of 'good', 'bad', 'poor', and so forth are the same whether these epithets qualify (work of) 'art' 'painting', 'symphony', 'sculpture', and the like. The differences in the meaning, and hence the analysis, of "X is good (bad) art" on the one hand and "X is a good (poor) poem (painting or symphony)" on the other hand are due

solely to the differences in the meaning of the words qualified by 'good', 'poor', and so on—'art' or 'work of art' on the one hand, and 'poem', 'symphony', and so forth on the other hand.

In (a) "X is good (poor) art," X is judged to be good of its kind, just as in (b) "X is a good poem" X is judged to be good of its kind. But in (a) the kind of object involved is the whole class of art objects, including paintings, sculptures, works of music, and so forth as well as poems, whereas the kind of object involved in (b) consists merely of the class of poems. That is, the grading of X in (a) is performed in relation to the whole class of art objects, and utilizes one or more of the general criteria of artistic goodness, while the grading of X in (b) is performed in relation to a particular subclass of art objects, namely, poems, and utilizes one or more of the criteria of poetic excellence as opposed to (i) the general criteria of artistic goodness and (ii) the more specialized criteria of musical, architectural, or pictorial goodness, and so on.

The foregoing difference in what (a) and (b) actually *assert* entails corresponding differences in what (a) and (b) *logically imply* about the *work*, X; they do not themselves—for that depends on the meaning or uses of 'good', 'bad', and so on—entail any differences. What I have in mind will be immediately seen if we state what (b) logically implies about X. Briefly, it implies (i) that X realizes in an appreciable degree, under standard conditions, one or more and usually several of the *general* aims of poetry (which are, as we saw in Part I, those of art in general). That is, it implies that a qualified judge will find it enjoyable; hence that it is capable of evoking a fairly strong emotional response of a pleasurable nature in a qualified judge. If it satisfies the imagination and intellect as well as the feelings, it will be generally regarded as a very good or excellent poem. It will also be generally regarded as a very good or excellent poem if it satisfies any one of the foregoing in a very high degree: if, for instance, it contains very original or powerful ideas, or very original and signficant imagery. (In satisfying the demands of the imagination it will also satisfy, at least to some extent, the demands of our emotional "faculty"—similarly if the ideas it contains are humanly significant, and are expressed in a verbally pleasing way.) On the other hand, X will be regarded as a great work, a master-

piece, if it is thought to possess the capacity to satisfy all the aims of poetry (or of art) in a highly integrated fashion, and therefore in a very high degree.

The scope and significance of the ideas expressed and the imagery conveyed, and the depth and sweep of the feelings evoked, will also be an important factor in determining the degree of X's poetic excellence. This brings us precisely to the second major implication of "X is a good poem" with regard to the qualities X has. For (ii) this judgment implies that X possesses the necessary means for realizing these aims of poetry and of art in general which it does realize and that it possesses certain unspecified kinds of sensuous or nonsensuous N-features enabling it successfully to realize its aims, which make it an *effective* (thus a good) poem. As with "X is good art," "X is a good poem" implies nothing as to what the actual good-making features of X are. But it is clear that since the latter judgment refers to X as a *poem*, it implies first that the N-qualities possessed by X are the kind possessed by poems in general, qua called poems, that it employs words as its medium—probably in verse form, since the word 'poem' is not qualified by the adjective 'prose'. The kind of N-qualities X possessed would be spelt out further if our judgment is, say, "X is a good epic poem," or "X is a good sonnet," or even "X is a good lyric poem." The second part of that which "X is a good poem" implies about X's N-features is that X's *specific* N- hence A-features give it the capacity to realize its particular and general poetic (and artistic) aims well, under E-conditions. The degree of success implied in the judgment varies with the choice of value term—'very good', 'excellent', 'first rate' (also 'masterly', 'great')—indicating progressively greater or more marked success in the work's realization of the aims of poetry than 'good'.

We can now state, abstractly and schematically, the gist of what the judgment "X is a good poem" logically implies about X's N-qualities, as follows: "X is a good poem" logically implies that X possesses a certain unspecified subset of N-qualities a, b, c, d, and so on or a, d, r, n, and so on or w, x, y, n, and so on or . . . which enable it to serve in a considerable degree some or all of the aims of poetry (and of art). These aims may or may not coincide, however, with

some or all of the goals (if any) the artist himself had in mind in creating the work. The following should be noted about the foregoing implication:

(1) That "X is a good poem" does *not* imply that X possesses some particular property—an alleged property "good"—or one particular set of properties, which makes it a good poem. (The same thing is, *a fortiori*, true of "X is good *art*.") The set of good-making N-features which X as a matter of fact possesses is one subset of a large number of alternative subsets of such N-features. As schematically indicated, some of these possible subsets may partly overlap in different ways, to different extents. That is, while poem X may possess (say) the subset *a, b, c, d* of goodness-making N-features, another good poem Y may possess, say, the subset *a, d, r, n;* so that two of the good-making features of X and Y coincide, though they may be differently related to each other in the two poems. Thus two poems X and Y may be good because, among other things, the imagery in them is striking and original, and both are noteworthy for their verbal "music." On the other hand, X and a third poem Z may be good for quite different reasons; the subset of good-making features Z possesses may not have any features in common with the subset possessed by X.

Our thesis that different poems (symphonies or paintings) may be good of their kind for partly or wholly different reasons, that good poems (symphonies or paintings) are not good by virtue of their possession of a certain feature, "good(ness)," in common, is borne out by an analysis of the reasons or criteria we—critics and laymen—give for judging a particular poem X, Y, or Z to be a good poem. For such an examination reveals the striking *diversity* and *multiplicity of N-* (hence *A-*) qualities and relationships which we point out (the "criteria features") as evidence of X's, or Y's, or Z's goodness as a poem. For to give reasons for the goodness of a particular poem X is, in one form of this activity,[8] to point out explicitly the qualities or relationships which the judge believes X possesses, and which in his opinion make it a good poem. These criteria features are, jointly, one or another of the alternative subsets of good-making N- (and so A-) features which are *implied* by the judgment "X is a good poem." That is, to support the judg-

ment "X is a good poem" is to point out, from among the many possible subsets of good-making features which may be found in different poems, actual or possible, that particular subset which the judge believes X possesses and makes it a good poem. The correctness or incorrectness of the judgment will then depend on whether (a) X does actually possess the alleged features, and (b) these features are good-making ones relative to poems. That is, whether they are among those features that are implied by "X is a good poem."

(2) That fact, if it is a fact, that "X is a good poem" logically *implies* rather than asserts that X possesses certain (unspecified) good-making features is of prime importance. For this means (a) that any "naturalistic" account of 'good' in its aesthetic uses would commit an error. (Cf. Moore's Naturalistic Fallacy in his discussion of the "characteristically ethical" use of 'good' in *Principia Ethica*.) Indeed, any view which holds that "X is a good poem" (say) *asserts* and so *means* that X possesses some particular sensuous or nonsensuous feature or set of features—certain images, ideas, symbols; a certain description of some object, scene, person, or experience, and so on—would commit one form of the error which Moore labeled the Naturalistic Fallacy, using this expression in a very inclusive sense. The same is true if it is held that "X is a good poem" *asserts* or *means* that X has the capacity to produce certain kinds of effects such as to give pleasure to the qualified reader or listener under standard conditions (Subjectivism.) In both types of cases the error would consist in identifying two different things: the meaning of "X is a good poem" with the proposition, or conjunction of propositions, which states the *reasons* for X's being a good poem, and enumerates the features that make X a good poem ('X's' good-making features).[9] But they do not make it so in the sense that there is such a thing as a simple, "nonnatural" consequential property" called "good (ness)" whose presence *depends* on the presence of these features in X. These features make X a good poem in the sense that they enable it to give enjoyment to qualified perceivers when attended to under *E*-conditions by stimulating their feelings, or their feelings and imagination or intellect, and so on.

The upshot is that the criteria or good-making *N*-features of X

are not "defining features" of 'good poem'; they do not provide us with any kind of definition of 'good' in the present, aesthetic sense of it.

That "X is a good poem" does not mean or state "X had certain unspecified features *a*, *b*, *c*, *d*; or *a*, *n*, *r*, *s*; or . . ." is shown by the fact that the right-hand side proposition consists of a *disjunction of* simple *propositions* each of which enumerates one subset of features *a*, *b*, *c*, *d*, or *a*, *n*, *r*, *s*, and so on. It is clear that no proposition can be synonymous with a disjunction of propositions. It would also not do to suppose that "X is a good poem" is synonymous with *any one* of the propositions in the disjunction. If this supposition were true, *only one particular subset* of good-making features *a*, *b*, *c*, *d*, or *a*, *d*, *r*, *n*, or . . . could be correctly given as evidence for the excellence of *any* poem; namely the particular subset of features which occur in the definiens of the expression 'good poem'. But this is plainly contrary to fact. It is contrary to the actual practice of laymen and critics alike, who support their aesthetic judgments that two or more poems X, Y, and so forth are good by pointing out partly or wholly different features in each as criteria features of goodness. We frequently meet a similar variety in the reasons given by different critics—or even the same critic at different times—for their belief that a particular poem is a good poem. It is true that people disagree as to whether a particular quality or relation, or a set of these, possessed by a given poem, is a good-making feature of it (sometimes, even of any other poem).

Whatever the reasons for this disagreement, no disputant who knows the meaning of 'good poem' claims, or can validly claim, that he is right and his opponent wrong because "X is a good poem" *means* "X has features *a*, *b*, *c*, *d*" (the features he regards as *the* criteria-features of X's being a good poem). His opponent can point out by appeal to ordinary usage, as careful analysis of this usage shows, that no *logical* contradiction would be committed if one holds that X is a good poem but lacks features *a*, *b*, *c*, *d*— something which cannot possibly be true if "X possesses qualities *a*, *b*, *c*, *d* [in certain relationships]" gave us the meaning of "X is a good poem." Similarly with any other features that may occur in any poem, good or poor, which may be supposed to provide us with

the signification of 'good poem' or "X is a good poem." It should be added that a contradiction would implicitly obtain if we assert "X is a good poem" but at the same time deny that X possesses *any* of the *possible subsets* of good-making features in the disjunction *a, b, c, d,* and so on, or *a, c, r, n,* and so on or . . . and so on. But this would logically show that "X is a good poem" *asserts* and so *means* that X possesses either *a, b, c, d,* and so forth or *a, c, r, n,* and so on or. . . . The contradiction would arise because "X is a good poem" logically implies that X possesses one or another of these possible subsets of good-making features. For "X is a good poem" logically implies this by virtue of its meaning; to assert "X is a good poem," but deny that it possesses any subset of good-making features as a poem, would be to *assert* that X is a good poem but to *imply* that X is *not* a good poem. And this, by the nature of logical implication, involves a logical inconsistency.

The present test of noncontradiction, I should add, provides us with the second fundamental argument why "X is a good poem" cannot state or mean that X possesses certain specified or unspecified qualities. This argument is an application, to the aesthetic uses of 'good' ('poor', and so forth) of one statement of Moore's celebrated Open Question Argument, designed to show what Moore believed was the indefinability of 'good' in the characteristically ethical sense.

Our analysis of "X is a good poem," "X is good art," and other aesthetic judgments shows that normative aesthetic discourse—and in this it is similar to normative ethical discourse—is autonomous in the sense that it is not "translatable" into nonnormative descriptive language. (It is also autonomous in that it cannot be translated into the normative "language" of ethics or economics or other kinds of normative discourse.) As we saw in our analysis of "X is good art," the uses of the word 'good' can only be explained by means of other, equivalent normative aesthetic terms such as 'praiseworthy' or 'worthy of being praised', and the like. Let us note, however, that these expressions are not, strictly speaking, *synonymous* with 'good'. We would ordinarily say that a poem, a painting, or some other work of art, in the descriptive use of these words, is worthy of being prized because it is good. Its being good is a suffi-

cient condition of its being praiseworthy. Thus, "X is good art" entails "X is praiseworthy." But "X is a praiseworthy work" does not entail "X is good art" (or a good poem, painting, and so on), since a work of art may be praiseworthy for reasons other than artistic excellence. It may be so, for example, because it portrays its age or society faithfully, and is praiseworthy as a historical document. That is, 'praiseworthy' has a broader use than 'aesthetically good.' Similarly with "X is worthy of being prized" and "X is a valuable work" (or, a valuable poem, painting, and so on).

Despite the autonomy of normative aesthetic language, our analysis further shows that there is a definite link between normative and nonnormative language. This link is established by the logical implication between judgments of the form "X is good art" or "X is a good poem" or painting, and so forth) and the proposition "X possesses certain unspecified (kinds of) features a, b, c, d, or a, c, r, n, or. . . ." For these (kinds of) features a, b, c, d, and so on are all possessed by works of art as sensible objects or activities, or qua expressing ideas, possessing symbolic meaning, or evoking certain images, and so on. That is, they are "natural" features in G. E. Moore's sense of the word 'natural'. They are features referred to or described by descriptive, nonnormative expressions such as 'composition', 'orchestration of colors', 'rhythm', 'form', 'formal unity', 'coherent plot' (in a *partly descriptive* sense of 'coherent', 'organic unity', and so on).[10] Very frequently, however, these features *are* referred to by means of expressions that possess a highly positive emotive coloring. Examples are 'harmony' or 'harmonious', 'coherence' or 'coherent' (as value terms), 'unified' (theme, or plot), 'consistent' (characterization, plot), 'alive', 'powerful', 'vivid', 'full of movement'.[11] Moreover, many of these expressions are psychological terms. Both of these things are to be expected from the fact that certain features or kinds of features found in poems, paintings, or sculptures are judged to be good-making features because of the belief that they enable works exhibiting them to realize their affective aims as poems, paintings, or sculptures—or as *particular* poems, paintings, or sculptures.

What I said above about the "objective implication" of aesthetic judgments applies, with the necessary changes, to their "subjective

or affective implication"; the implication which, say, "X is a good poem" has about the kinds of effects X is capable of producing in qualified judges under standard conditions.

III

To end this discussion, I shall trace the precise relation between the uses of evaluative A-terms (those that comprise groups A, B, and C considered in Part I, Chapters 5 and 6) and the uses of 'good' and 'poor' as they are applied to art. In my "Art-Names and Aesthetic Judgments," alluded to earlier in this book, I maintained that art names are affective and so involve the notion of a capacity or power in their uses. If this is true, it would not be surprising to find that the A-terms in question likewise involve the notion of a capacity of some kind or other, and that these capacities are affective. By virtue of the affective character of art names, a painting, a poem, or a work of music is said to be good art, a good poem or work of music if it is considered capable of producing the kinds of effect it is expected to have as art (or as a particular kind of painting, poem, and so on), in a high or fairly high degree. This is directly connected with a work's possession or lack of possession of those "aesthetic qualities" which are designated by evaluative A-terms that grade positively, designate precisely those qualities which help a work to produce the kinds of effects it is expected to have as art (or as a particular kind of art). The opposite is true with A-terms that grade negatively. For instance, to speak of a painting as harmonious or unified is to regard it—as far as this feature is concerned—as good art, as possessing qualities which help make it good art. The opposite is true with lack of unity or harmony.

Second, to say that a work is harmonious or unified is to imply that it has certain unspecified N-features which are organized in some way or other, thereby making it harmonious or unified and so enabling it to give the qualified perceiver a sense of harmony or unity under optimum environmental conditions. The situation is different with the purely "descriptive" A-terms (group D). Those

N-features which, related or organized in certain ways make the work sad or gay, melancholy or cheerful, do not by themselves make it or help make it good or bad art. Within limits, they are compatible with its being either good or poor. Nevertheless, these A-features, and so the N-features responsible for them, often play a role in the work's goodness or badness considered in relation to other A-features,[12] including their contribution to the work's overall effect. For example, the melancholy of a certain melody, considered in relation to the gaiety of other, or the other, melodies in the symphony, opera, and the like may—depending on various other factors—lend it a valuable contrast and variety without disrupting its unity. Second, in order that a work may be properly said to be sad or melancholy, cheerful or gay, it must have *some* degree of artistic merit, though the merit does not have to be very great. That is, "X is a sad waltz," say, presupposes "X is at least fairly coherent, fairly effective, and so at least a fairly good waltz." A really poor waltz would not strike us as anything in particular.[13]

Further, just as there is no fixed number or combination of (any) N-features which necessarily (logically) makes a work harmonious or unified, there is no fixed number or combination of (any) A-features which necessarily (logically) makes it good (poor) art. We can therefore say, if we like, that the uses of the phrase 'good art', 'good poem', 'good painting', and their opposites are not governed by logically necessary-and-sufficient conditions. Or a judgment of the form "X is a good painting" or "X is good art" is not deductively related to its grounds or reasons, just as an A-ascription, "X is A_1," is not deductively related to its grounds or reasons. As we saw before, the relation between (a) "X has N-features A, B, C, D" and (b) "X is A_1" is not one of entailment. The same is true of the relation between "X is A_1,"[14] "X is A_2," and so forth and (c) "X is good (poor) art." This means that the relation between "X has N-features A, B, C, D" and "X is good (poor) art" is not one of entailment. The nondeductive relation between (a) and (b), and between (b) and (c), is a logical consequence of what appears to me to be the fact that 'delicate', 'tender', and so forth do not *mean* "having N-features A, B, C, D, and so on"; similarly, that 'good' does not mean "delicate," or "delicate and/or tender," or

"delicate and/or tender and/or powerful, and/or . . . ," and so on.

Some A-features only contribute to the goodness of a work and do not *actually suffice* (in the absence of certain other A-features), while some A-features do suffice, to make it good. In the latter cases we would say that "X is A_1 and A_2, and so on" implies, in a nonlogical sense, "X is good art." [15] Here 'make' has a different use from the use it has when we say that such and such N-features make or tend to make a work balanced, unified, and the like. The two uses are analogous, as can be seen from our analysis of the relation between A-ascriptions and "X is good (poor)" on the one hand, and between N-ascriptions and A-ascriptions on the other hand.

If many A-terms are evaluative, not merely "descriptive," and if the relation between A-ascriptions and judgments of the form "X is good (poor) art," "Y is a good (poor) poem," and so on is as described, certain important consequences follow. For instance, the activity of *evaluating* a work as good or poor art, or as a good or poor poem, painting, and so on, is implicit in the ascription of many A-terms to a particular work. Consequently, in the very act of drawing our attention to, or trying to make us see, A-features in particular works of art, critics go beyond the activity itself. They evaluate the work as possessing merit or demerit in some degree or other. In other words, the two activities are logically inseparable. [16] Thus I do not agree with Mrs. Hungerland that "in talk about a painting, the point in calling attention to N's is to get us to see A's." [17] This is just one important point in the critic's calling attention to N's. Or rather, the critic wants us to *see* these A's not only in order that we may appreciate or enjoy the work properly or fully, but also in order to convince us, to make us see (in a different sense of 'see'), that the work in question is good or bad of its kind. (Another way of stating the matter is that the proper appreciation or enjoyment of a work is a necessary condition of its proper evaluation—for judging whether it is *enjoyable*. If it is not an enjoyable work, our *not* enjoying it—which would constitute our recognition of its being indifferent or bad—is a necessary condition of its proper evaluation.) His appeal to certain N-features, and so his attempt to make us see the A-features, quite frequently though not always, constitutes his giving *reasons* for his evaluation

of the work as art. We do say that critics "argue," and by this we do not mean merely that they disagree, about the merits or demerits of this or that work, that a critic argues well or ill, convincingly or unconvincingly, for his evaluation of a particular work. True, we do not speak of the critic as reasoning, which is all to the good. 'Reasoning' is a little too stringent a term for the critic's giving reasons for his evaluations (whether or not he is challenged) or for justifying his evaluations when challenged. But this does not justify us in going to the extreme of denying (which is what Hungarland in effect does) that, in pointing out A-features, the critic evaluates in the way I have described. This, apart from the more general fact that one of the traditional tasks of the critic has been the evaluation of works of art, whether logically in conjunction with the pointing out of A-features or no. The upshot is that if we wish to restrict the critic's traditional functions by recommending or stipulating that he cease to pass value judgments on the works he describes, analyzes, interprets, and so forth, we must change the uses of A-terms (groups A, B, and C) by eliminating altogether the present evaluative aspect of their uses. Whether this is desirable is another matter, requiring a separate discussion.

NOTES

1. Throughout, I use 'directly', 'indirectly', 'explicitly' and 'implicitly about' in their ordinary meanings.

2. 'Imply' here is distinguished from 'mean' in the sense of "state" in the stated sense because in one of the latter's ordinary uses, 'mean' is employed in the sense of 'imply' in the present use of it. (It is also employed, I think more frequently than it is used to mean 'imply' in the present sense, in one sense of 'entail'.) What is implied by a statement P is, as we say, what is implicit in it; whereas what it means in the sense of 'states' is what it directly and explicitly asserts, what it says in so many words. The difference between 'imply' and 'entail' in the sense in which they are ordinarily distinguished is somewhat more difficult to discern. For 'imply' is here employed in a logical sense, just like 'entail'. (This is

most obvious in the formal logician's uses of the former word, which have always been logical ones.). Thus what a proposition P implies in our sense does *follow* from what P asserts. But it does not follow from it in the same sense in which what P entails follows from it. To borrow an example from G. E. Moore, when I say "Mr. Baldwin (the former prime minister of England) is rather a short man," the proposition it expresses implies the proposition "Somebody is called Mr. Baldwin." ("Imaginary Objects," *Proceedings of the Aristotelian Society*, Suppl. Vol. XII, [1933], p. 63.) As Moore rightly points out, the former proposition does not entail —and certainly does not mean the same as—the latter proposition. On the other hand, the proposition expressed by "All men are mortal" entails, for instance, the proposition expressed by "It is false that some men are immortal," rather than implying it. Similarly a conditional proposition entails and is entailed by—it does not imply and is not implied by— its contrapositive.

2. One main reason why I say "may express" is that the author may be sometimes merely repeating or reiterating someone else's opinion, in which case he may lack any personal interest in the work and so may not really care what happens to it. That is, a person who does not express (as opposed to pretend, or seem, to express) any personal *liking* for X, when he says "X is good art," would also normally not express, by his judgment, any desire to preserve it or see it preserved.

3. The following section is based on my "Art-Names and Aesthetic Judgments," pp. 35–40.

4. In my use of 'feature' I do not include, among a work's features, any ability it may possess to produce some impact or other on a perceiver. But the "dispositional" characteristics and relations of a work are certainly among its features as a work.

5. In the case of the valuations of professional critics, almost entirely.

6. For a discussion of features that are frequently prized for their own sake, see Chapter 12.

7. But the expression 'a poor fragment' (or "a poor fragment of a poem, novel, and so on") seems to me to be less commonly used.

8. The other, correlative form of this activity consists in pointing out the kinds of effects which X has on the (qualified) judge, which serve some or all of the aims of poetry (and of art). For example, it may consist in showing that X is moving, stimulating, full of feeling, or makes a powerful impression.

9. The present form of the Naturalistic Fallacy, in the present very inclusive employment of this term, may be called the Justificationist Fallacy.

10. These expressions are probably never used *purely* descriptively. That is, they probably always involve a pro-attitude toward their referent,

and so forth. But they are sometimes, at least, not *purely* appraisive either; they also refer to or describe certain sensible or nonsensible *properties* or certain *combinations of properties* discernible in works of art.

11. That is, A-feature.

12. Whether they are designated by A-terms in group D, or by terms in group A, B, and C.

13. It could be sentimental. But sentimentality is not an A-quality in group D. Not striking us as anything in particular is usually described by the use of the evaluative A-terms 'insipid', 'lifeless', and 'lacking character' (cf. Bouwsma's discussion of "character" in relation to A-terms in group D, in "The Expression Theory of Art"). And it is, itself, one main reason for judging a work as poor art.

14. Where 'A_1', 'A_2', and so on stand for some evaluative A-term.

15. But note that "X is A_1" or "X is A_2," and so forth logically implies, at least, "A_1 helps make X good (poor) art."

16. I have pointed out that A-terms in group D constitute, within limits, an exception to this. The same is true of the various other types of expressions commonly applied to art (for example, 'classical', 'baroque', 'symbolic', 'imagist', 'stream-of-consciousness', 'pastoral', 'lyric', 'bucolic', 'ode', 'Shakespearean sonnet') which are either completely or almost completely non-evaluative within limits, or have some nonevaluative uses.

17. *Op. cit.*, p. 290. See also pp. 289–90. But contrast Sibley, *op. cit.*, pp. 363–64.

18. Since certain sorts, types, or kinds of A-ascriptions are rendered appropriate and others inappropriate relative to a particular work of art in the light of the critic's interpretation of the work, we see an interesting logical relation between his interpretation and evaluation of a work. But no interpretation of a work logically determines its evaluation as good or bad of its kind.

Chapter 11

Reasons in Criticism—I

In this and the following chapter I propose to consider, in the light of the ordinary concept of the aims of art analyzed in Part I, some of the main criteria which professional critics and laymen employ, hence some of the main reasons they give in support of their aesthetic judgments. What is more important, I shall attempt to ascertain which of them constitute *proper* criteria of, or *good* reasons for, the judgments they are intended to support. I shall first consider the general relation between proper criteria of artistic merit or demerit on the one hand, and the ordinary concept of art as a whole and specifically the notion of the aims of art on the other. The criteria I shall then consider will all be what I call teleological criteria, or ones relating to the *effects* or kinds of effects which works of art are ordinarily expected to have. The criteria that relate to the formal, material, or technical features of works of art will be considered in Chapter 12.

We saw before, both in Part I and in the present part of the book, that the aims of art, which are essentially involved in the ordinary descriptive use of 'work of art' (or 'poem', 'symphony', and so on) logically determine the aesthetic uses of 'good' and the other aesthetic value terms we have. This means that whenever someone says, "X is good art" and his interlocutor asks, "Why?" or "What makes it so?," the proper reply would involve an appeal to one or more of the overall aims of art as determined by the ordinary uses of 'work of art', analyzed in Part I, Chapter 4. That is, the proper answer would be: "Because X serves aim A, or aims

A and B (and so on) of art." The degree of X's merit would be determined (a) by the effectiveness with which it serves that one aim, or each and every one of the over-all aims of art which it serves; and (b) by the number of the over-all aims it serves in the particular degree or degrees concerned. Similarly with "X is poor (or very poor) art," or "X is a poor (or very poor) work." In other words, the provision of good reasons consists in pointing out, and in showing—by appeal to the (i) sensuous or nonsensuous features of the particular work and/or (ii) the impact it has on qualified judges (the greater their number the better) under standard conditions—the extent to which the work serves one or more of the aims of art: the enrichment of human experience and hence human life, emotionally, intellectually, and imaginatively, by the use of some structured sensuous medium. We can say that a work is correctly judged to be good, or poor, to the extent to which it succeeds, or fails, to enrich human experience and life in one or more of the foregoing ways.

It is important to emphasize that the over-all aims of art partly or wholly provide *general* criteria of artistic excellence. I should, indeed, say that they provide general kinds of criteria of excellence. But I shall not do so since I wish to speak of the general criteria that are wholly determined by the over-all aims of art, or "teleological criteria" as I shall call them, as jointly constituting one kind of criterion. Those criteria that are only partly (logically) determined by the over-all aims of art, which pertain to the sensuous or nonsensuous features of a work or to the treatment of the medium, together constitute the second kind of criterion of excellence.

The affective aims of art place no restrictions, except in one special sense, on the specific content of the emotional, intellectual, or imaginative impact of any work on qualified judges. The aims do not therefore specify that certain feelings, moods, images, symbols, or ideas must or must not be evoked, expressed, or stimulated in us, as the case may be, in order that a work may be good art. As far as the over-all affective aims of art are concerned, no experiences, or any kinds of these, ideas or kinds of ideas, and imagery or kinds of imagery, can be properly said to be aesthetically good

("aesthetic") or aesthetically bad ("unaesthetic") per se, as feelings, ideas, images, or kinds of these.[1] Since our analysis in this chapter shows that the restrictions imposed by the over-all aims of art are the only ones imposed on the effects of works of art qua art, we can add that no feelings, emotions, ideas, or images can be properly said to be intrinsically "aesthetic," within the framework of the ordinary conception of art.

The restrictions which the aims of art do impose—namely, that a work should produce an enjoyable effect,[2] preferably of a profound and lasting character—pertain to the *general* nature of a work's effects. This constitutes a regulative principle with respect to (1) the quality, (2) intensity, and (3) duration of the emotional, intellectual, or imaginative effect on qualified judges under standard conditions. The qualitative aspect of this principle has two components. The first, we said, is that the overall effect must be pleasant. The second is more pertinent and comes nearest among (1) to (3) above to relating to the specific content of the effect. It grades works as regards excellence, other things being equal, in terms of profundity (or shallowness) of their emotional, imaginative, and intellectual impact. In the case of feelings, emotions, or other emotional experiences, degree of profundity is determined if not constituted by (a) the degree in which these are regarded as possessing what I shall call *human significance,* significance for man in his total setting, reality as a whole (or significance$_1$ for short); and (b) the degree in which these have what I shall call *specifically aesthetic significance* (or significance$_2$, for short). An idea, image, or symbol in a work of art (as well as a sensuous feature of the work) is significant$_2$ to the extent to which it heightens the work's overall pleasurable effect by reinforcing the effect produced by its other features. For example, this heightening of effect is achieved if all the parts together result in a work that, as a whole, possesses striking beauty. I should add that both (a) and (b) above are forms of aesthetic significance in a more inclusive use of 'aesthetic' than in (b). That is, significance$_1$ and significance$_2$ are aspects of the general significance (and so merit) which a work may possess *as art*.

We shall first consider significance₁ in some detail, then consider significance₂ in relation to it.

The significance₁ of a given feeling, emotion or other emotional experience involves one or more of the following: (i) the perceiver's relation to other persons, as well as his relation to a particular country, society, or age, or to mankind at large; (ii) the perceiver's or mankind's relation to nature; and (iii) the perceiver's or mankind's relation to God or other sources of being, if these exist or are believed to exist. An emotional experience is deemed significant₁ in the degree in which it is believed to arise from or otherwise pertain to the perceiver's humanity, his nature as man. For most good Western critics at present, I think—and rightly—the significance of an emotional experience is not affected, certainly not determined, by its presumed "nobility" or "loftiness," or the opposite. That is, it is not affected by whether it is the kind of experience associated with a rational or a morally good man— feelings or emotions of love, forgiveness, kindness, charity, compassion, a sacrificing spirit—or contrariwise, with an irrational or morally bad man. However, there are well-known examples of moralistic critics as well as moralistic aestheticians (Plato, Véron, Tolstoy) who have appealed to or advocated the appeal to this moral aspect of the emotional impact of works of art as a criterion of a work's "human" significance, hence over-all artistic merit. The moral "quality" of the emotional impact of works of art also appeals to these critics or aestheticians as a criterion of artistic merit apart from, or over and above, its alleged determination of "human," or purely "aesthetic," significance.

Much of the foregoing applies to the imaginative impact of works of art that have an appeal to the imagination. Thus the imagery utilized by a poem or novel, or the stimulation the perceiver's imagination receives from it, are deemed significant₁ or insignificant₁ in proportion as they pertain to "ultimate things" —the nature of man, God, or the entire supernatural world; Nature, the relationship of man to man, to Nature, or to God. The same considerations apply, and the same conclusions hold, with regard to their alleged moral quality in the case of those images or clusters of images which may be plausibly connected with man's

moral behavior and nature, or with moral goodness and badness in general.

The same applies to the ideas which a work may express, or generate in the qualified perceiver under standard conditions. Thus ideas are judged to be significant₁ or profound in proportion as they are about "ultimate" things—such as birth and death, toil, suffering and joy, happiness, tragedy and the triumph over tragedy, mutability, mortality and the longing for immortality, and so on. In the well-known expression of the Existentialists, the profoundest and hence most significant₁ ideas pertain to the "human condition," by whatever name it is called and in whatever guises it is clothed in different ages, and to man's attempts to transcend it.

We have seen that a major determinant of a work's significance₁ or insignificance₁ is the profundity or shallowness of the ideas it expresses or stimulates in our mind, the imagery it conjures up, and the emotional states it evokes, if any. This is closely related to a second major determinant (hence criterion) of significance₁; namely, the scope of these ideas, images, or emotional experiences, or how widely they apply. An idea is significant₁ *other things being equal*, in proportion as it is more widely applicable: the most significant₁ ideas being the most embracing, those we call "universal." Chief among the latter are *some* ideas which, considered as propositions in an extra-aesthetic role, are applicable to all mankind at all times. These significant₁ "universal truths" relate to an individual person or a particular group of persons, qua human beings, or to mankind as a whole. Others are true of Nature or reality as a whole at a certain time or at all times, including the purported timeless truths about God. The same is true of imagery. An image is significant₁ or the opposite, other things being equal, depending on the number of things of which it is an image. The same is true of symbolism.

The foregoing applies to emotional states, desires, or appetites. Once more these are significant₁ or the opposite, other things being equal, depending on their scope. This means that the most elemental, most universal feelings, emotions, urges, or desires, that is, love and hate, fear, anger, the sexual desire, hunger and thirst, the

craving for security, happiness, lust for possessions or power, or the desire to be loved, are among the most significant$_1$ of their kind.

The relation between profundity and generality is obvious: an idea, image, symbol, desire, drive, feeling, emotion, or other state or experience, with some notable exceptions (the idea of God) has scope in direct ratio to its profundity. Maternal and filial love, birth and death, suffering and joy, happiness and misery, are capable of being profoundly felt and are universal in scope. Every human being experiences some of them—is certainly capable of experiencing them—sometime in his life. And the ideas and images of these things are general to the same extent.

It is obvious, on the other hand, that generality is not a sufficient condition of profundity. There are many "universal truths" of the most commonplace kind such as that all men eat, drink, and sleep, that human beings are either males or females, and so on. Generality is a determinant of significance$_1$ only in conjunction with profundity, and then only as an adjunct.

The truth or falsity of ideas is a further determinant of significance$_1$ or the opposite, other things being equal, very closely connected with the concept of scope. A true idea in a work, true in the sense explained in Part II, Chapter 9, is generally regarded as more significant$_1$ other things being equal (to the extent to which the ideas endow the work with significance$_1$ or the opposite), than one which contains false ideas. The same is true of the ideas that a work may stimulate by means of its imagery, descriptions, or ideas, if any. Note that I said that other things being equal, a true idea is *generally regarded* as more significant$_1$ than a false idea. But a profound idea—and so, generally speaking, an idea possessing great scope—even if false, is more significant$_1$ than a true but shallow idea, even if it has great scope.

Truth, just like the other determinants of significance$_1$ (the same is true of significance$_2$), lends significance$_1$ to the ideas and the work as a whole only insofar as it serves the aims of art as art. Whatever "intrinsic" value truth may possess is irrelevant to, does not constitute a source of, the merit which true ideas may possess as part of a work of art or as stimulated by one. A true idea is

significant₁ to the extent to which it is (1) profound, and/or (2) original, and so helps the work produce a profound and lasting (hence enriching) intellectual, imaginative, or emotional experience in qualified perceivers under standard conditions.

An original idea, even if false, has greater power—in addition to the human significance it may have—and so has, directly or indirectly, greater imaginative and emotional impact than a true but commonplace idea. The perceiver must be aware of the originality of the former if it is to produce an appropriate effect, that is, he must be qualified in the present respect. It is a matter of common experience that many really commonplace ideas produce a strong impression on uneducated or semieducated readers of popular novels or stories, but we do not consider that as proof that the ideas are original or that these readers are qualified judges. Likewise the depth of an idea gives it tremendous intellectual and, very frequently, imaginative and emotional power over those who recognize its depth. For one thing, the profoundest ideas, which are also the most "existential" ideas, are those most charged with the greatest emotional and imaginative overtones. They are also the most fertile in the sense that they form part of a large web of equally fundamental, far-reaching "existential" ideas, and lead us almost insensibly from the one to the next. In this way, their emotional power is compounded of the emotional power of the whole cluster of elemental ideas, not (like shallow, unimportant ideas) drawn from each idea alone. The ideas of God, birth and death, suffering, and damnation and salvation are such highly fertile ideas. However, as with truth, depth and originality do not, in and by themselves, necessarily make an idea significant₂ as an ingredient of a work of art.

In order that an original and profound idea which is also true may have the maximum capacity to serve the over-all aims of art by producing a profound and lasting enriching effect, it must be utilized to greatest advantage. And this is a second aspect of our earlier statement that the truth (similarly the originality and profundity) of ideas can have significance for a work of art by virtue of the function they are given, not by virtue of any "intrinsic value" they possess or may be thought to possess as true ideas.[3]

The profoundest and most original true idea in the world would have less, perhaps much less, value as part of a work of art, or as stimulated by one, if it does not help produce—directly or through its relation to the work's imagery, subject matter, and the like—any effect at all, or any effect of the kind described earlier. In order to have an effect, and an effect of the right kind, it must form an integral part of the work. Second, it must be expressed in concrete sensuous or imaginative form, must be clothed with the qualities of individual persons, objects, and the like. It must be, so to speak, given a local habitation and a name. And there will be further requirements in particular cases. This leads to a consideration of the means, material and formal, whereby a work produces its intended impact. It takes us to the imagery and symbolism of a work, if any, and its sensuous qualities as devices for the production of the desired impact. I need not add that these may also be enjoyable in themselves.

What we have said so far enables us to answer the following question: How can truth or falsity be a criterion of artistic merit or demerit if it is (1) irrelevant to the proper enjoyment of art and, more importantly, if (2) the notions of truth and falsity do not properly arise in relation to ideas insofar as they form part of a work of art? The answer to (2) is, I think, simply that a true (and profound) idea, being adequate to the world as a whole or some aspect of it, is of greater *direct* relevance and therefore importance or significance₁ to us as human beings who live and move and have our being in the real world, than a false idea which is not more profound. It therefore tends to have greater emotional appeal for us, since our emotional reaction to anything in our surroundings or in ourselves is generally greater in proportion as it is important or significant to us directly or indirectly. However—and this is why the truth or falsity of an idea cannot be judged apart from its profundity or shallowness, originality or triteness [4]—a comparably profound but false idea may have as much indirect impact as the foregoing has a direct impact. If a false idea is more profound, particularly if it is also more original, than a true idea, it may be (indirectly) more significant than a less profound (particularly a less original) true idea. Although it would not add to our

knowledge or understanding of the world or any particular exist-
ing thing, it may nonetheless widen our intellectual and imagina-
tive horizons by leading us to contemplate what might be or
what might have been; namely, the limitless ocean of pure possi-
bility. This has obvious value apart from its possible contribution
to our understanding of ourselves or the world. (Cf. the role which
false but fertile ideas have played in the history of philosophy or
science.) Moreover, this widening of our mental horizons may
broaden or deepen (and in every case enrich) our emotional life
by helping us to "live in possibility," to borrow a pregnant phrase
of Søren Kierkegaard's. It may help us have imaginative experi-
ences which we would be actually denied in our entire life. Fur-
ther, such an idea may have value, by contrast with what we know
about ourselves or the actual world, insofar as it may bring into
relief the qualities they do (and those they do not) possess. It may
thus enable us to gain greater insight into the nature of real things,
including ourselves and the human condition. These things are
well illustrated by the celebrated closing lines of Keats's "Ode on
a Grecian Urn," beginning with, "Beauty is truth, truth beauty.
. . ." Many readers will undoubtedly think of the ideas these lines
express as dubious or downright false, though others would say
that they are ambiguous. But the power of their intellectual, imagi-
native, and emotional suggestiveness is unmistakable.

Most of what I have said about ideas applies to the plot or story,
characterization, and descriptive elements of novels, plays, stories,
and dramatic, narrative and descriptive poems. Some of them also
apply to representational sculpture and to portraits, landscapes,
seascapes, still lifes, and other forms of representational paint-
ing. So what we said about the various determinants of significance
in relation to ideas applies to them. But in their case the counter-
part to truth is "truth to life" in the sense of lifelikeness. And con-
versely with falsity. That is, if the characterization, description, or
plot is original or profound, truth to life is a source of significance
and therefore merit. But let us note, first, that "truth to life" is
distinct from both literal fidelity to or "agreement with" facts
("scientific" or "philosophic" truth), and verisimilitude as I shall
use this word. A work, or some part of it, achieves verisimilitude

to the extent to which it creates the impression or illusion, hence gives a sense, of reality. For this to be true, that which is portrayed or described must appear probable. (Cf. Aristotle's *De Poetica*.) This may or may not be achieved by a description or portrait "faithful" to "facts." It is commonplace that truth to life does not mean photographic likeness, going to great (in some contemporary novels, extreme) lengths in chronicling, documenting, and piling up minutiae. On the other hand, an illusion of reality can be created by a work which is *not* true to life. The difficulty and real achievement lie in creating the impression of reality (verisimilitude) and, at the same time, actually being true to life, or vice versa.

Second, it must be noted that here too profundity and originality are logically, and so axiologically, prior to truth value as determinants of significance—hence of truth. For example, I regard D. H. Lawrence's and Jean Paul Sartre's characterization and depiction of human relations as much more significant—much more original and profound—than those we find in the pages of thousands of books on the market. Yet I am convinced that the conception of human nature and human relations in them is highly one-sided and distorted. In the case of Sartre, the reason is that his characterization is an application of a defective, though partly true, conception of man and the universe.

I stated earlier that in addition to its quality, intensity and duration—or jointly, the "quantity"—of a work's impact are criteria for its aesthetic worth. Empirically, there appears to be a simple, direct relation between the latter two. Within limits, the more intense the effect, the longer it stays with us (compare and contrast physical sensation). I say "within limits" because in certain exceptional cases the emotional impact of a work may be so powerful that the perceiver is unable to endure it for more than a breathless moment: his nerves seem to be numbed under the tremendous strain.

Although the appeal of laymen and critics to the amount of a work's effect is directly traceable to the generic aims of art (the production of an intense and lasting, as well as profound, effect as an aim of art) its use as a criterion of worth extends beyond the

confines of art. For example, many moral philosophers, hedonists in particular, regard intensity and duration as a (some regard it as the only) measure of the worth of particular pleasures or pleasurable experiences. This is not an arbitrary invention of moral philosophers. These notions are part and parcel of our everyday evaluative apparatus in morality as well as other realms of value. Similarly duration is, I believe, widely regarded as an important factor in determining the relative worth of states of happiness; the longer the span of one's happiness, the more valuable one's state is deemed to be. Similarly with the theologian's, the religious believer's, the mystic's, or the classical philosopher's conception of heaven or paradise, the vision of God, the contemplation of God *sub specie aeternitatis*, the contemplation of Platonic Forms, or whatever the particular ultimate reality or supernatural world is envisioned to be.

Durability is, plainly, also a criterion of other types of value. Objects, both natural and artificial, are ordinarily regarded as good of their kind if they are durable, other things being equal. Of two knives, cars, diamond rings, or houses, the better is regarded as that which, other things being equal, is the more durable. The proviso "other things being equal," which arises in relation to our entire discussion of duration (also intensity) as a measure of excellence, is absolutely essential. Duration is a criterion of value *only* if the object or thing in question possesses some value or goodness to begin with, for other reasons.[5] Thus, a particular work may be regarded as good art if it produces an intense *and* lasting *pleasurable effect*; it would be almost certainly regarded as good art if that effect is also profound.

Durability, by itself, is neutral. The more lasting a good thing is, the better it is; its value persists longer, making it possible for us to enjoy it longer and thus more than we would otherwise. This is why philosophers from the ancient Greek thinkers on have regarded the "quality" of being eternal, hence immortality, as an attribute of the most perfect entities such as Platonic Forms, God, The One, Brahma, Natura Naturans, the Absolute. Similarly with the notion of personal immortality. The converse—that the longer a bad or otherwise undesirable thing exists the worse it is—is likewise true. No wonder Satan, the incarnation of evil, is conceived as eternal,

like God Himself (although some believe that he will be redeemed on the Day of Judgment!). Correspondingly, length of existence is immaterial in the case of something, if that is possible, to which no value concepts are applicable. On the other hand, something to which these concepts apply but is completely worthless may be (I think in many instances will be) regarded as *more undesirable* than it would otherwise be in proportion as it is durable. But being more undesirable does not mean, in this context, that we would regard it as possessing *less value* than other objects or states of affairs, also completely worthless, which are less durable; or that we would have regarded it as less worthless had it been less durable! Clearly, there are no degrees of worthlessness. We would regard it as more undesirable than otherwise because it wastes more of our time. It tends to interfere with (and may even make impossible the enjoyment of) something that possesses value, at the time in question.

The preceding example brings to mind two related but logically distinct things: (1) the duration of a work's impact; and (2) the duration of the work itself, as a particular work. Duration is a criterion of value, other things being equal, with regard to both (1) and (2). In some of our other examples, however, it operates as a criterion of value chiefly or wholly in one of these two ways, that is, in the case of objects such as knives, cars, or houses it chiefly arises in relation to (2). My concern at the moment is (1). I shall deal with (2) in Chapter 12, where I shall say something about the relation between the two.

We have seen how and why duration, as a criterion of excellence, is logically secondary; that, logically speaking, it operates only after intensity of effect has been considered. The same is true, only more so, with regard to the quality of the effect. Duration becomes a criterion of excellence only after (a) quality and (b) intensity of effect have been considered, and the worthwhileness of the effect (and to that extent, the work which produces it) has been judged in their light. It may be that we sometimes deem a work good art if it produces an intense and durable effect, independent of the quality of the effect. But I do not think that it is generally (especially professionally) deemed excellent, especially great, art

unless the effect is also qualitatively profound: which, includes the deeper (for the greatest works, the deepest) human emotions and desires, and thoughts of the highest objects that are presumed to exist. The principle we applied to intensity also applies to duration: the more lasting the effect, given that it is of the above quality, the more worthwhile it is.

I said that we sometimes deem a work good art if it produces an intense and durable effect, independent of its quality. I mean by this "apart from its being, on the whole, a pleasing effect." I think this observation is mostly true, if at all, with respect to comedy, burlesque, and farce. But in the latter two genres of literature we would, I think, speak of "good farces" or of "burlesques" but not of "good art." The reason is that farces and burlesques are generally regarded as a low form of art, or even as mere entertainment —using 'art' in an honorific sense, as involving an achievement of a certain degree or higher,[6] in a more exclusive or restricted sense than it is often descriptively employed. This use is nonetheless a *descriptive*, not an evaluative, use.[7] It is certainly not the evaluative use I frequently referred to in Part I. However, it draws higher the line between art and nonart. This is a feature of, or is made particularly easy by, the openness of the ordinary concept of art. (See also Chapter 12.)

It is interesting to observe further the relation between the qualitative profundity of an effect and its intensity and duration. I think it is true that by the meaning of the phrase, 'response of a qualified perceiver under standard conditions,' the qualitatively deeper an impression is, at least within limits, the more intense (hence also, within limits, the more enduring) the effect tends to be on qualified perceivers under standard conditions. I add this qualification because, in order that the foregoing may be true, the perceiver must be affected by the particular work as deeply and strongly as it is capable of affecting the audience or spectators. The sensuous features and the ideas, imagery, or symbolism in the work must be given full play, and so the conditions under which they are perceived must be optimum. It is to be expected that a man who does not, say, grasp the subtleties of the psychological insights of Dostoevsky, or the full philosophical or existential significance of

the ideas of a Thomas Mann, a Sartre, a Camus, a Brecht, or an Ionesco, will not be moved as strongly; the impact on him will not be as lasting as on someone who has a mature and profound understanding of human nature. The same is true of the ideas expressed in the works of the foregoing authors.

An important point which emerges from the preceding discussion is that the pleasurableness or unpleasantness of a work, particularly on the first encounter, must be taken with a large spoonful of salt as a criterion of the work's merit or demerit. Most emphatically, it should not be taken as the sole criterion. However, temporal and hence psychological "distance" from the work, as well as further encounters with it, would render pleasurableness or unpleasantness a more reliable gauge of the work's aesthetic worth. Repeated encounters are particularly important because they may very well— and we ordinarily think that in the case of a qualified judge they will [8]–cause the perceiver to enjoy, or enjoy only in the appropriate degree, the most harrowing tragedy. The same is true of shallow farces or melodramatic "sad works" which one may have originally enjoyed far beyond their true deserts.

In Part I we encountered the notions of unity and lack of unity of effect a number of times. Indeed, we met them primarily or wholly in our discussion of the different current meanings of 'form' in relation to art, and the overall aims of art. What I wish to do right now is to discuss unity and lack of unity of effect as constituting teleological reasons over and above the ones we have so far discussed, for the artistic goodness or badness of particular works. The question which arises at the outset is why unity of effect, which is widely appealed to, *is* a criterion of excellence. The answer is quite simple, and relates our present discussion to the preceding one.

(1) (a) Part of the answer, it seems to me, is that unity of effect is prized (partly) because the effect produced by a work, including its effect on qualified judges under standard conditions, cannot be strong and lasting unless it is unified. Since unity of effect is scalar in character, a work's capacity to produce a strong and lasting impression is greatly enhanced, other things being equal, by the degree of unity possessed by its effect. Whether anything more than

a rough relation exists between the different degrees of affective unity and the strength and durability of the effect can only be ascertained experimentally. At present, ar far as I know, no precise answer is available. Be that as it may, we normally suppose, rightly I think, on the basis of our general knowledge of the effects of works of art or other objects, occurrences, or states of affairs, that if these things evoke, simultaneously or within a relatively short time, incompatible feelings or emotions (in the sense of feelings or emotions that are antithetical or mutually exclusive *in their nature*), the strength of each will be partly or wholly dissipated and neutralized by the others. The net result will then be a feeble over-all effect, and far from lasting. Or the effect will be a confused medley of feelings or emotions without rhyme or reason. This includes the emotional effect the work produces by means of the ideas, symbolism, or imagery it contains, and its sensuous qualities and organization. It also includes the effect it produces by the interplay of the former and the latter components of the work.

(b) A second, likewise empirical reason, is that unity of effect is naturally pleasant. More precisely, the effect of a work (in particular, on qualified judges) under standard environmental conditions is the more pleasing (at least in a rough way), other things being equal, the greater its unity. The terms 'harmony' and 'harmonious effect', commonly used interchangeably with 'unity' and 'unified effect', respectively, reflect this.

(c) Another part of the answer is supplied by the relation between unity of effect and the *quality* of the effect that a work produces under standard conditions. It is true that unity of effect pertains to the *relations* between the constituents of a work's effects: it does not affect these components themselves. But the depth or shallowness of the effect pertains precisely to the relations between the constituents of the effect. However, and this constitutes an indirect relation between the two, any degree of disunity in the effect will incapacitate the work from producing a strong and lasting impression by virtue of whatever degree of qualitative depth it possesses. The disunity fragments the experiences, ideas, or imagery, which may possess a certain intrinsic depth, and so makes it difficult, sometimes impossible, for them to have or to produce, as

the case may be, the intensity they would have been capable of if the effect were unified.

Further, and perhaps most important, disunity of effect decreases or destroys for the perceiver the aesthetic and human signficance, and so the value, of the experiences which the work's various sensuous and nonsensuous components are capable of evoking by virtue of whatever intrinsic depth they have. The broadening and deepening of our emotional, intellectual, and imaginative life by our experience of these feelings, by our pondering on these ideas and so on is curtailed and, in extreme cases, altogether prevented by disunity of effect. The latter does not affect the qualitative depth or shallowness of the effect; but it prevents the full realization of the goals at which the ideas, images, and sensuous components of a work aim, and which they would have otherwise succeeded in realizing by virtue of their content—assuming that it is intrinsically profound. This provides a basis for comparison and contrast between different works of art—even works belonging to different art forms—in our grading of them relative to one another and therefore also, by implication, in terms of an absolute scale. For a discussion of this important general point, see Chapter 12.

(2) The three partial answers to the question given under (1) above attempt to justify the appeal to unity of effect, as a criterion of aesthetic excellence, by claiming that unity of effect is actually conducive to the various aspects of a work's full realization of its aims, discussed in some detail in this chapter and elsewhere. Although this may be (I think it is) generally true, unity of effect can be properly justified on the basis of its instrumental role; it can also be justified as a component of the over-all aims of art. Indeed, it is unusual, I think, for critics or laymen to attempt to justify it in the former way, if and when they are challenged to justify it. At any rate, we can justify it on conceptual grounds by maintaining that it is itself a component of the affective aims of art as we understand them; that it is logically involved in the ordinary concept of art. That is, it seems to me that the over-all affective aim of art, as determined by ordinary usage, is the production of a unified affect which is, as a whole, as pleasing and as qualitatively profound, as strong or intense and as lasting as can

be. The demand that the effect be unified prescribes the desired *relation* between the components of the effect: feelings, emotions, moods, and so forth. It does not constitute an additional *kind* of prescribed effect.

The justification of unity of effect, as a component of the over-all affective aims of art, is stronger than its justification as being actually conducive to the full realization of the other components of these aims themselves. For the appeal to the reasons given under (1) above, which rest on empirical grounds, is in principle open to all the limitations which empirical knowledge is heir to: the lack of certainty and finality, the approximate character of many empirical generalizations, and so on. In other words, it is quite easy at the time I am writing for anyone who wishes to challenge the justifiability of appealing to unity of effect as an aesthetic criterion, to reject the alleged empirical evidence for its "instrumental value," since (as I myself mentioned) there is as yet no rigorous scientific evidence, as far as I know, in support of this thesis. This way of attempting to justify unity of effect may engender more disagreement in actual practice than it resolves. In contrast to this, the onus of rejecting unity of effect on logical (semantic) grounds is considerably greater to my mind.

II

In this chapter I examined some of the general teleological criteria of the goodness or badness of poems, paintings, sculptures, and so forth qua (called) art. In other words, we have seen one—the teleological—kind of justification which critics and laymen offer in supporting judgments of the form: "X is a good art," "Y is poor art," "W is a great work of art," and so on. I shall end this chapter by inquiring whether any *additional* criteria are actually appealed to, and are logically required, for the *teleological* justification of judgments of the form: (1) "X is good literature"; "Y is an excellent work of music"; "W is a poor painting"; (2) "N is a good poem"; "V is a fine novel"; "S is a poor symphony"; (3) (a) "A is a good Shakespearean sonnet"; "R is an excellent Italian

opera"; (b) "D is an excellent nineteenth-century romantic poem"; "R is an excellent baroque building"; and "T is a poor French neoclassical tragedy." Briefly, the answers to these questions are the following:

(1) No criteria or reasons, other than those hitherto discussed in relation to a work qua called art, obtain. The various art forms do not possess any special aims of their own, over and above those they possess as species of art.[9]

(2) The answer is similarly in the negative in the case of works of art qua called poems, symphonies, or novels—and for the same reason.

(3) (a) Here the answer may be either positive or negative. It is the former with respect to genres, forms (form$_1$), or other kinds of art which, qua that genre, form, or kind of art, aim to produce certain special effects or have other special goals such as the inculcation of certain kinds of ideas, or of certain moral, political, or religious attitudes. This is true of comedies, tragedies, tragicomedies, satires, didactic poems, or other forms of didactic literature; or of paintings, requiem masses, elegies, military marches, funeral marches, and so on.

The answer to our question is in the negative where no such special effects or goals are involved in the ordinary or technical meaning of the name we apply to the work(s) in question. Examples are Shakespearean, Italian, or other kinds of sonnets, Italian, German, or other kinds of opera (not, however, operas as classified into tragic or comic), and so on.

The same is true of (3) (b). In the case of the foregoing judgments and others of the same kind, a work is judged *good or poor of its kind* in a more restricted, specific, or relatively specific sense of this phrase than "X is good art" or "Y is poor art," which are judgments of goodness or badness of a general kind (qua art in general).

Although in the case of some of the preceding kinds of judgments the answer to our question is in the negative, we shall see in Chapter 12 that there may nonetheless be further criteria, of a formal or material nature, applicable to works of art as belonging to some particular genre, kind of art, or form$_1$. That is, there may

be additional reasons pertaining to the "defining" formal or mate-
rial features of some or all of the foregoing genres, forms₁, or kinds
of art. Indeed, this is actually the case, as was stated in our dis-
cussion of the "defining" features of such genres and forms₁ in Part
I, Chapter 3.

NOTES

1. Cf. our discussion of this point in Part I, Chapter 4.

2. Which by the meaning of 'enjoyment' is a feeling, and so takes care
of (though in a minimal sense) the minimal emotional demand of art.

3. Note that, by the nature of the case, the truth value of an idea can
neither augment nor diminish its possible significance₂ as part of a given
work.

4. Also, apart from the way in which it is employed in the work.

5. But see Chapter 13.

6. Here 'art' is employed in the sense of 'fine art' or 'highbrow art'.
And to say that something is art in this sense is to imply that it is good in
a more *general kind* of sense than the specific sense of 'good' in "X is
good art."

7. Relative to any member of the class of (fine) art. It is, nonetheless,
evaluative relative to "lowbrow art."

8. This, as well as all the foregoing statements about the reactions of
the qualified judge, are analytic by virtue of the definition of a "qualified
judge" as a person who reacts (a) appropriately, and (b) in the appro-
priate degree, with the appropriate intensity or lack of intensity, pleasure
or displeasure, and so forth, and (c) for the appropriate length of time,
relative to the qualities and so the aesthetic merit of the particular work,
if and when he perceives it under the appropriate conditions.

9. Cf. Part I, Chapter 4.

Chapter 12

Reasons in Criticism—II

I

In Chapter II I attempted to show that the generic aims of art, which are determined by ordinary aesthetic discourse, provide in a general way broad criteria of aesthetic merit or demerit some or all of which are in actual use. I also outlined some of the more important of these teleological criteria (or *T*-criteria for short). In this chapter I shall continue my discussion of reasons in aesthetics by considering the applications of *T*-criteria to the sensuous and ideal features—qualities and interrelations—of works of art. That is, I wish to show how these criteria enable us to evaluate the formal, material, and technical features of a work as strengths or defects, as helping to make the work a good or a poor poem, and so on, good or bad art. Since the features of a work are the (causal, psychological) means whereby a work aims to realize, or succeeds in realizing, the goals of art in general,[1] we see that the means constitute strengths or defects in the work to the extent to which they enable it to realize these goals, or hinder it from realizing them, respectively. Thus, qua *features of some particular work of art X*, they are good-making or bad-making features of it.

Further, the critic ascertains the degree of X's goodness or badness by the often rather complicated weighing of its merits and demerits, hence by consideration of its good-making and bad-making features. In the case of some works, however—those we call extremely good or extremely bad, respectively—hardly any

"weighing" is involved. In the former case, the works's demerits will be negligible compared to its merits. In the latter case it is the opposite, but I agree with Margaret Macdonald that the idea of the critic " 'proving' a value judgment by the *mere* listing of criteria-characters seem(s) inappropriately mechanical." [2] The generic aims of art, hence T-criteria, cannot tell us by themselves what particular features of X are actually good-making or bad-making features of it, since they do not, by themselves, determine good-making or bad-making features either in general or in individual cases. Indeed, from our analysis of the ordinary uses of 'poem', 'painting', 'symphony', and so on in Part I, it is seen that the possession of no one particular determinate or relatively determinate feature or set of these is a (semantically determined) requisite for properly calling a poem a "good poem," and similarly with bad poems. In other words, there is no reason (stemming from linguistic usage) why all good poems should have in common one determinate or relatively determinate set of such features. The same is true of other kinds of art. Also, works belonging to different art forms need not have any common determinate or relatively determinate features, or any particular set of such features, in order that they may all be properly called "good art." In short, 'good' in the present sense does not refer to any particular feature or set of features either when applied to works belonging to different art forms or to works belonging to one and the same art form, genre, kind, or form$_1$ and so forth. (But it would be misleading to say that it therefore refers to nothing at all.) T-criteria merely constitute a general regulative principle. They merely stipulate by implication—and then only as long or insofar as they are not modified or altogether discarded—that in order that a work X may be good art, its features must be such as to enable it to satisfy them (T-criteria) in an appreciable degree. Whether any particular feature of X is good-making or bad-making relative to X as a whole can only be determined by the experience of qualified persons: by the total effect it helps produce under E-conditions. Further, as Dr. Helen Knight shows in her "The Use of 'Good' in Aesthetic Judgments," [3] we do as a matter of fact appeal to diverse criteria features in judging different works, even those belonging to the same genre or kind (two

lyrics, epics, still lifes, and so forth). The reason, according to our account, is that different works may be capable of satisfying T-criteria by means of any number of different, or different combinations of, sensuous or nonsensuous features. As we saw, these criteria are extremely general.

If the foregoing is correct, the justification of "X is a good poem (work)," in the last analysis, can be expressed in the following deductive argument:

(1) X produces an impact I under E-conditions; and
(2) I is a certain kind of impact, K (it is intense, enjoyable, and so on); but
(3) K is a kind of impact which makes the term 'good poem (work)' applicable to the poem (work) that produces it.
Therefore, X is a good poem (work).

Therefore, (1) is an empirical proposition, and (3) is a semantic rule, constituting the regulative principle, the general criterion, involved here. On the other hand, (2) is a classificatory proposition, so to speak, resulting from the application of a work, 'K', to some fact, here work X.

I said that good-making or bad-making features vary immensely with different art forms, genres, or other kinds of art. However, actual examinations of the good art that we have reveals, I think, that there are various crisscrossing "family resemblances" between the criteria features of different works belonging to the same genre or art form, or even works belonging to different genres or art forms. The number and degree of these resemblances vary greatly with the particular genres, $form_1$, kinds of art, or art forms involved. For example, good novels and good short stories—or even good plays—have greater resemblances than good novels and good symphonies. These resemblances rest on the crisscrossing "family resemblances" we actually find between the qualities and interrelations of poems, plays, symphonies, and so on in general, that is, whether

good or bad. For all *complex* N-features [4] of poems, or plays, or symphonies, and so forth, of a *general* nature (that is, features that may be shared by other poems, plays, or symphonies) may be, in principle, criteria features of particular works.

Looking at the matter from another angle, the *reasons* which people give in support of their grading of individual works or groups of works, as *kinds of reasons*, have wide or relatively wide applicability. Nevertheless, the *precise* or *specific* meaning of each statement expressing a given reason differs from one art form to another, or from one genre to another, with the difference in the uses of such evaluative terms as 'balance', 'rhythm', 'orchestration' (of colors, or musical tones, and so on), 'lilt', 'cadence', 'grace', 'charm', and so on, in relation to different art forms or genres. But their *general* meaning retains enough similarities to permit analogies between balance in a painting and balance in a sculpture, rhythm in a poem and in a prose work and, to a lesser extent, in a poem and in a work of music. But this is useful as long as the disanalogies or dissimilarities present are clearly borne in mind. This point is well brought out by F. R. Leavis in emphasizing—opposing T. S. Eliot whom he takes to task on this matter —the difference between "verbal music" and the music of the musician. In speaking of Milton's use of language, which Eliot praises, he says:

> If one aims at advancing the business of critical thinking one must insist that this "sound" [in Milton's use of language] is an entirely different thing from the musician's. Milton's interest in sound as a musician was an entirely different thing from his interest in "sound" as a poet, and a man may appreciate the "music" of Milton's verse who hasn't ear enough to hum *God Save the King!* [5]

Again:

> What is the "work"? It is certainly not the pure sound—no poet can make us take his verbal arrangements as pure sound, whatever his skill or his genius. And once we recognize that meaning must always enter largely and inseparably

into the effect, we see that to define the peculiarities that make Milton's use of language appear to be a matter of specializing in "verbal music" isn't altogether a simple job.[6]

The trouble with Leavis's view, however, is that it goes to the other extreme, and overemphasizes the differences between "verbal music" and the musician's music. We find an anlogous overemphasis on the differences between criteria features, or the diversity of aesthetic valuation, in the case of a number of linguistic analysts.[7] The "family resemblances" between some of them tend to be ignored or minimized. Fortunately, they rarely if ever go as far as to say that the *meaning* (or uses) of such words as 'verbal music', 'rhythm', 'lilt', 'cadence', 'balance', 'composition', 'grace', and 'dynanism', varies even with respect to two sonnets or two sonatas—or better, two Shakespearean sonnets, and two Beethoven sonatas belonging to the same "period." At the same time, it is difficult or impossible to say exactly how far we can legitimately carry the distinction; since we have no precise criteria for determining whether two very similar uses of a given expression correspond to a single sense or meaning, or two distinct but very similar senses or meanings.

We pointed out earlier that the sensuous or nonsensuous features of a work of art constitute good-making or bad-making features in the degree in which they contribute to, or hinder, the work's realization of the generic aims of art, hence satisfy T-criteria. The situation is however complicated by two major facts we came across before; namely (a) that certain genres of art have special aims of their own; and (b) that individual works may have a special aim or special aims as particular works. Thus with respect to (a) we get certain special criteria for the evaluation of works which have certain specific or relatively specific aims insofar as they belong to some particular genre or other subclass of art. For example, in evaluating a tragedy, we grade it as a good or poor tragedy in the degree in which we think it succeeds in realizing the aims of tragedy, of evoking "pity and terror" and other "tragic" feelings, under standard conditions. Thus its qualities or relations which are

thought to be responsible for its success or failure, in the particular degree, are praised or condemned as strengths of weaknesses of it. The same is true with the other genres or kinds of art referred to above.

It is essential to note that the special criteria employed in relation to the foregoing are the only ones in terms of which we evaluate them. That is, as in the case of kinds of works which do not include, in their uses, the notion of some special aim or aims, we do not appeal to *two* sets of criteria—one set applicable to them as art *simpliciter*, so to speak, and another set applicable to them as art of a certain kind (qua tragedy, comedy, farce, and so forth). The *general* criteria of artistic merit or demerit—those which are applicable to all works of art, irrespective of their kind—are *built into the relatively specific* criteria by means of which we evaluate them as good or poor of their kind. In judging a tragedy as a good or poor tragedy,[8] we are, at the same time, judging it as good or poor art.

The situation is not, indeed, different *in the present respect* from what it is in the case of all other genres or forms$_1$. We evaluate a poem, say, which does not qua (called a) poem involve some particular aims specific to poems,[9] as good or poor *art* in evaluating it as a good or poor poem. Further, we apply in both kinds of cases the *same teleological criteria* of merit discussed in Chapter 5. In both types of cases, we attempt to ascertain such things as the depth, significance, and originality of the ideas expressed by the particular work (if any), the originality of its imagery (if any), and the depth, intensity, and durability of its emotional impact, and so on.

The important difference between the two classes of works, with respect to their valuation, arises solely with respect to the evaluation of their sensuous and nonsensuous N-*qualities* and *relations*. For clearly a tragedy can only evoke "tragic" feelings or emotions by virtue of at least some of these N-features. In grading it as a tragedy (hence also as art), we evaluate its various features in terms of the contribution or lack of contribution which we think they make to it as a tragedy. This *includes* an evaluation of their contribution or lack of contribution to the kind of total effect which

a tragedy is expected to have on qualified persons under E-conditions; namely, evoking certain kinds of feelings or emotions, expressing or stimulating certain kinds of thoughts, or creating a certain kind of atmosphere. No analogous demands are made on a poem, say, qua poem.

The fact that a particular work, whether it belongs to our first or our second class, may have a certain *individual aim* such as conveying a certain moral, social, religious, political, "existential," or other "message," or evoking some very special effects,[10] introduces a further complicating factor into the picture. In any case, even a more modest work that does not form part of some school or movement may (and, if it is any good, will) aim at creating some more or less novel effect, express some more or less fresh ideas, and so on. So it would seem that there *should* be, even if none were or are in actual use, some criteria pertaining to the aims of particular works. Indeed, we do find such criteria in actual use, giving us a partial evaluation of a work in terms of its success or failure to realize its special aims. As a matter of fact, some people tend to go too far in this direction by making it the sole basis of evaluation. Such a view would maintain that we must always *limit* our criticism of a work to what *it aims* to do; we should not criticize it for not doing (hence not doing well) what it never set out to do.[11] The truth lies between this extreme and the opposite extreme; actual pieces of criticism bear out my view, I think. We praise an artist's technical ability, as evidenced by the work being evaluated, in realizing what appears to be the work's aims; or we may praise it for the originality of its form, theme, subject matter, language, and so forth—whether or not we think what the work aimed at was worth doing, was what the work (or a work of art in general) should do. Also, we normally praise the work for the imaginative and emotional efects it produces, and/or the ideas it stimulates—but only if these things are thought of as being in line with the generic aims of art. What is more, we reserve the highest praise to those works which, in serving their own special ends, also serve the aims of art in general. Thus, whatever praise we may lavish on the work for the technical skill it displays or the originality of its form, content, or effects, we condemn it for doing what it did,

if this is not consistent with the general aims of art. In such cases, we maintain that the work should have done, or attempted to do, something else in line with the generic aims of art: nay, which furthers these aims in a high or very high degree.[12] Thus in some cases we may say that a particular work is a good or successful (or very successful) piece of reporting, or a successful piece of propaganda, but not a good novel or play. Or we say that a given work is a good philosophical treatise, but not a good poem, and so on. However, the artist can counter by maintaining that he is interested in giving art a new aim, rather than merely attempting to perpetuate its already-accepted aims. Whether he wins out would depend on many factors, but the excellence of what he produces—particularly if he is part of a wider movement led by equally talented men—is sometimes one of them. Unfortunately, all sorts of social, political, moral, religious, or ideological factors, wholly unrelated to the particular work or its merit, or to art as a whole, often determine whether such works are eventually accepted. Social Realism in the Communist world illustrates this perfectly.

The relevance of this to the controversy relating to knowledge of the *artist's aims* is obvious. We would properly praise the artist insofar as we praise the work, and condemn him insofar as we condemn the work *if and when* we rightly suppose that the work's special aims were (also) those of the artist himself; that the special effects produced are those which the artist himself wished to produce.[13] This shows us one way, over and above the way(s) discussed in earlier chapters, in which knowledge of the artist's intent, if any, is necessary for the judicial evaluation of his originality, technical ability, and understanding of the "nature of art."

II

In the above section I spoke in general terms about criteria of artistic merit and demerit, and those features which make poems,

paintings, and so forth good or poor art. I shall now illustrate the central points made there and in Chapter II by considering a few important criteria of considerable generality that arise (with the appropriate differences in each case or kind of case) in relation to the aims, and the formal, material, and technical aspects of a work of art. Two of these are coherence or unity, and originality.[14] These criteria illustrate very clearly, among other things, the fundamental principle we have outlined in this and the preceding chapter; namely, the fact that reasons for aesthetic valuation relating to the sensuous or nonsensuous features of works of art are properly justified, at least ultimately, in terms of the aims of art.

(1) In Chapter 11, I discussed one important use of the notion of coherence or unity: its use with respect to the general teleological criteria of artistic merit. There we pointed out that *unity of effect* is a fundamental criterion of aesthetic merit, and we attempted to justify it. We also applied that notion to the ideas, imagery, and symbolism that may occur in particular works of art; that is, we maintained that their coherence with one another, and with the sensuous features of a work, is a condition of their being able to serve—individually and collectively—the generic aims of art.

Now the ideas, imagery, or symbolism that may occur in particular works constitute what we have been referring to in this work as the nonsensuous *features* of (some) works of art. As such they constitute, together with the work's sensuous features (which are the means whereby they themselves are concretely expressed or conveyed in the works in which they occur), the *means* whereby a work of art as a whole achieves its goals as art. (This remains whether or not the expression of ideas constitutes a generic aim of art.) So if unity of effect is a criterion of aesthetic excellence, it follows that a given work is partly judged to be good or poor art to the degree in which it produces a unified effect under standard conditions. But what *is* a work that possesses unity of effect, in terms of the features it possesses, its form$_1$ and content? It is a work whose various parts or aspects, nonsensuous and/or sensuous, cohere with one another, a work possessing unity of form and content. In other words, those works which are said to be coherent

or to possess unity, concerning their nonsensuous and/or sensuous features, are simply those able to produce a unified effect under standard conditions. This means, among other things, that it would be utterly confusing to look for a *single* relation, or kind of relation —or even a single set of relations or kind of relations—in works of art, as constituting their unity. The notion of coherence, as applied to the relationship between the qualities of a work, makes sense only insofar as the work is seen in relation to us, the perceivers.

In and by itself as an object, activity, or set of qualities, it is of course a complex of elements which are related spatially, temporally, thematically, and so on. But these relations, as such, cannot be said to give the work unity, in the sense in which critics employ these words, or in any other aesthetic sense. The work is either unified or lacks unity—more precisely, it possesses or lacks some degree of unity or other—in relation to us, the perceivers. It produces or fails to produce a unified effect in us, by virtue of its qualities-in-relation. Which particular combinations of colors, lines, forms, masses, tones, words, and so forth produce a unified effect in one and the same person or in different persons, out of the infinite possible combinations of these things, and why they do so, is an important psychological question meriting thorough investigation by psychologists, sociologists, and aestheticians. But whatever the biological, psychological, or cultural reasons for this in individual instances, it is a fact that certain combinations and not others do produce a unified effect in particular persons or groups, at a given moment or in a given period; these are called "harmonious combinations," and the work is said to be a "harmonious, coherent work." And it is commonplace that what strikes one man or one group as harmonious, coherent, or unified at one time strikes another man or group, at the same or another time, as inharmonious, incoherent, or lacking in unity. This relativity of effect must not, however, lead us to ignore or minimize the importance of the qualities-in-relation which produce these effects. That is, unity is not merely "subjective"; and the undoubted relativity in our reactions here should not be exaggerated. There are, after all, many works (the so-called classics chief among them)

which have continued to strike many generations of perceivers as possessing contentual-cum-formal unity of a very high order, judged in terms of the effect they have, or have had, on them. The human constitution, biologically and psychologically speaking, is perhaps such that certain elementary or simple combinations of sensuous and/or nonsensuous elements, found in works of art or in nature, strike most or all men as harmonious or inharmonious. But the contrary supposition does not materially affect our central point.

It is, of course, a commonplace historical fact that critics and laymen have frequently utilized various alleged formal or non-formal standards of harmony, coherence, or unity which are determined by their users' personal—often peculiar—conception of art. It is also commonplace that these conceptions sometimes utilized a concept of art which is different from, or even opposed to, the concept of art determined by the then ordinary and/or critical aesthetic discourse. In any case, some of these concepts of art are often different from the present-day ordinary concept. Equally important, some of these standards themselves were formulated without regard to, hence were not based on, the general aims of art. It is not surprising, therefore, that they frequently conflicted with these aims. We have already pointed out that these aims do not seem to have materially changed, *in what we now call the West*, over the years, so far as concerns the ordinary concept of art.

Many of these standards—and the restrictions they imposed on the form or content of works of art in general or works falling under a particular art form, genre, or kind of art—have proved to be arbitrary, without sound aesthetic justification. They have either impeded the creation of new good art, or led to the creation of mediocre or positively bad art. Fortunately, some of them, such as the unities of place and time in drama or the banning of parallel fifths and octaves in music, have proved incapable of holding down the genius of the greatest artists, who were able to use them to good effect when they did not expressly ignore them. In any case, and even if these or like prescriptions always had, as a matter of fact, a beneficial effect on art, the logical test of their

adequacy or inadequacy is their conduciveness, or the opposite, to the creation of works that satisfy as fully as possible the aims of art. The same applies, I should add, to any other kind of criterion or standard that was, or is, in actual critical use. (See, for instance, our later discussion of "form" and "completeness.") Thus I am aware that, as a matter of fact, critics have not always judged a work as coherent or incoherent by noting the kind of impact it had on them. And even when they have done so, they may have sometimes had in mind some particular kind of effect as determining coherence.

The relevance of the foregoing remarks to the notions of "form" and "completeness," which were discussed in Part I, is clear; it is seen that 'form', in our *fourth* sense of this word, can be defined in terms of the concept of unity of effect. So defined, a work of art will be formally unified or organic in the present sense in the degree in which its formal-cum-material features, nonsensuous or sensuous, are conducive to the production of a unified effect in qualified perceivers under E-conditions. Since unity of effect is a criterion of excellence, this shows very clearly (as we stressed in Part I) that organic form, form$_4$ (or rather, a high degree of organic unity) is a *general good-making* "feature" of works of art —a "feature" which may be used to distinguish good works from poor works, rather than works of art in general from other things. It is clearly in this evaluative way that Frank Lloyd Wright, for instance, speaks when he advocates integration or organicity in architecture ("organic architecture," as he calls it), as in the following quotations taken from his *The Natural House*:

Integration as entity is first essential. And integration means that no part of anything is of any great value in itself except as an integrate part of the harmonious whole.[15]
"Form follows function" is mere dogma until you realize the higher truth that form and function are one.
Why any principle working in the part if not working in the whole? [16]

This is also clearly seen in his strictures on traditional architecture (p. 43).

Even those aestheticians who ostensibly distinguish art from non-art in terms of "organic form" tend to slip into an evaluative use of this expression as when they speak of all "true," "real," or "genuine" art as possessing organic form (or in Susanne Langer's theory, as being an organic form).

The criterion of unity of effect also helps determine the extent to which any given form$_4$ "fits" the content of a particular work, and vice versa. For the form$_4$ *and* the content of a work are properly evaluated in terms of their joint contribution or lack of contribution to a unified effect under E-conditions. There are, to be sure, other T-criteria which are applicable to the form$_4$ or the content of a work alone, and other criteria which are applicable to the two together.

Passing to aesthetic completeness (or "wholeness") and incompleteness,[17] we can readily see how these concepts are likewise determined teleologically. A work is artistically complete or incomplete by virtue of the kind of effect it has under E-conditions. It is the former if its *total* effect, under these conditions, is "well rounded." It is artistically incomplete if, as we say, something is missing or lacking in the effect as a whole. The cumulative effect —to the extent to which the particular work may have such an effect—is cut off abruptly, without reaching either a climax or a smooth, natural resolution. (Contrast, for example, the last scene of each of Shakespeare's later tragedies, or the "dying fall" of some works of music.) In this sense Schubert's "Unfinished Symphony" and Coleridge's "Kubla Khan" are certainly complete, while Keat's *Hyperion* is not.[18]

The relation between these things and unity of effect is that only if a work is aesthetically complete can it have perfect unity of effect; consequently, if it has perfect unity of effect it will be aesthetically complete. Stated in terms of the work's features, a work can be *perfectly* organized, will possess form$_4$ in a very high degree, only if it is aesthetically complete. Therefore, if a work is perfectly organized it will have a well-rounded effect, assuming that it will

have any effect at all, under E-conditions. On the other hand, a work can be aesthetically complete without being completely organized. If this were false very few or no actual works of art would be aesthetically complete. Yet many extant works of art are aesthetically complete.

Nonetheless, in the more obvious instances of aesthetic incompleteness one can tell that the work is incomplete in this sense from the incompleteness of its plot or story, its descriptions, or what it represents, and the like, as the case may be. It is also directly perceivable in the case of some works of architecture that are incomplete in a formal₁ or material sense—in the more common and very general use of 'incomplete'. In none of these types of instances does the perceiver need to go to the work's effect on him or on others to discover that the work is aesthetically incomplete. Note that aesthetic incompleteness, but not aesthetic completeness, admits of degrees. The latter is a limit, not a range. This is why 'aesthetically complete' can be used interchangeably with the aesthetician's 'whole'. However, both 'complete' and 'incomplete', and their cognates, as well as 'whole' in the present sense, are technical or semitechnical words and should be used cautiously. Many of the other evaluative expressions used by critics are so; the same warning applies to them.

The more unified a work with regard to its nonsenuous and sensuous features, the greater the proportion of its features, other things being equal, which contribute to its aesthetic aims. In the same way, the less coherent a work is the greater the proportion of its features, other things being equal, which positively hinder the realization of its aesthetic aims, or contribute nothing to it.

(2) Passing to originality, it may be immediately noted that, unlike many other criteria employed by critics, it is applicable to all of the multifarious features of a work of art—formal, material, technical—as well as to the impact it has, or is intended to have, on the perceiver. It is therefore broader than the notion of coherence, which is clearly inapplicable to the techniques employed in the creation of a work of art. But it also differs from that criterion in another important respect. In actual critical practice, it is only partly prized for its conduciveness to a more powerful and

lasting impact on the perceiver under E-conditions. I think it is also prized in the West "for its own sake." In any case, it can be in principle so justified. For, as I pointed out earlier, the concept of originality is part of the concept of creativity (originality is a form of creativity) which in turn is part of the Western concept(s) of art.

It is clear why originality is prized insofar as it is conducive to a more powerful and lasting impact than lack of originality. For what is original is unfamiliar, even unexpected, sometimes not even remotely conceived, hence striking, exciting, or effective. The opposite is true of the commonplace. Hackneyed language, symbols, forms or melodies, and pedestrian ideas or conventional treatment are ineffective. They fail to stimulate; they give no new experiences, insights, ways of looking at everyday objects, or ourselves. On the contrary, they are irritating in exact proportion to their commonplaceness. Familiarity here as elsewhere breeds "contempt." The psychological mechanism whereby originality and so the unfamiliar in art stimulates, provokes, absorbs us is simple and well known. As Hume describes the matter in general terms in relation to the ideas of identity and difference:

What is . . . expected [and we may add: "hence is familiar"] makes less impression, and appears of less moment, than what is unusual and extraordinary. A considerable change of the former kind seems really less to the imagination, than the most trivial alteration of the latter. . . .[19]

This is partly due to the fact that what is original, by virtue of its unexpectedness or unusualness, attracts and rivets our attention to the work, while no such thing happens in the case of that which lacks *all* originality. Such a work scarcely begins to leave any impression on us, whatever virtues it may have. Since originality or lack of originality is a matter of degree, what we are saying is true in particular instances in the degree in which the work is original or not original.

A second reason, it seems to me, why originality is universally prized by professional critics and the educated layman in the West is that originality is an integral part of the notion of creativity; while the latter has been *part* of the *concept of art* as far back as we can go. This is in striking contrast to certain other cultures: in general, highly traditional cultures, such as those of Asia. In the West, the demand that the art of the present should not be a mere replica of the past, that it must say something new or say the old "eternal verities" in a new way, that it must reflect its age, time, and, in that sense, be "progressive" is found even in the conparatively most conservative ages or times. But this reminds us that originality in art, like certain other criteria of artistic merit employed by critics at one time or another, such as *economy* and *discipline* or *restraint*, has been more stressed at certain times than at others in the history of the West. It is commonplace, for instance, that the late nineteenth century and the first decade or so of the present century were conspicuously lacking in that attitude and in the striving to achieve it; while the present century has been, so far, striking in the tremendous, almost revolutionary, emphasis it has placed on originality. (I find that in the Arab Middle East there is a general tendency on the part of the public not to take a work's originality or lack of originality, except in the technical sphere, into any serious account in evaluating it. The only thing which is widely prized is technical ability, especially virtuosity in the execution of music.)

The striving for originality in practice is fraught with grave dangers. Unfortunately, originality has frequently been confused—not least in this century—with mere novelty, even outlandishness, and the pursuit of the bizarre and exotic. Since what is original is unusual, unfamiliar, sometimes even extraordinary (out of the ordinary), it is easy to assume that the converse is also true: that whatever is unfamiliar, unusual, or extraordinary is original, and so good. Hence the common pursuit of novelty for its own sake, of difference for the sake of difference. This is immensely aided by the increasing struggle of the individual to assert his fast-vanishing individuality in the face of the ominous pressures of uniformity and conformity, impersonality and depersonalization. Also, it takes

effort and time (sometimes a long time) even for the critics to sift the original from the merely novel.

The forces of conformism and uniformity have always been oppressively strong and ubiquitous (though in a different way) in the various Asian cultures and subcultures, in contrast to the West, which has known individual liberty and has cherished individuality for a long time. This partly explains the still sporadic efforts of artists and intellectuals in the East to throw off the shackles of tradition and assert their individuality. Moreover, in the East (at least in the Middle East) as opposed to the recent West, the forces of uniformity and conformism have not been those of dehumanization. They have been, rather, forces which impel the individual to submerge himself in the "larger whole" of the clan or community. There was and is a warmth and humanity, a fellow feeling, a sense of belonging in this surrender of the individuality —which is lacking in the highly sterilized and impersonal atmosphere of the modern mechanized or industrialized cities of Europe and the United States. But the extent of neither of these should be exaggerated.[18] Even the latter is in danger of being exaggerated out of all proportion at present, especially by the young who are seriously concerned about this *maladie d'esprit*. Their rage against it is part of a rejection of the Establishment and what they believe it stands for, a rejection of its norms and values. The effects of this rage on their attitude toward the tradition of art and the current standards of art criticism are of considerable practical significance. We shall return to this phenomenon, but for a different reason, in Chapter 13.

The craving for novelty and technical virtuosity are bedfellows. Drawing on T. S. Eliot's celebrated phrase, we may say that virtuosity for its own sake is one form of "excess" in the "objective correlative" over the thought expressed and the feelings or emotions evoked by a work. I say "one form" because, if Eliot is right, we have in *Hamlet* a form of "excess" in the "objective correlative" which is quite different from what we are talking about: *Hamlet's* failure as Eliot understands it has nothing to do with virtuosity for its own sake.

Corresponding to the condemnation of virtuosity for its own

sake by responsible critics, "seeming artlessness," expressed in the well-known statement "art lies in hiding art," is widely praised. For example, in praising Turgenev's seeming artlessness in his fiction, the critic is praising the opposite of virtuosity for its own sake. The critic praises the directness and simplicity of the means of expression, such as the language and plot in the writer's depiction of life in Russia as he knew it, and in the creation of unforgettable living and highly individual characters. The epithet 'seeming' is, however, necessary in order to distinguish what we are talking about from artlessness in the sense of artistic naïveté or lack of artistry. Hiding art is commonly regarded by critics as the height of artistry.

In the prizing of novelty and virtuosity for their own sake we have two chief instances of a phenomenon of major importance in aesthetic valuation. I mean that what may have been originally regarded as good merely "as a means" gradually comes to be regarded as good "in itself." This phenomenon, as I had occasion to note before, was first pointed out by Aristotle. It is also discernible in other value situations than the moral and the aesthetic.

Our discussion of virtuosity for its own sake brings us to the important notions of restraint or discipline, and economy, hence simplicity of means of expressions—which provide us with widely employed criteria of aesthetic merit. Virtuosity for its own sake is one form of extravagance with regard to means of expression. It can also be regarded as one form of lack of restraint or discipline, though these terms are not usually applied to it. There is at least one other main form of lack of economy, which is unrelated to virtuosity; indeed, 'lack of economy' is usually limited to this latter form. In this form, it consists, as with virtuosity for its own sake, in doing "too little with too much." But it refers to the employment of sensuous or nonsensuous materials which are superfluous or have little significance (significance$_2$) as elements of the particular work. They contribute little or nothing—in every case less than we feel they should—to the work as a whole. Some of the works of the nineteenth-century Romantic and Victorian writers and composers are well-known examples: some of the poems of Shelley, Byron, Tennyson, and especially Swinburne; some of the

compositions of Chopin, Schumann, Berlioz, Saint-Saëns, and Tchaikowsky. In some of the works of Paganini, who was of course a master virtuoso both as performer and composer, we find brilliant technical virtuosity coupled with a good deal of artistry. His caprices for unaccompanied violin are good examples. These works are not merely bravura pieces, but one can argue that Paganini could have done still more with all the consummate technical resources he had and drew upon. For example, compare and contrast Paganini's caprices with J. S. Bach's partitas for unaccompanied violin. The same is true of many of the works of Liszt.

Economy and simplicity, as well as restraint, are major characteristics of classical and neoclassical art at its best. In our day T. S. Eliot, by his own admission, is a classicist both as critic and as poet; though the term 'classicism' (and 'romanticism' too) sounds more than a little old-fashioned to many ears. Eliot's *Four Quartets*, together with, for example, Rilke's *Duino Elegies* and many of Ezra Pound's poems, constitute some of the best examples of economy and discipline in contemporary poetry. Eliot's temper as a critic is well illustrated by his criticism of Marlowe and Shakespeare in the following passage:

> Marlowe's rhetoric consists in a pretty simple huffe-snuffe bombast, while Shakespeare's is more exactly a vice of style, a tortured perverse ingenuity of images *which dissipates instead of concentrating the imagination,* and which may be due in part to influences by which Marlowe was untouched.[19]

Here Eliot is taking Marlowe's exaggerations of expression and artificiality, *and* his virtuosity, to task. I think it is partly the latter that he criticizes in Shakespeare. The part of the quotation I italicized is also significant, because Eliot implicitly links the vice to which he refers to the dissipation of the effect of Shakespeare's imagery. Indeed, although Eliot's concept of the "objective correlative" is not perfectly clear, we can say, I think, that lack of economy, simplicity, and restraint—not only virtuosity for its own sake—can be

regarded as forms of "excess" in the objective correlative of a work of art.

NOTES

1. Among other things. For it also aims to realize, by means of these same features: (a) its own individual aims as a particular work, and (b) the more general aims of art of its kind, if any, as a (certain kind of) tragedy, if it is a tragedy, or a (certain kind of) comedy, if it is a comedy, and so on.

2. "Some Distinctive Features of Arguments Used on Criticism of the Arts," *Aesthetics and Language*, p. 128.

3. *Ibid.*, pp. 147–60.

4. That is, complexes of interrelated qualities.

5. "Mr. Eliot and Milton," in *The Common Pursuit* ([n.p.], 1922), pp. 13–4.

6. *Ibid.*, p. 14.

7. For example, Helen Knight, *op. cit.*; William E. Kennick, "Does Traditional Aesthetics Rest on a Mistake?" *Mind*, Vol. LXVII. No. 267 (July, 1958), pp. 317–34. Margaret Macdonald, "Some Distinctive Features of Arguments Used in Criticism of the Arts," *Aesthetics and Language*, pp. 114–30, and Stuart Hampshire, "Logic and Appreciation," *ibid.*, pp. 161–69 seem to be other examples.

8. In contrast to judging it as, say, a good or poor classical tragedy.

9. But if a particular poem happens to be an epitaph, say, we evaluate it, as an epitaph, in the same sort of way as we evaluate a tragedy.

10. Either as part of some particular school or movement, or by itself. Literature belonging to the "theater of the absurd," or the "theater of cruelty" (such as Le Roi Jones's *The Toilet* and *The Slave*) are good examples of the former.

11. It is noteworthy, however, that this controversy is frequently phrased in terms of what the particular artist, rather than the work he created, set out to do.

12. This is the logical counterpart of praising it for succeeding in what it set out to do, that is, on the technical skill it displays.

13. Cf. Edward Wagenknecht on Virginia Woolf: "Virginia Woolf was less interested in individual characterization than in interpreting the *essential* nature of universal experience" (*Cavalcade of the English Novel*

[New York, 1945], p. 525); and, "Virginia Woolf was often reproached for her failure to create memorable characters. She was less interested in Mrs. Brown than in 'Mrs. Brownness,' less concerned about individuals than about 'the meaning which, for no reason at all,' sometimes descended upon them, 'making them representative,' not of, say, Mr. and Mrs. Ramsey, but 'the symbols of marriage, husband and wife' " (*Ibid.*, p. 526). Wagenknecht points out that she was striving for a metaphysical and a psychological unity, the latter "making the whole individual human life a recherche du temps perdu." (*Ibid.*, p. 528. Cf. also Wagenknecht's discussion of her equal unorthodoxy in the treatment of time, pp. 528 ff.) However, Wagenknecht himself criticizes her in the following way: "While one must not, in the matter of the creation of character, for example, condemn her for failing to accomplish something she never attempted, one must also admit, I think, that it is at least very doubtful whether the novel can long survive having substituted Mrs. Brownness for Mrs. Brown" (*Ibid.*, p. 532).

14. Note that in this chapter I speak of coherence and originality as both criteria of artistic excellence and good-making features of some works, though obviously in different respects. By virtue of the fact that coherence and originality are criteria of excellence, we call certain features of some works coherent or original and thus consider them as good-making features of the particular works.

15. (New York, 1954), p. 22.

16. *Ibid.*, p. 19.

17. As opposed to certain conventional *formal*₁ or like criteria in use in various periods of history. As we said in Part I Chapter 3, that sense of 'complete' or 'incomplete' is irrelevant to a work's merit or demerit as art; it is a descriptive, not an evaluative, use of these words. That is why, in "X is an incomplete or unfinished symphony," the word 'symphony' is used descriptively, not evaluatively or as short for 'good symphony'.

18. Cf. our discussion in Part I, Chapter 3.

19. *Treatise of Human Nature*, edited by L. A. Selby-Bigge (Oxford, 1955), p. 258.

20. For some of the negative aspects of the culture see my "The Mask and the Face: A Study of Make-Believe in Middle Eastern Society," *Middle East Forum* (February, 1961), pp. 15–18.

21. "Marlowe," *Selected Essays* (New York, 1960), p. 101. Italics mine.

Chapter 13

Art and Society

In this concluding chapter I shall round off the discussion in Part III by relating it to Part I: hence, by implication, to Part II as well. The discussion as a whole will illustrate a very important facet of the valuation of art not brought out in Part I or, so far, in Part III. This facet is the relation of aesthetic value to other types of value, and so the relation of art and society as a whole in a given place and time.

I

The intimate relation of moral and social values on the one hand and aesthetic standards on the other hand, in a given place and time, has often been noted by writers on art. Herbert Read puts the matter in general terms, in relation to literary criticism:

> It [literally criticism] is the valuation, by some standard, of the worth of literature. You may say that the standard is always a very definitely aesthetic one, but I find it impossible to define aesthetics without bringing in questions of value which are, when you have seen all their implications, social or political in nature.[1]

In the present part of the chapter I shall take a closer, though necessarily rather brief, look at some of the ways in which (I) eco-

nomic, social, moral, political, religious, or other types of value (hereafter referred to as "life values")[2], hence (II) the actual conditions prevailing in the particular society at the time, and (III) the climate of opinion—the scientific, philosophical, theological, or other kinds of beliefs—of the age influence the standards of aesthetic valuation in practice. In order to talk intelligently about their influence, we must distinguish the following three things. In the first place, we must exclude from our discussion (A) the utilization by students of history and other social scientists of social, political, and other criteria or standards for the valuation of works of art, particularly literary works considered as historical or sociological documents, as a mirror of the particular age or society. The value of a novel or play in this sense varies directly with its usefulness as a source of correct information about the mores, morals, customs, foibles, life, outlook, and so on of the artist's age or society or some other age or society. The criteria of merit and demerit in this sense are much the same as those applied to straightforward historical, sociological, or anthropological writings. It is clear that the kind of value or disvalue attached to a work of art in terms of these criteria is unequivocally extra-aesthetic value or disvalue, or else the words 'good' and 'bad', and the like have a nonaesthetic use in such judgments as "T. S. Eliot's poems are excellent revelations of the human condition in the Age of Anxiety." They are also, just as clearly, nonmoral uses.

In the present way of looking at works of art, they are judged as *useful* or *useless* in the way just described. This serves to distinguish the present way, and the sort of criteria applied here, from something else, with which it can be easily confused. I mean (B) the application to works of art—allegedly qua art and not as social or historical documents—of straightforward or unadulterated moral, social, political, religious, or ideological criteria. These are imposed from outside. This itself must be distinguished from (C) the employment of criteria (1) resulting from the *transformation* of social, moral, political, or other types of standards of value into bona fide *aesthetic* standards of valuation. In this type of case as against the imposition of standards from without ([B]), the stand-

ards in question are successfully adapted to art, become aesthetic standards; it is clear, however, that the most resolute efforts to do so may sometimes fail to adapt them properly to it. On the other hand, (2) it is conceivable that some such aesthetic standards are derived not so much from specifically religious, economic, moral, political, or some other type of value as from more general principles that are common to them all, or, at least, common to the appropriate ones among them, qua values. These principles appear to be criteria features common to economic, social, moral, and/or other goods as valuable or desirable in some sense or respect, for some reason or other. An outstanding example of this was discussed earlier in this book; namely, the notion of durability, which is utilized in relation to art as the duration of the impact of a work of art, positive or negative.

The distinction between "aesthetic" and "extra-aesthetic," of what constitutes an aesthetic criterion or standard as opposed to an extra-aesthetic one, is made here, as elsewhere in this book, in terms of what I believe are the everyday uses of 'art' or the everyday concept of art. Although I have my own views on the subject, some of which are evident in this chapter, I have not concerned myself much in this book either with defending or with modifying these uses or this concept. That is logically the most basic step for aestheticians who, like the present author, take everyday aesthetic discourse as their analytical point of departure. The step can come only when the everyday conceptual framework has been laid bare. The present book is almost wholly concerned with the latter.

Our concern in this book in general, and Part III in particular, is of course only with (C) above.

In the rest of this section, I shall consider a number of extended examples to illustrate concretely and to bring out clearly some of the complexities of the influence of our earlier factors, (I) through (III), on aesthetic standards. (I) We have seen that the notion of duration is utilized in relation to art as the duration of the impact of a work of art, positive or negative—as a criterion of merit or demerit. This notion has its analogue in the notion of durability in the economic sphere. This is the notion of durability as applied to commodities such as items of clothing, houses, rec-

ords, books, and household gadgets. It is noteworthy that in the case of physical objects, the notion is closely connected with the notion of physical strength. Since the concept of strength in this sense is inapplicable to art, we find it transformed into the notion of strength of effect, and thus connected with duration, since the stronger the impact of a work (indeed anything), the longerlasting it tends to be, though the converse is false.

The notion of durability (as opposed to duration) applies to *plastic* works of art. But there is no logical connection between the duration of a work's impact and the life span of the work. Within very broad limits there is also no contingent relation between the two. This is presumably why the minimal stability, and hence durability, of a particular painting, sculpture, or work of archi-tecture is not a criterion feature of merit. A canvas or sculpture that does not disintegrate in a hundred years is not, for that rea-son, a better (or worse) work of art than one that exists for only a few seconds or minutes.[3] This is why this notion is implied in the descriptive, not the evaluative use of 'art'. If a work exists for only a brief moment, it is, *as a matter of fact*, difficult or impossible to enjoy it properly; what enjoyment may be derived from it will be fleeting and, so, lacking in strength. Strength of effect, which is another criterion feature of aesthetic value, is actually difficult or impossible to achieve if the source or cause of the impact (which in this case is partly or wholly a sensible thing) has an extremely short life span. This qualification is important since it shows the disanalogy between this type of case and, for example, mystical experience. The great mystics testify that the latter is as fleeting as it is intense and profound.

With regard to human qualities, the notion of strength, naturally associated with durability, emerges transformed as the virtue called strength of character; while durability reemerges as physical and moral, or mental endurance, dogged persistence, and the over-coming of difficulties.

The notion of durability (with the appropriate changes) also arises in the social and political, as well as the moral, spheres in our valuation of what we call the stability or instability, permanence or impermanence, of social, political, economic, religious, or other

institutions. (The emphasis on tradition, which continues to be very great and pervasive in Great Britain and in the greater part of Asia, is one illustration of this.)

The notion of duration of effect in relation to art, which we noted earlier, is but one manifestation of the value traditionally placed on the duration of satisfying—that is, pleasurable—mental, emotional, or physical states, constituting an essential ingredient of the everyday notion of happiness. It is possible, though, that the value ascribed to the duration of enjoyable experiences associated with good art is an *extension* or *application* of this psychological and/or moral criterion of value, rather than an instance of a criterion feature stemming from a common axiological source.

Anyone in his twenties who reads the preceding paragraphs would very likely protest that their author is a "square" out of touch with reality; he would be inclined to cite this case as a good example of the generation gap. And, of course, if we stop at the above remarks the accusation would be perfectly correct. For there is at present, among European and American youth, a strong tendency to reject the traditional emphasis on duration and durability, stability or permanence, some of whose expressions we have just outlined. This tendency embraces many or all walks of life and is being increasingly reflected in contemporary, especially experimental or avant-garde, art. All this is a result of and clearly manifests the increasing tendency of the younger generations to break away from the values associated with their parents. Kinetic art and especially self-destructive art (also experiments with light, including colored lights) are some expressions of this. The prizing of personal experience, so long as it is intense[4] and significant, no matter how short or ephemeral, probably reflects among other things the young generation's feverish immersion in and self-abandonment to the present moment and the pleasure of the moment—the burning of life's candle at both ends. This is a reaction to the uncertainty and precariousness of the future in an age of savage turmoil, large-scale destruction of life and property, dehumanization and astounding inhumanity, irrationality, and the constant threat of atomic holocaust.

Together with the extremely rapid pace of present urban life in

the West and the tremendous rate at which scientific advances and technological changes (if not also men's attitudes and way of life) occur, this is beginning to convince even the post-thirty generations (thirty being the magic dividing line for the young) of the soundness of the new attitudes. Some of us are beginning to accept (though others resist) the protestations of the young that there is nothing wrong with things that endure but for a day, so long as the experiences we can derive from them are enriching and satisfying, that being ephemeral does not rob the object, experience, or relationship of an iota of its value. One of the most noteworthy illustrations of this is the drastic modification or even, in some cases, repudiation of the traditional concept of marriage as an enduring or relatively enduring relationship. The emphasis is now shifting away from duration toward the sheer quality of the relationship.

Long before the rise of the current trends in art and the present social revolution initiated by the young, the commercial world of cars and fashions made a fetish of being "fashionable," regarded as synonymous with being "different," "new," "modern," "latest" —which implies "only for a year" or "only for a season"—and so "the best."

In sum, I think it is no exaggeration to say that our concept of time in relation to value is undergoing a profound change; with it go our age-long Platonism in the West (of which Plato's theory of Forms is itself only one outstanding reflection) regarding the character of the real and the ideal. But in Western civilization, as opposed to Eastern civilization, the quest for permanence (most notably reflected in philosophy, religion, and art) has been, since its beginnings, counterbalanced by the dynamic, Heraclitean quest for change, novelty, creativity, adventure, and the conquest of the physical and human environments. (Again, process philosophies, such as Heraclitus's own philosophy, are only one sort of manifestation of this.) We can go as far as to say that the Apollonian and Dionysian impulses, which Nietzsche regards as pervasive forces in Western culture and art, can be regarded as but one partial manifestation of the opposing tendencies I have discussed above. What is more, the dynamic (hence Dionysian) impulse

appears to be gaining ascendancy. There is no clearer or better expression of this than current American society and art.

(2) Another example of changing attitudes toward art—in this case toward standards of valuation themselves—radiates from changing attitudes toward life and society as a whole, and the idea of authority. It illustrates another basic facet of the current rebellion of American and European youth against the Establishment and the rejection (at least in theory) by the more radical elements among them of all that it stands for. I have in mind the tendency to reject (a) general, and especially (b) fixed or more or less fixed standards of value, believed to be applicable to all art. An extremely important part of their rejection of tradition is their great emphasis on the uniqueness of the individual and the individual situation. This has found its chief expression in the rejection of general standards of moral and personal value, and as an offshoot of this,[6] the rejection of general aesthetic standards. A "situation aesthetics" seems to be emerging in the manner of current "situation ethics." An important facet of this, which I have observed in the case of a number of my young American students in aesthetics, is their tendency to reject the special authority of professional critics, who appear to carry no special weight with them. At the same time, the rejection of what the young appear to think is the rigidity and fixity of the standards wielded by established critics and the general public over thirty [7] probably stems in part from their view or intuition of life as fluid, dynamic, and ephemeral—which as we saw has special and poignant reasons over and above youth's perennial awareness, in all ages and periods, of the impermanence of youth and its joys. Compare and contrast this with the passionate vision of the young poets of all time, but especially those who embody the spirit of Romanticism, of the tragic mutability of all things noble and fair. Contrast also Keats's "A thing of beauty is a joy forever" and Gerard Manley Hopkins's explicit and impassioned Christian Platonism.

Our discussion in (1) above illustrates the important fact that the various sorts of criteria features of value considered form "families" or "families of families," and are connected by what appear to be crisscrossing resemblances in a way strongly reminiscent of

A-features exemplified by art and things other than art. (See Part I, Chapters 5 and 6, also Part III, Chapter 12.) This is not an accident, since *evaluative* A-features are criteria features of aesthetic value.

(3) A further illustration of this pattern is seen in the case of coherence as an evaluative concept. The word 'coherence,' which applies to many kinds of things besides art, has more or less different specific meanings, or at least uses, in its application to works of art on the one hand and to scientific and philosophical theories on the other. The same is true with its applications to other kinds of things. In the case of scientific and philosophical theories, coherence is mainly or wholly logical coherence, coherence of ideas, logical consistency and relatedness, whereas coherence in relation to art commonly involves something quite different. Differences in specific use or meaning do arise, I think, even in relation to different art forms or even genres, and so on. Again, coherence is connected with unity and with order, which are also traditional good-making features. But note the sea change that occurs in the conceptual passage from unity and order as these notions apply to art—leaving aside the more or less subtle changes that occur in the passage from one kind of art, or even one work, to another—to unity and order in the social, political, and legal spheres, and so on.

(4) The emphasis of the Greeks on beauty in art, which such thinkers as Lessing in *Laocoön* and Nietzsche in *The Birth of Tragedy* pertinently stress, is another good illustration of the pervasive or ubiquitous character (with the appropriate changes) of certain types of standards of value, of types of reasons given for the valuation of different sorts of objects, activities, or states of affairs. It further illustrates the fact that in a given age or society certain families, or families of families of features, are selected or favored, as good-making features, from the innumerable possible families of features; and that certain other families, or families of families of features, are selected as bad-making features. (In many instances, of course, the good-making and bad-making features in question are opposite or antithetical features.) These selections are consciously or unconsciously prompted by current or by past events, and/or by economic, social, political, moral, or religious conditions, together with the values they engender or in terms of which they them-

selves are interpreted, organized, or understood. The notions of harmony, order, unity, balance, economy, restraint, and moderation, which figure so prominently in the classical Greek ideal of beauty and in the greatest Hellenic art [8]—and which inspired all subsequent classical and neoclassical art—are exemplified everywhere in Hellenic culture. In the moral sphere we find them in the ideal of moderation in human conduct; and this finds its clearest and most vigorous expression in Plato's "aesthetic" ethics (the good life, hence happiness, as a harmony between the three parts of the soul under the aegis of reason) and in Aristotle's Golden Mean.[9] (This element is also found, in a more extreme form, in the philosophy and life of the Cynics and their philosophical descendants, the Stoics.) Without necessarily subscribing to Nietzsche's interpretation in toto, the following passage from his *The Birth of Tragedy* illustrates various facets of the Apollonian ideal of moderation and restraint in fifth-century B.C. Greek society:

> Apollo, as ethical deity, exacts measure of his disciples, and,
> . . . to this end, he requires self-knowledge. And so, side by
> side with the esthetic necessity for beauty, there occur the
> demands "know thyself" and "nothing overmuch"; conse-
> quently pride and excess are regarded as the truly inimical
> demons of the non-Apollonian sphere, hence as characteris-
> tics of the pre-Apollonian age—that of the Titans; and of the
> extra-Apollonian world—that of the barbarians. Because of his
> Titan-like love for man, Prometheus must be torn to pieces
> by vultures; because of his excessive wisdom, which could
> solve the riddle of the Sphinx, Œdipus must be plunged into
> a bewildering vortex of crime. Thus did the Delphic god in-
> terpret the Greek past.[10]

To the extent that these observations are correct, they provide us with further illustrations of our thesis.

Turning to modern times, the emphasis on "truth and expression" as opposed to beauty in recent and contemporary Western art, can be regarded as but one significant expression of realism

(and in the nineteenth and twentieth centuries, naturalism) which pervades all walks of life. It is for example, manifested in the hard-headed empirical, technological, this-worldly, practical temper of modern science and technology, and, analogously, in business, international relations, morality, and religion. The modern artist takes the whole of visible nature [11] as his province as opposed to the merely beautiful in it, and thus parallels the modern scientist, who takes the entire cosmos, from the infinitesimally small to the almost infinitely large, as his domain; both parallel the modern explorer's, businessman's, and soldier's mental outlook in making the globe the field of their diverse activities. Another commonplace is that the chief single source of inspiration of the characteristically modern outlook, as opposed to the characteristically Greek and medieval outlooks, was and continues to be the natural (and more recently, the human) sciences. The roles of religion (Christianity) and philosophy should not be ignored or minimized; the fact is that the shifting interrelations of all these forces provide the warp and woof of the many-hued and fascinating tapestry of modern values.[12]

(5) It should be remembered in the present context that the influence of life values on art has a further dimension. These values not only influence or help determine the criteria of aesthetic valuation but, through them, influence the kind of art that is produced in that age, country, or society. For the extant criteria of excellence that are specially favored by the particular age or society (and they may include newly introduced criteria) may exert a powerful conscious or unconscious force on practicing artists—particularly the young and more impressionable among them. But the influence may be negative as well as positive. As history teaches us, the art created under the influence of such social forces may be a reaction to, or a protest against, rather than in conformity with the standards generally favored by critics or the general public. The present age, in Communist countries as well as in the West, amply illustrates this; though clearly the protest and reaction against traditional values and the status quo (the Establishment) are far more extensive and untrammeled in the latter. There is, equally clearly, a great deal of real or merely outward conformity to the demands of the ruling hierarchy in the Communist world, which has no exact parallels in the West.

Further, the original art of a particular age or society—its new

forms, styles, techniques, media, themes, ideas, and modes of symbolism—demands and in a sense itself creates new specific or relatively specific criteria by which it is to be judged. (One can almost say that a work or a group of works of art is original in proportion as it demands new, or even new sorts of, standards of valuation.) Some of them may coincide with the standards under the influence of which the new art may have sprung, but others may be "generated" by the new art. This is one way of stating the well-known fact that *good* art, however much it may reflect the values and outlook of the times, also transcends them, striking out in unprecedented ways. This is clearly true of good art that arises as a reaction to that which the age represents; but it may also be true of good art that arises in sympathetic response to the current values and outlook. In both types of case the new art underlines the failure or limitations of the traditional criteria, in terms of which they are, certainly at first, usually judged. Nevertheless, this employment of traditional criteria has its good side, much as we may rail against it. All new art must demonstrate that it merits being judged in terms of criteria specially adapted to what it aims to do, such as the means of expression it utilizes and the kind of impact it strives for in the appropriate circumstances.

Practicing artists may be among the chief instruments that a particular age or society may use to introduce new standards of aesthetic value or to modify existing ones. They may also be innovators in their own right, not (or not just) instruments. An artist may evolve a new vision of art or of the world, or both. He may see the world in a new way, transforming his view of art. Or the opposite may happen; or the two may come about simultaneously. The former is illustrated by Joyce Cary's discussion of Croce's concept of intuition (intuiting) in relation to Monet.[13] Art inspired by a new vision or conception tends to give rise to new criteria features of excellence, provided that it meets with general, or at least critical, acclaim. Other artists, or critics and aestheticians, may help it achieve recognition as good art, and even succeed in popularizing it, consequently enabling the special aesthetic qualities ("values") it exemplifies to gain wide acceptance.

In some instances the foregoing two—or these together with the life values prevalent in that society—may be interconnected in vari-

ous intricate ways. For instance, critics or aestheticians, under the influence of particular philosophical or scientific theories, as well as changes in values and social attitudes, have sometimes popularized concepts of art different in some degree from the concept(s) in currency. Or an artist or school of art may be inspired by some philosophical or scientific theory to create new kinds of art, embodying new "values" (cf. "existential" art). Also, the life values that may give rise to new criteria of excellence may sometimes be a partial product of the scientific, philosophical, or religious world view(s) constituting the age's climate of opinion. Such views or theories can therefore influence art both directly and indirectly.

One of the ways in which metaphysical theories influence the criteria of aesthetic goodness or badness is through the category preferences (to use P. F. Strawson's convenient phrase) and other evaluative elements they frequently exhibit. For as has been recently noted,[12] many traditional ("revisionary") metaphysical theories and systems are partly evaluative and not purely "descriptive" in character, often contrary to their authors' view of them. We may add that the evaluative elements themselves frequently reflect the general intellectual (cognitive) and axiological climate of opinion of the time. On the other hand, they may partly or wholly reflect their authors' personal values, and may be in opposition to the prevailing values and attitudes.

The complex interrelations of art, science, philosophy, religion and theology, and life values, in a given place and time, can be summed up in Figure 1.

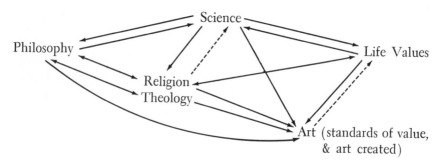

Figure 1

The type of criteria or standards of value that we have concentrated on in this section, and which we will consider further in the next section, consist in what I shall call "nonhistorical standards" (A-standards). (The term 'absolute standard' is inconvenient because of its undesirable connotations. There is no implication here that A-standards are fixed and unchanging, or that they are a priori in any metaphysical sense.) It is also these criteria which I have considered in this book as a whole; for example, in the first three chapters of Part III. I shall now consider briefly a different type of standard which I shall call "historical standards" (H-standards), and which I have not hitherto considered. Part of the practical importance of this type of standard arises from the fact that it is sometimes appealed to by critics or laymen; while part of its theoretical as well as practical interest derives from the fact that verdicts based on H-standards may differ from, even conflict with, verdicts based on A-standards. It is possible for a work to score high in terms of H-standards and low in terms of A-standards, or vice versa. The disputes this may engender parallel and are not wholly unconnected with disputes regarding the "proper" or the "best" way of presenting a historical play or opera, or appreciating a historical novel or painting. Likewise with the appreciation of the art of other countries or cultures. (See earlier in Part III.)

To judge a work by an H-standard is to evaluate it from a historical perspective rather than "absolutely," independent of its historical or cultural matrix, purely as a work of art. It is to judge it in terms of its influence, its contribution to the times or to posterity. The criteria of a work's contribution may be provided by either (1) the nature and extent of its salutary or deleterious *aesthetic* influence on other art, or (2) the nature and extent of its *extra-aesthetic*—moral, philosophical, social, or over-all cultural—influence. The contribution of a work in sense (1) consists in its influence on contemporary or later art. As far as (2) is concerned, the standards utilized and the valuations reached are patently extra-aesthetic and pertain to nonaesthetic value. These must be distinguished from the standards utilized and the valuations reached when art is looked upon as a source of information about some country, age, or society. The valuation of a work in terms of its

influence as art is, strictly speaking, also extra-aesthetic. Judged by strictly aesthetic, A-standards, a work's influence on other art, no less than its influence for other reasons, is logically distinct from its merit or demerit as art. Also, a work's influence on other art may be, in actual practice, quite disproportionate to its aesthetic value. A great work can conceivably have, for any number of reasons, little or no influence of either kind for long stretches of time or even indefinitely. (Compare the fate of J. S. Bach's music until its "rediscovery" by Mendelssohn in the nineteenth century.) Again, the influence of a great work can be greatly bad; it may encourage a host of bad imitations, demoralize capable artists; and so on. The opposite may be true with regard to atrocious works, but this is hardly a matter for debate.

The point here is that H-standards may be influenced or partly determined by the prevailing conditions in a given age or society, including its values, climate of opinion, and the like; similarly with changes that occur in these factors. For at a particular time what is regarded as the significant or important forms of influences a work can have, and the order of importance assigned to these forms of influence themselves, may be influenced or determined by the foregoing factors. Thus, in one place or time a premium may be placed on the political influence as opposed to, say, the moral or religious influence of a work. The former may even come to be regarded as more important than the work's possible influence on contemporary or subsequent art, and so on. At the present time in the West, the general tendency is for the political and social influence of art to be moved to the fore, while religious influence tends to be pushed to the background. And this is clearly a reflection of the age as a whole. By the same token, the hierarchy of forms of influence appealed to in the valuation of art by H-standards is contingently connected with the changes or developments in A-standards that we noted earlier in this chapter. The two types of standards naturally tend to go hand in hand; though there is no a priori reason why there should be a precise correspondence between them.

II

Having considered in Section I the impact of a culture or age on the criteria of aesthetic excellence utilized there and then, I shall now, more briefly, consider some of the things that may happen to the uses of 'art' in the descriptive sense under the influence of changing patterns of value, historical events, and so on.

As already noted in Part I, chapter 3, in relation to the influence of Marxism on the Western concept(s) of art, one of the changes brought about may pertain to (1) the generally accepted *aims* of art. But the above facts may, in addition to or instead of (1), sometimes (2) effect changes in the generally utilized *means* of artistic "expression." Indeed, changes in or additions to the aims of art normally necessitate, in a factual sense, changes in means of expression. These may include the utilization of new means of expression, including some which may be veritably trail-blazing. The converse is not true. The ceaseless quest of artists for new means of expression in, say, the West since its beginnings has not resulted, as far as I can see, in any fundamental additions to the traditional aims of art. (Whatever changes Marxism has effected, if any, in the concept of art in the Communist world are not due to any breakthroughs in the means of expression. On the contrary, Communist, particularly Soviet and Chinese art, has been lagging far behind Western art in this respect.) There may be—as not infrequently happens in ages of transition or rapid change such as the present age, most notably in the West—sharp or profound divisions respecting the "real" aims of art, and/or the "proper" means of artistic expression. To the extent that the former happens, divergent concepts of art in the descriptive sense of 'art' may arise at variance with the generally accepted everyday (lay) concept(s) of art in the descriptive sense,[15] as well as with one another. The division of opinion may even lead to sharp splits in the everyday concept itself, generating two or more rival concepts, both or all of which may then gain currency. And of course the division in the latter may be

either a cause or an affect, or first an effect, later a secondary cause, of the divisions in the former.

I pointed out in Section I that the creation of "ephemeral" art, which I regarded as an expression of the present time, can be regarded (among other things) as the source of new criteria features of aesthetic goodness or badness. Now some ephemeral works at least are regarded as *good* art by the devotees of the avant-garde. Whether in any instance (a) such works have come to be recognized or accepted as art in the descriptive sense independent of their valuation as good art, or whether (b) they were, from the start, regarded as good art and therefore only by implication recognized as art in the descriptive sense, is difficult to say. Quite likely both processes occur or have occurred in the case of different people. Whether (b) has happened in the case of "ephemeral" art (or, similarly, in the case of so-called happenings), it is perfectly conceivable that it should. And if some or all of these "constructions" or "happenings" are regarded as good art in that way, the implication of relative stability or durability in the descriptive sense of 'art' is, by implication, eliminated. The implicit logic is elementary: if such constructions or happenings can be good art, then *a fortiori* they can be art—good, bad, or indifferent. (See Section I.)

Further, the very impermanence of this kind of art may be a source of aesthetic appeal to its devotees. If it is, it entails the tacit addition of new kinds of (sensuous) criteria features of aesthetic goodness to the large assortment of criteria features on which Western critics and laymen have been drawing in their valuation of art. The employment of these qualities as criteria features of goodness can then be viewed as a cause of the above-mentioned change in the everyday use of 'art' in the descriptive sense.

The above process can also obtain as a result of people's appeal to certain novel features of new kinds of art, as bad-making features. But the likelihood of its actually happening is very small. The reasons are not far to seek.

A more radical and dramatic illustration of our above point is provided by the "art" of Christo Javacheff, a Bulgarian artist whose "art," in the words of *Time*, "consists of wrapping things—big things." [16] His latest "work" consisted of his covering the craggy

inlet, Little Bay, near Sydney, Australia, under a "clingy, opaque, icky, sticky polypropylene plastic . . . the last relic of a disposal civilization." [17] Earlier, he "wrapped" the *Kunsthalle* in Bern, a fountain in Spoleto, and the Chicago Museum of Contemporary Art.[18] The significance of his latest "work" for the uses of 'art' or the concept of art is fairly obvious. The objects he had "wrapped" before were all man-made objects, some (hopefully) works of art themselves. But the crags of Little Bay are strictly part of nature, are "natural objects"; and as I pointed out in Part I, Chapter 2, natural objects—we should now say, more precisely, natural objects in their natural or original condition, setting, or surroundings, untouched in any way by the human hand, heart, or mind—cannot be, as such, works of art in the usual unextended literal use of this expression. That is, the "natural" part of a work of art is (or, until this kind of art came into existence, *was*) normally regarded as just the "medium," not *part* of the finished work, the work of art, and certainly not the entire work.

The wrapping of Little Bay deliberately alters the *appearance* of the crags;[19] the "work of art" here has a man-made component in the polypropylene plastic. Calling this "art" does not really break down— *certainly not completely*—the traditional boundary between "art" and "nature," any more than does calling Japanese gardens or the works of George Segal art. But like these "works" or kinds of "works," it sharpens and (re)defines, or forces us to sharpen or (re)define, the borders of (and to some extent broadens) the everyday concept of art; by including among bona fide works of art things for which no definite linguistic provisions existed in actual usage. Further, if a sizable or influential group of people such as prestigious critics come to view some of the "works" of Javacheff as good art, this would help establish or strengthen the redefinition brought about. At the moment, opinions seem to differ "as to what it all means." I should add that the same basic mechanism is also operative in the case of the works of Segal, or even, in a somewhat different way, Japanese gardens.

Again, drastic inroads on the traditional distinction between "fiction" and "fact," "art" and "life," are made by such recent literary compositions as Truman Capote's *In Cold Blood* and some of

Norman Mailer's writings. But the line between "art" and "nature" is completely or almost completely obliterated by some of John Cage's "compositions," which literally consist of uninterrupted stretches of silence.[20] What I said above, for example in relation to Javacheff, therefore applies, *mutatis mutandis*, to these and to works of the same sort.

A somewhat different phenomenon must be finally noted; namely, the logical "transformation" of criteria and so of criteria features of goodness into criteria, hence criteria features, for the application of 'art' (or 'painting', 'poem', and so on) in the *descriptive* sense. Here some criteria, or criteria features, are—generally unwittingly —treated as (are given the function of) criteria of art in the descriptive sense. The result may be, theoretically speaking, either (a) the replacement of the *ordinary* concept employed at that time, O, by a different concept of art, O', or (b) merely a redefinition of O by its being narrowed down to *some* of the things which we would ordinarily consider to be *good* art. Neither (a) nor (b) has actually occurred as far as I know, at least in the West. This is not surprising in view of the considerable conservatism which underlies the everyday concept of art as opposed to the concepts of art that aestheticians and practicing artists (and I think to a lesser extent, critics) employ or propose. Thus, instead of either of the foregoing, we find many actual instances of (c) philosophical concepts of art, proposed in the form of real definitions, which in point of fact consist in "honorific redefinitions" of the everyday concept of art. This important fact was clearly pointed out by Morris Weitz in his now-classic "The Role of Theory in Aesthetics," to which we have already referred earlier in this book. An interesting point not noted by Weitz is that the various concepts of art proposed by many classical and recent aestheticians (the Expression theory, Tolstoy's Communication theory, Formalism, Intuitionism, Organicism, and so on), which claim to demarcate the concept of art in general employment, are (i) *honorific* in nature, and (ii) *redefinitions*, only if we think of them (as Weitz himself does) in relation to the everyday concept of art. Considered in themselves they are, logically speaking, examples of the transformation of some or all of the criteria of goodness that are in currency at the particular time—or

of certain new criteria proposed by the particular aesthetician—into criteria of art in the descriptive sense. The result is a descriptive (at least in intent) use of 'art' that is narrower than (and different from, not only with respect to borders) the word's everyday descriptive use.

Weitz and other aestheticians, such as W. B. Gallie and Beryl Lake, have given us an important explanation of this phenomenon. But in some instances at least, it probably falls short of the whole explanation. For one way well wonder why so many aestheticians, some quite different from others in temperament or outlook, separated by decades or even centuries, should so consistently conform to the same pattern, especially as this pattern is rightly regarded by Weitz, Gallie, Lake, and so forth as being unwitting or unconscious. The aesthetician, so the explanation goes, thinks he is doing one thing, but, in effect, does something quite different. He wishes to dramatize a certain selection of criteria of *goodness*, as the really important or valid (or the *only* really important or valid) criteria of goodness (Lake); what he in fact does is to refashion a concept of art different and narrower in some respects from the current everyday concept of art (Weitz). So the question persistently arises: Why does he not say in plain language that such and such criteria of goodness are really the most important, or even the only, valid criteria of goodness? Is it merely muddleheadedness that prevents him from doing so; or is it merely an unconscious or semiconscious fear that if he did do so the chances of his stipulation or recommendation being accepted would be greatly diminished? For it appears to be a psychological fact that stipulations disguised as statements of putative fact are generally more effective or persuasive than overt stipulations. Such disguised recommendations help "make true" what they seem to be saying *is* true!

I do not think so; though both of these factors are probably present in many instances. My view is that there is a strictly philosophical explanation, in terms of the history of philosophy itself, of this rather curious phenomenon. The key to it, and I offer it only as a partial explanation, is the nature of definition as conceived by Plato and especially (or at least more explicitly) by Aristotle, which like the rest of their philosophy exerted a great influence

on subsequent philosophic thought. By this, I mean Plato's identification of a thing's essence with its peculiar goal or purpose, and Aristotle's identification of a thing's formal and final causes, at least with regard to animate things. Consequently, a definition of something "X" in the Platonic or Aristotelian manner is framed in terms of X's purpose or goal, which is thought of as providing its defining features or essence (form). Thus 'art' is defined in terms of its (alleged) aims or final cause; and the latter is identified with the essence of art. A clear example is provided by Tolstoy. Instead of saying "Art aims at the communication of the artist's emotions . . . ," Tolstoy says "Art *is* the communication of the artist's emotions. . . ." But it must also be said in fairness that he does say such things as "Art . . . is a means of communication . . ."; and "it [art] is a means of union among men. . . ." [21] As a consequence of the former way of speaking, the distinction between good and poor art is seen as a distinction between *degrees* or *extents* of communication; whereas, if communication is not converted from a criterion of goodness into a criterion of art in the descriptive sense of the word, all sorts of things could be called art even if they are incapable of communicating any feelings or emotions in *any* degree. Because of Tolstoy's confusion, such things cannot possibly be works of art, even extremely poor art.[22] Hence a logical switch occurs, from what *should be* or *ought to be* to what *is* the case. The "actual" is defined (understood and explained) in terms of the "ideal." In the case of Plato and Aristotle, this is the logical counterpart of Plato's Logical Realism and Aristotle's metaphysics. But compare and contrast "Man *is* a *rational* animal."

The above remarks apply, *mutatis mutandis*, to the other theories or types of theories Weitz considers, such as the Expression theory, Formalism, and Organicism.

NOTES

1. "Psycho-analysis and Literary Criticism," *Selected Writings of Herbert Read* (New York, 1964), p. 99.

2. I use 'type (or kind) of value' merely for convenience, because it is in current use. But I should make it clear that this is not intended to imply that there is some kind of entity—quality, relation, and so on—called "value," of which there are various species. Nor do I wish to imply that there are entities called "moral values," "aesthetic values," and so forth though not an abstract universal called "value." The bases of the classification of "values" into types or kinds, as far as I am concerned, are (1) the subject matter in question—moral conduct, works of art and natural beauties, and so on—in relation to which we apply various grading labels; and (2) the sorts of reasons we can justifiably give for our value judgments, in each type of situation or case. (1) and (2) in turn determine the distinction between different senses—moral, aesthetic, and so on —of the grading labels that can occur in these value judgments.

3. This should be distinguished from the fact, noted in an earlier chapter, that if a work *has aesthetic merit* its preservation would be a good thing, while its destruction or loss would be a bad thing.

4. Of course, the effect of ephemeral art can linger in the mind and heart long after the work ceases to exist. But because of the brevity of its life, it cannot be enjoyed—and cannot be enjoyed over and over again— by many people.

5. The prizing of intensity theoretically allies the young with the older generations. In actual fact it separates them, for the capacity and the desire for intensity unfortunately tend to decrease with age.

6. This is a very common and important phenomenon. Life values, particularly moral values, have very often influenced and changed aesthetic values; but the opposite has seldom if ever happened in the West. (I do not know whether it has ever happened in the East, either.)

7. It is noteworthy, however, that this fits nicely with the more radical views of some linguistic philosophers, such as Stuart Hampshire and Margaret Macdonald, regarding aesthetic valuation and general standards of value.

8. Cf. Lessing's discussion, in *Laocoön*, of the demands of beauty as against the demands of "truth and expression," and the triumph of the former in the celebrated statuary known as the *Laocoön*.

9. Cf. Nietzsche's discussion of the role of the Apollonian element in the evolution of classical Greek (Hellenic) art and its culmination in the fusion of the Apollonian and Dionysian impulses in Attic tragedy. (*Op. cit., passim.*)

10. *Op. cit.,* p. 300.

11. Cf. Lessing, *op. cit.,* p. 132.

12. This is one reason why I think Tolstoy greatly exaggerates the actual influence of the various religions—or what he calls the religious perception of the age—on what the particular age or society (generally) deems good or bad art. (Cf. *Philosophy of Art and Aesthetics,* pp. 381–82.)

13. "The Gap Between Intuition and Expression," in M. Rader, *op. cit.,* pp. 104–05.

14. For instance by Nicholas Rescher, in "Evaluative Metaphysics," *Metaphysics and Explanation* (Pittsburgh, [n.d.]), pp. 62–72.

15. The everyday concept of art as a general rule is more conservative, lagging behind some or all of the concepts of art formed or utilized by the progressive critics and, especially, by the trail-blazing artists of the age. But it is more progressive than many of the concepts of art formulated by aestheticians!

16. November 14, 1969, p. 56.

17. *Ibid.*

18. *Ibid.*

19. Sydney Art Critic James Gleeson significantly says: "It pleases the eye and it is mysterious. Our uncertainty *as to whether we are responding to the beauty of nature or the beauty of art* merely adds piquancy to the experience." (*Ibid.* My italics.)

20. Discontinuity in some contemporary works of art is a further reflection of the present age in the West, and illustrates the rejection of certain traditional aesthetic values and their replacement by other, newer values.

21. *Philosophy of Art and Aesthetics,* pp. 385, 379, and *passim.*

22. The confusion of criteria of goodness and—or their transformation into—criteria of art as a whole is clearly seen in Tolstoy's discussion of the three conditions: individuality, clearness, and sincerity, which according to him decide "the merit of a work of art, as art, apart from subject-matter." He says: "Thus [by means of these three conditions] is *art divided from not art,* and thus is the *quality of art, as art,* decided, independently of its subject-matter. . . ." (*Ibid.,* p. 384. My italics.) It is noteworthy, however, that Tolstoy's second criterion or standard of aesthetic goodness, whether the feelings a work transmits are good or bad, does not suffer any transformation; since its application presupposes that what is so judged *is* art, on the basis of the *first* criterion or standard.

Index